EXTRA/ORDIN/

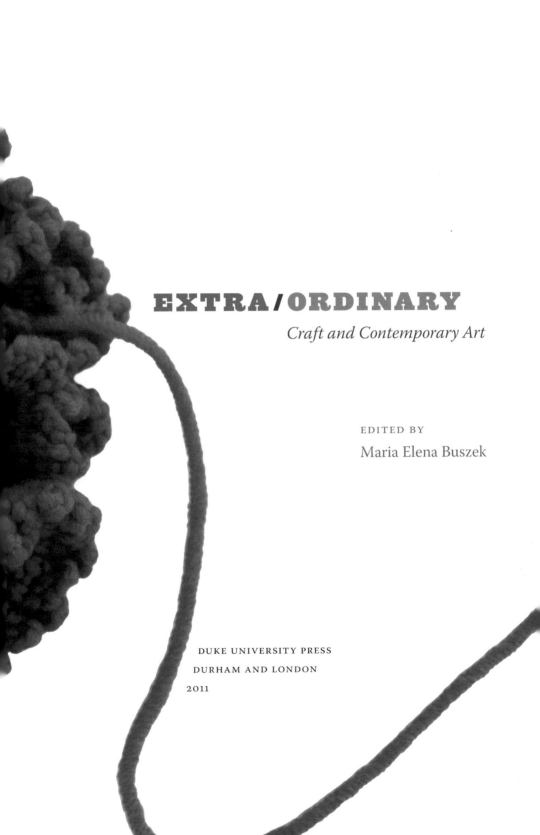

EXTRA/ORDINARY

Craft and Contemporary Art

EDITED BY

Maria Elena Buszek

DUKE UNIVERSITY PRESS

DURHAM AND LONDON

2011

Printed in the United States of America
on acid-free paper ∞

Designed by Heather Hensley

Typeset in Warnock Pro by
Tseng Information Systems, Inc.

Library of Congress Cataloging-in-
Publication Data appear on the last
printed page of this book.

Duke University Press gratefully
acknowledges the support of the Center
for Craft Creativity and Design, which
provided funds toward the production
of this book.

CONTENTS

vii List of Illustrations

xi Acknowledgments

1 Introduction: The Ordinary Made Extra/Ordinary
Maria Elena Buszek

REDEFINING CRAFT: NEW THEORY

23 Making and Naming: The Lexicon of Studio Craft
M. Anna Fariello

43 Validity Is in the Eye of the Beholder:
Mapping Craft Communities of Practice
Dennis Stevens

59 Super-Objects: Craft as an Aesthetic Position
Louise Mazanti

83 Fabrication and Encounter: When Content Is a Verb
Paula Owen

CRAFT SHOW: IN THE REALM OF "FINE ARTS"

99 How the Ordinary Becomes Extraordinary:
The Modern Eye and the Quilt as Art Form
Karin E. Peterson

115 Wallpaper, the Decorative, and Contemporary Installation Art
Elissa Auther

135 Handwork and Hybrids: Recasting the Craft of Letterpress Printing
Betty Bright

153 Elastic/Expanding: Contemporary Conceptual Ceramics
Jo Dahn

CRAFTIVISM

175 Craftivist History
Betsy Greer

184 Rebellious Doilies and Subversive Stitches:
Writing a Craftivist History
Kirsty Robertson

204 Craft Hard Die Free: Radical Curatorial Strategies for Craftivism
Anthea Black and Nicole Burisch

222 Loving Attention: An Outburst of Craft in Contemporary Art
Janis Jefferies

NEW FUNCTIONS, NEW FRONTIERS

243 Put Your Thing Down, Flip It, and Reverse It:
Reimagining Craft Identities Using Tactics of Queer Theory
Lacey Jane Roberts

260 Men Who Make: The "Flow" of the Amateur Designer/Maker
Andrew Jackson

276 Crochet and the Cosmos: An Interview with Margaret Wertheim
Maria Elena Buszek

291 Contributors

295 Index

ILLUSTRATIONS

INTRODUCTION

1 Gael García Bernal and Charlotte Gainsbourg in *The Science of Sleep* • 2

2 Joyce Scott, *Out To Dry*, 1991 • 6

3 Ghada Amer, *Another Spring*, 2005 • 7

4 Yinka Shonibare, *Three Graces*, 2001 • 9

5.1, 5.2, and 5.3 Janine Antoni, *Slumber*, 1993 • 10

6 Sonya Y. S. Clark, *Afro Abe II*, 2007 • 12

FARIELLO

1 Doris Ulmann, portrait of Ethel May Stiles, 1930s • 25

2 Iron sketch by Samuel Yellin Metalworkers • 29

3 Young African American women in woodworking studio, Hampton Institute, Virginia • 31

4 Fireside Industries students at Berea College, before 1904 • 33

5 Cherokee basket weaver Eva Wolfe with river cane baskets • 37

6 Catalogue cover for Rose Slivka's *The Object as Poet*, 1976 • 38

MAZANTI

1 Alev Siesbye, untitled bowls, 2004 • 63

2 Justin Novak, *MotelHaus Objects*, 2003 • 63

3 Edmund de Waal, *The Long View*, 2007 • 64

4 Edmund de Waal, *Predella II*, detail from *The Long View*, 2007 • 64

5 Jes Brinch and Henrik Plenge Jakobsen, *Smashed Parking*, 1994 • 66

6 LifeStraw®, 2005 • 69

7 Anne Tophøj, *Cultured Primitiveness—Exclusively Folksy*, 2005 • 76

8 Anne Tophøj, detail from *Cultured Primitiveness—Exclusively Folksy*, 2005 • 76

9 Anne Tophøj, detail from *Cultured Primitiveness—Exclusively Folksy*, 2005 • 77

OWEN

1 Ann Hamilton, *Indigo Blue*, installation/performance, 1991/2007 · 87
2 Ann Hamilton, *Indigo Blue* (detail), installation/performance, 1991/2007 · 87
3 Bean Finneran, *Red Oval*, 2008 · 91
4 Piper Shepard, *Chambers* (detail), 2002 · 91
5 Josiah McElheny, *From an Historical Anecdote about Fashion*, 2000 · 92
6 Elaine Reichek, *Sampler (The Ultimate)*, 1996 · 94

PETERSON

1 Untitled "Bars quilt," ca. 1890–1910 · 102

AUTHER

1 Andy Warhol, untitled (*Cow Wallpaper*), 1966 · 116
2 General Idea, *AIDS*, 1988 · 123
3 Robert Gober, untitled, 1989 · 124
4 Virgil Marti, *For Oscar Wilde*, 1995 · 128

BRIGHT

1 Robin Price in collaboration with Emily K. Larned et al., *Slurring at bottom: a printer's book of errors*, 2001 · 141
2 Robin Price in collaboration with Emily K. Larned et al., *Slurring at bottom: a printer's book of errors*, 2001 · 142
3 Ken Campbell, *Firedogs*, 1991 · 144
4 Ken Campbell, *Firedogs*, 1991 · 146

DAHN

1.1 Keith Harrison, *Last Supper*, 2006 · 154
1.2 Keith Harrison, *Last Supper* (detail), 2006 · 154
2 Clare Twomey, *Trophy*, 2006 · 156
3 David Cushway, *Sublimation* (detail), 2000 · 163
4 Clare Twomey, *Consciousness/Conscience* (detail), 2000 · 165
5 Daniel Allen, untitled, from *The Absent Figure* series I, 2005 · 168

GREER

1 Betsy Greer, *Anti-War Graffiti Cross-Stitch*, 2007–8 · 181
2 Betsy Greer, *Anti-War Graffiti Cross-Stitch*, 2007–8 · 181
3 Cat Mazza, screen capture of knitPro program · 182
4 Legwarmers appropriating commercial logo · 182

ROBERTSON

1 Greenham Women's blockade of Brawdy Airfield Pembrokeshire, 1982 • 185

2 Marianne Jørgensen with the Cast Off Knitters, *Pink M.24 Chaffee*, 2006 • 197

3 Lisa Anne Auerbach, *Warm Sweaters for the New Cold War*, Steal This Sweater project, 2006 • 198

4 I Knit UK, one portion of the Knit a River (for Water Aid) project, May 2007 • 199

BLACK AND BURISCH

1 Peace Knits banner, 2005 • 207

2 and 3 Marianne Jørgensen with the Cast Off Knitters, *Pink M.24 Chaffee* (in progress), 2006 • 208

4 Barb Hunt, *antipersonnel*, begun in 1998 • 209

5.1 and 5.2 Barb Hunt, *antipersonnel* (details) • 211

6 and 7 Wednesday Lupypciw's Handi Crafts, Handy Cats workshop, 2006 • 213

8 Revolutionary Knitting Circle of Calgary, Peace Knits banner; Kris Lindskoog, *I want to do something nice for the planet*, 2006 • 216

9 "Craftivism" panel discussion at Stride Gallery, August 5, 2006 • 217

JEFFERIES

1 Participants in Shane Waltener's *Sweet Nothings: An Intimate History of Cake Making*, 2005 • 233

2 Shane Waltener, *Sweet Nothings: An Intimate History of Cake Making* (detail), 2005 • 234

3.1 Sonya Schonberger at work, 2007 • 236

3.2 "Extreme Crafts," Contemporary Art Center, Vilnius, Lithuania, 2007 • 236

ROBERTS

1 Lia Cook's Jacquard loom, pictured with *Resting Digits*, 2005 • 250

2 Lia Cook, *Big Baby*, 2001 • 250

3 Liz Collins and Knitting Nation performing on Governor's Island, 2005 • 252

4 Liz Collins with her knitting machine • 252

5 Josh Faught, *Nobody Knows I'm a Lesbian*, 2006 • 256

6 Josh Faught, *Nobody Knows I'm a Lesbian* (detail), 2006 • 256

JACKSON

1 Glynn Edwards, sea kayak, 2006 · 261

2 How-to illustration, *Practical Householder* (UK), August 1961 · 262

3 The Amateur/Professional continuum · 264

4 *Make: Technology on Your Time* cover, February 2005 · 271

BUSZEK

1 Margaret Wertheim, *Orange Anemone*, from the *Hyperbolic Crochet Coral Reef* · 277

2 The Institute for Figuring, *Hyperbolic Crochet Coral Reef* · 280

3 *Ladies Silurian Atoll*, from the *Hyperbolic Crochet Coral Reef* · 282

4 The Institute for Figuring, *Hyperbolic Crochet Coral Reef*, 2009 · 285

ACKNOWLEDGMENTS

The editor would like to express her appreciation to the contributors of *Extra/Ordinary: Craft and Contemporary Art* for their hard work in developing the essays for this volume and tracking down the works that illustrate them. Thanks, too, to the many artists, galleries, and institutions that helped us in our endeavor to make this book as beautifully illustrated as it is thought provoking. I am truly indebted to the many scholars, critics, curators, and artists who first encouraged me to find an outlet for the bridge-building scholarship and artwork to which this book is dedicated, particularly Michele Fricke, Garth Johnson, Glenn Adamson, Namita Gupta Wiggers, Patricia Malarcher, Carolyn Kallenborn, Cary Esser, Mo Dickens, and my students at the Kansas City Art Institute, where I taught in the years that this book came to fruition, and whose work never ceased to inspire me with its boundary-shattering brilliance. I am also grateful to Duke University Press's editorial director, Ken Wissoker, for taking on this project and for the guidance he and his editorial staff (especially Leigh Barnwell and Tim Elfenbein) provided to see it to completion. Duke's anonymous peer reviewers offered thoughtful, generous comments that shaped the book's final form.

The editor and contributors all wish to acknowledge that their work was supported by a Craft Research Fund Grant from the University of North Carolina, Center for Craft, Creativity and Design. Lacey Jane Roberts's essay was additionally supported by the Center for Craft, Creativity and Design through its Graduate Research Grant. The CCCD's financial support was absolutely crucial to the completion and publication of this volume, and its long-standing dedication to the funding of craft research is

unique and commendable. We are honored by its decision to support this project so generously.

Finally, several of the contributors would like to thank the various institutions, conferences, and publications that nurtured the research published here. A previous version of Dennis Stevens's essay was published in the proceedings of the New Craft Future Voices Conference organized in 2007 by Duncan of Jordanstone College of Art and Design in Dundee, Scotland. Additionally, an excerpt from his essay was included within an article titled "Redefining Craft: From Front, Back and Side to Side" published in the October/November 2009 issue of *American Craft* magazine. An earlier version of Karin Peterson's essay appeared in the Winter 2003 issue of the journal *Sociological Perspectives*. Kirsty Robertson is grateful to the Social Sciences and Humanities Research Council of Canada and the Dean's Travel Grant, University of Western Ontario, for providing research funding for her contribution. An earlier version of Anthea Black's and Nicole Burisch's essay "Craft Hard Die Free" was presented at the New Craft, Future Voices Conference, and the authors wish to acknowledge the Canada Council for funding the research and presentation of this essay. Andrew Jackson presented earlier versions of his chapter at the Conference of the European Academy of Design at the Izmir University of Economics, Turkey, in 2007 and at the New Craft, Future Voices conference. His thanks go to the referees and delegates at those events for their helpful feedback and advice.

ᴀry **Made Extra/Ordinary**

In Michel Gondry's film *Science of Sleep* (2006), the director's alter ego, Stéphane, summarizes his attraction to the female protagonist Stéphanie when he says: "She makes things with her hands. It's as if her synapses were connected directly to her fingers."[1] Like Stéphane and Stéphanie falling in love as they play with Stéphanie's cloth and yarn sculptures, audiences have fallen in love with Gondry's works through his spectacular manipulation of these very "low-tech" materials in films like *Eternal Sunshine of the Spotless Mind* and music videos for artists such as Björk and the White Stripes, which present worlds where musicians play knitted instruments and stuffed animals come to life (see fig. 1). The essays in this anthology propose that it is unsurprising that such old-fashioned, handmade images and objects should resonate with artists and audiences in our high-tech world. In today's information age the sensuous, tactile "information" of craft media speaks, as Stéphane does, of a direct connection to humanity that is perhaps endangered, or at the very least being rapidly reconfigured in our technologically saturated, twenty-first-century lives—thus, demonstrating the extraordinary potential of these seemingly ordinary media and processes.

This return to the handmade associations of craft media is one that the contemporary art world has been exploring in relation to just this issue. (In fact, to coincide with the film's release, Gondry's meticulously made props and sets were exhibited at New York City's blue-chip Deitch Gallery as exemplary of this phenomenon.)[2] This impetus to counter the tyrannical pressure of technology with handicraft is nothing new. Since the early nineteenth century, Arts and Crafts pioneers such as the English

1 Gael García Bernal as Stepháne and Charlotte Gainsbourg as Stephánie in director Michel Gondry's *The Science of Sleep*, a Warner Independent Pictures release. Photo: Etienne George.

critic John Ruskin and the artist William Morris proposed that the particularities of craft knowledge might temper the corrupting influence of the Industrial Revolution with the righteous, even spiritual, nature of thoughtful labor, and the Studio Craft movement that rose in its wake has consistently posited this same notion as technology has become increasingly ubiquitous in our lives. As articulated by the art historian Glenn Adamson, this "pastoral" perspective of craft traditions, taken up in defiance of our exponentially more high-tech world, has led to romantic associations with media such as clay, fiber, glass, and wood by both the artists and collectors drawn to them.[3] But these associations have given way to a dilemma for emerging artists working in craft media today: the craft world that embraces and promotes these media is nearly as exclusive in its insistence upon maintaining the romance of these media as the so-called art world is in its romance with the conceptual. Contemporary artists working in these media with a primarily conceptual bent are caught in the middle, finding acceptance in neither camp, a situation that led the art historian Howard Risatti to declare less than a decade ago that "the role and identity of craft in modern and postmodern society are probably the most important issues facing the field today."[4]

Alas, Risatti's solution to this identity crisis has been to encourage artists working in craft media to draw strength from the various functions that those media have historically provided and to focus on that which has historically differentiated the "applied arts" from the "fine arts"—a solution embraced even by those who have actively sought to elevate the status of craft media in the contemporary art world.[5] Indeed, most writing on artists working in such media not only tends to take for granted historical tendencies to associate them with a "craft culture" separate from fine arts traditions but also proudly discusses and dissects this separation as a badge of honor. As a contemporary art scholar, I find it interesting that this strategy appears to have been born of the same era and philosophical underpinnings as the modernist art theory that strictly policed and prioritized such divisions of art and craft in the first place. As the art historian M. Anna Fariello has argued, if we are to use perspectives from Ruskin to the feminist scholar Roszika Parker as our point of departure, the still-lingering definitions of craft as "technical knowledge" and art as "aesthetic" or "conceptual knowledge" arguably began not with late modernism but the era that literary scholars call "early modern," with the hierarchies imposed upon the arts by the High Renaissance.[6]

Ironically, however, the Arts and Crafts movement that Ruskin's writing instigated ultimately proved as elitist as it was naive, as criticism on the subject of craft doubled back to focus not on the everyday and sociohistorical relevance of craft media but on the preciousness and particularities of those media in regard to the objects they produced. As the Industrial Revolution progressed and many craft practitioners came to embrace its potential on both creative and social levels, the principles of the international Arts and Crafts movement that emerged in the mid-nineteenth century had by the mid-twentieth merged with those of the period's modernist movement, as the alleged "honesty" and "transparency" of craft media were embraced by a generation of artists in the years around the Second World War. During this time, the "high modernist" theory of intellectuals such as Clement Greenberg was held up as a template by which great art might be judged and created. It provided a model that promoted works that rejected the sentimental or propagandistic qualities of popular culture and embraced what Greenberg posited as a continuum of "genuine" modern art that began with Edouard Manet's break from realism and the impressionists' subsequent search for a self-critical process of art production—a process that

Greenberg believed "logically" led not only to a constantly progressing avant-garde perpetually beyond the grasp of the limited intelligence of the masses but also specifically to a contemporary art that embraced abstraction and truth to materials.[7]

This was also the moment in the United States when, as intellectuals like Greenberg tracked the development of the avant-garde out of Europe and into the then-contemporary American abstract-expressionist movement, the GI Bill transformed art education—and the conflation of these phenomena, in turn, transformed craft culture as art departments expanded to include, and often combine, fine and applied art programs as students in record numbers and from an unprecedented range of backgrounds entered American colleges.[8] In this environment, the studio practices sanctioned by modernist theory crossed over into functional craft—where artists embraced its principles of a medium's "essence" as part of their chosen media's history—and, as Risatti and others have written, so-called studio or fine craft emerged to claim these media, liberated from function, as just another in the growing toolbox of the contemporary abstract artist.[9] Groundbreaking ceramists like Peter Voulkos and Jim Leedy and fiber artists such as Lenore Tawney emerged in this heady time, creating expressive, sensuous, abstract work very much of a generational piece with the canvases of contemporaries such as Mark Rothko and Helen Frankenthaler.

But, interestingly enough, Greenberg's influence reached its apex at precisely the point at which new art developments had formed to pose challenges to his particular, inflexible continuum of art history's "natural" development, as artists of what would come to be referred to as the "postmodern" era emerged to challenge Greenberg's narrow and "self-reflective" definitions of art. While such theory rightfully defended the historical relevance of creative avant-gardes and experiments with abstraction since the nineteenth century, in the process it also expressed a disdain for—indeed, generally defined art *against*—work from or influenced by the realms of the popular or the utilitarian. And as part of a larger project of questioning the increasingly stringent limitations of modernist theory against which artists were beginning to chafe in the years immediately following the Second World War, artists across the Western world began to gravitate toward popular imagery, genres, and media. Artists such as Robert Rauschenberg and Agnes Martin applied their education in abstract expressionism toward works that referenced (indeed, in the case of Rauschenberg's groundbreaking *Bed* of 1955, lit-

erally utilized) quilts and decorative-art patterns in ways that little resembled modernists' model of abstraction's "pure" visuality; pop and "funk" artists like the ceramist Robert Arneson were creating works in craft media that directly appropriated kitschy pop-cultural and scatological objects and drew attention to their revelatory potential; and artists' collectives such as Fluxus and the Situationist International brought together work in media like clay and letterpress with high-tech new media such as audiotape and video in ways that reflected their respective desire to mix and merge the historically separated concepts of art and life. Clement Greenberg's influential theory of a linear and elite history of art—or what he called art's avant-garde "mainstream"—would be rejected by these artists in favor of an altogether different mainstream: one that looked to common rather than elite culture for inspiration.

That not only marginalized media but individuals would move from the sidelines to an increasingly central role in postmodern art practices should not be surprising given the value that their generation placed on the media and genres of so-called low culture as an alternative to modernism's sense of art-with-a-capital-A. Contrary to the aesthetic and moral values that Greenberg had previously placed on a straight, male, Eurocentric artistic elite and its specialized audience, early postmodern artists placed great faith in the value of folk and popular arts that had traditionally been viewed as the realm of women's, queer, and non-Western cultures as a means of communicating beyond an elite community and letting the "real" world back into the art world. Such strategies would also bring a political charge to this work and these arts, as evidenced in the use of ceramic, fiber, and bead work by artists—such as Faith Ringgold, Judy Chicago, Joyce Scott (see fig. 2), and Miriam Schapiro—coming from the era's civil rights and feminist movements. The doors that this generation opened for those that followed have led to a view that craft media are simply among many that may or may not serve any artist's purpose in our contemporary art world. For artists working today media, naturally, still matter—but they are generally chosen with regard to the sociohistorical underpinnings of a medium, rather than any essential regard for or desire to plumb its unique material properties. Today we enjoy an art world where artists like Cindy Sherman have the opportunity to apply their concepts to media as different (and previously denigrated) as photography and ceramics; artists like Jeff Koons can build bodies of work around the economic and historical meanings behind porcelain and polychromed wood; and Ghada

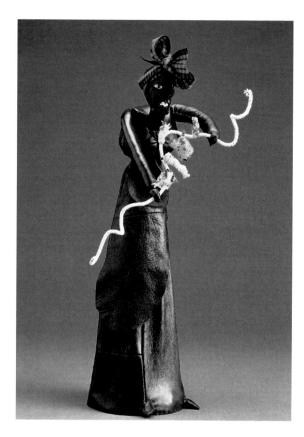

2 Joyce Scott, *Out To Dry*, 1991, beads, leather, wire, and fabric, 20 × 8 × 8 inches. Photo: K. Takeno.

Amer can build an entire career around the simultaneous "masculine heroism" and "feminine handiwork" of her monumental, stitched paintings (see fig. 3). Emerging artists in today's art world enjoy a tremendous amount of freedom in exploring such craft media—so much so, in fact, that one might argue that art students today often take this freedom for granted as they develop their studio practice.

But these artists have not been embraced, or even acknowledged by the museums, magazines, and of course academic programs that emphasize craft in their mission. This returns us to the lingering "romance" of craft that these institutions too frequently perpetuate. Granted, few of these artists obsess over conventions of "craftmanship" or are completely—or, in the case of Koons, even remotely—involved in the actual making of their work in craft media. And this fact leads us back to the issue of the primacy of materials by which most artists working in— and, moreover, critics and scholars writing about—craft media still

3 Ghada Amer, *Another Spring*, 2005, acrylic, embroidery, and gel medium on canvas, 78 × 72 inches. Copyright Ghada Amer, courtesy Gagosian Gallery.

judge them, and by extension construct what "counts" as craft today. Indeed, as the art historian Jean Robinson has rightfully argued, craft criticism "has not kept pace with [these] artists," turning as it does "on description, biography, formal analysis or technical advice; if content is discussed, [it is] ignored or downplayed."[10] And with the exception of texts such as Roszika Parker's groundbreaking *The Subversive Stitch* and recent anthologies such as the late Peter Dormer's *The Culture of Craft* and Fariello's and Paula Owen's *Objects and Meaning*, it appears that scholarship attempting to redress this problem of craft discourse in relation to contemporary art is rare. It is striking that it took until the publication in 2007 of Glenn Adamson's *Thinking through Craft* for a prominent member of one of these craft-focused institutions (Adamson is a curator and head of research and graduate studies at the Victoria and Albert Museum) to prove willing not only to challenge the nostalgic—and, as he points out, frequently disingenuous—"pastoral" fetish of his community but to do so while engaging the work and theory of the broader contemporary art world in a significant, single-volume scholarly treatise.

Galleries and museums do better by artists in their willingness and ability to spotlight work that falls between the cracks. This is evidenced, in the last decade or so, in groundbreaking shows such as the New Museum of Contemporary Art's "Labor of Love" in 1996, and the South London Gallery's "Lovecraft" in 1998; more recent exhibitions like "Extreme Crafts" at the Center for Contemporary Art in Vilnius, Lithuania, and the British Crafts Council's traveling "Boys Who Sew"; the wildly popular "Radical Lace and Subversive Knitting" and "Pricked: Extreme Embroidery" exhibitions at the Museum of Arts and Design (formerly the American Craft Museum); and the cutting-edge curatorial philosophy of museums such as the Museum of Contemporary Craft in Portland, Oregon. In this same span of time, efforts to recognize the blurring lines between art and craft resulted in changes of name for institutions like the American Craft Museum: the California College of Arts and Crafts became California College of the Arts; the Kentucky Foundation of Arts and Crafts became Kentucky Museum of Art and Design; and the Southwest Center for Craft added the word *art* to its title. These decisions caused tremendous dismay among members of the studio craft community, who had largely failed to notice the increasing presence of craft media in venerable contemporary art exhibitions worldwide— for example, Ricky Swallow's wood sculptures representing Australia

4 Yinka Shonibare, *Three Graces*, 2001, printed cotton textile, three fiberglass mannequins, and three aluminum bases. Installation: 63¼ × 64 × 89½ inches. Collection of the Speed Art Museum, Louisville, Kentucky.

in the 2005 Venice Biennale and the notorious "quilter" Tracy Emin's work representing England in 2007; Kori Newkirk's beaded sculpture and the Forcefield collective's fiber sculptures and costumes included in recent Whitney Biennials; and artists such as Emin, Grayson Perry, Yinka Shonibare (see fig. 4), and Simon Starling, who were nominated for and awarded England's prestigious Turner Prize after each came to prominence for work in clay, fiber, and wood. Today one also finds artists like the ceramist Clare Twomey and the woodcarver Yoshihiro Suda, who are relatively traditional practitioners in their media but with undeniably sophisticated conceptual strengths, embraced by international curators and gallerists of all stripes—to say nothing of world-renowned artists such as Annette Messager, Mike Kelley, Kiki Smith, Rosemarie Trockel, and Janine Antoni (see fig. 5), in whose respective, decade-spanning oeuvres craft media have been extensively explored. Still, catalogues with scholarly essays that go beyond Robinson's noted "description, biography, formal analysis or technical advice" in regard to the historical and conceptual relevance of craft media are relatively

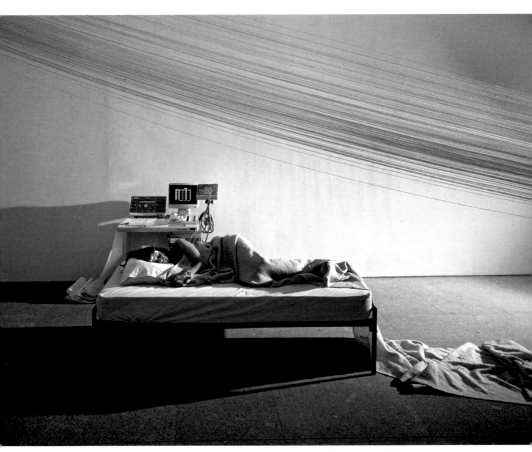

5.1, 5.2, and 5.3 Janine Antoni, *Slumber*, 1993, performance with loom, yarn, bed, nightgown, EEG machine, and artist's REM reading, dimensions variable. Courtesy of the artist and Luhring Augustine, New York.

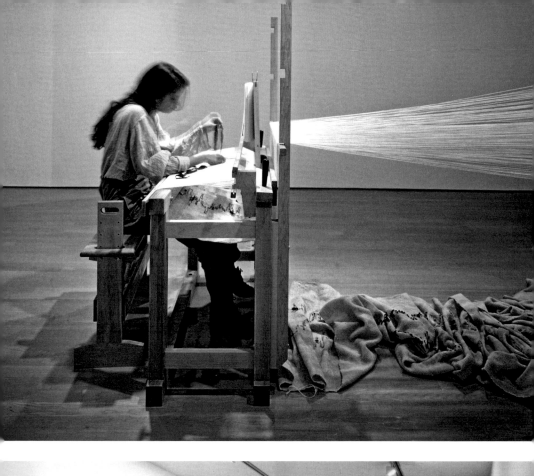
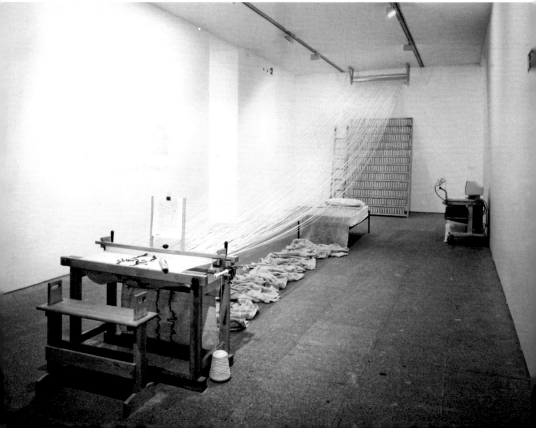

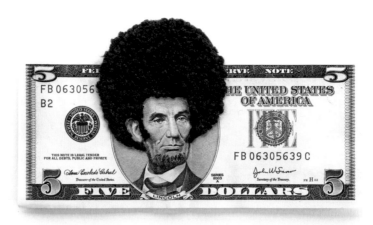

6 Sonya Y. S. Clark, *Afro Abe II*, 2007, thread and five-dollar bill.
Photo: Taylor Dabney.

few and far between. I hope that the essays in this anthology will begin
to fill the void.

These essays seek to further the sense of meaning with which craft
media have been imbued in the years since the dawn of postmodernism.
On the one hand, the authors pay homage to the sociohistorical tradi-
tions through which the blurring of lines between art and craft began
with the Arts and Crafts and Studio Craft movements; on the other, they
have the arguably unprecedented luxury of a contemporary discourse
and market that takes these disintegrating lines for granted. The essays
demonstrate that many artists drawing on craft culture do so in ways
that revel in its boundary-crossing potential, but in ironic and ambiva-
lent ways different from (or even poking gentle fun at) the romantic or
moralizing sensibility with which their predecessors often approached
these media—a fact made immediately clear when one compares the
subtle abyss that separates the work of Joyce Scott from, say, that of
Sonya Clark (see fig. 6). Both of these celebrated artists work primarily
with fiber, stitching, and beads, and both are dedicated to work address-
ing the relevance of women's and African American history from a de-
cidedly political perspective, yet the form that their work takes and the
statements it makes reflect the differences between the craft of their re-
spective generations—differences that the contributors to this volume

attempt to articulate. Yet this book's authors also pay homage to the traditions that contemporary craft references, recognizing the potential of these traditions to transform the ordinary into something surprising, subversive, and poignant, even when "craft" is addressed in performance rather than pots, or process rather than product. The result, I believe, will help to introduce the art world to the sophisticated thought concerning the craft culture referenced and celebrated by artists promoting new ways of thinking about the role of craft in contemporary art. By that same token, I hope that it will similarly instigate a much-needed dialogue between this generation of (what the ceramist and webmaster Garth Johnson calls) "Extreme Crafters" and their predecessors—who at present are, at best, working in a parallel universe to (or, at worst, with confusion or disdain toward) many of the emerging, conceptually focused artists whose work actually depends on and pays homage to the trails blazed by their predecessors.

.

This book begins with a series of essays that break down the history of craft traditions and the fraught relationship of craft to the fine arts as developed and defined since the nineteenth century. All these essays also analyze this history to posit new theories concerning the role of craft media in the twenty-first-century art world. M. Anna Fariello's essay "Making and Naming: The Lexicon of Studio Craft" analyzes groundbreaking nineteenth- and twentieth-century texts on craft theory and education rooted in the relevance of hand skill, revealing the ways in which craft culture has historically defined itself against the so-called fine arts. Fariello compellingly makes the case that has been argued by the craft community for 150 years: that craft theory cannot be assimilated neatly into that of contemporary art but instead merits its own language and measures. Dennis Stevens, however, in "Validity Is in the Eye of the Beholder," argues that the domain of craft is at a generational crossroads and is presently expanding to embrace aspects of cultural hybridization that have not previously been recognized or articulated within the traditional studio craft community whose definitions of craft Fariello reasserts. He contends that while the field is still adhering to disciplinary boundaries of the twentieth century—where groups organize themselves according to the materials and associated processes of their chosen medium—it is also expanding in the twenty-first century

into areas not previously considered. Stevens also credits the rise of what the media has coined the "Netroots" movement as impacting the field of craft, as many of the Generation-X and Generation-Y makers are using the democracy of the Internet and its nonhierarchical and decentralized format not only to market their work but also to express their views and exchange and debate ideas in contradistinction to the baby boomers, who have been in the position to dominate the institutions and markets on which these fields have been dependent for the last several decades. Stevens forcefully argues that the studio craft community needs to pay close attention to this new generation of crafters or risk obsolescence, as those who would be their successors are joining the fray of today's interdisciplinary and technologically minded art discourse—with or without them.

Louise Mazanti's essay "Super-Objects" offers "a theory for contemporary, conceptual craft" that stands between Fariello's and Stevens's very different perspectives. While Mazanti agrees with Stevens that craft practices should no longer be inextricably bound to their specific material, she also agrees with Fariello's perspective that the inherent associations of hand making and sensuality with craft media afford it the potential to unite art and everyday life that objects of so-called fine art do not. Citing Hal Foster's call for a "semi-autonomous" object in contemporary art, Mazanti argues that many contemporary artists are drawn to craft media because they produce "super-objects": alternatives to the world of things among the world of things itself, which occupy a unique position in visual culture, different from either art or design but drawing on (and even binding) both. In this way, Mazanti proposes craft as a practice that aims to integrate the utopian intellectual ideals of art within the practical objects of everyday life, and one with "a specific role to play *beyond materiality*." Similarly, Paula Owen's "Fabrication and Encounter" takes this notion of craft's historical integration into the experience of everyday life but refocuses it—as do several of this anthology's contributors—through the lens of the art theorist Nicolas Bourriaud's notion of "relational aesthetics," proposing the relationship between artist, object, and viewer as a new "aesthetic" field by an emerging generation of artists. Owen compares artists such as Rirkrit Tiravanija and the late Felix Gonzales-Torres, who have come to fame in the contemporary art world by creating work dependent upon interactivity, sensuality, material culture, and/or process, with artists such as Piper

Shepard and Josiah McElheny, who similarly "consider the tactile or sensual aspects of their work to be integral to their intent, as well as to the social relationships that this quality spawns."

Perhaps unsurprisingly, because of this smart, often spectacular relational quality of their work, Shepard and McElheny are among artists whose highly conceptual work has been embraced by precisely the kinds of contemporary art museums and galleries that also show the likes of Tiravanija and Gonzales-Torres. In light of this phenomenon, the second part of the present volume is dedicated entirely to scholarship regarding the uses and exhibition of craft media in the fine arts world, beginning with Karin Peterson's essay on the collectors Jonathan Holstein and Gail van der Hoof, "How the Ordinary Becomes Extraordinary: The Modern Eye and the Quilt as Art Form." The work of this pair transformed museum curators' and art critics' understanding of patchwork quilts, and in turn craft media in general, in the context of contemporary art institutions. Drawing on Holstein's accounts of their efforts in the 1970s to persuade the Whitney Museum to mount an artistic exhibition of their collection of over one hundred patchwork quilts, primarily of Amish origin, Peterson's essay emphasizes the ways in which Holstein and van der Hoof used a modernist aesthetic framework—focusing on themes of formalism, artistic autonomy, and innovation—to argue the artistic merits of quilts. By using the "white cube," modernist architecture of the art museum and its built-in practices of exhibiting and interpreting art for audiences familiar with avant-garde visual-art practices, their privileged, modernist reading of quilts as works of art addressed the objects in ways emphasizing their parallels to abstract expressionism—a practice that continues today in shows such as the Whitney's "Quilts of Gee's Bend" exhibition in 2003. In contrast, Elissa Auther discusses the antimodernist, pop-art rebellion reflected by Andy Warhol's postmodern use of wallpaper in his work of this same period to negate the opposition of fine art to decoration that modernists sought to maintain in their policing of the lines between art and craft.

In "Wallpaper, the Decorative, and Contemporary Installation Art," Auther continues her discussion of wallpaper in the work of postmodern artists up to the present, such as Robert Gober and Virgil Marti, highlighting a resurgence of interest in this conceptual and material category of the decorative. Auther argues that this category has fostered a more open use of media traditionally associated with craft in the contempo-

rary art world, particularly by artists aggressively pursuing queer and feminist counterpoints to a contemporary art world in which heterosexual masculinity is still a privileged position.

Betty Bright's essay "Handwork and Hybrids" investigates the venerable intellectual tradition of modern book arts while insisting that craft remains at its core. Starting with the relevance of bookmaking to both the philosophy and practice of William Morris, Bright lays out a genealogy for ways in which craft and concept are married in the very different work of contemporary fine-press printers such as Robin Price and Ken Campbell. In their books, we find these artists capitalizing on the sensuous potential of the act of reading in ways that allow audiences inundated by today's stream of high-tech communication a direct experience "involving intellect, emotion, and the body." Similarly, the art historian Jo Dahn's contribution looks at the conceptual branch of contemporary ceramics, focusing on ways in which audience's sensuous confrontations with clay are becoming an increasingly prominent experience in exhibition and performance spaces. However, unlike Bright's celebration of craft's physicality, Dahn emphasizes the "dematerialization" of the clay object per early theories of conceptualism, which artists like Clare Twomey, David Cushway, and Daniel Allen use primarily as the sign of the intellectual process from which it arose. She argues that such artists have not rejected the ceramic object out of hand, but their uses of temporality and performance in their craft-based skills and materials challenge and extend the boundaries of what ceramics can be. In relation to such developments, Dahn contends (as do all the essays in this section of the book) that the conventional designations *art* and *craft* seem increasingly irrelevant.

Yet these designations persist, and nowhere more defiantly than in the international do-it-yourself (DIY) movement, tinged as it is with the kind of politically charged pastoral sensibility of related cultural phenomena from the popular sphere—from the slow food movement's philosophy of "eco-gastronomy" to the hipster "Stitch n' Bitch" knitting clubs springing up to connect like-minded people in real rather than virtual spaces. This notion of the inherently rebellious nature of today's DIY crafters has been influentially dubbed "craftivism" by Betsy Greer and links the authors of the book's third section. Greer's Craftivism.com website has inspired and connected makers across generations and nations with her assertion that "each time you participate in crafting you are making a difference, whether it's fighting against useless material-

ism or making items for charity or something betwixt and between." Her contribution to this volume is a very personal history of craftivism, linking handicraft to activism by highlighting its ability to provide an outlet for the myriad emotions conjured by post–9/11 politics, frustrations over corporate injustice, and a world simultaneously connected and divided by technology.

In her essay "Rebellious Doilies and Subversive Stitches: Writing a Craftivist History," Kirsty Robertson discusses more formalized examples of contemporary craftivism across a number of seemingly disconnected scenes and scenarios, including the global art world and the front lines of political protests, to suggest some possible reasons for their simultaneous emergence and disconnect from previous histories of resistance. Using fiber arts as a case study, Robertson argues that the familiarity and ubiquity of textiles enable a unique approach to the examination and critique of our global communicative and economic networks. Yet she is troubled that the political effectiveness of such radical craft practices relies inherently on the gendering of textile work and essentializing stereotypes of womanhood and domesticity. Ultimately, however, Robertson is heartened by the ways in which craftivist culture unifies the seemingly oppositional issues of identity politics and global politics, difference and connection. And in their essay "Craft Hard Die Free," Anthea Black and Nicole Burisch consider the future as they investigate curatorial strategies for such craftivist work. They articulate the need to critically consider ways in which these various types of craft, hobby-craft, and craft/art hybrids simultaneously impact and exist outside of current strategies of both fine art and studio craft display and discourse, and they argue that the necessarily messy nature of radical craft and its intersections with gender, queer, and anticapitalist politics offer productive trouble to future notions of institutional curating. Indeed, Janis Jefferies's essay "Loving Attention: An Outburst of Craft in Contemporary Art" explores the burgeoning openness of such institutions to craft media and vice versa, through a spate of conceptual craft exhibitions mounted to great acclaim in Europe between 1997 and 2005, marking a shift in valuing the significance of the handmade object within contemporary art practice. Here materials are at the center of a wrestling match between ideas of craft and creativity, played out against a backdrop of leisure activities and hobbies in which popular notions of craft and labor define the language of "makeover" and home improvement television programs. In these exhibitions, popular modes

Maria Elena Buszek 17

of craft reproduction are critiqued and subverted or play with our ex-
pectations of genre and experience. As Jefferies argues, such exhibitions
have tracked the emergence of a new generation of artists wishing to
celebrate and challenge the notion that "to craft is to care," using prac-
tices ranging from cake decorating to metalwork to floristry to make
their points.

The approaches to politicized crafting addressed in this third section
of the book have made room for new considerations of feminism, queer
crafting, tacit knowledges and skill sharing, and anticapitalism. The final
section is dedicated to analyses of such new functions and frontiers for
craft. In "Reimagining Craft Identities Using Tactics of Queer Theory,"
Lacey Jane Roberts discusses the hierarchies of class, race, and gender
with which different definitions of the term *craft* are associated and
suggests that queer theory can teach craft how to exploit its marginal-
ized position in the scheme of art history through its tactics of reclama-
tion, reappropriation, performance, and disidentification. Addressing
work ranging from the internationally known AIDS Memorial Quilt to
the lesser-known, anti-sweatshop protest performances of Liz Collins's
Knitting Nation, Roberts explores how crafting becomes a manner to re-
sist stereotypes and to challenge the constructed systems of visual and
material culture. Andrew Jackson's contribution to this section analyzes
a rarely discussed aspect of craft and identity through its examination of
masculinity in DIY culture—in reference not to the subcultural founda-
tions of craftivist uses of the term but rather its perhaps more popular,
big-box-store associations. In his essay "Men Who Make," he focuses
on the experience of men who pursue making activities in the context
of home and the relationship of this practice to both conventional and
alternative constructions of domesticity.

The book concludes with a discussion of craft as addressed in a field
with which it is rarely popularly associated: science. My interview with
Margaret Wertheim, the science writer and cultural historian who
founded the Institute for Figuring (IFF), is dedicated to her research
on the depiction of hyperbolic space—a modern geometric concept in
which lines cavort in aberrant formations. In 1997, the Cornell mathe-
matician Daina Taimina finally worked out how to make a physical
model of this supposedly unrepresentable hyperbolic plane using cro-
chet. In response to this groundbreaking discovery—and the "hard sci-
ence" community's lack of interest in its implications—Wertheim and
the IFF instigated a series of books and exhibitions on the subject which

dare to suggest that craft knowledge might hold the answers to some of the most challenging scientific questions of the post-Enlightenment world.

NOTES

1. Michel Gondry, *The Science of Sleep*, DVD, dir. Gondry (2006, Los Angeles: Warner Home Video, 2007).
2. The exhibition was titled "Michel Gondry: The Science of Sleep, an Exhibition of Sculpture and Creepy Pathological Little Gifts," Deitch Projects, New York, September 6–30, 2006.
3. See Glenn Adamson, *Thinking through Craft* (Oxford: Berg, 2007), chap. 4.
4. Howard Risatti, "Metaphysical Implications of Function, Material, and Technique in Craft," *Skilled Work: American Craft in the Renwick Gallery* (Washington, D.C.: Smithsonian Institution Press, 1998), 34.
5. For Risatti's most recent and compellingly argued positions on the matter, see *A Theory of Craft: Function and Aesthetic Expression* (Chapel Hill: University of North Carolina Press, 2007).
6. See Fariello, "Regarding the History of Objects," *Objects and Meaning: New Perspectives on Art and Craft*, ed. Fariello and Paula Owen (Latham, Md.: Scarecrow Press, 2005), 2–21.
7. See Clement Greenberg, "Avant-Garde and Kitsch," *Art in Theory, 1900–1990: An Anthology of Changing Ideas*, ed. Charles Harrison and Paul Wood (Oxford: Blackwell, 1992), 530–41 (first published in *Partisan Review* 6, no. 5 [fall 1939]: 34–39); and Greenberg, "Modernist Painting," *Art in Theory, 1900–1990*, ed. Harrison and Wood, 754–60 (originally published in *Arts Yearbook* 4 [1961]:109–16).
8. See Beverly Sanders, "The G.I. Bill and the American Studio Craft Movement," *American Craft* 67 no. 4 (August/September 2007): 54–62.
9. See Risatti, "Metaphysical Implications of Function, Material, and Technique in Craft," 31–32; and Rob Barnard, "Paradise Lost? American Crafts' Pursuit of the Avant-Garde," *Objects and Meaning*, ed. Fariello and Owen, 56–65.
10. Jean Robertson, "Feminism and Fiber: A History of Art Criticism," *Surface Design Journal* 26, no. 1 (fall 2001): 39–46.

REDEFINING CRAFT New Theory

M. Anna Fariello
.

Making and Naming

THE LEXICON OF STUDIO CRAFT

I used to think that it was possible to carry on deeper conversations about craft using the formalized language shared by art history, aesthetics, and criticism. I no longer believe this. Craft as a field to be discussed in depth cannot be shoe-horned into the Cinderella slipper of a language based on principles of what was once called "fine" art. Scholars and writers attempting to apply a language structured on the painted image to volumetric form face frustration. Of this phenomenon, Paul Greenhalgh, as curator of ceramics at the Victoria and Albert Museum, quipped, "Ceramics is occasionally the subject of art history, but more often it is its victim."[1] The very term *fine art* negates the historically egalitarian values of craft and its influence on the visual arts in this regard. For such debates to be productive, craft must have its own discipline-specific vocabulary, one grown organically from its own practices.

The essence of craft is bound to the hand, to the process of working, of *making*. Beginning with imagination and laying out the parameters of design, it is the skill of the hand that results in a thing well made, a thing that rightfully can claim the title of "craft." This essay proposes new ways of considering craft in the context of aesthetics and material culture and serves to broaden the dialogue by tracing a stream of ideological writing that has run parallel to the mainstream but well outside it. And none too soon—in the twenty-first century, craft seems to be on everyone's mind. It is newly intriguing and poses an exciting challenge to established ways of thinking, making, seeing, and classifying objects.

There is no clear line partitioning craft from art, like a highway sign that marks the state line: *You are now leaving the world of Art and entering the brave new world of Craft.* Rather, notions of what constitutes "craft" and "art" form a fluid continuum as part of the larger spectrum of material culture. But even a view of craft and art along a continuous line does not provide easy answers. One reason for this difficulty is that the issue is too complex to be answered as an either/or question. *Is it craft? Is it art?* The craft-art continuum is not constructed along a single line but is interwoven from multiple strands of thought, assumptions, and practices. Together, these form the tapestry of our understanding.

There are some who think that "craft" and "art" are a matter of quality, that these terms are not nouns but qualitative adjectives. An art professor colleague once responded, when I argued for a language of craft, that good craft is art anyway. While I agree that good craft is certainly art, I intend to show that the identity of craft embraces *more* than art. My intention in this essay is to untangle the multiple strands of ideas that inform the identity of craft at a particular point along the continuum of material expression. For want of a better term, I will call this point Studio Craft, where certain assumptions, intentions, characteristics, and practices converge, which I would like to discuss from its earliest manifestation as Arts and Crafts in the late nineteenth century through its institutionalization as defined by the American Craft Council in the 1940s.

Studio Craft is not a new term. Others have used it in their attempt to devise a way to describe a certain approach to making, embracing more than simplistic and superficial definitions. Bernard Leach in *A Potter's Book* (1940) struggled with a definition in a chapter he titled "Towards a Standard." "A new type of craftsman, called individual, studio, or creative, has emerged, and a new idea of pottery is being worked out by him as a result of an immensely broadened outlook," he wrote.[2] Studio Craft is not the craft of hobby "crafters," nor the mass-production of "craft" retailers. On the other hand, Studio Craft is not the craft of those who have abandoned the term altogether, substituting the misnomer "design" for craft itself. Design is a well-respected intermediary, the working out of problems that stand between concept and execution. Still, design is but a plan and does not necessarily include the skillful making that results in a finely finished piece. Craft departs from its corollaries—

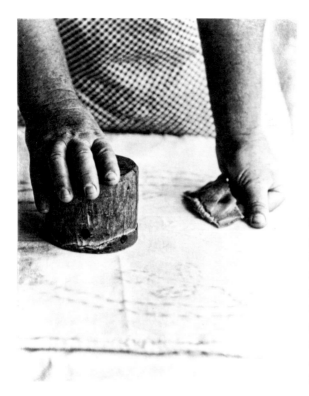

1 Doris Ulmann, portrait of Ethel May Stiles, maker of tufted spreads, 1930s. Used with special permission from the Berea College Art Department, Berea, Kentucky.

art and design—in its embrace of execution, the *making* of the work (see fig. 1). Design is but one-third of the creative triad that informs craft as a discipline.

THE MARK OF THE HAND

The making of an object is a key attribute of Studio Craft. While some would require the *hand* making of a work as necessary for an object to be called craft, not all craftsmen agree. "'Craft' as you may know, comes from the German word 'Kraft,' meaning 'power' or 'strength'. . . . We cannot fake craft. It lies in the act." So wrote Mary Caroline Richards in her 1960s-era book *Centering*, a work that proposed a philosophical and theoretical foundation for craft practice and facilitated the development of craft as a professional field of inquiry. Richards went on to say what she meant about a craftsman not being able to "fake craft" in explaining how "the strains we have put in the clay break open in the fire." Craft objects, beautiful or not, are a record of what went on in the studio between maker and material. If the maker was at odds with the material in the way Richards suggests, the work—at some point—reveals the truth

of its making. Each mark—in clay, wood, stone, fiber, glass, pigment, or metal—is the archaeological evidence of an action taken by its maker. Indeed, the object as document embodies a material reenactment of a studio-based craft practice.[3]

On the economic continuum, a work of art generally outpaces a work of craft in most cases. We accept this as a truism of our time, although this circumstance is based on specific notions of art compared to a more vague understanding of what is meant by craft. How fortunate for art that an inherent part of its identity is that it is considered genuine, expressive, and good! Somehow the word *art* implies *good* art; if you want to talk about bad art, you had better preface your description accordingly. Art compared to craft seldom includes amateur or hobbyist "art." We seldom think about the mass-produced "art" found on urban streets, the "art" depicted on greeting cards, or the "art" that fills kitschy gift shops. To its credit, "art" insinuates a rarified form, with samples found in museums and history books. Craft, to its detriment, is too often thought of as the smallest trinket, something produced in quantity with little forethought. But what qualities prop up these perceptions? Are they valid? For the sake of this discussion, I make comparisons here using the best of each genre. The best of craft, like the best of art, can be beautiful, inspiring, challenging, intriguing, and compelling.

The roots of a studio-based craft practice can be traced to the methods of making used to produce the earliest human-made aesthetic objects. Much of manual work and *all* artistic practice fell within what we would call craft process today. Throughout history and up into the Middle Ages, the making of any object was centered in a cottage industry. Whether pottery or painting, or painting on pottery, objects were made in similar ways in terms of the *scale* of production. Individuals, families, neighbors, clans—small numbers of people—worked together to produce a particular type of object.

With industrialization, craft production changed, not so much as a product but as a way of working. Early in the Industrial Revolution, change was evident in how weavings were made. Weaving moved from the privacy of the home, where a single loom was commonly found beside the home hearth, to undergo the most dramatic changes of any of the crafts at the time. With the invention of the steam-powered loom in the late eighteenth century, followed by the introduction of a wool-combing machine, the meditative and personal environment of the home loom gave way to the cacophony of the factory floor. In contrast

to the individual craftsmen working holistically on a product, factory workers were considered "operatives," who completed a single operation in a series, a system that became known as the division of labor.

John Ruskin, social critic and Oxford professor, lamented this situation, creating a pun from the term *division of labor*. Ruskin wrote, "It is not, truly speaking, the labor that is divided; but the men:—Divided into mere segments of men—broken into small fragments and crumbs of life; so that all . . . that is left in a man is not enough to make a pin, or a nail, but exhausts itself in making the point of a pin, or the head of a nail."[4] This division of labor, along with sweatshop conditions and the exploitation of children, was common in the new industrial environment.

On the factory floor, craft process was forced to abandon its traditional roots, leaving behind aesthetic expression, craftsmanship, and control in favor of standardization, efficiency, and quantity. Moreover, industrial process removed the hand—*manu*—from *manufacture*, leaving *facture* (to make) as the root of the word *factory*. Within this new environment stripped of the human touch, design was moved off the factory floor as well, fracturing holistic craft process while breaking apart the operations of production. Emerging from this situation, however, was a chorus of voices articulating qualitative measures that were to become the evolutionary ancestor of contemporary craft. The most dominant and recognizable philosophical tributary contributing to the future of Studio Craft came in the form of the Arts and Crafts movement. Although "crafts" is not listed first, it remained tightly bound to "arts" in a symbiotic relationship.

In the wake of Ruskin's evangelical pronouncements, in 1861 his fellow Englishman William Morris founded a company with the long subtitle "Fine Art Workmen in Painting, Carving, Furniture, and Metals." Combining "fine art" with "workmen," and "painting" with "carving, furniture, and metals," Morris provided a good example of how *naming* conveys the intent of craft practice and its evolutionary development. Morris began in earnest to experiment with the goal of producing beautiful objects to transform society into a socialist utopia. Although he succeeded in producing finely crafted objects, these items did not enter into the homes of the ordinary worker as he had hoped. Instead, objects made by Morris and Company were purchased by the upper-middle class. In spite of this failing, Morris succeeded in defining an aesthetic and work ethic that had a profound influence on what would become the Studio Craft movement.

Yet this nineteenth-century union of art and craft as promoted by the English Arts and Crafts movement was immediately eclipsed by the seduction of modernism in the early twentieth century. Modernism, for all its democratic rhetoric, excluded most attributes of the Arts and Crafts movement in its celebration of individual expression. Surrealists defined art as psychological; abstraction deemed it self-referential; Futurists proclaimed it ahistorical; Dadaists claimed it was immaterial; Cubists approached it as analytical. One might go so far as to say that, at this juncture, craft and art stretched to opposite poles along the craft-art continuum.

During the same period, a different set of qualities and intentions revolved around the nucleus of craft. Arts and Crafts, as well as the emerging American Studio Craft movement, remained tactile rather than psychological, functional rather than self-referential, material rather than immaterial, holistic rather than analytical, social rather than individual, and traditional rather than iconoclastic.[5] With the growing dominance of modernism's aesthetic mainstream, craft went underground. Its ideals formed upstream tributaries that flowed into a swelling of interest that remained outside the modernist "art" world.

Despite the growing dominance of modernist hierarchies in the "fine arts" at the start of the twentieth century, the ideas and enthusiasm for craft did not wane. A proliferation of Morris societies, the *Craftsman* magazine, and a growing community of craft promoters and producers were evidence of the Ruskin/Morris vision everywhere. Gustav Stickley's Morris Chair promised functionality and "honest" construction. The production of Mission furniture, with its hallmarks of heft and exposed construction, was widespread. Louis Comfort Tiffany adapted the quintessential medieval art form of stained glass to domestic application in the American Northeast. The Midwest saw the development of a new kind of factory, such as Cincinnati's Rookwood Pottery Company, which produced a new kind of "art" pottery not subject to a strict division of labor (although, in truth, most pieces were not made wholly by a single individual). Utopian communities, like Rose Valley in Pennsylvania, were founded in pursuit of a holistic lifestyle based on quality craftsmanship. In Philadelphia Samuel Yellin adapted the Gothic style to twentieth-century metalwork to create an imposing sense of significance to the public buildings of a still-young country (see fig. 2). In the mountain South, craft advocates like William Frost and Allen Eaton promoted handwork as evidence of a purely American culture. On the

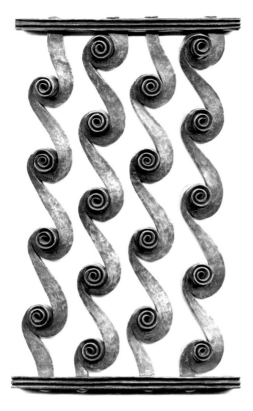

2 Iron sketch by Samuel Yellin Metalworkers. Image courtesy of Samuel Yellin Metalworkers Co.

cusp of the twentieth century, Studio Craft remained outside the dominant art historical canon—and certainly outside its history books—to thrive in decentralized pockets of creative activity.

EDUCATION OF THE HAND

The Arts and Crafts movement grew in England under the reign of Queen Victoria during an era generally perceived to be one of strict morality. Such morality was characterized by prescribed modes of behavior that resulted in a "no-touch" society. This mental state, grafted onto material culture, resulted in homes filled with tasty visuals: things— and lots of them—that seldom measured up in terms of tactile value. How many Victorian settees were visual delights but impossible to sit upon? Part of the growing Arts and Crafts advocacy was an emphasis on product functionality and design education. Hands-on educational programs were proposed for large numbers of people: design education for workers in industry, manual education for school children, and

technical education for paraprofessionals. In England, a national system of government-funded design schools was authorized in midcentury, while in America the emphasis was on manual training for children and industrial education for secondary school students.

In America the stimulus for the introduction of crafts into the public school curriculum came from some unexpected places. After the Civil War, "industrial institutes," established to educate former slaves, formed a parallel educational system in which handwork played a central role. Booker T. Washington's Tuskegee Institute, established in Alabama in 1881, served as a model for hundreds of public and private African American academies that sprang up throughout the South. Although seldom recognized as part of the craft tradition, schools such as Tuskegee echoed Ruskin in their emphasis on handwork as a significant aspect of the learning experience. Washington promoted "mind-training" as the "logical component of heart-training";[6] both informed coursework based on a hands-on approach to education. Classes in wood, metal, textiles, and leather were common.

Beginning in 1895, with his speech at the Cotton States Convention in Atlanta, Washington was the most vocal American advocating an education of the hand. He was inspired by his own educational experience at Hampton Institute in Virginia (see fig. 3). In a phrase reverberating from Ruskin, Hampton founder Samuel A. Armstrong championed "training the hand, head, and heart." After Tuskegee was established, the philosophies of Hampton and its offspring intertwined, one echoing the other. "The worth of work with the hands [is] an uplifting power in real education," wrote Washington in an article published in the *Craftsman* magazine. Well into the twentieth century, industrial institutes promised that their curricula would restore "dignity to labor" and utilized handwork as a means to that end. Washington, in particular, was cited in the *Craftsman*, linking African American institutions to other craft schools via their common ideological underpinning. The popular *head-hands-heart* motto adapted from Ruskin was the basis for many independent schools that were established throughout the segregated South. Christiansburg Industrial Institute, an African American Quaker-supported school, was located across the state from Hampton at Virginia's western border, near Blacksburg. Christiansburg promoted its industrial curriculum alongside academic work; its 1899 catalogue placed them "on an equal footing . . . by training the hands as well as the head."[7]

Scholars who have criticized industrial programs for fostering a

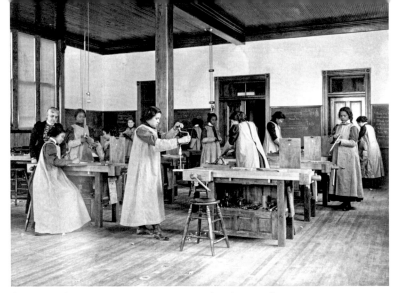

3 Young African American women in woodworking studio, Hampton Institute, Virginia. Library of Congress, Prints & Photographs Division [LC-USZ62–119868].

less than rigorous curriculum have not appreciated the high value that handwork held at the time. Granted, today—when "technology" means "electronics"—it is difficult to imagine a time when "high tech" meant hand skill. However, in those first decades of the twentieth century, the skill of the blacksmith, for example, was highly valued. A letter written to school funders in 1902 by the principal of Christiansburg Industrial Institute complained that he could not find anyone to teach blacksmithing at the rate the school was offering. To attract a qualified smith, the school had to pay him at the same rate as the principal, making the blacksmith instructor the highest-paid teacher on campus.[8] This preference was not new. Blacksmiths were so critical to the economies of the colonies and later to the states that in 1788 the North Carolina legislature gave three thousand acres of state-owned timberland to each practicing smith. Although devalued in today's economic marketplace, the skill of the hand was a mark of professionalism and industry before being eclipsed by modernist principles.

In a wide-ranging approach, some hands-on educational programs provided manual training to elementary students as a prelude to industrial education at the secondary level. Each level of the sequenced curriculum had its own goals. Manual training was aimed at enhancing hand/eye coordination and visual/tactile perception; industrial programs targeted skill development and craft production. Offering courses at both the primary and secondary level, Christiansburg Industrial Insti-

tute provided craft-based instruction to a full spectrum of students. According to Principal Edgar A. Long, "handicrafts taught in the schools" could enhance "the observational powers of the child." In a speech before the National Association of Teachers in Colored Schools in Nashville in 1916, Long argued that educators should concern themselves with "sense training." Through the well-honed use of "eye or ear or hand," Long encouraged teachers to allow their students "to observe the things about them and intelligently interpret them," rather than transmit information "second hand" through books and teacher-led interpretation. Advocating for more classroom time "devoted to training the perceptive powers," Long proposed that students "should be taught to see by seeing, to hear by hearing, to feel by touching . . . [to develop] a practiced eye, a deft touch, an acute ear, [and] a skillful hand [as a] foundation for professional training." To that end, Christiansburg taught "Weaving, Raffia knotting, Basketry, Chair caning" along with construction trades, such as carpentry and blacksmithing.[9]

Of all of America's early-twentieth-century educators, John Dewey had a particularly profound impact on the developing public school system. A prolific writer, professor, and supporter of hands-on education, Dewey moved away from rote educational models that evolved from private school practice and instead responded to changing school demographics. He established the Laboratory School in Chicago to serve students from a variety of backgrounds, including poorer immigrant communities, and was one of the founders of the Progressive Education Association. While Dewey promoted a hands-on classroom methodology, he also encouraged the teaching of art as a core component of the curriculum. Stressing process over product, Dewey elaborated on his philosophies in a book aptly titled *Art as Experience* (1934), in which he explained, "Art denotes a process of doing or making. . . . Every art does something with some physical material, the body or something outside the body, with or without the use of intervening tools, and with a view to the production of something visible, audible, or tangible. So marked is the active or 'doing' phase of art." Dewey connected aesthetic experience with the physical process of making and the intimacy of tactile experience.[10]

Expressing his advocacy for a manual training approach in words similar to Long's, Dewey wrote, "As we manipulate, we touch and feel, as we look, we see; as we listen, we hear." Moreover, for Dewey, the totality of the aesthetic experience aimed for a "vital intimacy of connection."

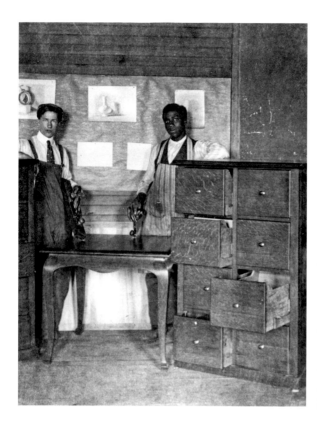

4 Fireside Industries students at Berea College, before 1904. Image courtesy of Berea College Archive, Berea, Kentucky.

Both Dewey and Long fit within the broader framework of progressive education as it filtered into the developing American education system. Like the better-known John Dewey, Edgar A. Long advocated "learning by doing." "What is the purpose of a school?" Long wrote, observing that "mere book knowledge" was giving way to a broader view. "We are standing at the threshold of a new era in education . . . [in which] books are but tools." [11]

In the rural South, where dozens of schools established craft programs, the most influential was Berea College in eastern Kentucky (see fig. 4). By 1902 Berea students were producing Arts and Crafts objects similar to those made professionally in the Northeast. Berea offered courses in carpentry, bookbinding, weaving, tin, and ironwork. Closely connected to the emerging national craft agenda, the designs for Berea's student-produced Mission furniture may very well have come from such magazine articles in the *Craftsman* as "Lessons in Practical Cabinet Work." Berea titled its crafts department Fireside Industries, and the

name came to be used generically throughout the southern highlands to indicate quality-level craft production.

Advocates of progressive education wove together varied philosophical strands of nineteenth-century thought into a movement popularizing hands-on educational methods. With such promise as a foundation, craft programs sprang up in many American cities. The U.S. Bureau of Labor bulletin in 1904 listed courses in blacksmithing and fresco painting at the New York Trade School, "experimental weaving" at the New Bedford (Massachusetts) Textile School, and spinning and rug weaving at the Hampton Institute.[12] In the Appalachian South, these ideas culminated in a widely accepted establishment of "fireside industries" for whites and "industrial institutes" for blacks. Kept separate by state-sanctioned segregationist policies, fireside industries and industrial institutes operated as parallel systems of craft-based education. Their worlds converged on a pedagogical stage where philosophy was applied to methodology and channeled into action.

There was a consensus among handwork advocates that craftwork was useful in developing character through the discipline of a steady craft practice. In "An Educational Program for Appalachian America," Berea president William Frost linked handwork with moral character. With "skill in homespun manufacture there is an inculcation of manners. . . . Truthfulness, honesty, and hospitality," he wrote. A later essay removed any doubt as to the metaphoric value of craft objects in absolving a marginalized people. "Berea discovered their worth and promise . . . [but] it was necessary to bring forward every available evidence to prove the natural capacity of the mountaineers." Across the Allegheny Mountains in Virginia, Edgar Long concurred, "If we agree, and I think all must agree . . . the object of study is to mold character. . . . Books are only one set of tools to be used in this process." While many of these new schools operated regionally, the *Craftsman* gave them voice on a national stage. Its issues regularly covered craft education in articles such as "Manual Training and Citizenship," "Industrial Art in Public Schools," "Some Craftwork in a Southern High School," and "The Moral Value of Hand Work," the latter over the byline of Booker T. Washington himself.[13]

COMMUNITY IN ACTION

In Appalachia as in England, the craft worker was the direct ideological link between socioeconomic reforms and the handmade object, more

so than in the North, where aesthetics became a dominant purpose. Concrete differences between rural and urbanizing sections of America widened the gulf between agricultural and industrial lifestyles. Moreover, more marginal populations—rural mountain whites and southern blacks just a single generation removed from slave-run plantations—were thought to lag hopelessly behind a growing modern ideal.

Early educators like Booker T. Washington and William Frost emphasized that a disciplined craft practice could be "uplifting" to the individual. But as the twentieth century progressed—and especially as the country moved toward the Great Depression—craft production was adapted for its potential to "uplift" entire populations. Such uplift programs were established to aid the poor in economic and social development, as well as character. In the hundreds of mission, settlement, and independent schools that were founded during this period, students and community neighbors created high-quality, handmade objects that were marketed and sold through school promotions.

During the first decades of the twentieth century, the mountain South was attracting educators who wanted to try their hand at creating new societies in places they perceived to be cultural "survivals." The folk and settlement schools that proliferated in the region formed educational enclaves that identified elements of local culture and focused on traditional craft skills. In spite of different audiences served, the majority of schools fostered hands-on education and promoted handicraft production. Their aesthetic values and ties to the greater arts community varied widely.

Some Southern Appalachian schools have had a lasting impact on the craft field; Arrowmont School of Arts and Crafts (founded as the Pi Beta Phi Settlement School in 1912), John C. Campbell Folk School (1925), and the Penland School of Crafts (founded as Penland School of Handicrafts in 1929) continue today as highly regarded institutions. Known by different names and existing for various purposes, the many schools and craft production centers that operated as part of the southern Craft Revival—Allanstand Cottage Industries, Biltmore Estate Industries, Spinning Wheel—can be best appreciated in terms of the nation's larger focus on hands-on education and activity.

The mountains of North Carolina were also home to Black Mountain College. Founded in 1933, Black Mountain promoted an integration of art forms. The weaver Anni Albers was part of a group of influential European artists who came to North Carolina from Germany. Trans-

planted from the Bauhaus, Albers taught at the experimental and short-lived college, founded on the heels of other experimental—albeit more traditional—educational programs in the region. "We touch things to assure ourselves of reality," wrote Albers. She later wrote *On Weaving*, elaborating on tactility in a chapter titled "Tactile Sensibility." "No wonder a faculty that is so largely unemployed in our daily plodding and bustling is degenerating. Our materials come to us already ground and chipped and crushed and powdered and mixed and sliced, so that only the finale in the long sequence of operations from matter to product is left to us: we merely toast the bread. No need to get our hands into the dough. No need—alas, also little chance—to handle materials, to test their consistency, their density, their lightness, their smoothness."[14] While Black Mountain eschewed the traditional culture that surrounded it in favor of a more avant-garde, modernist-inspired approach to education, it nevertheless shared goals with other mountain schools. Important to each of these educational programs was a desire to create a holistic community in which hands-on education, material culture, and life itself were part of a seamless existence that was creative and inspiring at its core.

FUNCTION AS MEANING

Those of us who went through the university in the latter half of the twentieth century were trained to define craft less by its making and more by its use, in contrast to the objective and distanced presence of art that was analyzed as a fait accompli. But can craft and art be subdivided in other ways that can help us understand the meaning of craft? In *The Shape of Time* (1962), George Kubler divided all visual culture into three rather unorthodox categories. He grouped paintings, textiles, and mosaics into a category of "planes" and labeled sculpture as "solids." Containers—which he called "envelopes"—included architecture and pottery. Kubler's categories depended on *function* as something he recognized in all forms of art. But for Kubler, function related to the geometry of the object rather than to its use. He claimed, "By this geometric system, all visible art can be classed as envelopes, solids, and planes . . . [ignoring] the traditional distinction of 'fine' and 'minor,' or 'useless' and 'useful' arts."[15]

Function, the way I define it, is an abstract attribute of material expression. For example, the envelope of containment can represent protection or possession, the way a cozy room or comfortable coat envelops

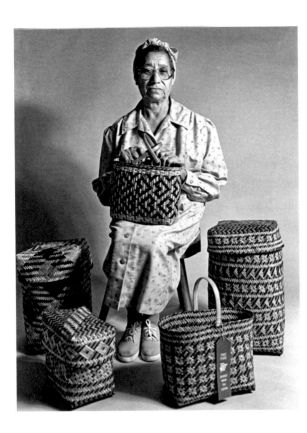

5 Cherokee basket weaver Eva Wolfe with river cane baskets. Image courtesy of the Qualla Arts and Crafts Mutual, Inc.

the body, satisfying basic human needs. The ability to hold, to save, and to possess are functional attributes. Considering the first human-made objects, a container may have been the most valuable possession a family could own. Containers separated the precious from the ordinary, the valued from the valueless. We save, we store, we sometimes hoard, and, certainly, we isolate certain possessions apart from others. It is this abstract concept of function that supports the identity of Studio Craft. As such, the notion of containment is useful for theorizing and articulating *function* as an abstraction apart from the physical reality of *utility* (see fig. 5).

Indeed, to understand the material aesthetic object—whether art or craft—the meaning of *function* cannot be limited to *use* alone. Function exists in the realm of the metaphysical, while *use* can be understood in physical terms. Does a teapot pour? Does it drip? For a building, function is more about performance. Of Kubler's envelope of architecture, the primary criterion for evaluating *use* would be whether the roof kept

6 Catalogue cover for Rose Slivka's *The Object as Poet*, published at the time of the Renwick Gallery exhibition, 1976. Image courtesy of the Renwick Gallery in cooperation with the Smithsonian Institution Press.

out the rain. But its *function*? The function of a federal courthouse is to inspire confidence in the judicial system it supports. Likewise, a cathedral impresses the faithful with the power of the Almighty. On a smaller scale, the *use* of a quilt may be as a bed cover, but its *function* is greater than the sum of its component pieces to encompass the autobiographical story of its making, its maker, and the entire quilt tradition. Aside from its *use* as a bed cover, its *function* embraces the quilt as document (of a family's cast-off clothing), as metaphor (the double meaning of providing warmth), as ritual (in its use on special occasions), or as a talisman (a healing or protective cover). Thus, the multiple functions of an object exist apart from its use and are made up of abstracted and layered intangible meaning, rather than physical properties alone.[16]

Taking this idea one step further, Rose Slivka explored the metaphoric function of craft in *The Object as Poet* (see fig. 6), a Renwick Gallery exhibition catalogue from 1977. "Craftsmakers and artists," Slivka wrote, "[reach] inside and beyond the physical nature of the object." While the physical is a point of departure, it is the intangible that gives meaning to the object. Slivka recalls growing up in a home where "objects were respected like tribal elders." She wrote, "The object is a visual

metaphor. . . . The object provides a thereness, a physical place: it holds the space, marks the terrain, the geography of the metaphor."[17] I would add that craft objects do all of these things with a dynamic quality that begs for interaction, rather than a passive "thereness" satisfied by mere visual perception alone.

MATERIAL SPIRIT

How well an object conveys its meaning depends on how much of the original intention—its artistic spirit—is conveyed to the viewer via the execution of its material. In the mid-twentieth century Henry Varnum Poor, in *A Book of Pottery: From Mud to Immortality* (1958), attempted to relate these two concepts. He wrote, "Perhaps the distinction between fine arts and applied arts could be made on some rough ratio between spirit and material. Certainly much painting and sculpture is pure exercise in craftsmanship, while many simple objects of clay and wood and metal reveal the most lofty spirit." Poor's ideas were clearly an extension of Arts and Crafts principles outlined a century earlier in Ruskin's *The Seven Lamps of Architecture* (1849). In this early tome, Ruskin claimed that the value of a building or artifact should not be based on its beauty or its history alone but rather on "that spirit which is given by the hand and eye of the workman."[18]

Ruskin's writing was immensely influential in its idea that material culture is imbued with a spiritual force and, as such, is a reflection of the character of its maker. As handwork was more "honest," so too did it embody complementary qualities of "happiness," "spirit," and "life" itself. The potter Marguerite Wildenhain continued the thread of this thinking in her book *The Invisible Core* (1973), using pottery as a path to vision. "Before a craftsman can think in terms of 'expression,' he will have to learn, so to speak, the language of his craft. . . . Here is the craftsman . . . trying to find the forms for the visions he has in his inner being, so as to make them visible to the outside world through his work."[19] As these thinkers and makers argued, for inner expressive vision to be conveyed outward it must take physical form.

Since 1943, with the founding of the American Craft Council, five media have almost exclusively defined craft in America: clay, wood, fiber, metal, and glass. This meant that potters, woodworkers, weavers, smiths, and glassblowers were counted as craftsmen, but others were not. But tradition has not always grouped makers according to Ameri-

can Craft Council definitions. By virtue of church commissions, painters in Leonardo's day were plasterers as well. The Italian biographer Giorgio Vasari counted goldsmiths in with other sculptors. As the world became more mechanized, weavers found themselves at the forefront of industry. So too roles defined by technique are problematic in delineating craft. An internationally renowned sculptor, for example, uses the same welding techniques as an auto mechanic. Something other than technique or material must contribute to the identity of Studio Craft.

So much of today's writing about craft is predicated on a definition based on material selection, the five "craft" materials. However, this simplistic, albeit convenient, definition misses the point. A workable definition of craft depends very little on technique or medium at all. As I hope that I have revealed in this discussion of recent craft history, craft, as a discipline, is not so much about materials as it is about an *approach* to materials.

My own view of the craft/art continuum is on a sliding scale, with imagination and skill as part of every creative act. Art is imagination, with or without skill; craft is skill, with or without imagination. Studio Craft—the best term we have thus far—identifies a particular point on this continuum, the place where imagination and vision meet skill and craftsmanship. Mindfully made, craft process and objects deserve to be named. Although the vocabulary of art history can be used to explore some aspects of a studio-based craft practice, it is not sufficient to embrace its multiple meanings. To be talked about, understood, appreciated, and valued, craft must have a language of its own. Craft's multiple interpretations—as document, ritual, metaphor, and talisman—depend on attributes that define core values that makers bring to the studio.

The lexicon of Studio Craft includes naming objects as hand-marked, holistic, social, functional, tactile, material, and spiritual. Its meaning, whether in the production studio or the classroom, is rooted in multiple values, including the physical process of making, an intimacy of tactile experience, the "truth" of its materials, the discipline of daily practice, and the skill of the hand. Skill—applied to material—in the hands of a maker with imagination yields the very best of Studio Craft. Those open to the expressive message of craft can *read* its meaning if given appropriate conceptual tools. We *read* the mark of the hand on every object. Whether recognized or not, every mark left on the work is a record of a decision made and an action taken by the hands that literally formed it.

1. Paul Greenhalgh, "Discourse and Decoration: The Struggle for Historical Space," *American Ceramics* 11, no. 1 (1993): 46–47.

2. Bernard Howell Leach, *A Potter's Book* (New York: Transatlantic, 1940), 12–13. While the term *crafter* has the advantage of being gender neutral, it has come to be used almost exclusively by hobbyists. Peter Dormer, in *The Culture of Craft: Status and Future* (Manchester: Manchester University Press, 1997), used the term *craftist* to avoid the gendered term *craftsman.* My preference is the discipline-neutral word *maker.*

3. Mary Caroline Richards, *Centering in Pottery, Poetry, and the Person* (Middletown, Conn.: Wesleyan University Press, 1962), 12. Please note, however, while I am a strong supporter of the dominance of the hand in Studio Craft, some of today's craftsmen are quite comfortable with machine production and/or manufacture of their work. For a discussion of what I mean by "object as document," see "'Reading' the Language of Objects," *Objects and Meaning: New Perspectives on Art and Craft*, ed. M. Anna Fariello and Paula Owen (Lanham, Md.: Scarecrow Press, 2003), 148–75.

4. John Ruskin, *The Seven Lamps of Architecture* (London: Smith, Elder, 1849), 165. Edward Lucie-Smith divides the history of craft into three periods based on the amount of control ascribed to the maker, in *The Story of Craft: The Craftsman's Role in Society* (Ithaca, N.Y.: Cornell University Press, 1981).

5. Even the most iconoclastic of object makers share form with their traditional counterparts. A chair, whether made by Chris Burden, Judy McKee, or Shadrack Mace, remains a chair.

6. Booker T. Washington, *Tuskegee and Its People: Their Ideals and Achievements* (New York: Appleton and Co., 1903), 7.

7. S. C. Armstrong, "From the Beginning," in *Twenty-Two Years' Work of the Hampton Normal and Agricultural Institute at Hampton, Virginia* (online reprint), American Antiquarian Society Online Resource, at http://mac110.assumption .edu/aas/default.html (visited September 8, 2008). Booker T. Washington, "The Moral Value of Hand Work," *Craftsman* 6, no. 4 (July 1904), 393. *Catalogue of the Christiansburg Industrial Institute, 1897–98* (Cambria: Institute Press, 1898), 5–6.

8. Friends Freedmen's Association, "Report of the Committee on Education, Manual Training and Publications" (1902), courtesy of the Friends Historical Society / Swarthmore College. The report references Christiansburg Industrial Institute in Virginia where male teachers were paid $40 a month and female teachers $35. The salary for principal and blacksmith instructor was $45.

9. Edgar A. Long, "The Industrial High School as an Aid in the Preparation of Teachers / A Paper Read before the National Association of Teachers in Colored Schools in Nashville, Tenn. July 29, 1916, by E. A. Long," reprinted in *A Vision of Education: Selected Writings of Edgar A. Long*, ed. M. Anna Fariello (Christiansburg: Christiansburg Institute, 2003), 126–29. "Theory and Practice: Everyday Pedagogy Theory and Practice," unpublished manuscript in the collection of Christiansburg Institute Museum and Archive, attributed to Edgar A. Long.

10. John Dewey, *Art as Experience* (New York: Minton, Balch, and Co., 1934), 47–50.

11. Ibid., 47–50. "Annual Report of Principal," attributed to Edgar A. Long, Montgomery County (Virginia) Public School records, 1919, reprinted in *A Vision of Education*, ed. Fariello, 61. "President's Annual Report / Negro Teachers' and School Improvement League of Virginia," circa 1912, attributed to Edgar A. Long, reprinted in *A Vision of Education*, ed. Fariello, 123.

12. William Frost, "Berea College—President's Report," *Berea Quarterly* 7, no. 2 (November 1902): 19–30. "Lessons in Practical Cabinet Work: Some New Models for Students and Home Cabinet-Workers," *Craftsman* 13, no. 2 (November 1907), 214–18. Department of Commerce and Labor, *Bulletin of the Bureau of Labor* 54 (September 1904): xi–xii.

13. William Goodell Frost, "An Educational Program for Appalachian America," *Berea Quarterly* (May 1896): 8. "Fireside Industries at Berea College," 1907 brochure in the collection of Berea College Archive, unpaginated. "President's Annual Report / Negro Teachers' and School Improvement League of Virginia," circa 1912, attributed to Edgar A. Long, reprinted in *A Vision of Education*, ed. Fariello, 123. "Manual Training and Citizenship," *Craftsman* 5, no. 4 (January 1904): 406–12; "Industrial Art in Public Schools," *Craftsman* 22, no. 3 (June 1912): 345–46; "Some Craftwork in a Southern High School," *Craftsman* 21, no. 6 (March 1912): 688–91; Booker T. Washington, "The Moral Value of Handwork," *Craftsman* 6, no. 4 (July 1904): 393.

14. Anni Albers, *On Weaving* (Middletown, Conn.: Wesleyan University Press, 1965), 62.

15. George Kubler, *The Shape of Time* (New Haven, Conn.: Yale University Press, 1962), 15.

16. For a lengthy discussion regarding my proposed methodology for understanding the meaning of craft objects, see Fariello, *Objects and Meaning*, 148–75.

17. Rose Slivka, *The Object as Poet* (Washington, D.C.: Renwick Gallery, 1977), 8–9.

18. Henry Varnum Poor, *A Book of Pottery: From Mud to Immortality* (Englewood Cliffs, N.J.: Prentice-Hall, 1958), 82. Ruskin, *The Seven Lamps of Architecture*, 184.

19. Marguerite Wildenhain, *The Invisible Core: A Potter's Life and Thoughts* (Palo Alto, Calif.: Pacific Books, 1973), 40–41.

Dennis Stevens
· · · · · · · · · · · · · ·

Validity Is in the Eye of the Beholder

MAPPING CRAFT COMMUNITIES OF PRACTICE

he term *craft* may be difficult to define, but online and public dialogues are revealing that many of the field's twentieth-century-based assumptions about disciplinary practice are currently being challenged. Gradually, it is becoming apparent that the domain of craft is at a generational crossroads and is presently expanding to embrace aspects of cultural hybridization that have not previously been recognized or articulated within the status-quo craft community. It appears that the craft field is simultaneously adhering to the disciplinary boundaries of the twentieth century while also expanding into areas not previously considered. The validation of a maker's work has become merely a matter of where one chooses to look and what one considers to be his or her field of practice, since many communities can coexist simultaneously as their existence is derived primarily from mutual understanding, a common set of practices and a shared sense of legitimacy. This essay considers the impact of the Internet on craft practice and examines various contemporary and historical philosophical theories as they relate to the study of aesthetics, identity, culture, politics, epistemologies, and the sociology of knowledge, as well as the development and dissemination of ideologies within craft communities of practice.

Similar to forms of blue-collar labor, craft work requires tacit knowledge—often called "personal know-how"[1]—as originally defined by the scientist and philosopher Michael Polanyi and is motivated by an ethic of working with one's hands.[2] However, when this ethic is juxtaposed with the concept of capitalism, one

can see that there is a disconnect between the ideology of craft work and that of the economic system that supports it; namely, that capitalism seeks efficiency in all matters, while craft, though it possesses many positive attributes, will always be a highly inefficient way of getting the job done. In terms of sociological status, the blue-collar work of craft is sequestered in the lower strata of the social spectrum of contemporary society.

The disparity in occupational status between manual and intellectual work can be attributed to the innate sociocultural reality that some forms of intelligence and knowledge are more highly valued over others. For example, as the metalsmith and craft writer/theorist Bruce Metcalf has noted, the cognitive psychologist Howard Gardner's theory of multiple intelligences defines the core capabilities of logical-mathematical intelligence as reasoning, the recognition of abstract patterns, scientific thought and investigation, and performing complex calculations.[3] Correspondingly, a suitable career choice for persons with expertise in this particular domain might be that of scientist, mathematician, lawyer, doctor, or philosopher. However, when we speak in terms of the bodily-kinesthetic knowledge upon which the crafts are built, it seems that sweating is politely reserved for the gym and recreational or hobby activities—except in the cases of extreme athletic talent, which is then suitable for public display as entertainment. Therefore, a commitment to creative expression via craft materials and processes is often saddled with certain baggage, and thus certain sacrifices.

This is not to say that one does not face sacrifices within other creative pursuits or that one cannot earn a living, even a good living, as an artist working in craft materials. But this statement is intended to impart that reality suggests, first, that one can only do so much work oneself without needing help to produce more "product," and second, as with other forms of creative expression, in order to be recognized as a professional within the field of craft, one must produce within a certain framework of expectations that are limited by and often at the mercy of recognized sources of validation, among them the museum, the media, and the marketplace. Quite simply, if a maker wants to be validated, a specific and sometimes limiting range of expectations pertains—first among them, the shared standards of legitimacy within his or her own community of makers who tend to be limited to a particular medium of craft. The few craft artists who manage to earn what would be considered a blue-chip income without compromising their artistic principles

have often done so through hard work, tenacity, and the successful capitalization of the sociocultural tendency toward the collection and fetishization of handmade art objects by wealthy patrons.

Realistically, however, the number of collectors is limited; for the average person, it is certainly easier to resolve needs and desires related to art, design, and functional or decorative objects via ubiquitous retail outlets such as Walmart, Kmart, Ikea, Target, Pottery Barn, and Williams-Sonoma. The choice of where to spend money usually depends on one's budget, aesthetic sensibility, and ease of access. It takes extra effort to seek out handmade art objects; functional, one-of-a-kind objects made by "studio craft" artists do not always stack well in cabinets; works of sculpture are often too big for homes; a family only needs so many quilts. And indeed sometimes people just simply run out of room for functional handcrafted furnishings. After a time even the most dedicated collectors of handmade art objects need to ask themselves the question: can I continue to express my appreciation for objects made by hand and not necessarily own them all?

Culturally speaking, it seems that the importance of valuing the handmade becomes increasing relevant the further technology takes us away from the tangible experience. As the handmade art object continues to be replaced by mechanized processes or cheap imitations, creative handwork galvanizes the craft community through its shared values: dexterity, care, skill, and tradition are ideals that are embedded in the social environment within the multiple domains of craft practice. Presumably, in well-made and considered functional craft objects, one can find physical and psychological comfort through an honest and utilitarian aesthetic. Further, the ineffability of the tacit experience with a handmade art object draws upon values such as nuance, gesture, and integrity, but these are not concepts that are easily understood or appreciated by popular audiences. Rather, these are values which are socially constructed and they are often held by people who have somehow been indoctrinated into the practice of craft in its traditional form. At times it seems that the craft community's commitment to these particular shared ideals enables people to gather together and feel comforted about the changes that are occurring around them by seeking solace in the tacit. Objects of traditional craft connect people metaphorically and metaphysically to tangible, sensory experience; for many, these works of craft become the last remnants of the real.

This collective commitment to a shared a set of ideals is how crafts-

people form community. Community, in this sense, is perhaps best characterized by the German sociologist Ferdinand Tönnies's term *Gemeinschaft*, which refers to a holistic bonding that occurs organically among groups of people through association, connection, or alliance and is marked by shared beliefs as well as collective kinship.[4]

In the larger civil society (which Tönnies describes as *Gesellschaft*[5]), it could be argued that a society's attitudes, beliefs, and values are often reflected in the construction of space as a social by-product as well as in the range of consumptive practices in which the society collectively engages.[6] Examples of these consumptive choices include where to shop, what to buy, what to wear, what to use in their kitchen, what to place in the home and where to place it, and the like. All of these choices reflect what people consider to be important, and the sum of these choices is manifest in the construction of individual and societal identities. As the British sociologist Anthony Giddens suggests, "All social choices (as well as larger and more consequential ones) are decisions not only about how to act but who to be."[7] As such, it seems that valuing craft and choosing to be a maker of craft in contemporary society is inherently a decision about identity and lifestyle as much as it is about values.

According to John Storey, lifestyle is a condition of modernity occasioned by the rise of mass-consumption and consumer culture.[8] Lifestyle and the commodity culture that is often associated with it are ironically, as I will address later in this essay, often the very set of social conditions that craft strives to act against.[9] However, in striving to distinguish itself as a community which is distinct from consumer culture, particularly in its shared belief that handmade art objects are nobler than those that are mass-produced, the craft community nonetheless distinguishes itself as a lifestyle via its own ideology.

To this end, communities of practice are formed when social units are united by common areas of concerns or interests, interact regularly, share a common vocabulary, and, even without acknowledging it, learn with and from one another in the process.[10] These are often self-organizing social systems in which members of a community are informally bound by what they do and what they have to learn from each other through their engagement in shared activities.[11] Communities of practice define themselves along three dimensions. First, they are joint enterprises that are continually renegotiated by their members. Second, they function through mutual engagement in an activity that binds the members together as a social unit. And third, they produce a shared

repertoire of communal resources, routine sensibilities, artifacts, vo-cabularies, and styles that have been developed over time.[12] Using these distinctions as our guide, it becomes clear that the field of craft consists of multiple communities of practice, as each group organizes itself according to the materials and associated processes of the domain.

Accordingly, such fields as ceramics, glass, textiles, jewelry, black-smithing, and woodworking are separate communities of practice, for each of these communities shares a common sensibility. They learn from one another through their gatherings at conferences and exhibitions as well as by way of collective perusal of the publications associated with their fields. In effect, it is through the social nature of their practice that they create their own realities.[13] Each closely connected, craft-based community of practice has an internal system for indoctrinating and validating its members. In particular, each community has its own internal vocabulary, organizational structures, celebrities, and value systems with which individuals must become conversant in order to participate. Within each community of craft practice, the indoctrination process is transmitted socially via dialogue at shared group activities associated with the various organizations, their conferences, and the ancillary events where people gather such as workshops, parties, and exhibition openings. Through the commonality of working by hand and with traditional materials, these fields of practice remain united within the larger domain of craft. However, each community distinguishes itself from another through a shared language and communal dialogue. To a large extent, this niche making is what sets craft apart; generally speaking, contemporary art practices remain fragmented, represented as they are by professional organizations such as the College Art Association and periodicals such as *Art in America*, *Artforum*, and *ArtNews*.

Yet within many of these craft communities today, although tradition is acknowledged, the makers are not adhering to conventional expectations. A new variable has entered the domains of practice: the rise of citizen journalism and what the media has coined the "Netroots" movement. Many Generation-X and Generation-Y object makers are using the democracy of the Internet and its nonhierarchical and decentralized format not only to market their work but also to express their views and to debate and exchange ideas beyond the tightly knit, medium-based enclaves with which their work might conventionally be associated. The advent of blogging and the relatively low cost and accessibility of Web-based e-commerce systems and Web-publishing

platforms have enabled craft artists with little technological savvy (or with friends who are adequately equipped) to begin promoting themselves and their ideas through the Internet. This has, in effect, created new communities of practice which are quite different from the more traditional forms of craft practice described above. It seems that youthful artists working in craft media are focused on carrying out their own version of truth relative to their own epistemological perspectives and generational experiences.

At the core of this movement is the belief that the old structural systems are not working anymore. This is a normal evolution, as younger generations are often ready to defy the work of older generations as soon as the opportunity presents itself. Arguably, it is the job of any young artist to reject the assumptions of the previous generation; this is how new territory is discovered. As the cultural critic Dave Hickey asserts with regard to contemporary art in general: "I feel perfectly able to judge the technical competence of any visual endeavor. I do not, however, see how anyone can pass an informed and sensitive judgment on the work of someone ten to twenty-five years younger than they are. The work of these young people must, almost of necessity, repudiate everything you believe in. And if it doesn't, it's probably not their work, just stuff they thought you'd like."[14]

Before further elaborating what could be quickly discredited as a simplistic series of generalization about generations and social movements and the experience of two largely diverse groups of people, I want to clarify the intention and meaning behind my use of broad labels such as baby boomer and Gen X. With such references, I am thinking in terms of "political generations." The feminist writer Nancy Whittier describes a political generation as "a group of people (not necessarily of the same age) that experiences shared formative social conditions at approximately the same point in their lives, and holds a common interpretive framework shaped by historical circumstances."[15] In this instance I am arguing that much of the tension we are seeing within craft has to do with allegiances and historical conditions set forth by one political generation and being confronted by another. Clearly, we can see a disconnect between the ideals and values of the baby boomers and second-wave feminists and the newer perspectives of the Gen Xers and third-wave feminists.

Second, my use of these terms is intended to be read in light of the sociologist Max Weber's concept of the ideal type, a useful analytic de-

vice for the comparative study or analysis of social and economic phenomena. In describing the concept, Weber writes, "An ideal type is formed by the one-sided accentuation of one or more points of view and by the synthesis of a great many diffuse, discrete, more or less present and occasionally absent concrete individual phenomena, which are arranged according to those one-sidedly emphasized viewpoints into a unified analytical construct"[16]; thus, the use of ideal types is not intended to reveal or adequately describe all the characteristics and elements of any given sociological phenomenon but is rather a tool for its analysis in abstract terms.

With these clarifications in mind, it is important to consider the pending demographic shift between the baby boom generation (born between 1946 and 1964) and Generation X (born between 1965 and 1981), as these two demographic groups have quasi-oppositional views on the definitions of art and craft. The differences in points of view and the inherent generational differences are a result of the two generation's distinct evolutionary histories. Currently, baby boomers are in the positions of authority, have the majority of the money, and do most of the collecting of craft; therefore, they alone are allowed to be the arbiters of validity in the dominant, traditional model of craft culture: the museums, galleries, and journals dedicated to craft media. It seems that Generation X can do nothing but keep working hard and waiting for their day. However, the caveat here is that technology has given the Gen Xers a voice. To understand how this concept of generational differences impacts our cultural theories, definitions, and classifications surrounding the concepts of art and craft, we must look at the distinct origins of each demographic group.

Artists of the baby boom generation established their understanding of art based on the traditions of modernism, and while they do not necessarily maintain an allegiance to modernist methods in their present work, they nonetheless view their world in light of a distinct artistic hierarchical order. Conversely, Gen-X artists cut their teeth on the tenets of postmodernism, and their worldview is a more loosely structured, interdisciplinary construct than the baby boomer ideal. . The baby boom generation experienced modernism as part of their educational development because many of their college art professors and role models were modernist artists. Generation X, however, abides by a different framework because their art professors and mentors were quite often baby boomers, who were by this time teaching the merits (if not necessarily

practicing the tenets) of postmodernism. It is important to consider how this rejection of the old and the subsequent generational quest for newness continues to affect our theoretical viewpoint. This concept is important because it is at the root of crafts' problems today.

So far this essay has addressed various forms of power and how it is used to assert hegemonic control over the ways in which new ideas have been either rejected or assimilated into craft culture. As originally defined by Gramsci, hegemony occurs within modern societies when power is exercised through the perception of "common sense" rather than through force or coercion, resulting in the empowerment of certain cultural beliefs, values, and practices to the partial exclusion of others.[17] Hegemony influences the perspective of mainstream history, as history is written by the victors. When groups of people feel dominated, subordinated, or exploited, they can challenge the hegemony through radical forms of protest, even, at times, forming themselves into subcultures which differentiate themselves by new values, often defined by their opposition to the values of the larger culture or community of practice to which they belong. Case in point: the emerging subdomain of the craft movement which, for the purposes of this essay, we will call do-it-yourself (DIY) craft.

DIY craft refers to a form of domestic creativity that emerges from a do-it-yourself ethos that seeks to confront mass market consumerism and the perceived homogenization of culture as a result of the aggressive expansion of big-box retailers and multinational corporations. The DIY craft movement makes a conscious effort to avoid crassness, but DIY craft is unquestionably about style, irony, and sometimes a touch of kitsch. It is about wit and humor and it is about being "in the know" from a young person's perspective, but it is also about the choices that we make as consumers. However, DIY craft does not often seek validation within the traditional methodologies of the museum, the media, or the market; it is rather motivated by a desire for creative and economic freedom from the same.

In contrast to the structure of the Studio Craft movement discussed in this volume by M. Anna Fariello, the products of the human hand within DIY craft are produced generally through social activities that are related to community activism and third-wave feminism,[18] with allegiances to the 1980s punk movement, zine activity, and the early 1990s Riot Grrrl movement. At its essence, this form of crafting demonstrates a "because we can, dammit" form of domestic creativity that,

while inspired by second-wave feminists' appropriation and celebration of craft media traditionally stereotyped as "feminine," often makes many of those women who came of age during the women's liberation movement of the 1970s cringe over its openness and ambivalence. Because these emerging Gen-X and Gen-Y artists have more choice to make whatever they want in our contemporary art world—unlike the more clearly hierarchical modernist art world of their predecessors—many of them choose to create using traditional domestic processes such as knitting, quilting, weaving, sewing, and decoupage with little, if any of the strident politics that attended similar work by their predecessors.

However, just as feminism's second wave was a sociopolitical response to power and perceived forms of male domination, as well as the evolution of pluralism at the start of the postmodern era, most DIY craft has emerged as a radical force of resistance and activism that seeks to subvert systems of hegemonic power. Predominantly driven by the ideology of third-wave feminism, DIY craft comprises loosely connected groups of individuals with a general collective interest in reshaping, or at least taking a stand against, what they view as the inequities of social and economic power within capitalism. The DIY craft movement is socially based and at times it reaches out as social activism; for some, crafting is a form of political protest, perhaps against sweatshop manufacturing or big-box consumerism, for others, it is about self-sufficiency and getting "off the grid," as their parents may have termed it. In any case, it is a new rethinking of the oft-repeated, second-wave feminist assertion that "the personal is the political."

Admittedly, the DIY craft movement is reminiscent of the 1970s craft movement in this regard, but rather being an intentional realignment within any particular strategy of public engagement, in actuality it is a rather unintentional remix of the earlier movement's principles and aesthetics. The 1970s craft movement was driven by a specific set of values that rejected mass culture and its forms of production; similarly, DIY possesses a core ethos that rejects mass market consumerism and the homogenization of culture. During the 1970s, many artisans were interested in resurrecting traditional crafts; DIY artisans are likewise pursuing a similar cause with subtly familiar aesthetics and a radically different outcome. The difference inheres in how the DIY work is positioned semiotically within the culture. The 1970s craft movement was primarily interested in offering work that sought to re-present traditional crafts as a way to reconnect modern culture to a tradition of making things

ourselves without reliance on the tools of modern mechanization. In contrast, DIY craft has embraced the commercial and capitalistic ethos of modern society and has thus positioned itself as a witty, nostalgically ironic, and somewhat aloof response to what the American craft movement represented in the 1970s. In a large sense, DIY crafters seem to have embraced the realities of how the culture of capitalism, marketing, and corporate co-optation have pervaded American lives since the 1970s—and essentially negated all of the 1970s' naive aspirations of ever living independent of capitalism's reach. DIY craft also offers biting sarcasm with regard to the presumed role of domestic creativity within our culture, especially by way of its often unabashed embrace of crochet, needlepoint, and knitting. Quite ironically, these are forms of domestic production that many second-wave feminists previously denounced and rejected for their role in subjugating women to the home. For DIY practitioners, these methods are not only symbiotic with Gen-Xers' cynicism toward the potential of radical change; they also cut to the core of what third-wave feminism is all about. This form of craft is interested in making a cultural statement. Often, on the surface the work looks like common and sometimes kitschy objects intended to be disarming, but at second glance these works are frequently subversively loaded with signification. DIY crafters deploy parody and satire as cultural commentary. Certainly, these strategies still constitute craft or crafting, just not "craft" as we have traditionally known it, laden with earnest meaning concerning the inherent, positive morality of making. Instead, they seek comment on the present through the postmodern deployment of nostalgic irony.

Concurrent with the rise of the DIY craft movement, a new form of craft fair has emerged over the past several years in many cities throughout the United States. Examples include the Renegade Craft Fair in Brooklyn and Chicago; Art vs. Craft in Milwaukee; and Bazaar Bizarre, held in Boston, Los Angeles, Cleveland, and San Francisco. While these fairs reflect some characteristics of traditional crafts fairs, the difference is that the vendors are mainly Gen Xers who are commercially savvy, art-educated, conscious of good design, and who seek to transform what was once considered mere feminine and domestic forms of creativity and decoration into something new. In these fairs, it seems that DIY craft as a subculture has an interest in capitalizing on the subversive allure of hipness in an effort to subvert hegemonic systems of taste and consumption. At DIY craft events, one frequently senses a

palatable measure of tastemakers' confidence. These craft practitioners are insiders because they have not only built up social capital through communal work sessions in crafts production but have also embraced their inner geek and built an identity for themselves via the social community of craft that exists on the Internet.

A tremendous number of bloggers are using the technology of the Web to address and celebrate this emergent field, and their taglines are descriptive of the common themes among DIY craft practitioners. For example, ExtremeCraft.com touts itself as "a compendium of craft masquerading as art, art masquerading as craft, and craft extending its middle finger," while Craftster.com exclaims "No tea cozy's without irony." In contrast, SuperNaturale.com *"celebrates ingenuity, creativity and the handmade," while* Craftivism.com is *"documenting the crafty life, stitch by political stitch" and* WhipUp.net focuses on "handcraft in a hectic world." These are just a few examples within a large, loosely connected community that blogs in an attempt to document a vast democratic system of object makers who care little about status or fame but much about creativity, irony, and subverting the greed- and ego-driven components they see within the capitalistic economic system—traditional craft communities included.

As we have seen, craft is at a crossroads in that, after fifty years of trying to sort out its identity within the shifting tides of modernism and postmodernism, the old regime of American craft is suddenly confronted with a new, nebulous cultural force that shares its name. Certainly, within society and social trending, one can anticipate that the youth will attempt to carry out their own version of truth, through whatever means are possible. Just as the baby boomers' countercultural activism in the 1960s was a response to the conformity of the 1950s, DIY craft is not at all interested in American craft's hierarchies, power structures, or institutional methods for confirming status.

However, despite these differences, it does seem that if we dig below the surface, it is possible to locate a shared raison d'être for craft. An analysis of craft's ethos leads us back through a long history of resistance to both the industrial revolution and the general tendency of technology and capitalism to replace the more genuine and authentic forms of human production, namely, the things made by hand. Yet aside from the tendency of history to repeat itself, we must not underestimate the struggle of the youth to be understood and to live out their generational experiences and "truths" in their own unique manner; theirs are

the paths that will lead the culture to new places and, ultimately, new reasons for being.

As the conceptual artist and writer David Robbins suggests: "Every generation of artist configures culture to match its own experience. The conditions of our upbringing imprint us and when we come to maturity we return the favor, imprinting our sensibilities upon the culture and bending it to our wills."[19] It is with these words in mind that one can assert that craft today comprises multiple groups with their own goals, ambitions, and internal methods of knowledge production and sharing; these groups are navigating their own way through previously unmapped territories.

During their youth, the baby boom generation, and also the second-wave feminists, believed that revolution was necessary to change the world. During their formative stages as adolescents and young adults, they experienced political turmoil including the Vietnam War, the assassination of John F. Kennedy, and the struggles associated with both the civil rights and women's liberation movements. Correspondingly, young adults in the mid-1960s were portrayed by the French filmmaker Jean-Luc Godard as "the children of Marx and Coca-Cola."[20]

In contrast, young adults in the mid-1980s are described by David Robbins as the children of Barthes and Coca-Cola, and he further describes his shared generational experience as having "no use for 60's naïveté or 70's embitterment."[21] He further comments on his shared experience as a young adult in the 1980s: "Cynicism springs from disappointment, disappointment from naïveté; obvious, it seemed to us, that to ward off the cynicism's black flowers, naïveté had to be nipped in the bud. We wielded the shears cheerfully."[22]

Somewhere in the transition and despite Robbins's generational claim to success, a mere decade later the cynicism returned in full bloom within the Gen Xers and third-wave feminist attitudes toward the media and political change. In contrast to the baby-boom experience, punk rock, grunge, hip-hop, and mass-consumerism constituted the experiences of these groups as adolescents and young adults. As a result of these experiences as well as the history that they inherited from their parents' generation, somewhere within their ethos the Gen Xers and third-wave feminists began to see the inherent difficulty, and perhaps the impossibility, of changing the world through direct political action. Today these groups' efforts to bring about political change often remain subversively masked within their culturally fluent use of irony, satire,

and parody. Further, as the first generation to grow up with MTV and the Internet, Gen X's media literacy and methods for engaging with the culture are strikingly different from how their parents did business.

Gen Xers and third-wave feminists alike have a strong sense of semiotics, whether they have studied Roland Barthes or not, and they like to use the tools of the re-mix, namely, satire, parody, and irony along with an occasional tinge of cynicism or nihilism, respectively drawn from their grunge and punk influences, to make cultural statements that often manifest themselves via their nostalgically ironic aesthetics. Often their experience with culture is such that their creative outcomes are aimed at drawing our attention to the chasm between a diverse range of experiences and "truths" that are at the root of the postmodern condition, underscoring the idea that the Western metanarrative is dead and truth can be found relative to one's own experience, or, to put it more esoterically, relative to one's own unique social phenomenological experience.[23]

DIY craft seeks to redefine the antiquated nomenclatures of artist, maker, craftsperson, designer, and small-business owner. Although the DIY movement has a certain reverence for what American craft represented, it is unquestionably an independent and burgeoning cultural and economic force, as evidenced by its own magazines, websites, fairs, books, television programs, and documentary video projects.[24]

At least in the short term, the difficulty will continue to be whether these two distinct fields will be able to accept their differences and evolve into a dynamic, singular entity that unites to celebrate all things handmade,[25] or whether they will continue to operate apart from one another and move in distinct directions, a result of each community's inability to reconcile the other's divergent social constructs. My intuition is that the challenge to unite these two distinct fields of craft will continue to be difficult, primarily because their systems of knowledge are derived from several very different worldviews.

I argue this closing point on the basis of a brief essay by Walter Truett Anderson, which discusses how distinct worldviews within contemporary Western societies have their own languages for public discourse.[26] In looking at the two fields of craft through the lens of Anderson's articulations, I believe that it is possible to better understand the lines of logic which I have articulated in this essay. The worldview that I have argued for here can be best described as social constructionist, and in a similarly postmodern sense the DIY craft field is operating from the

perspective of what Anderson would define as "postmodern player." As I have described, DIY crafters enjoy irony as an expressive part of their attitude, and according to Anderson's formulation, they like to "play mix-and-match" with various aspects of our cultural heritage. In contrast, traditional studio craft, as I have known it, generally can be summarized as having two hybridized systems of logic. The first is "neo-romantic" in that it primarily rejects modern and postmodern worldviews and desires to return to a spiritual and ecological golden era, prior to both the Industrial Revolution and the age of Enlightenment, like Europe during the sixteenth century when craft guilds were popular. Studio craft's second system of knowledge seems to fit within what Anderson would call "social-traditional" in that it holds beliefs that are reliant upon the more classical truths of Western (and sometimes Eastern) civilization. Within social-traditional craft logic there seems to be a general yearning to return to the time of craft's greatest optimism, the days in which Aileen Osborn Webb was leading the charge. Also, within this perspective, the objective seems to be to produce objects whose meaning is clearly understood within a "universal" sensibility; often this leads to a discounting of postmodern thought as mere frivolous pedantry.

The larger challenge for the craft field, if we can label it cohesively, is for its members to use this mapping of epistemological landscapes to learn how to better understand and talk to one another. This is assuming, of course, that what I have outlined above is deemed to be "true," which, ironically, is the whole point of my endeavor here. Validity within craft is entirely dependent upon the manner in which the map is conceptualized and manifested. Who gets to draw the map and who "beholds" it matters more than ever as we confront the enormous shifts evident in craft's communities in the early twenty-first century.

NOTES

1. Tacit knowledge is personal and rooted in action, and it is evidenced by skill and craft; it is also difficult to codify or measure.
2. Michael Polyani, *Personal Knowledge: Towards a Post Critical Philosophy* (London: Routledge, 1958), and *The Tacit Dimension* (Garden City, N.Y.: Doubleday, 1966).
3. Bruce Metcalf, "Craft and Art, Culture and Biology," *The Culture of Craft*, ed. Peter Dormer (Manchester: Manchester University Press, 1997), 77. See Metcalf's essay for a more detailed explanation of Gardner's theory of multiple intelligence and its relationship to craft theory; see also Howard Gardner, *Frames of Mind: The Theory of Multiple Intelligences* (New York: Basic Books, 1983).

4. Ferdinand Tönnies, *Community and Civil Society*, trans. Jose Harris and Margaret Hollis (New York: Cambridge University Press, 2001), 17.

5. Ibid.

6. For further context, see Pierre Bourdieu, *Distinction: A Social Critique of the Judgement of Taste*, trans. Richard Nice (London: Routledge, 1984); Michel De Certeau, *The Practice of Everyday Life* (Berkeley: University of California Press, 1984); and Henri Lefebvre, *The Production of Space*, trans. Donald Nicholson-Smith (Oxford: Basil Blackwell, 1991).

7. Anthony Giddens. *Modernity and Self-Identity: Self and Society in the Late Modern Age* (Cambridge: Polity, 1991), 88.

8. John Storey, *Cultural Consumption and Everyday Life* (London: Arnold, 1999).

9. Marx was the first to clearly articulate the notion that would later become known as commodity culture; for a more contemporary context and also a critique of Marx's notion of critique of political economy, see Jean Baudrillard, *For a Critique of the Political Economy of the Sign*, trans. Charles Levin (Paris: Denoël, 1972).

10. See Etienne Wenger, Richard McDermott, and William Snyder, *Cultivating Communities of Practice: A Guide to Managing Knowledge* (Boston: Harvard Business School Press, 2002).

11. Jean Lave and Etienne Wenger, *Situated Learning: Legitimate Peripheral Participation* (Cambridge: Cambridge University Press, 1991).

12. See Wenger, McDermott, and Snyder, *Cultivating Communities of Practice*.

13. For example, ceramists have professional organizations such as the National Council on Education for the Ceramic Arts and journals like *Ceramics Monthly*, *Clay Times*, and *Ceramics Art and Perception*; fiber artists have the Surface Design Association and *Fiber Arts*, *Surface Design Journal*, and *Selvedge*, among other publications.

14. Chris Scoates, "Speed and Fire: An Interview with Dave Hickey," *Sculpture*, May/June 1996, 31.

15. Nancy Whittier, "Turning It Over: Personal Change in the Columbus, Ohio, Women's Movement, 1969–1984," *Feminist Organizations: Harvest of the New Women's Movement*, ed. Myra Marx Feree and Patricia Yancey Martin (Philadelphia: Temple University Press, 1995).

16. Max Weber, *The Methodology of the Social Sciences*, trans. Edward A. Shils and Henry A. Finch (New York: Free Press, 1997), 88.

17. Antonio Gramsci, *Selections from the Prison Notebooks*, ed. and trans. Quintin Hoare and Geoffrey Nowell Smith (New York: International Publishers, 1971), 180.

18. *Third-wave feminism* is a term used to describe a new form of feminist activity that emerged in the early 1990s. At its core, it seeks to challenge what it considers to be the failures and shortcomings of second-wave feminism; particularly its perceived assumptions of universal female identity and what the third-wave views as an overemphasis on the experiences of upper-middle-class white women.

19. David Robbins, *The Velvet Grind: Selected Essays, Interviews and Satires (1983–2005)*, ed. Lionel Bovier and Fabrice Stroun (Dijon: JRP/Ringier and Les presses du réel, 2006), 108.

20. In *Masculin, feminine* (1966), directed by the French filmmaker Jean-Luc

Godard, an intertitle between scenes states: "This film could be called The Children of Marx and Coca-Cola."

21. Robbins, *The Velvet Grind*, 108. Roland Barthes (b. November 12, 1915; d. March 25, 1980) was a French literary critic, literary and social theorist, philosopher, and semiologist. His work extended over many fields and he influenced the development of schools of theory including structuralism, semiology, existentialism, Marxism, and poststructuralism.

22. Robbins, *The Velvet Grind*, 108.

23. Jean-François Lyotard, *The Postmodern Condition: A Report on Knowledge* (Minneapolis: University of Minnesota Press, 1985); Alfred Schütz, *The Phenomenology of the Social World* (Evanston, Ill.: Northwestern University Press, 1967).

24. *Handmade Nation, The Documentary*, directed by Faythe Levine (Milwaukee DIY, 2009).

25. Imogene Blog Archive, "Confessions," 9 March 2008, http://www.imogene .org/blog/.

26. Walter Truett Anderson, "Four Different Ways To Be Absolutely Right," *The Truth about the Truth: De-confusing and Re-constructing the Postmodern World*, ed. Anderson (New York: Tarcher/Penguin, 1995), 110–16.

Louise Mazanti
.

Super-Objects

CRAFT AS AN AESTHETIC POSITION

In contemporary discourse, craft is first and foremost discussed as a practice whose main feature is either its tight sociocultural or aesthetically based relation to a specific material or a set of practices. Craft is either seen as a practice with a long tradition of working with specific materials, or as a practice based on a certain approach to the working process. In short, the conceptual frame for craft is often seen as premised on "tradition," "material," or "process."[1] The aim of this essay is to address why neither of these viewpoints successfully expresses what I would like to suggest as the core identity of craft. I am very well aware that talking about "core identities" of cultural practices will instantly make alarm bells sound among academic cultural workers. Clearly, different cultural practices subscribe to different cultural, social, economic, and even political agendas. And as the literature of art sociology so richly demonstrates, discourses are social constructions and vary over time.[2] But even though the flux is constant, definitions and new identities are indeed formed and can be localized; we act, write, teach, exhibit, politicize, and buy based on certain expectations in certain cultural fields. And in a contemporary setting, the viewpoint on craft is often this: craft applies to material and technique.

An example of this dominant perspective is the way the editors Shu Hung and Joseph Magliaro present the participating artists in the book *By Hand: The Use of Craft in Contemporary Art*. They write in the introduction: "The thirty-two participants are unafraid of letting a bit of themselves show through in their final products. They are happy to leave their fingerprints on their

work in an attempt to get closer to their own lives and to the lives of others."[3] In their book, craft is clearly reduced to a process: a means to carry out an artistic agenda. Furthermore, the citation underlines this by pointing to the traces of the making process—the "fingerprints"—which guarantees a kind of authenticity.

If we look at the cultural field that incorporates art, craft, and design as a whole, it is particularly important to examine how different expectations condition the understanding of the different fields. In the conceptual framing of these practices that are all concerned with the production of objects and meaning, we can find a whole set of theoretical and philosophical preconditions for discussing cultural definitions and possible core identities, preconditions that, when examined in depth, actually reveal a kind of theoretical backbone that points to a new, different understanding of craft in contemporary culture.

Let us therefore take a closer look at the above words from Hung and Magliaro, which offer a useful perspective in this last point: "an attempt to get closer to their own lives and to the lives of others." What we see here is an art/life dichotomy to which I will return. At this stage, I mention it to introduce an idea to develop theoretically—that one can find a position for craft that is defined by its relation not to a specific material but rather to the role that it performs in the world of objects. In other words, the position shifts from the "making" to the "doing" of craft.

This viewpoint also involves the discourse of design. Design is largely kept out of sight when the identity and artistic position of craft is discussed. Design largely represents the marketplace values of craft, as we can see in an article from the British *Crafts* magazine's feature "The Craft of Design Art," in which Corinne Julius writes: "With the public increasingly unlikely to see or understand the process and production of objects, the hand-made and even the seemingly hand-made are becoming more and more attractive. The human imprint is essential to craft, and this is where it has traction on the leading edge of design."[4]

We should note that in relation to design, craft plays the same role as it does in relation visual art; the "handmade" and the "human imprint" are central characteristics in a search for authenticity that meets the needs of the alienated consumer in our industrial age. This notion is the main point in the Danish design critic Henrik Most's writings on craft in relation to design: "Craft can challenge the conventions of industrial design and enhance product differentiation by adding innovative

aesthetics and forging a deeper relationship with the world of things."[5] Again, we find a search for authenticity in this "deeper relationship with the world of things" typical of traditional associations with craft, but, significantly, articulated by Most alongside the design features of "innovative aesthetics" and "product differentiation."

Here we can draw two conclusions: again, process plays an essential role in the way craft is conceptualized, and this "human imprint" functions as a way to make the object special by differentiating it from the line of unconscious, anonymous, and mass-produced products. Moreover, this points to another pertinent finding that is not represented in the art/craft perspective: "the world of things." In regard to design, craft is conceptualized as a making approach, but it is materialized in a product culture of functional objects. I believe that this is worth taking a step further. One of the main points of departure for this essay is that design holds an important clue for understanding the identity of craft, because design represents a discourse that incorporates what we could call the culture of everyday life.

In the outskirts of the craft-as-art discourse, then, we have an art/ life dichotomy that is also recognizable in the craft-as-design discourse, since design is immediately tied to functional objects, in which craft is invoked to provide them with a sense of authenticity. This gives us the opportunity to shift cultural perspectives of craft understood as a process to craft understood as a specific artistic and cultural practice: a body of (made) objects, which play a specific role compared to other kinds of objects in contemporary artistic and consumer-oriented practices. If the term *material culture* covers all manmade objects, we could say that under this umbrella art, design, and craft objects play different roles—roles that originate in historical, economical, political, and philosophical conditions, which are not fixed positions. And I would like to propose that the role of craft objects is the most blurred of the three. I therefore suggest that we move from the "making" to the "being" of craft, from the "process" to the "doing," to the role it performs in contemporary culture.

I propose the term *super-object* as descriptive of what I see as a core identity of craft and the position it inhabits in contemporary culture. Unlike the use of the term introduced by the ceramics scholar Garth Clark in *A Century of Ceramics in the United States* (1979) to denote the stylistic characteristics of a ceramic movement of the 1970s[6]—which

relates to super-realism in sculpture and painting—I see and use it as a metaphor for the role craft objects play in contemporary society compared to other kinds of objects and practices.

At this point it is essential to reiterate "the role craft objects play," as the aim of this essay is to point to a receptive position—an aesthetic position in the field of contemporary culture. When talking about "craft identity" I do not mean an essential identity to be fixed on certain objects but one that can be applied successfully, if flexibly, to certain kinds of objects, where craft is an independent aesthetic position.

THE SUPER-OBJECT

The term *super-object* serves as a framework to describe the role of craft as a position that draws on both visual art and design discourses while still acting as an independent practice with an independent meaning. A super-object is an object that exists parallel to the object category of the design commodity, at the same time as it contains (super-)layers of meaning that relate to visual art. These layers of meaning can be either aesthetically based, as we would see it in the Danish ceramist Alev Siesbye's classical aesthetic and sculptural values (see fig. 1), or conceptual, as in the American ceramist Justin Novak's *MotelHaus Objects* (2003) (see fig. 2), which transposes formal vocabularies of different domestic pleasure zones. But very often we would see them interact, as in the British potter Edmund de Waal's "site-sensitive" installations of porcelain pots that often interact with different predefined settings (see fig. 3). The use of the term *super-object* thereby implies that I draw a quite precise line between craft as an independent cultural practice, and craft as process and means to make visual art or design: The super-object stands as a metaphor for craft as an independent practice, for a body of objects that grow out of design because they have a form-typological relation to functional objects, even as the objects' artistic (aesthetic or conceptual) content is central. Just think of de Waal's "pots" that look like books in shelves (see fig. 4) but which clearly deny function in order instead to articulate hidden perceptions of the room. In all these ways they seem to be meant to be perceived as objects—pots, books, shelves—containing condensed super-layers of meaning.

As I will show, the position as super-object holds true for craft in both a historical and a contemporary sense. The position as a super-object is special because it takes a semi-autonomous position, which both visual art and design draw on in their most experimental expressions. Semi-

1 Alev Siesbye, untitled bowls, 2004, hand-coiled stoneware, (*left to right*) height: 9 inches, diam. 9¾ inches; height: 7 inches, diam. 11½ inches; height: 9¼ inches, diam. 11 inches. Photo: Patrick Muller.

2 Justin Novak, *MotelHaus Objects*, 2003, slip-cast porcelain; sizes range from 9 cm to 23 cm. Produced with the support of the Walbrzych Porcelain Factory, Walbrzych, Poland.

3 Edmund de Waal, *The Long View*, 2007. Installation view, New Art Center, Salisbury. Left: *Just Lately*, two white lacquer cabinets, each 16¼ × 16¼ × 5 inches, and sixty-one porcelain vessels in five white glazes. Center: *Predella II*, thirty-nine thrown porcelain vessels, six glazes, and white lacquer cabinet, 47¼ × 51¼ × 7¼ inches. Right: *Tristia*, two white lacquer boxes, each 19¾ × 15¾ × 13¾ inches, and thirty-one yellow glazed porcelain vessels.

4 Edmund de Waal, *Predella II*, detail from *The Long View*, 2007.

autonomy means that craft, on the one hand, refers to the fundamental idea about art as existing in an autonomous space—referring to its own aesthetic logic—and, on the other, refers to the more profane everyday object that is theoretically framed by material-culture studies and a general design discourse. The super-object simply materializes what could be called the dichotomy between art and life, referring to both spheres at the same time. Again, we could mention de Waal and his notion of "site-sensitive" objects; by not being "site *specific*," de Waal's objects can be placed precisely in a semi-autonomous position. They are "sensitive," yet simultaneously "self-containing"—a kind of autonomous everyday object that makes the art/life dichotomy highly relevant. For this reason, one could say that the cultural position of craft binds visual art and design together, since craft represents the ultimate response to the art/life, and therefore art/design, dichotomy.

This fact makes it relevant to put forward the concept of the avant-garde. Avant-garde theory is an established field of research within literature and art theory that is concerned with this tense relationship between art and life. As I will show, avant-garde theory still serves as an underlying reference for the discussion of contemporary cultural practices, especially regarding art practices in a societal context. From this point of view, in the field of contemporary cultural practices, craft as a super-object occupies an important position that has not been fully recognized as yet. Therefore, let us take a closer look at contemporary visual art, design, and craft practices in order to see how they are positioned within the art/life dichotomy of the avant-garde. As we do this, craft, as conceptualized by the metaphor of the super-object, will stand out as an obviously important position that is not covered by typical definitions of art or design. In other words, with the super-object we can begin to define a cultural position for craft as an independent practice, beyond its mere existence as a tradition, material, or process.

VISUAL ART AS "CONTEMPLATIVE WORMHOLES"

I want to discuss some examples from current visual art and design that I feel carry essential points regarding current practices of art and design, beginning with the Danish visual artist Henrik Plenge Jakobsen. Plenge Jakobsen insists on an art practice that has a social agenda; he represents a generation of artists whose work transgresses the logic of the specific artwork by focusing instead on the situation in which the spectator meets the work. To Plenge Jakobsen the mission of art is to compose a

5 Jes Brinch and Henrik Plenge Jakobsen, *Smashed Parking*, 1994, in *Wonderful Copenhagen*, temporary public art project, Kongens Nytorv, Copenhagen. Cars, city bus, and caravan, 78¾ × 39⅓ × 11¾ inches. Photo: Dorthe Krogh. Courtesy of the artists.

contemplative and critical space that comments on existential, societal, and global issues. One of his most recognized projects is *Smashed Parking* (1994, together with Danish artist Jes Brinch: see fig. 5). A number of scrapped cars and busses were tipped over and dispersed on the noble public square Kongens Nytorv in central Copenhagen, where they were further ravaged and smashed by the artists as a kind of performance during the opening—a ravage continued by anonymous youngsters in the evenings during the course of the installation's run. The project meant to question the art world's bourgeois aesthetics and behavior regarding a so-called work of art, and the work's popularity among the youthful vandals who "contributed" to the project suggest its success—indeed, it was so successful in this regard that the authorities were forced to cancel the exhibition and clean up the space.

In an interview about his artistic practice Plenge Jakobsen said: "To me the important thing is to be out in the same world as [international mass media like] cnn and *Bild Zeitung*. You really have to get involved. The works must function as cracks and empty spaces and contemplative wormholes. They have to be a part of the real world while at the same time insisting on their own specific agenda."[7] This presents a double

position: "out there," making a difference in the discourse of the real world but still devoted to the "inside" logic of the art world, respecting the autonomy of art according to an avant-garde position. This position clearly addresses avant-garde theoretical positions as initiated by the German critic Peter Bürger in his seminal book *Theory of the Avant-Garde* (1974). Bürger's point of departure is an analysis of the modernist, bourgeois concept of art that he claims developed in the latter part of the nineteenth century and evolved into the affirmative aestheticism of modernist critics such as Clement Greenberg. As *l'art pour l'art* autonomy, it was isolated from influencing life: art radically divorced from any reality other than its own. Drawing on the Marxist tradition, Bürger further argues that the main goal of what he calls the "historical avant-garde"—Dada, Surrealism, and Russian Constructivism—was to strive toward reintegrating art and life: to revolt against the sociocultural power structures in order to reconstruct society in terms of new ideals. This could be done only by deconstructing the very idea of an autonomous art that modernist critics had claimed as these movements' primary legacy. In this, Bürger proposes that the avant-garde faces a paradox that haunted the discourse of art throughout the twentieth century. That is, without the privileged position of autonomy, art loses its critical position: "An art no longer distinct from the praxis of life but wholly absorbed in it will lose its capacity to criticize it, along with its distance."[8] Bürger therefore sees no possibility other than to finally question whether it is at all desirable to dissolve the autonomy of art.

As Plenge Jakobsen suggests, art since Bürger has found its own way of dealing with this paradox: a "wormhole" that operates on both levels, carrying out a critical practice in the middle of audiences' daily life. It is therefore worth noting that in contemporary visual art practice and criticism, the avant-garde's theoretical split between autonomy and dissolution is still manifest as a vital point of friction. What may seem to be just a formal, experimental practice actually draws on what Bürger articulated as the avant-garde's striving to transform society. It relates to the historical avant-garde's urge to provoke the bourgeoisie but bears the mark of contemporary practice by having left the ultimate modernist institution of art—the art museum—as a point of friction. Yet it is important to note that such projects only gain their intended meaning when contemplated as "art." Without the platform of being an artwork, the project does not communicate: the critical friction guaranteed by the conception of autonomous art, even though this practice is not

caught by the paradox of Peter Bürger. What we see, then, is a tendency in contemporary visual art to work within the logic of the art/life dichotomy by aiming to reintegrate art and life, by moving art out of the institution and into the everyday through strategic interventions in the lives of its audiences.

DESIGN TO IMPROVE LIFE (AND BOTTOM LINES)

Simultaneously, the design field has undergone a dramatic change from its public reputation as the (superficial) aesthetic styling of lifestyle products. We see this in designers' search for craft authenticity, but it is also visible in the problem-solving aspect of design. For example, in 2005 the biannual world design event Index: was inaugurated in Copenhagen with the subtitle "Design to Improve Life." Major global issues such as pollution, housing shortages, unemployment, and armed conflicts were addressed from a design perspective. The declared goal of Index: is to be "dedicated to change global mindset by showing and exploring how design can improve life,"[9] and one of the activities is to award the lucrative Index:Award. Among the award winners in 2005 was the LifeStraw™ (see fig. 6)—a drinking straw that eliminates disease-causing bacteria, allowing the user to sip water from any source—and in 2007 an award was granted to Mobility for Each One, a locally producible, low-cost leg prosthesis.

At the inaugural Index:, the term *strategic design* was introduced to a broad international audience, underscoring the ways in which design has sought to gain a new identity. Instead of being associated with modernist virtues of "good design" based on how ordinary consumer products are currently used, the goal of strategic design is the creation of products that solve fundamental problems in the world. As Richard Koshalek, president of the Art Center College of Design, said about this current design practice in the Index:2005 special issue of *Monday Morning Weekly*: "Designers are becoming more involved in the decisions that really make a difference."[10] Those decisions entail the development of new solutions to existing global problems, as Index: suggests. However, improving life is only one side of strategic design. Koshalek elaborates the other side: "The trend is developing, not surprisingly, in parallel with the demands from society for more innovation—and for new, more conscious ways to foster it. This is partly due to the fact that global companies cannot go much further down the road of streamlining their processes."[11] Strategic design is thereby also a tool for the market-

6 Vestergaard
Frandsen Disease
Control Textiles /
3PART, LifeStraw®,
2005.

driven innovation with which is it traditionally associated, known as the
"creativity economy." In this way, many threads come together. Strategic
design suggests a situation where creative thinking is mixed efficiently
with an instrumental agenda: either to directly improve people's lives
or to improve the corporate innovation economy that affects them, or
indeed both.

It is important to note how design has thusly broken radically with
aesthetics and the privileged object, in order to operate strategically. Be-
hind the rhetoric of innovation we see a compelling mix of bottom-line
thinking and a commitment to taking responsibility in solving serious
global problems. Returning to the avant-garde position of Peter Bürger,
design seems to have taken a shortcut: it works, changes, and operates
in real life with the apparent aim not of transforming art into life but
providing life itself with the potential to change through the objects it
creates. The difference, however, is that the main concern for economic
profit lurks beneath the surface of this idealistic ethos. While the avant-
garde transformation of society is subversive and builds on the destruc-
tion of existing values, design is much more pragmatic and thus also

more affirmative. It simply draws on the idealistic ethos but moves freely between pragmatism and idealism, as can be seen with the LifeStraw™, which has enormous humanistic as well as economic potential. In the context of Index: the idealistic, humanistic scope is stressed, while the original cooperation between the disease-control textile manufacturer Vestergaard-Frandsen and the industrial design firm 3PART also had a calculated economic benefit.

CRITICIZING DESIGN

The German philosopher Wolfgang Welsch takes up this pragmatic aspect of design in his concept of aestheticization. In *Undoing Aesthetics* (1997), Welsch argues that aesthetic standards have come to serve in new areas of society, outside the traditional realm of the aesthetic: "We are without doubt currently experiencing an aesthetics boom. It extends from individual styling, urban planning and the economy through to theory. More and more elements of reality are aesthetically mantled, and reality as a whole is coming to count increasingly as an aesthetic construct to us."[12] Welsch extends this diagnosis into a critique of design as "furnishing reality with aesthetic elements, sugar coating the real with aesthetic flair" that mostly serves "economic purposes," indicating, as he states, that "if advanced Western societies were able to do completely as they wish, they would transform the urban, industrial and natural environment *in toto* into a hyper-aesthetic scenario."[13] In this way Welsch depicts a society in which design is a fundamental agent of capitalism and globalization.

In his intriguingly titled *Design and Crime* (2002), the American cultural theorist Hal Foster takes up this construction. The book's title paraphrases the Viennese architect Adolf Loos's (in)famous essay "Ornament and Crime" from 1908, in which Loos attacked the period's prevailing Jugendstil for its claustrophobic, all-over ornamentation, which leaves culture with what Loos termed no "running room." According to Foster, this is exactly the situation of contemporary culture, whereby display has become the prevalent concept in a society dominated by spectacles, brand identity, and a merging of marketing and culture. In this society, he writes, "we experience an almost seamless circuit of production and consumption."[14] Foster explicitly reacts against this by pointing to the necessity of reestablishing a critical "running room" beyond the all-encompassing circle of designed consumption. However, he locates this running room in the contemporary art world, where he

70 SUPER-OBJECTS

finds a kind of "strategic autonomy" in which art is both autonomous—existing according to its own logic—and relates sufficiently to everyday life to form a true opposition to design's "seamless circuit of production and consumption."

This is precisely the position that Plenge Jakobsen addresses in his conception of a "contemplative wormhole." Seen from an avant-garde theoretical perspective, whether the idealistic intentions of design are taken for granted or not, we are left with the friction between design's seamless sliding into society and the critical friction of art's challenge to the same. Design and avant-garde visual art are thereby positioned as practices which work with idealistic agendas but which face oppositional sets of problems. While design faces the challenge of becoming *too* instrumentalized for the benefit of the fundamental, capitalistic goals of the real world, thereby losing its transformative power, for art the question is how to find a way to *become* instrumental, in order to actually get involved in the real world outside its autonomous zone. But even though the practices seem oppositional, they do not represent a true dichotomy. Artist-designers and designer-artists alike work with similar strategies.[15] Both approaches are engaged in idealistic questions about how to change contemporary society.

WHAT'S LEFT OVER: THE PRIVILEGED AESTHETIC OBJECT

In this context, the identity of craft does not look like much. The observation by Shu Hung and Joseph Magliaro that began this essay suggests that craft functions as the "authentic" part of visual art. By bearing the "mark of the hand," craft has an intimate relation with its maker and thereby becomes a promise of something authentic in reaction to more conceptual (and thus, it is suggested, depersonalized) visual art. Yet this is a very convenient position. As is abundantly addressed in several essays in this volume, the elevated status of visual artists is, for the most part, desired by those within the craft community, whose identity has been unclear within and marginalized by both the art and design communities. The current repositioning of craft as a contemporary art strategy by artists such as Kiki Smith, Kent Henricksen, Carolyn Salas, and Victoria May should be seen in this light, and it should be questioned whether this search for authenticity really can count for the core identity of craft. And while Hung and Magliaro focus on the contemporary gallery world, Corinne Julius and Henrik Most address craft as a practice that adds product differentiation and innovative aesthetics

to products in the design world. In both cases, while visual art and design are positioned as engaging in idealistic, intellectual issues, craft is promoted as authenticity, technique, or aestheticization. It confers "humanity" on both the conceptual forms of visual art and depersonalized, innovation-oriented design.

This position is relevant, because it contains a much more far-reaching meaning than that revealed at first sight. In this construct, what craft is left with in both fields is the role of privileged aesthetic object. This is a largely neglected category in the practices of both contemporary visual art and design, which, as we have seen, are (seemingly contradictorily) occupied with an effort to make a difference in and have an influence on life praxis; in neither is the aesthetic autonomy of the object seen as a way to engage it. This point is poignant because it is one of the main reasons why craft has been relegated to the periphery of cultural practices. Conceived as being too "neat and nice," too focused on the aesthetic of a specific material, craft has never been able to set the agenda for a contemporary culture—an agenda that, as Peter Bürger points out, throughout the twentieth century has constantly drawn on the friction between art and life as set by the historical avant-garde. In the attempt to transgress the border between art and life without ending in Bürger's paradox of the avant-garde, visual art has constantly broken with its own institutionalization as art. The position of fulfilling the subversive intentions of the avant-garde simply presupposes the constant negation of its own limits, in order not to ossify into affirmative institutionalization.

Yet it is obvious that the traditional aesthetic, material-based craft object has difficulties in meeting these demands. Instead, as addressed in the introduction to this anthology, it has ironically subscribed to a modernist art concept in which it was never fully recognized. Craft has therefore mainly been perceived as a harmless practice, at best able to guarantee a relation to what has been lost in contemporary art and design: the privileged aesthetic object embodying notions of beauty, sensuousness, skill, and authenticity. In other words, craft has engaged with the leftovers of visual art and design. However, in this seemingly resigned position there is a potential that has not yet been fully realized. This can be glimpsed by returning to and pairing Most's remark concerning "a deeper relationship to the world of things" and Hung's and Magliaro's articulation of craft's attempt "to get closer to their own lives and to the lives of others." In combination, "the world of things" and an

"attempt to get closer to one's own life and the lives of others" provide us with a compelling path between two theoretical approaches: namely, *material culture studies* of everyday objects and social relations on the one hand, and an *avant-garde theoretical* approach to the relation between art and life on the other. This point actually has a wide-ranging significance when coupled with the conception of craft as a privileged aesthetic object, as it constitutes an unrecognized category of cultural practice when seen in light of the avant-garde efforts to reconcile the split between art and life. One might ask why the avant-garde should be expected to frame a repositioning of craft in contemporary culture. Why not turn it the other way around and question the whole idea of the avant-garde project, in order to reposition autonomy and craft aesthetics, as seems to be already happening within the visual art world? The answer, in fact, has a historical basis.

CRAFT AS AVANT-GARDE

As noted earlier, Peter Bürger defined the original intentions of the avant-garde as seeking to reintegrate the lost relation between art and life. This particular point is important, because related intentions can be found where craft originates as a modern practice, in the British Arts and Crafts movement. A common perception of Arts and Crafts is that the movement was established as an opposition to the products of the Industrial Revolution, when mass production had become prevalent, and beauty and skill retreated in favor of a rationalized process of production. Beside this common perception, however, there is another aspect of the Arts and Crafts movement that has not received as much attention. As the Norwegian art historian Ingeborg Glambek has suggested, the movement can also be seen as a reaction against the increasing autonomy of visual art.[16] This conception reflected the influence of German Idealism, primarily the writings of Immanuel Kant, which categorized aesthetic knowledge as a separate, privileged field of knowledge and laid the philosophical groundwork for modernist art theory. Aesthetic knowledge gradually manifested in the concept of *l'art pour l'art*: a focus on the internal, formal premises of art, as it was seen, for example, originating in early modernist movements such as Impressionism. The Arts and Crafts movement was actually based on the very same paradox of the avant-garde that Peter Bürger would articulate many decades later: that autonomy is incompatible with a social responsibility. The Arts and Crafts movement's answer to this was an attempt to re-

integrate art into life praxis by adding beauty and pleasure to the objects of everyday life, as well as the very processes by which they were produced—a corrective to the Industrial Revolution's alienation of the worker that William Morris had learned from the writings of Karl Marx.

I would like to note that this movement can be characterized as avant-garde in its artistic and social devotion. In this context, this now-canonical movement—whose influence is shared by the art, design, and craft communities alike—might be recognized as originating from a practice that gradually developed into the practice of craft in the twentieth century. Thus, in the Arts and Crafts movement there is a direct relation between art and life that manifests itself precisely in the privileged aesthetic object, whose formal and functional relation to life praxis becomes immediately apparent. The fact that it *is* a paradoxical position can be seen clearly in the way in which Arts and Crafts ended up as both elitist and dogmatic in the way its ideology was gradually manifested in luxury goods and a cult of the unique. The historical avant-garde of Peter Bürger took over here, further determining avant-gardism as an artistic practice that was an- (even anti-) aesthetic, noninstrumental, and clearly subversive, while modernism, for its part, defied affirmative instrumentalism by fully unfolding as *l'art pour l'art*: both artistic lines as oppositions to everything that craft represented. Along the way, craft was excluded from its early avant-garde position, ending up in the shadows of modernism where we find it now, struggling with a blurred identity.

In his book *The Invention of Art*, the American philosopher Larry Shiner draws up the line of art's cultural history, encompassing "The Great Division" as he calls the eighteenth century's division between fine arts and minor arts that resulted in the art/life dichotomy.[17] Shiner localizes some historical points of "resistance" to the art/life dichotomy, and precisely in the movements addressed above: the Arts and Crafts movement, Dada, and conceptual art.[18] This pedigree is relevant, as it situates craft as a potential heir of the avant-garde, even though modernist art claimed that mantle. As Shiner writes: "It is not surprising to see the fine art-versus-craft division used to appropriate the arts of other cultures; it is surprising to see it used to divide the very crafts that Morris hoped would overcome it. Although the proponents of what has been called the 'crafts-as-art movement' claim to have overthrown the barrier between fine art and craft, the actual effect of the movement has been to divide the studio crafts into art and craft approaches."[19] As such,

the original intentions of the Arts and Crafts movement to overcome the art/life dichotomy failed in the short term, having the oppositional effect when rechristened "studio craft."

However, the fact that craft as a modern practice originated in an ideological climate that placed great importance on the friction between art and life means that it is relevant to look for these *original* avant-garde intentions in contemporary craft. My intention is to show that the avant-garde theoretical context, combined with the understanding of craft as privileged aesthetic objects related to material culture, can lead to a greater understanding of craft as an aesthetic field. Let us therefore turn to an example of current craft practice that makes this sensibility clear.

MATERIAL CULTURE RELATIONS: ANNE TOPHØJ

The practice of the Danish ceramist Anne Tophøj illustrates how fruitful it is to set the avant-garde as a theoretical framework for contemporary craft. Born in 1960, Tophøj cannot be easily placed within generational or stylistic frames. In a departure from the practice of her generation of renowned Danish ceramists, her work centers less on artistic autonomy than on the relation between humans and things, in what could be seen as a "material cultural perspective" based on the fact that Tophøj never leaves functionality out of sight. The exhibition project *Cultured Primitiveness—Exclusively Folksy* shown at the Nationalmuseum in Stockholm in 2005 is a good example. Tophøj was invited to make a show-case exhibition in the museum's impressive stairway (see fig. 7).[20] Her response was to exhibit different pieces of tableware all referencing the traditional Danish coffee table. The exhibition consisted of numerous different, easily recognizable objects—cups, plates, dishes, centerpieces, and bowls—all of which were obviously unfit for their presumed function. A rough aesthetic, bearing clear signs of the making process, and formal elements refusing demands of user-friendliness clearly indicated that a utilitarian function was not the main purpose of these objects (see fig. 8). This basic observation was supported by the fact that the objects were displayed in two original, old-fashioned glass-covered exhibition cases recalling the display of artifacts of cultural history. What we should note at this early stage, then, is that the objects themselves are nonfunctional. They are contextualized as aesthetic objects for contemplation—yet not as art objects.

Tophøj's conceptual point of departure was the fact that craft and

7 Anne Tophøj,
Cultured Primitiveness—
Exclusively Folksy,
2005. Installation view,
Nationalmuseum,
Stockholm. Photo:
Hans Thorwid /
Nationalmuseum.

8 Anne Tophøj,
detail from *Cultured*
Primitiveness—
Exclusively Folksy, 2005.
Photo: Hans Thorwid /
Nationalmuseum.

9 Anne Tophøj, detail from *Cultured Primitiveness—Exclusively Folksy*, 2005. Photo: Hans Thorwid / Nationalmuseum.

design objects undergo an essential transformation when they are institutionalized and displayed as parts of an art museum collection. Locked into exhibition cases, the formerly functional wares are linked to a conception of autonomy for which they were not originally intended. Referring to the exhibition title, in this way the "folksy" everyday-life objects are "cultured" into the sphere of art. In other words, the "thing" becomes an "object."[21] As an act of resistance Tophøj chose the opposite course: she made tableware. She made objects associated with use but which, in this case, were intended for showcase display, are vast in number, and have the sketchlike touch of an exercise or study; objects which resist both functionality and artistic autonomy, and thereby have a tantalizingly unstable identity (see fig. 9). The work constantly shifts between notions of art, design, and craft: the colors of the glazes on the tableware imitate the color palette of the paintings by the Swedish romantic artist Carl Larsson that hang on the walls of the exhibition room, paintings which are reflected in the glass of the exhibition cases. Not incidentally, Larsson is most famous for his intimate home decors which bridged Swedish folk culture and early modernism.

Through this conceptual gesture Tophøj demonstrates a strategic and conscious play with the status and identity of objects and their position in history and contemporary discourse. She presents the exhibition of

her ceramics as a staged statement, or a defined platform for expression, not as a neutral platform for aesthetic contemplation: an "exhibition about exhibitions" with "objects about objects." And with this gesture, Tophøj moves the role of the object in the forefront. Not the role of the artwork—in that case Tophøj's approach would not be new or remarkable—but the role of the "leftover": the privileged aesthetic object whose meaning is performed as an avant-garde strategy.

The dialogue with the physical surroundings and the familiarity of the functional forms means that the autonomous objects of the showcase seek to transgress their own autonomy in order to reach out and recapture their performative role in everyday life practice: the "objects" strive to become "things," but their use is blocked by the glass-covered showcase. This illustrates the paradox of the avant-garde: as art, it is by definition blocked from intervening in the everyday. This fact creates a friction between autonomy and everyday life. In another reference to the project's ambiguous title, by this transgression of borders, the "exclusive" museum object becomes less so.

This gesture is the opposite of the most common avant-garde strategy, which, in general terms, has been to appropriate familiar, common (or "folksy") objects into an art sphere: Tophøj traverses autonomy, not as a *breach* with the privileged aesthetic object but by actually *creating* such an object! This fact is crucial. In actually creating a privileged aesthetic object that breaks with its own autonomy, she carries out an avant-garde practice that is essentially different from previous positions of visual art. This resistance is also present as she questions the form of things. Instead of making traditional tableware, Tophøj rethinks its physical form, all the way down to her basic choice of specific materials. Through her experiment with the casting slip—for example, by exposing it to innovative techniques like centrifuging and vibrating—the objects, as she expresses it, "have found their own form."[22] The material has been interfered with as little as possible by the conscious hand and mind, allowing it to be formed by gravitation. Again, the title plays a role here: "cultured primitiveness" refers to the raw material that has been given the "cultured" form of tableware. In this way, the objects function as experimental stages of material culture, objects that do not have a fixed identity or function but which exist as pure objects that come into being as noninstrumental material culture artifacts.

This "pure object," before it is materialized into the instrumental logic of (consumer) culture, holds a pertinent position when related

to the avant-garde theoretical context. Instead of just commenting on society, like Plenge Jakobsen's "contemplative wormholes," Tophøj's objects *add objects* to society that are in principle immediately functional. They insist on addressing life praxis and can be conceived of as objects that exist in tandem with "real-life" material culture objects. Yet by virtue of being nonidentical, privileged objects that still maintain a direct relation to life, they represent a stage of society before it is manifested in a fixed form. The works are left at the stage of their potential, rather than a stage of suggested completion. In this phase, things, objects, the physical world could always be different, depending on the logic applied. The ambiguous meanings of the title of Tophøj's work support this openness. The context of the museum is therefore just one way of revealing the various layers of meaning in the series. Placed among functional wares in the home, the meaning of the work is actually further stressed: in the museum, the objects question the logic of things, sensuous impulses, and everyday practices. And as aesthetic objects, the effect is no less subversive.

This position truly contributes to the avant-garde search to reintegrate art and life, underscoring the fact that this potential *is* among the things with which we surround ourselves. When craft represents a practice that adds privileged aesthetic objects to the everyday world of things, it not only criticizes and reflects on society according to, or granted from, the world of art; it offers an alternative, already established link between art and life. Thus, Bürger's paradox between the fact of being an artwork and the claim to make a difference, realized in Foster's semi-autonomous position, gains a new perspective. As Tophøj shows, it is possible to operate from the typology of the privileged aesthetic object, while at the same time maintaining an operational friction to everyday life.

THE SUPER-OBJECT AND THE AESTHETIC POSITION OF CRAFT

This is the position of the super-object. Instead of promoting craft as a practice that is inextricably bound to a specific material, looking at craft objects in relation to other cultural practices shows that craft has a specific role to play *beyond materiality*. Craft addresses the art/life dichotomy in a specific way, by embodying precisely the semi-autonomous position that Hal Foster calls for. Craft is not born of the same struggle for aesthetic autonomy as the avant-gardes of visual art, nor has it had

to reintegrate art and life, which has led the avant-garde to constantly challenge the limitations of its own position. Craft inhabits another cultural position; it is an aesthetic that has never recognized the art/life dichotomy, which means that craft has never had to challenge its own limits in order to reintegrate art and life. It embodies both by its mere existence. This means that as much as craft needs to be seen in relation to the avant-garde, it also needs to recognize the relevance of design discourse.

One of the most important premises for this material culture/design discourse is that objects always exist in a social context. The title of the influential book *Wild Things* by the sociologist Judy Attfield underlines this by claiming that things can only produce meaning by circulating in a social context.[23] In this way they become "wild," that is, they gain meanings that were not originally intended. They break with the existing order and create new systems of value. This theoretical framework is useful when applied to craft, as it is crucial to understand the way that craft actually embodies the position of the "wild thing." The super-object acknowledges such new systems of value; it embodies them as alternative realities, but from within material culture itself. In this way, they go from parallel objects to everyday-life objects—objects that could potentially and comfortably circulate in a social setting. They are not appropriated everyday objects conceptually transformed into art, as in the work of Plenge Jakobsen. Super-objects simply do not need a transformation because they always already embody this artistic position. Their aesthetic or conceptual surplus value negates the "seamless circle of production and consumption" that Hal Foster critiques. And this is the point where craft gains its independent aesthetic position.

Super-objects function as privileged objects—the objects of desire of consumer culture—at the same time as they expose the logic behind those same established systems of value, manifesting the critical friction of Foster's semi-autonomous "running room" that neither visual art nor design possesses in their core definitions. And this position of craft has arguably been there all the time: a semi-autonomous position that keeps forcing contemporary visual art into testing new "wormhole strategies." It is this friction of craft, existing between art and life, that produces the backbone of its identity—and not the specific material, technique, or skill employed in its making. The element of the handmade in practices of design and visual art is not just a search for authenticity in an imma-

terial world. It points to a search for integration between art and life that craft has been performing all the time.

NOTES

1. The writings of Peter Dormer are seminal. Recent examples of this argument can be found in Glenn Adamson, *Thinking through Craft* (Oxford: Berg Publishers, 2007); Jorunn Veiteberg, *Craft in Transition* (Bergen: Bergen National Academy of the Arts, 2005); and Paul Greenhalgh, ed., *The Persistence of Craft: The Applied Arts Today* (London: A and C Black Publishers, 2002).

2. See, for example, Howard S. Becker, *Art Worlds* (Berkeley: University of California Press, 1984); Pierre Bourdieu, *Distinction: A Social Critique of the Judgment of Taste* (London: Routledge, 1984); and Larry Shiner, *The Invention of Art: A Cultural History* (Chicago: University of Chicago Press, 2001).

3. Shu Hung and Joseph Magliaro, *By Hand: The Use of Craft in Contemporary Art* (Princeton, N.J.: Princeton Architectural Press, 2007), 8.

4. Corinne Julius, "The Craft of Design Art," *Crafts*, July/August 2008, 16–18.

5. Henrik Most, "Shall We Come Together?" *Kunstuff* 7, no. 3 (2005): 21.

6. Garth Clark and Margie Hughto, *A Century of Ceramics in the United States, 1878–1978: A Study of Its Development* (New York: Abbeville, 1979).

7. Quoted from Lotte Folke Kaarsholm, "Kritisk kunst er ikke bare brændende biler" ("Critical Art Is Not Just Burning Cars"), *Information Daily*, March 14, 2005. Author's translation. The article was one of a series concerning the status of avant-garde today.

8. Peter Bürger, *Theory of the Avant-Garde* (Minneapolis: University of Minnesota Press, [1974/1979] 1984), 50.

9. See Index: Design to Improve Life website, http://www.indexaward.dk/.

10. Quoted from Sune Aagaard, "New Understanding Calls for New Solutions," *Monday Morning Weekly* 31, special design issue in collaboration with Index:, September 19, 2005, 13.

11. Ibid.

12. Wolfgang Welsch, *Undoing Aesthetics* (London: Sage Publications, 1997), 1–3.

13. Ibid.

14. Hal Foster, *Design and Crime—and Other Diatribes* (London: Verso, 2002), xiv.

15. Just to mention a few, the British design team Dunne and Raby's "Design Noir" represents such an approach, as does the work of the Danish artist/design group Bosch and Fjord, which creates innovative spaces for corporate companies, while RACA designers give public spaces a new social dimension. See www.dunneandraby .co.uk, www.bosch-fjord.dk, and www.raca.dk.

16. Ingeborg Glambek, "One of the Age's Noblest Movements," *Scandinavian Journal of Design History* 1, no. 1 (1991): 47–76.

17. Larry Shiner, *The Invention of Art: A Cultural History* (Chicago: University of Chicago Press, 2005), 5.

18. Ibid., 7.

19. Ibid., 274.

20. Anne Tophøj, *Cultured Primitiveness—Exclusively Folksy*, exhibited at "Craft in

Dialogue 6: Anne Tophøj, Denmark," Nationalmuseum, Stockholm, November 29, 2005, to January 29, 2006.

21. In this context, *thing* refers to a mundane world of everyday objects, while *object* refers to an open, aesthetic position. I have developed the terms further in the article "Life among Objects and Life among Things" on the ceramic artist Anders Ruhwald. Available on Ruhwald's blog, http://ruhwald.net/?p=57 (accessed July 5, 2010).

22. Anne Tophøj, studio interview with the author, October 13, 2005.

23. Judy Attfield, *Wild Things: The Material Culture of Everyday Life* (Oxford: Berg Publishers, 2000).

Paula Owen
· · · · · · · · · · ·

Fabrication and Encounter

WHEN CONTENT IS A VERB

The world is not what I think, but what I live through.
—Maurice Merleau-Ponty, *Phenomenology of Perception*

A few years ago, as I approached the rural home and studio of the sculptor Mara Adamitz Scrupe, I spied her small figure digging a trench high in the riverbank along her property. Her intention was to create a solar-powered, illuminated work incised in the contour of the surrounding wooded hillside, which would glow for those crossing the bridge below. For her, the phenomenal and conceptual dimensions of this enterprise were profoundly intertwined with the process of manually digging the trench, much as they were for Chris Burden in his *Honest Labor* (1979), in which he dug a trench by hand in order to question the roles of mental and manual processes in art.

How do we understand a trench dug by hand—or, for that matter, an effusively beaded, life-size environment by Liza Lou or the miniature clothes sewn by Charles Le Dray? And what of the private, obsessive performances of Linda Hutchins's typed patterns or the grueling labor of a Janine Antoni performance/sculpture (see fig. 5 in the introduction)? For these artists, the process is inextricable from the final result. Their emphasis on the process of fabrication, I would argue, springs from an impulse curiously similar to such artists as Rirkrit Tiravanija or Felix Gonzalez-Torres, for whom the final result is dependent on the process of viewer participation. In all these cases, the art object per se, what Nicolas Bourriaud in *Relational Aesthetics* calls "a dot on a line," is subsidiary to the activity that surrounds it.[1]

While it has long been understood as a part of contemporary art practice, thoughts on the role and valence of this kind of work, such as Bourriaud's, are constantly surfacing. The setting is widening for the object, that "dot on a line" or artistic "thing," and the form of a work cannot be reduced to "the simple effects of a composition, as the formalistic aesthetic would like to advance," he says, "but is a linking element, a principle of dynamic agglutinization."[2] The object links us to thoughts, memories, sensations, histories, and relationships rather than being an end in itself with a predetermined meaning. It is instead a catalyst for any number of unpredictable effects.

The deemphasis of the actual object in favor of the activity surrounding it is intriguing to consider from a variety of perspectives, not least because it concerns such disparate artists employing such diverse forms and processes, but also because it subverts the logic on which much of modern society is based and it challenges our assumptions about what constitutes an aesthetic encounter. It can also induce a collaborative or social experience by collapsing "the distinction between performer and audience, professional and amateur, production and reception," according to Claire Bishop in her collection of essays, *Participation*, which addresses "the claims and implications of artistic injunctions to participate."[3]

Building on instances of interactivity in the work of the Dadaists, who suggested that the meaning of art was not necessarily fixed by the artist, this approach merges art and life as an alternative to evoking art history or art issues to establish meaning. In the 1960s and 1970s, for instance, Fluxus artists not only involved the audience but extended the art experience to outside the gallery walls, while Chris Burden used his own body as both subject matter and site in his performance pieces.

Examining the process of fabrication and the process of encounter today also provides a new theoretical platform from which to consider craft objects, both traditional and contemporary. Reframing the relationship between artist, object, and viewer expands the opportunities to find relationships and artistic significance in and among many art forms, including craft objects and practices. In contrast to the fetishism of technical virtuosity which sometimes engulfs this field, the content of many craft objects and practices today can be understood as investigations of interactivity, sensuality, material, culture, and/or process.

Bourriaud asserts that "[Modern] art was intended to prepare and announce a future world," but that today "the role of artworks is no longer to form imaginary and utopian realities but to actually [provide] ways of living and models of action within the existing real, whatever the scale chosen by the artist."[4]

The artist Mierle Ukeles has been such a model of action in her almost thirty years of public art projects with the Department of Sanitation in New York City. Ukeles's "maintenance art" includes numerous performance pieces, a mirror-clad garbage truck, various installations, and other works documenting her sociopolitical principles and personal involvement with such a surprising yet ubiquitous institution of our everyday life. Roger Welch is another early example of those artists whose process included their own interaction with both the subject matter and the audience. His project *Memory Map* (1973) began with him inviting senior citizens into the gallery to describe their childhood hometowns to him while he drew what they described using an opaque projector. As they mapped their recollections with ink and blocks of wood on the walls and the floor, the gallery eventually was filled with their collaborative work.

Notable figures in such work today include Gerda Steiner and Jorg Lenzlinger, whose works require audience participation in order to be fully realized. In their project *Found and Lost Grotto for Saint Antonio* (2006), visitors were asked to search the many small items suspended within a cavernlike construction for anything that provoked a memory, which the visitors were encouraged to take away with them, so long as they replaced the item with a drawing of it and a written description of the memory it conjured. Rirkrit Tiravanija's projects have been called "quietly hostile takeovers" because he turns gallery spaces into sites for people to get together and do normal, sociable things like eat or nap, confounding audience expectations of the art experience. According to Tiravanija, "art has many different levels and you have to find your own level."[5]

And spectator participation in art today extends the practice of participatory completion into dizzyingly hybridized realms as access to new technology makes interactivity more and more feasible. *Vectorial Elevation*, a project produced by Raphael Lozano-Hemmer to celebrate the coming of the year 2000 in Mexico City, expanded on an earlier

version in Dublin in which he erected twenty-two robotic searchlights. Not only could their luminescence be observed in the night sky; their movement could be watched and controlled over the Internet by hundreds of people in far-flung locations.

In contrast to such large, collective experiences, the critic Suzanne Ramljak emphasizes private interactivity in her theories on the power of the intimate encounter. In her essay "Intimate Matters," she cites the work of Alyssa Dee Krauss, who is also propelled by an interactive impulse, but on a scale quite different from Lozano-Hemmer's epic lightshow and also providing a sense of where craft practitioners enter the discourse on the process of the encounter. Krauss's jewelry is intended to generate a heightened sense of self-awareness because it is perceived only by the wearer and is usually hidden from sight. Some pieces are fur-lined, meant to be worn against the skin; others integrate secret messages in Braille or Morse code. "What inspires me is . . . the idea that people develop personal, sentimental, or intellectual affinities with objects," says Krauss.[6] The relationship between the object and the viewer (or wearer, in this case) is built around what Bourriaud calls the "transivity," or the tangible properties of objects that "introduce into the aesthetic arena that formal disorder which is inherent to dialogue."[7] The act of wearing, using, or participating with an art object neutralizes the distance between the object and the viewer, allowing for the experience to be personal, ephemeral, associative, and responsive, much like conversation.

Indeed, it is often the tangible properties of art that extend the aesthetic experience in ways that the artist cannot predict. The critic Polly Ullrich calls this the "aesthetic of immersion" and describes it as "an event of the body" requiring "the juxtaposition of our embodied selves and our corporeal world within a technological and scientific worldview that relies on decoherence and cybernization to explain and depict the material environment and human relationships."[8] According to the artist Ann Hamilton, whose complex, metaphorical installations are intended to communicate through the senses (see figs. 1 and 2), "the loss of contact with the living world, and more particularly, the dearth of unmediated experiences with the natural, is a major source of many contemporary ills, psychological and social, ecological and environmental." She uses her work to disrupt viewers' expectations by bringing them back into contact with raw materials and the sensate.[9]

Whether expressed through an engagement with the process or an

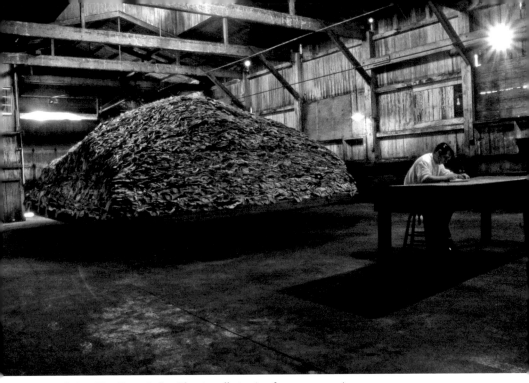

1 Ann Hamilton, *Indigo Blue*, installation/performance, 1991/2007.
Photo courtesy of Ann Hamilton studio.

2 Ann Hamilton, *Indigo Blue* (detail), installation/performance, 1991/2007.
Photo courtesy of Ann Hamilton studio.

engagement with the audience—in cyberproductions, everyday activities, or private encounters—this kind of art replaces detached contemplation with physical engagement and the visceral response that accompanies it. This approach accepts the totality of human perception and sensation as a rich and embodied way of being in the world. In her essay on workmanship, Ullrich observes that "scholars and artists—even those in media that seem most dematerialized—are now working out a kind of integration of the visceral body and the cerebral mind that centuries of Western thought have attempted to deny."[10] Indeed, speaking to the dominance of this integration, it is notable that Robert Storr's exhibition for the 2007 Venice Biennale was titled "Think with the Senses—Feel with the Mind." The old model fades away, replaced with an understanding that consciousness emerges from a network of cognitive, experiential, and perceptual functions.

THE PROCESS OF FABRICATION

While Bourriaud concentrates on art that involves spectator participation, his general "dot on a line" thesis applies also to works in which the process of fabrication is as important as the finished object or the interaction with the object. In these works, the content is not wholly fixed but occurs—at least in large part—during production.

The term *process art* has been used to describe such works and has been tied to variable points in art history, though the deconstructivist thought of the early 1960s is generally cited as a starting point. Driven in part by a reaction to minimalism and more recently to conceptualism, the rise of process art can also be attributed to the critiques of the canon of Western aesthetics by feminist and non-Western artists. As such, process art often advances concepts attendant to the body and senses, poses questions about the properties or origins of its materials or methods, and emphasizes change and transience in works that are not meant to endure.

While the term *process art* is elusive—because it has evolved over the past forty-some years and because it describes many varying intentions and ways of working—at least four dominant ways in which it functions can be identified. First, the process can be a form of aesthetic discovery evident in the result, as in the action paintings of Jackson Pollock or the poured color canvases of Morris Louis, which are as much about the novel and physical process as they are about the final image. This approach continues among contemporary artists such as William

Anastasi, who allowed the motion of the New York subway to create a graphite drawing on paper that he held in his pocket.

Second, the process can also be set in motion by the artist who allows the art to occur over time, as in works by Robert Smithson and Andy Goldsworthy. Though several decades separate them, they create works that are intended to evolve or disintegrate. Smithson's earthworks were created to change with the elements in order to underscore his interest in the concept of entropy. Goldsworthy's environmental sculptures also change over time with the weather and the seasons, contradicting both the notion of market value and of existential permanence.

In a third take on how the process of fabrication is significant to the artist's intent, the process of making and the material from which it is made may be crucial to the content and meaning of the work, as evidenced by Rosemarie Trockel and Tom Joyce, who elect materials and methods that are replete with associations. The feminist contentions of Rosemarie Trockel's knitted works are dependent on the anachronistic, usually domestic or quotidian means of fabrication. Joyce creates sculpture from cast-off iron—junk and decommissioned weapons—using ancient blacksmithing techniques in order to intensify his global, sociopolitical, and environmental concerns.

Finally, the art may emerge from the process of performing the work, as it does for Cathy McLaurin and Dave Cole, whose works are incomplete without the performative aspects. McLaurin's multilayered works often include the artist performing a unifying task within the installation such as meditating over objects sent to her by friends, around which she has drawn in rice flour. In Cole's *Knitting Machine* (2005), the cumbersome process of knitting a large American flag with heavy equipment and gigantic knitting needles becomes a metaphor for U.S. foreign policy.

The artist and critic Kathleen Whitney has posited another, nuanced view about certain process art, calling it the "art of the difficult." She notes that this art combines concept and process and that its "most salient characteristic is a fetishism of effort." While this work includes intricacy and obsessive repetition, it is set apart by the fact that it can be "carried on indefinitely. Because it is not generated from a basic compositional strategy that considers or creates the conditions for completion, the work can be extended into infinity. Within this sensibility, the process of making is entirely open-ended, there is no stopping point defined by logic, concept or narrative." Whitney goes on to say that "the final

interpretation of the work is also open-ended, mutable, and changed by each repeated encounter."[11]

Craft practices in particular lend themselves to this interpretation. Bean Finneran, for instance, references both mass production and Whitney's "art of the difficult" in her endless, rolled clay tubes, which she eventually forms into enormous, sea urchin–like forms (see fig. 3). Piper Shepard creates large-scale panels of complex, hand-cut patterns that are as much about her repetitive and laborious process as they are about the ultimate, lacelike beauty and the space they occupy (see fig. 4). Finneran and Shepard are among a noticeable set of artists today who purposefully record their toil and time through the action of making. While many of them are associated with craft practices and materials, others are not. What is notable is that artists from many disciplines, including craft, are grounded in similar conceptual positions based in process, in contrast to other contemporary artists who turn fabrication over to others.

Josiah McElheny, who is a prime example of an artist aligned with craft practices and training but who is recognized also as a leading contemporary artist, considers the actual methods of construction to be vital to his work's content. McElheny creates metaphorical glass objects and installations that convey stories that he calls "historical fiction." His works are self-critical and conceptually rich because, while he has mastered the technical aspects of the medium, the works call into question the mechanisms and assumptions of glass-making traditions, art history, and social class. In *From an Historical Anecdote about Fashion* (see fig. 5), a work from 2000 comprising blown glass objects in a display case, McElheny mocks the often oppressive artifice of style and fashion by recreating Venini vases from the 1952 Venice Biennale designed to echo the hourglass contours of designer dresses (and a regressive view of femininity) of the 1950s. McElheny's view is consonant with that of a cadre of contemporary artists who believe that the process of fabrication cannot be separated from the significance of the work, many from the craft field among them.

CRAFT AND PROCESS

It is noteworthy that many artists aligned with the craft world have long espoused the significance of process—both in fabrication and encounter—maintaining that content and meaning emerge during use, as well as from the materials themselves and the traditional methods of

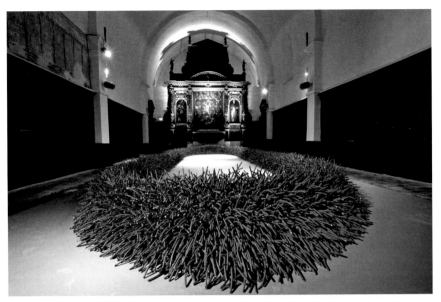

3 Bean Finneran, *Red Oval*, 2008, 48,000 curves of low-fire clay with glaze and acrylic stain, 30 feet × 14 feet × 16 inches high (approximate dimensions). Installation view, Chapelle de la Misericorde at the Twentieth Ceramic Contemporaine Biennale Internationale, Vallauris, France. Photo: Gabriel Giordano.

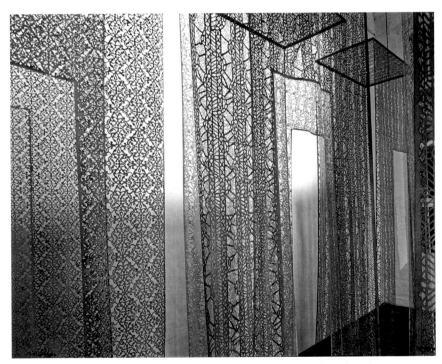

4 Piper Shepard, *Chambers* (detail), 2002, hand-cut cloth, gesso, ink, and steel armature. Photo: Dan Meyers.

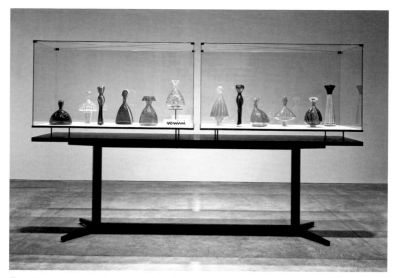

5 Josiah McElheny, *From an Historical Anecdote about Fashion*, 2000, blown glass objects, display case, and five framed digital prints. Dimensions of display case: 72 × 120 inches. Collection of the Whitney Museum of American Art, New York. Courtesy Donald Young Gallery, Chicago. Photo: Tom Van Eynde.

fabrication that are rich in social and cultural history. In addition, many craft artists and crossover artists consider the tactile or sensual aspects of their work to be integral to their intent, as well as to the social relationships that this quality spawns. Irvin Tepper has said, "From earth, water, and fire, I make cups that are thin, cracked, and on the verge of coming apart. My cups are fragile, translucent, and made of porcelain. They teeter, leak, and do not work. They bear witness to past faces, events, and conversations."[12]

Though the experiential in art—the interactivity of the work, the artist, and the viewer—has been widely acknowledged in environmental, performance, installation, and electronic forms, it is also a tenet of the craft arts. The long history of the craft arts is built around the artistic significance of the physical: the properties of the materials, the tactility, intimacy, use, and the rituals which require them. Moreover, as in the case of contemporary artists such as McElheny, whose use of craft processes is intentionally excessive in order to accentuate the distance between the complexity of the real and the ease of representation, it is possible for contemporary craft practice to uniquely subvert our assumptions about class, time, and value.

Marcia Tucker's "Labor of Love" exhibition in 1996 at the New Museum of Contemporary Art in New York City, for instance, included artists working in craft forms whose works posed questions about the relationship of the personal, the political, and the physical. Tucker drew attention to the ways in which "artists from a variety of backgrounds and cultures are recouping once-denigrated skills and processes in order to examine critically the relationship between the visual arts and everyday life; their work destabilizes artistic boundaries in order to reflect, comment on, and critique other kinds of boundaries in the lived world of social relations."[13]

These artists were among a growing number in the 1990s who adopted craft practice as a way of rejecting the expectations of the art world in order to examine social, personal, political, and cultural content. The time was right for crossover artists such as Ken Price, Anne Wilson, Martin Puryear, Michael Lucero, and Lynda Benglis to gain attention through their intellectually challenging ideas conveyed in and about craft media and practice. Alongside these established figures, then-emerging artists like Elaine Reichek began using embroidery as a means of examining beliefs and preconceptions about aesthetics and culture (see fig. 6), and Shari Urquhart's feminist narratives took on new authority when she switched from paint on canvas to massive hooked rugs, while Bill Davenport's knitted light bulbs and beer bottles scorned mass production and consumer culture. Reichek, Urquhart, and Davenport are only three of the many who chose craft practices and materials because of the meaning and history embedded in them, and because they challenged then-reigning assumptions about the nature of art.

Likewise, in the wake of exhibitions like "Labor of Love," many students and young artists have begun adopting craft and craftlike techniques and materials in order to exploit their associations for ironic purposes. While many did so without knowing of their craft world antecedents, they were driven to respond to a postmodern cultural environment flush with global influences, a material environment teeming with consumer debris, and a general environment that was becoming increasingly divorced from direct experience because of the ubiquity of technology in everyday life.

In their search for a relevant mode of expression, such artists turned increasingly to the process of fabrication and the process of encounter to find meaning. As Howard Risatti says in *Skilled Work*, "For an applied-art object—a container, support, or shelter—is not a cultural construc-

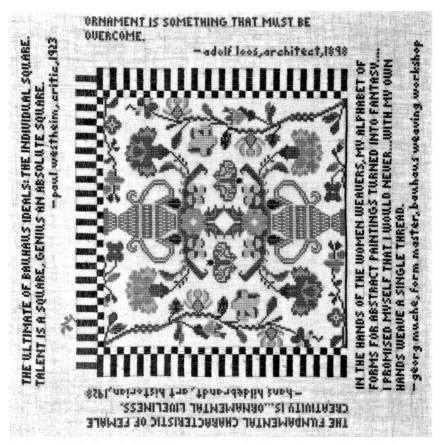

ORNAMENT IS SOMETHING THAT MUST BE OVERCOME.

—adolf loos, architect, 1898

(left margin) THE ULTIMATE OF BAUHAUS IDEALS: THE INDIVIDUAL SQUARE. TALENT IS A SQUARE, GENIUS AN ABSOLUTE SQUARE. —paul westheim, critic, 1923

(right margin) IN THE HANDS OF THE WOMEN WEAVERS, MY ALPHABET OF FORMS FOR ABSTRACT PAINTINGS TURNED INTO FANTASY... I PROMISED MYSELF THAT I WOULD NEVER...WITH MY OWN HANDS WEAVE A SINGLE THREAD. —georg muche, form master, bauhaus weaving workshop

(bottom) THE FUNDAMENTAL CHARACTERISTIC OF FEMALE CREATIVITY IS...ORNAMENTAL LIVELINESS. —hans hildebrandt, art historian, 1928

6 Elaine Reichek, *Sampler (The Ultimate)*, 1996, embroidery on linen, 21¼ × 21¼ inches. Courtesy of the artist and Nicole Klagsbrun Gallery.

tion, a representation, or a substitute for something else; it is the real thing."[14] Rirkrit Tiravanija adds to this argument and draws a parallel between applied art and his work, giving the example of

> going to the Metropolitan and looking at the Ming vases or a nice pot, or all objects from certain time. They are put in a position to be cataloged and understood in an order. For me that order of things basically neglects use. I was looking at Thai objects because that is my reference. We have particular pots. So in the Metropolitan it is for aesthetic reasons that they are shown. . . . There is a kind of mis-understanding of other cultures because you never know how it was used. So then I decided to find a way, to address this issue of use or

misuse by reusing it. So I would say that by reusing it basically means to take that antique bowl and put food in it—put life back into it. In that process I realized I can fill it and leave it there, but there is still no use, when you make a pot of tea, people have to drink it. So that is what I did.[15]

Works that emphasize "the real" by favoring viewer participation and other physical experiences found in either the process of fabrication or encounter also reflect a postmodern psychological stance: our disorientation and doubt. Like worry beads, spontaneous memorials, or Madame Defarge knitting her way through the French Revolution, these works represent our physical ways of working through the uncertainty that we live with, especially since the events of September 11, 2001. In the self-conscious acts of touching, marking, assembling, repeating, stitching, or meditating, the mind and body are interiorized. These are grounded, physical responses to an unstable environment rather than assertions of ideological prowess.

Moreover, the new perceptual modes that are available in the expanded setting for art today reflect the inherent hybridity of contemporary art process and practice. The artist Robert Morris noted in 1970 that "art itself is an activity of change, of disorientation and shift, of violent discontinuity and mutability, of the willingness for confusion even in the service of discovering new perceptual modes."[16] Morris and many diverse artists since then have focused a constant if occasionally faint light on the importance of the process of fabrication and encounter in contemporary art and have introduced these concepts into the critical dialogue. Striving for ways to be both conceptually and physically engaging, this argument insists that the art object itself is only one component of aesthetic experience, and that the physical and sensory aspects of that experience inform the theoretical and cognitive. Artists, ideas, methods, and materials associated with craft have been at the heart of this reorientation and may have forever changed what we expect from art.

NOTES

1. Nicolas Bourriaud, *Relational Aesthetics* (Dijon, France: Les presses du reel, 2002), 21.
2. Ibid., 20–21.
3. Claire Bishop, "Introduction: Viewers as Producers," *Participation*, ed. Bishop (London: Whitechapel; Cambridge: MIT Press, 2006), 10–17.
4. Bourriaud, *Relational Aesthetics*, 13.

5. Delia Bao and Brainard Carey, "In Conversation—Rirkrit Tiravanija," *Brooklyn Rail*, February 2004, http://www.brooklynrail.org/.

6. Alyssa Dee Krauss, unpublished artist's statement, 1999.

7. Bourriaud, *Relational Aesthetics*, 26.

8. Polly Ullrich, "Workmanship: The Hand and Body As Perceptual Tools," *Objects and Meaning: New Perspectives in Art and Craft*, ed. M. Anna Fariello and Paula Owen (Lanham, Md.: Scarecrow, 2004), 194–214.

9. Lynne Cooke, "The Ann Hamilton Experience," *Interview* 29, no. 7 (1999): 54–56.

10. Ullrich, "Workmanship: The Hand and Body as Perceptual Tools," in *Objects and Meaning*, ed. Fariello and Owen, 200.

11. Kathleen Whitney, "Difficult: An Introduction," *Artlies* 41 (2003): 3.

12. Jo Farb Hernández, *Irvin Tepper, When Cups Speak* (San Jose, Calif.: Natalie and James Thompson Art Gallery, San Jose State University, 2002), 9.

13. Marcia Tucker, "A Labor of Love," *A Labor of Love* (New York: New Museum of Contemporary Art, 1996), 14.

14. Howard Risatti, "Metaphysical Implications of Function, Material, and Technique in Craft," in Kenneth Trapp and Howard Risatti, *Skilled Work: American Craft in the Renwick Gallery* (Washington, D.C.: Smithsonian Institution Press, 1998), 47.

15. Bao and Carey, "In Conversation—Rirkrit Tiravanija."

16. Robert Morris, "Statements (1970)," Conceptual Art and Conceptual Aspects, exhibition, 1970, New York Cultural Center, New York, available at http://www.ubu.com/.

CRAFT SHOW In the Realm of "Fine Arts"

Karin E. Peterson
· · · · · · · · · · · · · · · ·

How the Ordinary Becomes Extraordinary

THE MODERN EYE AND THE QUILT AS ART FORM

> EXTRAORDINARY: *Of a kind not usually met with; exceptional; un-*
> *usual; singular. Now with emotional sense, expressing astonishment,*
> *strong admiration.*
> —*Oxford English Dictionary*, 2nd edition

Perhaps the quintessential American craft product is the patchwork quilt. Until very recently, quilts were thought of as ordinary, everyday bedcovers pieced by women to make worn fabric last longer and to create warmth for their families. Quilts made of fine materials and intricate stitching were saved for display on guest beds; those demonstrating strong technical skills were awarded prizes at state and local fairs. Quilts that were exemplary of a particular place and time were archived by history museums along with furniture, pots, silverware, and other artifacts.

The cultural understanding of quilts began a radical transformation in the summer of 1971 when Jonathan Holstein and Gail van der Hoof persuaded the Whitney Museum of American Art in New York City to display their quilt collection.[1] The story of their efforts to convince museum officials, critics, and the public of the artistic merits of quilts underscores the power of art world institutions to define cultural value.[2] Holstein recounts the couple's experience in the twentieth-anniversary edition of the original exhibition catalogue. I draw on his writing to reveal how mobilizing museum resources allowed him to reshape the interpretation of quilts and thus to enhance their value. Holstein and van der Hoof were successful for a number of reasons: tim-

ing; the affordability of old quilts in abundant supply in antique shops across Pennsylvania, New York, and New Jersey; their connections within the New York art world; and their knowledge of contemporary art and aesthetics. This essay focuses on another factor: what I will call the *modern eye.*

THE MODERN EYE

Modern eye refers to a culturally dominant way of seeing and appreciating art in the twentieth century.[3] This mode of seeing is informed by modernist aesthetics and embedded in the institutional practices of Western museums of art. While there is scholarly disagreement over what exactly constitutes modernism in art,[4] three elements are important in this case: formalism (the notion that works should be appreciated by examining the combinations of line, shape, and color), artistic autonomy (art for art's sake), and originality. These modernist terms established a normative framework by which members of dominant art worlds evaluated and appreciated works of art. Works of art were more legitimate if viewers were able to assess them solely in terms of their formal visual qualities, their separation from worldly concerns (such as function and politics), and their "newness."

The term *modern eye* draws on the sociologist Pierre Bourdieu's "pure gaze,"[5] a concept that emphasizes how this way of seeing is socially shaped and linked to class privilege through the mechanism of distinction. Of particular importance is Bourdieu's argument that the pure gaze involves an act of detachment, an attitude of disinterestedness on the part of the viewer. In other words, Bourdieu argues that viewers who experience a work of art from an art-for-art's-sake perspective can do so because they have the privilege and capacity to distance themselves from worldly concerns as they stand before it. According to Bourdieu, this capacity creates a distinction between elite and popular classes because elites have the upbringing and economic ability to enjoy works "from afar."

The modern eye can be understood as not only an aesthetic theory but as an institutionalized practice. Scholarly work by authors such as Carol Duncan, Donald Preziosi and Claire Farago, and Ivan Karp and Steven Lavine have demonstrated the ways in which museums enact modern rituals for appreciating cultural objects.[6] Museums are places that regularly enact the modern eye, both explicitly through the "seeing lessons" they provide and implicitly through subtle signs that re-

mind audiences of how art "ought" to be approached. Architecturally, they provide isolated rooms, white walls, spotlighted pedestals, discrete identifying labels, and space for viewers to stand back from works of art and grasp their impact. The overall effect of the museum's arrangement of space is a decontextualization of the objects on view. The museum, which is structured to appear neutral, objective, and disinterested, privileges a special way of viewing objects within its walls; in this sense it can be understood as a set of institutional arrangements that are ideological in nature.[7]

A NEW KNOWING OF QUILTS

To become objects of higher cultural value, worthy of presentation in an art museum, quilts had to be transformed into autonomous artistic creations and seen as detached from traditional contexts. As long as the works themselves were seen as possessing everyday interests and locations rather than "pure" intention, art connoisseurs were not likely to take them seriously. In the case of quilts, a great deal of cultural baggage impeded a straightforward viewing through the lens of the modern eye.

In fact, the work of persuasion involved nothing less than an epistemological change—a shift in the very framework used to comprehend quilts. As Holstein states, "We had several concerns. The first was that everyone in America knew about quilts, but no one *knew* quilts. They were relegated to the 'decorative arts' by curators, collectors, dealers and art historians and were, we thought, little understood even in those books which were devoted to them or in which they had a significant presence."[8] It is clear that Holstein and van der Hoof understood what was at stake—the need to create conditions for a new "knowing" of quilts, one that would legitimate them as works of art. The modern eye, embedded in the institutional arrangements of prestigious art museums, could provide the tool to shift how people would understand these cultural works.

SNAPSHOTS OF PAINTINGS

Holstein and van der Hoof began collecting quilts in the late 1960s as they toured the New England countryside, making inexpensive purchases of quilts no one seemed to want (see fig. 1). With their sensibilities honed by participation in the New York art scene—in particular their knowledge of abstract expressionism—the two began articulating for themselves an understanding of quilts wholly separate from the tra-

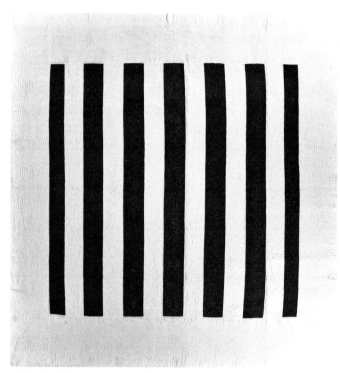

1 Untitled "Bars quilt," possibly made in Pennsylvania, circa 1890–1910, 79 × 75 inches. Jonathan Holstein Collection, International Quilt Study Center and Museum, University of Nebraska, Lincoln, 2003.003.0058.

ditional modes of appreciation. For them, bright patchwork patterns and large fields of color on a piece of cloth were modern *designs*; they were not looking for quality of handiwork or even of preservation—their lack of interest in the quilts usually understood as valuable was shaped precisely by their own socialization of looking at the world through the modern eye: "There certainly came a day when a particular quilt fit all of our evolving perceptions. There it was. I'm sure it looked just like one or another of the *snapshots of paintings* we carried around in our minds."[9] It is telling that the camera, as a tool of the modern eye, allowed for Holstein, in particular, to look at quilts in a way that "framed" them, in isolation with no context. As a photographer with experience in shooting paintings for New York art galleries, he was accustomed to envisioning objects from a variety of angles and to removing himself physically from direct contact with the object. This became a means for filtering what he and van der Hoof saw when looking at bedcovers.

Holstein's way of viewing quilts through the photographer's distancing lens supported a larger vision that developed for him as he mingled with members of the contemporary New York art world, including the abstract expressionist painter Barnett Newman. And given van der Hoof's background in fashion and textiles, concepts of form and design were strong suits in her knowledge base. Together, the couple cultivated a vision for quilts, informed by the modern eye and their specific backgrounds. This led them to begin to recognize in quilts resemblances to current painting styles in New York art galleries. The quilts that caught the couple's attention were not the ones that a traditional textile collector would have pursued. As Holstein describes it: "[The quilts] looked increasingly to us like modern painting, not necessarily American, more European, or international styles. A few, however, mimicked in startling ways some of the current art styles in New York, Pop, Op, the serial images of Andy Warhol."[10] Some of the quilts they found had repeated images. One quilt that Holstein and van der Hoof purchased, for example, used a pattern called "baby-blocks," which consisted of a series of cubes, the three-dimensionality emphasized by alternating light and dark pieces. The pattern of another, more unusual quilt consisted of the silhouette of coffee cups in bright blue on a white background. The Amish quilts they collected had broad fields of a few deep and contrasting colors. All of these, to Holstein and van der Hoof, looked very much like the effects abstract painters and their pop art successors were producing on canvas.

DISTANCE MAKES THE EYE GROW FONDER

Abstract expressionism and the practice of photography provided these cultural entrepreneurs with a unique way of understanding quilts. However, their way of seeing and knowing quilts was not just a framework but also a tool that might persuade others to reconsider the value of quilts. Holstein and van der Hoof developed a series of strategies for getting people to pay attention to formal qualities of their quilts and to move other issues (those typically considered important for quilts) to the background. These strategies had in common the distancing of the viewer, physically, from the object and the object from its original social contexts.

With the advice and connections of friends and acquaintances in the art world, Holstein and van der Hoof approached the Whitney Museum about the possibility of exhibiting their quilts. To convince the museum

staff that their exhibition would be appropriate for a modern art museum, they carefully prepared slides of the quilts that resembled in style and format Holstein's slides of paintings. It is significant that Holstein did not bring any quilts to his meeting with museum staff; the slides were more powerful tools of visual persuasion because they facilitated the detached perspective that the two collectors wished to cultivate.

Once on the calendar, Holstein and van der Hoof began rigorously selecting the quilts to include in the exhibition. The couple began by laying the quilts on a neighbor's expansive lawn and looking at them from the roof of the house—physically distancing them for a more detached view. As Holstein describes the scene: "It was an extraordinary sight, individual large canvases with the most wonderful shapes, lines, and colors, laid flat against bright spring grass under a brilliant sky."[11] This distanced manner of viewing meant that the two were able to make their selection irrespective of the quality of handiwork or materials.

> Though every quilt we chose had, in our opinion, something extraordinary visually to recommend it, it was not necessarily the best of its type in the collection. Some might even be judged by traditional standards as "ugly" or "in bad taste." Each, however, had its role in creating the overall effect we wanted and had to work well with all the others toward this. Our primary concern was the exhibition's total impact. Many quilts we chose were in terrible condition, frayed, stained, had material missing, were repaired (before we bought them) with materials later than the quilts on which they were used, etc. *This was unimportant to us, as we were looking only for particular visual qualities in quilts as they were at the moment, and nothing else.*[12]

When the selection had been narrowed, the couple considered how to display the quilts in the exhibit so that audiences would look at them with new eyes. Holstein writes, "We wanted them to hang evenly and smoothly without visible signs of a hanging system, *like paintings*."[13] They spent an entire day hanging the quilts on the white museum walls, judging their placement solely in terms of visual effect and disregarding chronology or place of origin—anything that might detract from total immersion in the visual experience: "One of the points of the exhibition was to show the aesthetic range and diversity achieved by pieced quiltmakers, and the point was probably better made by arranging the show for maximum visual impact than by historical or chronological develop-

ment."[14] That the collectors believed their display strategy would work is emphasized in Holstein's description of the hanging of his first quilt on the Whitney's walls:

> We picked an important spot on an end wall which we thought needed a single, extremely bold image. We decided to try the red and blue Log Cabin–Straight Furrow quilt from Pennsylvania. . . . Two installers, both artists, carried it with care to the wall, held the stave end high, and let it unfold down to the wall. It was an extraordinary moment. Everyone who was watching, gasped. I had seen the quilt hundreds of times, had folded and unfolded it, photographed it, examined it minutely; I knew it well. But as it came down the wall, it had a dignity which enlivened it in a way I had never seen. It was very beautiful; but more, it was commanding, a confident and powerful aesthetic presence. Everyone was held by it.[15]

FLAT ORIGINALITY

The work of getting the audience to perform the same distanced viewing to which the couple was so accustomed was supported by the writing for the exhibition itself. In his catalogue essay, Holstein emphasized the notion that quilters had artistic intentionality and that, like other artworks, each quilt was unique in its visual qualities, even when a pattern was widely shared. Holstein also took pains to persuade the audience to ignore the physical condition of the quilts on display, to focus instead on design.

In order to draw the public to the originality of design and form of the displayed works, Holstein made explicit references to abstract expressionist painters (among them Jackson Pollock, Clyfford Still, Willem de Kooning, Barnett Newman, and Mark Rothko) who were concerned with producing works that emphasized the two-dimensional surface of the canvas.[16] Holstein's writing also drew on conceptions of abstract art espoused by the art critic Clement Greenberg who, in arguing for the merits of the abstract expressionists, expressly deplored the "decorative," a word he might have readily applied to quilts and other household furnishings. Of particular relevance here, Greenberg contended that modern art was becoming purer as it moved away from perspectival painting and toward recognition of the "fact" that a canvas is two-dimensional. For him, abstract art came closest to achieving this as it eschewed representational art's striving for the illusion of depth on the

flat, painted surface.[17] Given that Greenberg's aesthetic theory established a hierarchy in which the abstract outranked the decorative and (as argued by Elissa Auther in this volume) art outranked craft, Holstein's use of Greenberg to make a case for his quilts is both ironic and strategic.[18] The patchwork quilts in Holstein's collection were those that most readily conformed to Greenberg's standards: they did not have narrative elements nor did they depict realistic scenes. More importantly, they were made from brightly colored materials and employed geometric shapes. Finally, the display of quilts flush against the museum walls facilitated reading them as two-dimensional. In the exhibition, quilts were essentially large-scale, two-dimensional objects, with design elements that were fundamentally flat and lacking in three-dimensional perspective. A passage from the catalogue essay illustrates the persuasive power of Holstein's writing in this regard: "There was at work a traditional American approach to design, *vigorous, simple, reductive, 'flat,' and bold use of color*, which can be traced through American art. . . . The best were valued aesthetically when they were made and have lost none of their power with passing time and fashions, exhibiting those extraordinary visual qualities which are ageless."[19]

The exhibition catalogue made quite clear the connections between abstraction and the visual experience of quilts: both the title of the exhibition—"Abstract Design in American Quilts"—and the catalogue cover—an image of a quilt with bold, broad stripes which obviously resembled an abstract painting and "did not instantly say 'patchwork'"[20]—worked to persuade the audience of this new way of seeing quilts.

THE MODERN EYE AND CULTURAL CONTESTS
OVER THE MEANING OF QUILTS

Three very different responses to the Whitney Museum exhibition—from art critics, from traditional female quilters, and from feminists—illustrate the cultural conflicts inherent in it, as well as those that developed afterward. These responses serve as a useful framework for exploring the way that the modern eye, once called into the service of enhancing the cultural value of quilts, also created (and continues to create) a series of contradictions within the quilting world and the art world as a whole.

Holstein was especially pleased with the review by the renowned *New York Times* art critic Hilton Kramer, known for his conservative views regarding contemporary art: "Hilton Kramer had understood the ex-

hibition completely, its aesthetic intent, its implication for an under-
standing of American design, the visual parallels to modern painting.
And he said one thing which showed our judgment about the content of
the show had been correct, that our balancing had worked: 'Among the
quilts, the aesthetic quality is generally so high that it would be foolishly
arbitrary to single out particular examples.' No quality comparisons of
this quilt to that, no concerns about workmanship, condition. . . . The
point had been understood. The exhibition was about an extraordinary
design achievement."[21] Kramer's statement was a blessing to Holstein,
a confirmation from the established art world. His vision for quilts had
been successful; others were willing to apply the detached, seemingly
disinterested modern eye to the quilts, to see them as art objects, with
no qualifications.

According to Holstein, however, the response of traditional women
quilters was ambivalent. But their protests were in a sense further proof
of his success:

> They [the women quilters] hated some of the quilts, which repre-
> sented everything the traditional rules of the craft told them to avoid:
> sloppy work and assembly, bizarre color combinations, nasty materi-
> als. Some of the quilts were even dirty, anathema to women with
> spotless homes and bed coverings. What did it mean? You go to a
> fancy art museum to see a quilt exhibition that's been written up
> all over, finally they've got something decent not like the stuff they
> usually show and when you get there you can't believe it, honest to
> God, it's a bunch of junk. "Didn't they know any better?" was one
> idea. It seemed possible. After all, what could people in museums
> know about such things? I sympathized with the attitude.[22]

Holstein's sympathy is difficult to read as much more than a dismissal of
the women. For him, it meant that he had in fact countered traditional
expectations about quilts.

Holstein's dismissal of women in the exhibition itself was addressed
in an essay by Patricia Mainardi, published in the *Feminist Art Journal*
in 1973, which took a slightly different stance from most criticism of
the show and was the most harshly critical. In particular, Mainardi took
issue with Holstein for ignoring "best quilts," those most prized by tra-
ditional quilters for their fine handiwork and intricate designs. She also
argued that Holstein's reference to abstract expressionism was a dis-
tortion of the quiltmakers' visual message: "Because our female ances-

tors' pieced quilts bear a superficial resemblance to the work of contemporary formalist artists such as Stella, Noland and Newman (although quilts are richer in color, fabric, design and content), modern male curators and critics are now capable of 'seeing' the art in them. But the appliqué quilts, which current male artists have not chosen to imitate, are therefore just written off as inferior art."[23] Mainardi argued that quilts are the original "Great American Art" but that the jargon and standards of the male-dominated art world have rejected their value and their "rightful" place in art history.

These three initial responses bring the implications for Holstein's strategies into focus. From Holstein's perspective, a humble cultural object had been successfully elevated to the highest level by having been granted the privilege of being displayed in a well-recognized art museum. Because of this exposure, quilts were more generally celebrated and people now had new ways of looking at them and understanding their significance as visual masterpieces.

From the perspective of some women quiltmakers and academic feminists, however, Holstein's efforts created what Bourdieu would call a kind of "symbolic violence,"[24] an erasure of the meanings and interpretations that nonelite (women's) culture might give to quilts. In this sense, the Whitney exhibition can be understood to offer an assimilationist rather than a transformative strategy. Quilts would be valued in the contemporary art world only to the extent that they looked like other things on display in the institutions of that art world: quilts had to "pass" to be worthy of the museum and its cultural rewards. The privileging of the modern eye meant that appreciating quilts with appliqué work, quilts with exquisite handiwork, quilts with personal meanings attached to them, was a less valid way to experience them.

CONTEMPORARY MEANINGS

The contemporary meaning of quilts has been shaped by Holstein's use of the modern eye, and also by other kinds of cultural arguments, including those of social historians and feminists. Since the 1970s, increased pressure for museums to be more inclusive of women and minorities in their exhibitions (pressure that had begun by the time of the Whitney exhibition) and the beginning of a rejection of modernism (by postmodernists, feminists, and multiculturalists) have meant that an exhibition like Holstein's original Whitney show would be less likely to be deemed unproblematic by museum curators.

But the Whitney exhibition and others that followed nevertheless had an important impact on quilters across the country, who work in a cultural environment that continues to struggle with the meaning of quilts and quilting. The practice of quilting today can be described as existing along a continuum from those who produce traditional quilts, to others producing nontraditional works but not adopting an artistic identity, to those who produce fiber art works or art quilts and who consider themselves professional artists. Some make clear distinctions between those who make traditional (read: nonoriginal) quilts and those who fully adopt the notion of producing "art" and draw on the modernist notion of originality, artistic autonomy, and formalism to discuss their work. Quilters, in other words, have added new categories to their repertoire, and contradictory standards for quilting often exist side by side in quilting worlds. Quilt publications that cater to quilters usually discuss quilts in distinct categories, as do publications about the quilt market. Greenbacker's and Barach's guide to the quilt market, for example, devotes separate chapters to antique pieced quilts, antique appliqué quilts, other antique quilts, contemporary quilts, art quilts, and African American quilts (which some scholars now argue have a separate set of traditions).[25] Their discussion of art quilts is instructive for understanding the dynamics of the relationship between contemporary quilters who base their work in traditional designs and those who produce something called the "art quilt." Significantly, the authors' criteria for evaluating what "counts" as an art quilt is based on the modernist notion of originality: "Their [art quilts'] collectibility comes from the skill and reputation of the maker in the same way that paintings and sculpture become collectible. Actually, the only method of distinguishing art quilts from contemporary quilts is by their level of innovation. . . . The use of innovative patterns, assembly or stitching techniques, or the use of mixed media classifies a quilt, for our purposes, as an art quilt."[26]

When professional artists use quilts as a medium, the influence of the modern eye is apparent. The quilts are generally approached not in terms of the maker's relationship to his or her family or even to the community but from the viewpoint of the professional artist and that of the detached "pure gaze." The modern eye offers a means for these artists to adopt a marginalized medium by providing legitimacy for their choice.

The norm of originality to "studio quilters," then, usually makes traditional technical concerns (such as attention to small, perfect stitching, preference for handwork over machine work, preference for replicat-

ing the traditional American repertoire of quilt pattern, preference for smooth rather than ragged or uneven edges) of secondary importance. In addition, the art quilts are intended to work as much as possible against utilitarian interpretation. No longer intended for beds, most are made for hanging on walls or have three-dimensional sculptural components. One strategy for minimizing utilitarian readings of their works is for artists to employ nontraditional materials and forms and a discourse that speaks in the language of modernism. An early maker of art quilts, Jody Klein, for example, describes the variety of media she uses to produce her "quilts" and talks about her work in ways that emphasize its formal qualities: "I am making assemblage constructions in a grid format of layered paper, painted surfaces, industrial felt, silk organza, metallic threads and silver and wooden rods. All are in 12 by 12 by 3 inch plexiglass boxes. In imposing a size limitation on myself, I am concentrating on the juxtaposition and combinations of opaque, translucent, and iridescent surfaces."[27]

Studio quilt artists draw on modern notions of autonomy, originality, and formalism to distinguish their work from that of other quiltmakers. To the extent that makers of art quilts share an art world with quilters who do not identify themselves as artists, highly divergent understandings of the practices and values coexist. The valuing of quilts for their personal meanings, for their fine execution, for their "decorative" beauty is often marginalized, even in guilds, which have fostered traditional quilting values.

A third category of contemporary producers is distinct for attempting to challenge the devaluation of women by a male-dominant art world, using traditionally female media such as textiles. Feminist artists such as Miriam Schapiro, Judy Chicago, and Faith Ringgold are examples of this practice. Ringgold, for example, creates "story quilts" that use the quilt medium to critique the so-called fine art world by calling attention to the ways in which it has excluded women and African Americans.[28] Drawing on feminist art criticism, feminist artists such as these use quilts to evoke women's heritage as well as to critique the dominant white male art world—a project sometimes at odds with the direction of the studio art quilt movement and its emphasis on formal design.

The conflicts and divergent values in contemporary quilt production are also present in contemporary museum displays of quilts. Even in a culture that criticizes modernism and white male elitism, the museum serves the function of legitimization, and its main tools for achieving it

still reside in the same resources: the enactment of the modern eye in display and of modernist criteria of evaluation in discourse.

"The Quilts of Gee's Bend" exhibition at the Whitney in 2003 illustrates this point. The exhibition, which originated at the Museum of Fine Arts in Houston, Texas, displays and interprets the quilting practices of African American quilters who live in a small rural community in Alabama.[29] The display strategies undertaken at the 2003 Whitney exhibition parallel Holstein's 1971 exhibition in the sense that the museum's white walls still frame the quilts, which are hung against them, with sufficient space for viewers to experience them as they would paintings — from afar, aloof, with little contextual interference.[30]

There are differences too, but primarily in discourse and not display. In the case of "The Quilts of Gee's Bend," much more emphasis is placed on the cultural history of the quilters and on the identity of the quilters. The language evokes the notion of originality: the quilters are called artists in this exhibit. The full-color exhibition catalogue uses traditional museum photography to display quilts on glossy white pages, isolated from context, to facilitate the modern eye. But the catalogue is also notable for what is different about it: quilters' biographies and stories, as well as photographic portraits, are included, as are discussions of the social history of these descendants of slaves and their relationship to quilts.[31]

"Is it art?" is a frequent question in contemporary quilting worlds. Were the Amish quilts that Holstein collected "art"? Were the appliqué quilts that he ignored "art"? As long as "art" exists alongside beautiful, human-made objects that are labeled "nonart," the label is an unsettling one because it perpetuates a hierarchy of value. Currently, the hierarchy of value, the distinction between art and nonart, is supported by the mechanism of the modern eye, a perspective that, although seemingly neutral, limits other ways of relating to, seeing, and experiencing human cultural production. This has implications for other cultural products in addition to quilts, among them African sculpture; craft media such as glass, textiles, and pottery; and outsider art.[32] Many of these cultural objects now find an uneasy place in the category "fine arts": partially admitted, yet always problematic from the perspective of what counts as art. These same objects, however, are often crowd pleasers precisely because they seem different from much mainstream art, especially the work produced since the 1970s, which often seems incoherent to the general public.

It is my contention that the modern eye remains a powerful and sometimes explicit source of legitimization, of argument for artistic merit. Museums provide a space in which the cultural value of quilts and other objects is negotiated through the rituals of modernist practices. The discourse and display supporting the modern eye continue to shape quilts into culturally legitimate objects, even as other kinds of meaning are added alongside them. The question becomes whether alternative "framings" of quilts are even available to us. Have the museum's implicit practices shaped the way we see to such an extent that alternative ways of seeing are not even possible? If the modern eye were not brought to bear on quilts, would they be in art museums at all?

Although the contemporary period seems filled with contradictions that allow for multiple readings of works, as long as the practices supporting the modern eye retain their force and their connections to the legitimating power of the institutions of art, it is likely that certain "seeings" will be privileged over others. The modern eye, as a mechanism of distinction, has yet to be replaced in contemporary culture by another eye that might be more pluralistic, open, and flexible with regard to the diverse and rich contexts from which objects arise.

NOTES

1. Because Holstein authored all the texts associated with the exhibition and because he and Gail van der Hoof separated between the initial exhibition in 1971 and the writing of the twentieth-anniversary catalogue, it is not easy to discern van der Hoof's involvement in all aspects of the couple's work. It is clear from Holstein's writing that he saw her as an equal partner in their endeavor.
2. Jonathan Holstein's and Gail van der Hoof's work is part of a larger cultural shift that was underway by the 1970s, a shift which was defined by a new interest in folk art and decorative arts among collectors and museums. Holstein's and van der Hoof's work is distinguished by a singular goal of transforming quilts using the frame of the modern eye. For an account of this larger transformation, see Julia S. Ardery, *The Temptation: Edgar Tolson and the Genesis of Twentieth-Century Folk Art* (Chapel Hill: University of North Carolina Press, 1998).
3. The phrase "modern eye" is an allusion to Baxandall's concept of the period eye; see Michael Baxandall, *Painting and Experience in Fifteenth-Century Italy*, 2nd ed. (New York: Oxford University Press, 1988).
4. An excellent overview of the problematic nature of the definition of *modernism* is Charles Harrison, "Modernism," *Critical Terms for Art History*, ed. Robert S. Nelson and Richard Shiff (Chicago: University of Chicago Press, 1996), 142–55. Harrison distinguishes between three primary definitions of the word that are relevant to art history. The first concerns modern painting as the depiction of modern life. The second concerns a stylistic tendency called modernism, which is con-

cerned with issues of representation in art; it is this definition that encompasses the works of so-called modern artists such as Picasso, Braque, and Duchamp. The third has to do with the development of modern art criticism, which Harrison calls *Modernism* (with a capital *M*). In this work, I am primarily talking about Harrison's third definition and not about how art represents the modern, industrialized world or about modernism as a specific style. When I refer to the "modern" art museum, for example, I am not simply referring to its contemporary nature but to a specific institution located socially and historically and shaped by the tenets of modern art theory that emphasize Kantian formalism in both discourse and display practices. See Pierre Bourdieu, *The Field of Cultural Production: Essays on Art and Literature* (New York: Columbia University Press, 1993) for a discussion of the development of modernism as an autonomous field.

5. Pierre Bourdieu, *Distinction: A Social Critique of the Judgment of Taste*, trans. Richard Nice (Cambridge: Harvard University Press, 1984).

6. Carol Duncan, *Civilizing Rituals: Inside Public Art Museums* (New York: Routledge, 1995); Donald Preziosi and Claire Farago, eds., *Grasping the World: The Idea of the Museum* (Burlington, Vt.: Ashgate, 2004); Ivan Karp and Steven D. Lavine, eds., *Exhibiting Cultures: The Poetics and Politics of Museum Display* (Washington, D.C.: Smithsonian Institution Press, 1991).

7. See, for example, Bourdieu, *Distinction*, n.vii; Brian O'Doherty, *Inside the White Cube: The Ideology of the Gallery Space* (Santa Monica, Calif.: Lapis, [1976] 1986); and Terry Eagleton, *The Ideology of the Aesthetic* (Cambridge, Mass.: Blackwell, 1990).

8. Jonathan Holstein, *Abstract Design in American Quilts: A Biography of an Exhibition* (Louisville: Kentucky Quilt Project, 1991), 27.

9. Ibid., 19–20.

10. Ibid., 20.

11. Ibid., 34.

12. Ibid., 12, emphasis added.

13. Ibid., 36, emphasis added.

14. Ibid., 38.

15. Ibid., 39.

16. Useful discussions of the rise of abstract expressionism and its dominance include Marcia Bystryn, "Art Galleries as Gate Keepers: The Case of the Abstract Expressionists," *Social Research* 45 (1978): 390–408; Diana Crane, *The Transformation of the Avant-Garde: The New York Art World, 1940–1985* (Chicago: University of Chicago Press, 1987); Duncan, *Civilizing Rituals*; Serge Guilbaut, *How New York Stole the Idea of Modern Art: Abstract Expressionism, Freedom, and the Cold War*, trans. Arthur Goldhammer (Chicago: University of Chicago Press, 1983); and Charles Harrison, Francis Frascina, and Gill Perry, *Primitivism, Cubism, Abstraction: The Early Twentieth Century* (New Haven, Conn.: Yale University Press, 1993).

17. Clement Greenberg, *Clement Greenberg: The Collected Essays and Criticism*, vol. 1, *Perceptions and Judgments, 1939–1944* (Chicago: University of Chicago Press, [1955] 1986).

18. See also Elissa Auther, "The Decorative, Abstraction, and the Hierarchy of Art and Craft in the Art Criticism of Clement Greenberg," *Oxford Art Journal* 27,

no. 2 (2004): 339–64; and Caroline Jones, *Eyesight Alone: Clement Greenberg's Modernism and the Bureaucratization of the Senses* (Chicago: University of Chicago Press, 2006).

19. Cited from the original 1971 exhibition catalogue essay, reproduced in Holstein's twentieth-anniversary publication from 1991 (Holstein, *Abstract Design in American Quilts*, 215, note 1, emphasis added).

20. Holstein, *Abstract Design in American Quilts*, 34.

21. Ibid., 43, emphasis added.

22. Ibid., 57.

23. Patricia Mainardi, "Quilts: The Great American Art," *Feminism and Art History: Questioning the Litany*, ed. Norma Broude and Mary G. Garrard, 343 (New York: Harper and Row, 1982).

24. Bourdieu, *Distinction*, n.vii.

25. Liz Greenbacker and Kathleen Barach, *Quilts: Identification and Price Guide* (New York: Avon, 1992).

26. Ibid., 275.

27. Cited in Joanne Mattera, ed., *The Quiltmaker's Art: Contemporary Quilts and Their Makers* (Asheville, N.C.: Lark, 1982), 14.

28. Faith Ringgold, *We Flew over the Bridge: The Memoirs of Faith Ringgold* (Boston: Little, Brown, 1995).

29. John Beardsley, William Arnett, Paul Arnett, and Jane Livingston, *The Quilts of Gee's Bend* (Atlanta: Tinwood, 2002).

30. Thanks to Michael Peterson, Laurie Beth Clark, and Sheryl Sawin for sharing their detailed observations of the Whitney exhibition with me.

31. For a fuller critical interpretation of the Gee's Bend exhibit, see Anna Chave, "Dis/Cover/ing the Quilts of Gee's Bend, Alabama," *Journal of Modern Craft* 1, no. 2 (2008): 221–53.

32. Karin Peterson, "How Things Become Art: Hierarchy, Status, and Cultural Practice in the Expansion of the American Canon," Ph.D. diss., University of Virginia, 1999.

Elissa Auther
.

Wallpaper, the Decorative, and Contemporary Installation Art

I've made a career out of being the right thing in the wrong space and the wrong thing in the right space. That's one thing I really do know about.

—Andy Warhol, *The Philosophy of Andy Warhol* (1975)

F or a show at the Leo Castelli Gallery in 1964, Andy Warhol covered the walls of the gallery with dozens of his *Flower* paintings. Noting the bizarre, wall-to-wall arrangement of pictures, the critic Thomas Hess remarked, "It is as if Warhol got hung up on the cliché that attacks 'modern art' for being like wallpaper, and he decided that wallpaper is a pretty good idea, too."[1] By his own admission, Warhol frequently scanned his reviews for new, good ideas, so it perhaps comes as no surprise that for his next Castelli show in 1966 he debuted the *Cow Wallpaper* (see fig. 1) as part of a double installation that also included his helium-filled, reflective pillows, the *Silver Clouds*.[2]

On the surface, Warhol's *Cow Wallpaper* appeared to be a simple lampoon of critical opinion, and in reviews of the period and later it was treated (along with the *Flowers* and *Silver Clouds*) as, at best, a minor work, marking the end of his genuine production as an artist. Rainer Crone's evaluation from 1970 is typical: "[The *Flowers*] are unique in Warhol's production by virtue of their meaningless image content—a dubious honor shared only by the Cow Wallpaper and Silver Clouds in all of Warhol's oeuvre. They are and will remain strictly decorative, 'upper class wallpaper,' to use Henry Geldzahler's words."[3] In the 1960s and 1970s, the "decorative" was a category to be avoided at all costs,

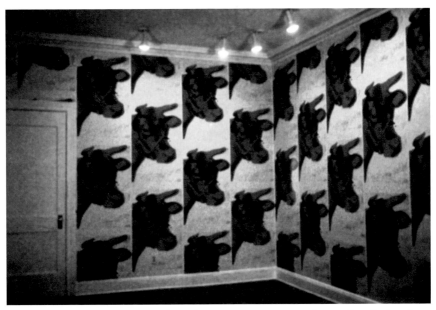

1 Andy Warhol, untitled (*Cow Wallpaper*), 1966, screenprint on wallpaper. Installation view, Leo Castelli Gallery, New York. Photo: Rudolph Burkhardt.

for the application of the term to a work of art was an emasculating taunt that reduced it to an interior-design solution—a joke, really, in the discourse of art at the time invested in notions of formal and intellectual rigor. Robert Morris's recollection that "the great anxiety" for artists of the period was the potential for one's work to "fall into the decorative, the feminine, the beautiful, in short, the minor" captures the web of pejorative associations circling around the term.[4] This web of associations also includes "craft," a category of form often conflated with the decorative by virtue of its status as a supplement to the work of art.[5] Not only has wallpaper been classified as a craft at various moments in the history of art but the criticism leveled against it for being nothing but artifice, surface, or meaningless repetition is also applied to craft.[6]

Evidence suggests that the *Cow Wallpaper* was hardly a degraded form for Warhol. Indeed, it seems to have been something of a signature work for the artist, emblematic of the importance of the decorative in his oeuvre. For instance, in 1968, for an exhibition at the Moderna Museet in Stockholm, Warhol papered the facade of the building with the *Cow Wallpaper*. In 1971, Warhol asked that the *Cow Wallpaper* be the sole work exhibited in his Whitney Museum retrospective, a request

that was denied but that ultimately resulted in the compromise solution of hanging the *Cow Wallpaper* as the ground for the rest of the works in the show.[7] The effect might be described as one of high decorative density, complicating, much to his pleasure I am certain, wallpaper's normal status as background for art. Warhol would rehang the *Cow Wallpaper* with the *Flower* paintings in 1972 and use it again for the premiere of his portrait series of drag queens, *Ladies and Gentlemen*, in 1975.

In addition to the *Cow Wallpaper*, Warhol would go on to produce two more papers in the 1970s: the *Mao Wallpaper* of 1973 upon which he hung the *Mao* silkscreens, packing the Musée Galliera in Paris and subsequent venues with up to 1,951 images of the communist leader, and the *Self-Portrait Wallpaper* which he used in his retrospective in Zurich in 1978. And on at least one occasion he suggested to a sitter, the dealer Holly Solomon, that an arrangement of six of her portraits be installed in her home in combination with a wallpaper that also featured her repeated image.[8] Clearly, wallpaper in Warhol's oeuvre never functioned as just background; it was, rather, conceived as art itself.

This inventory of Warhol's use of wallpaper demonstrates an engagement with the medium that is difficult to dismiss as a minor, insignificant aspect of his artistic oeuvre. However, there has been no systematic explanation of its meaning or legacy. In this essay, I argue that Warhol's wallpapers can best be understood as an embrace of the decorative and especially of the decorative's association with effete homosexuality and femininity. While the connection between wallpaper, the decorative, and femininity is secured through women's traditional place in the domestic sphere as homemakers, it is the discourse of camp that links wallpaper, the decorative, and homosexuality. To Susan Sontag, "all the elements of visual décor make up a large part of Camp. For Camp . . . is often decorative art emphasizing texture, sensuous surface, and style. . . . Many examples of Camp [wallpaper conceivably among them] are things which, from a 'serious' point of view, are either bad art or kitsch."[9] Although barely addressed by Sontag, the origin of camp as a mode of appreciation for "bad" or marginalized forms as "good" is found in gay male culture. Among other features, this is a mode of appreciation that responds to homophobia and the normative social order through the inversion or deflation of the hierarchies, priorities, and values of straight or high culture.[10] Warhol's embrace of wallpaper is a camp elevation of this low, kitsch medium through which he managed both to signify queer identity and to destabilize the art world's rigid separa-

tion of high art and the decorative. Insofar as Warhol put wallpaper at the center of his installations, he turned this traditionally "background" medium into high art and in so doing signaled the triumph of decoration with all of its feminine and queer associations.

Warhol's marvelous description of himself as being "the wrong thing in the right space" implies that Warhol himself was as much out of place as his art within the norms of the avant-garde art world, dominated as it was by the image of the hard-drinking, manly man. In response to his friend Emile de Antonio's description of him as "swish," Warhol wrote, "I'd always had a lot of fun with that—just watching the expressions on people's faces. You'd have to have seen the way all the Abstract Expressionist painters carried themselves and the kinds of images they cultivated, to understand how shocked people were to see a painter coming on swish. I certainly wasn't a butch kind of guy by nature, but I must admit, I went out of my way to play up the other extreme."[11] Relishing his "swish" image, Warhol differentiated himself from the masculine, "butch" norms of artists of his time with the same glee with which he disrupted the norms of painting with his wallpaper. Warhol's overall legacy relates to his vast expansion of the domain of art through the inclusion of popular culture (wrong things in right places). However, the significance of his wallpaper works, in particular, consists in the way that this opposition can signify queerness (being wrong *en toto*). This is the legacy represented by artists working in wallpaper today such as Robert Gober and Virgil Marti, among others, who similarly activate the decorative as the queer.

WALLPAPER AND THE DECORATIVE

The earliest wallpapers, dating to the sixteenth century, were expensive, hand-painted specimens that held a respectable place within the arts.[12] With the advent of printed papers in the mid-nineteenth century, however, wallpaper eventually became the commercial product we know today: an unassuming background for more important furnishings and works of art or a substitute for expensive materials such as marble, leather, and silk.[13] As its availability increased, wallpaper's aesthetic status declined, but its lack of uniqueness was only partly responsible for its subordination in the hierarchy of the arts. Its place and function within the home as a single, dependent element in a larger ensemble of domestic furnishings sharply distinguishes it from "fine art,"

which, in the modernist conception, was constructed as autonomous or aesthetically free from the contingencies of the everyday world or its display. The rhetorical force of critical evaluations of modern painting as wallpaper turns on the preservation of this conception.

The earliest references to wallpaper in art criticism date from the late nineteenth century, when on more than one occasion it was used as a way to degrade painting deemed incomprehensible as "real" art. In 1874, for instance, the French critic Louis Leroy mocked Monet's *Impression, Sunrise* (1874), decrying, "Wallpaper in its embryonic state is more finished than that seascape."[14] One year later the British critic Tom Taylor would similarly evaluate two of Whistler's paintings from his *Nocturne* series, asserting that "they only come one step nearer pictures than delicately graduated tints on a wall paper would do."[15]

The discernible hostility in these comparisons between painting and wallpaper belies an anxiety surrounding modern art's potential slippage into a lesser decorative mode. The fear was that painting might be viewed not as a superior aesthetic form but as a type of interior decoration like any other. This is an anxiety that peaks again with the emergence of full-blown, large-scale abstraction in the late 1940s and 1950s. In fact, the most well-known equation between painting and wallpaper dates from this period. Harold Rosenberg used the invective "apocalyptic wallpaper" in 1952 to describe the kitsch effects of the new gestural abstraction when it was devoid of authentic feeling, when it was only decorative. "Works of this sort," he exclaimed, "lack the dialectical tension of a genuine act, associated with risk and will. . . . Satisfied with wonders that remain safely inside the canvas, the artist accepts the permanence of the commonplace and decorates it with his own daily annihilation. The result is apocalyptic wallpaper."[16]

The "all-over," drip paintings of Jackson Pollock were especially vulnerable to comparisons to wallpaper. In 1948, *Life* magazine published the proceedings of a round table on modern art in which Pollock's *Cathedral* was discussed with the following question in mind: "Is modern art, considered as a whole, a good or bad development? That is to say, is it something that responsible people can support, or may they neglect it as a minor and impermanent phase of culture?"[17] Predictably, one of the round-table participants, in this case the writer Aldous Huxley, likened *Cathedral* to wallpaper for its unorthodox treatment of space and surface. "It raises a question of why it stops when it does," he

remarked. "The artist could go on forever. (Laughter). I don't know. It seems like a panel for a wallpaper which is repeated indefinitely around the wall."[18]

In the history of modernist art criticism, however, it was Clement Greenberg who most expertly exploited comparisons between painting and wallpaper. Following his predecessors, Greenberg continued to use the term *wallpaper* as shorthand for *decoration* and the loss of aesthetic autonomy associated with this latter category. But unlike Huxley, who was suspicious of gestural abstraction because of its lack of compositional order, Greenberg was an advocate of the new, "all-over" picture, and his goal was to secure abstract painting *as* painting, that is, as high art. So rather than reduce abstract painting to wallpaper, Greenberg distinguished them from each other, elevating abstract features such as surface flatness above the merely decorative. "That such pictures," he asserted in 1948—referring to abstract paintings where "every part of the canvas [is] equivalent in stress to every other part"—"should escape collapsing into decoration, mere wallpaper patterns, is one of the miracles of art in our age, as well as a paradox that has become necessary to the age's greatest painting."[19] In the same year, on the occasion of Jackson Pollock's solo show at the Betty Parsons Gallery, he wrote, "As before, [Pollock's] new work offers a puzzle to all those not sincerely in touch with contemporary painting. I already hear: 'wall paper patterns,' 'the picture does not finish inside the canvas,' 'raw uncultivated emotion,' and so on, and so on. . . . It is Pollock's culture as a painter that has made him so sensitive and receptive to the tendency that has brought with it, in this case, a greater concentration of surface texture and tactile qualities, to balance the danger of monotony that arises from the even, all-over design."[20]

As late as 1961 Greenberg would still be defending the significance of Pollock's work by differentiating it from wallpaper: "By means of subtle variations within the minimal illusion of depth, [Pollock] is able . . . to inject dramatic and pictorial unity into patterns of color, shape, and line that would otherwise seem as repetitious as wallpaper."[21] In each instance, Greenberg lauds Pollock's unification of the surface, his practice of distributing pictorial incident across the canvas to the edge of the frame, a feature of his work that led other viewers, such as Huxley, to dismiss it as wallpaper, that is, as a failed example of painting experienced as mechanical in execution and composition. To Greenberg, Pollock's genius as a painter lay in his ability to wrench from the

decorative the flat, all-over surface and use it in the service of high art. This approach to Pollock's work afforded Greenberg the opportunity to shore up the fragile boundary separating abstract painting from decoration, albeit at the expense of a real class of objects—wallpaper and other decorative arts and crafts, which remained artless.

WARHOL AND WALLPAPER

One reason wallpaper held aesthetic interest for Warhol was its utter lack of aesthetic autonomy, and the artist's installations incorporating the material can be understood as all-out assaults on the modernist fetishization of the autonomous work of art. As archival photos of his exhibitions demonstrate, from the beginning of his career Warhol resisted the conventional installation of his works that in part preserved painting's credibility as high art rather than decoration. To take only one example, Warhol's installation of the *Campbell's Soup Cans* in 1962—one after another, along a ledge around the perimeter of the Ferus Gallery in Los Angeles—mimicked the display of foodstuffs in the supermarket.[22] Benjamin Buchloh has characterized Warhol's use of serial repetition generally as a threat to the "boundaries of painting as an individual and complete pictorial unit."[23] Buchloh writes, "What had been a real difficulty for Pollock, the final aesthetic decision of how and where to determine the size of painterly action, or, as Harold Rosenberg put it, how to avoid crossing over into the production of 'apocalyptic wallpaper,' had now become a promise fulfilled by Warhol's deliberate transgression of those sacred limits."[24] As the ultimate attack on the sanctity of painting, wallpaper overturned the privileged place of originality, uniqueness, and autonomy essential to painting's superiority to decoration.

While recognizing that Warhol's wallpaper transgressed the boundaries of fine art, it is crucial to bring to light that this transgression was abetted by wallpaper's association with the decorative, the domestic, and the feminine. In 1966, when asked which made better settings for his paintings, homes or art galleries, Warhol retorted, "It makes no difference—it's just decoration."[25] In suggesting that art is just another form of decoration, Warhol breached the sacred divide between the domestic and the aesthetic; similarly his wallpaper productions repositioned the artist as an interior decorator, feminizing him through the medium's intimate association with the home and popular taste.

With this brazen celebration of decoration, Warhol's wallpapers can be read as a rejection of the heterosexual bravado relished in the image

of the male artist of the New York art world in the 1960s and 1970s, an extension of his artistic practice akin to "coming on swish." Warhol scholarship that attempts to recover the fact and significance of the artist's homosexuality to his work, including the queer contexts of its production and reception, supports the claim that his wallpapers are as much a signifier of sexual identity as they are an antipainting gesture.[26] Warhol's use of the phrase "disco décor" to categorize his *Shadows* of 1979, a series of paintings installed side-by-side around the perimeter of the Lone Star Foundation (formerly the Heiner Friedrich Gallery) in New York City, is another good example of this dual signification at play in a work conceived as a wallpaper-like, continuous surround.[27] The description "disco décor" was a double slam: not only did the word *décor* attempt to elevate the subordinate realm of the decorative but its coupling with the word *disco* served to celebrate the flamboyant world of 1970s queer identity.[28] As much as Warhol's wallpaper installations were interventions in the modernist hierarchy of media, his embrace of the decorative and its sites of deployment beg that they also be appreciated for their queerness.

WALLPAPER AND CONTEMPORARY INSTALLATION

In recent installation art, wallpaper has become something of a staple. Warhol's contribution to the expansion of the art world through the elevation of popular culture in his work is important to the emergence of installation generally, but the specific legacy of his wallpaper—its continued relevance more than forty years after its first appearance— lies in its ability to signify queerness.[29] In what follows, I'll examine the wallpapers of two artists, Robert Gober and Virgil Marti, whose work with the medium probes various aspects of identity and sexuality from a queer perspective. Additionally, I will reference the work of Christine Lidrbauch, an artist who has also worked with wallpaper, to illuminate the way the queer implications of the material intersect with contemporary feminist investigations of the decorative.

I begin, however, with an example of a wallpaper installation by the artist collective General Idea from the late 1980s (see fig. 2).[30] Titled *AIDS*, the installation is a double appropriation that keenly exposes wallpaper as a signifier of queerness and the centrality of Warhol to this operation. *AIDS* comprises a series of the collective's paintings of the acronym "AIDS" hung against a wallpaper of the same design. The work's serial repetition and decorative density directly recall Warhol's method

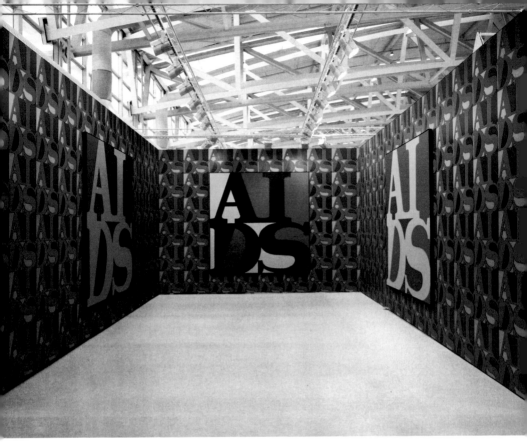

2 General Idea, *AIDS*, 1988, canvas mounted on wallpaper. Installation view, Galerie Stampa, Art Frankfurt. Courtesy AA Bronson.

of hanging multiples of the same image upon an identical wallpaper ground, as seen in, for example, the original installation of the *Mao* silkscreens against a corresponding wallpaper. In addition, the square format in which the letters A-I-D-S are compressed in two rows and the oblique counter of one letter, the D, was based on the well-known composition of Robert Indiana's iconic pop painting *LOVE* (1966). The significance of General Idea's *AIDS* wallpaper installation to my analysis of the decorative as the queer lies in its occupation and transformation of a felicitous catchphrase of the 1960s (Indiana's *LOVE*) and modes of presentation and materials categorized as decorative (Warhol's wallpapers and their installation). Here these elements are made over into an activist confrontation of the AIDS epidemic that in its larger public manifestation was instrumental to the political recuperation of the homophobic slur "queer" in the late 1980s.[31] This queering of Warhol's wallpaper installations continues in the work of Robert Gober and Virgil Marti.

Elissa Auther 123

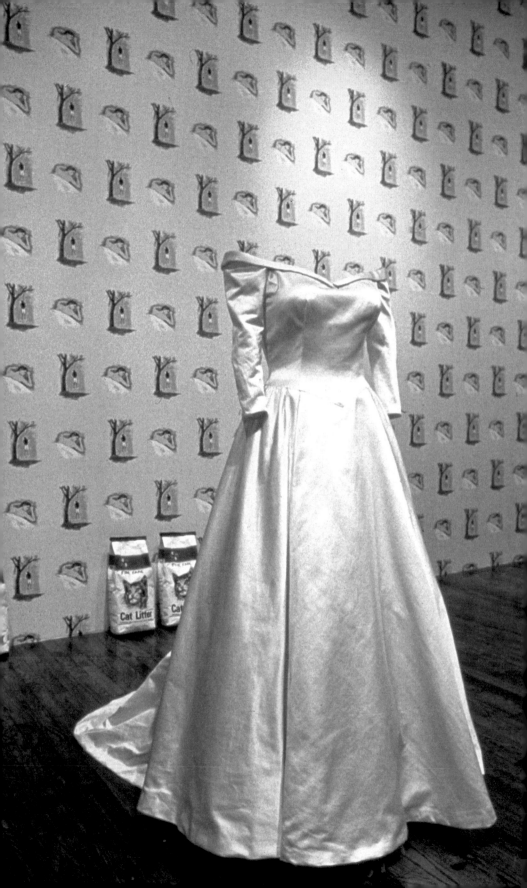

Gober's first wallpapers were created for his show in 1989 at the Paula Cooper Gallery, an installation motivated, according to the artist, by a desire to "do natural history dioramas about contemporary human beings"[32] (see fig. 3). In one room, Gober hung a paper consisting of a disturbing repeat pattern based on found images of two men—one white and sleeping, the other black and lynched. A second room featured a wallpaper consisting of line drawings by Gober of male and female genitals in white against a black ground punctuated at eye level by metal drains.[33] Dispersed throughout the installation were a number of hand-fabricated objects made by the artist, including a bag of donuts on a pedestal, bags of cat litter propped against the wall, and a wedding gown.[34]

Gober's use of wallpaper for this installation trades on the medium's association with domestic intimacy and its conventional function as a decorative or background pattern. Like his earlier distorted playpens and beds, anthropomorphized sinks, and displaced drains, the wallpapers for this installation undermine a conception of the home as safe, pure, comfortable, or familiar by acting as a distorting mirror. Gober's wallpapers turn the *heimlich* into the uncanny through repeat patterns of obscene and violent imagery. What is reflected is a view of the processes of socialization, especially the internalization of normative identities and desires, as brutal and traumatic. For instance, the juxtaposition of the *Hanging Man/Sleeping Man Wallpaper* with the wedding gown prompts questions about how heterosexual fantasies, desires, and gender identifications are entwined with racial violence and sexual oppression. As a gay man, Gober's place within the world he has created in this installation is parallel to the historical relation of wallpaper to art, a place outside of it that threatens its existence. It is in their disguise as the familiar that his wallpapers function as queer, leading us back to what is known and normative but newly revealed as dangerous or damaging.

For his exhibition at the Jeu de Paume in Paris in 1991, Gober installed his third wallpaper, called *Forest*, based on a small watercolor of a New England forest. Gober flipped the reproduction in four directions, creating a kaleidoscopic effect.[35] In this kaleidoscopic effect of the wallpaper, a fracturing of its image created through mirrors, the queer once again comes into play by destabilizing normative conceptions of identity and desire. Applied to or emerging from the paper are three wax sculptures of body parts of a Caucasian male: a pair of buttocks embellished with a musical score and two pairs of legs placed shins down,

3 Robert Gober, untitled, 1989. Installation view, Paula Cooper Gallery, New York, September 30 to October 28, 1989. Courtesy of the artist. Photo: Andrew Moore.

one clothed in pants and black oxfords with three protruding candles, the other in white briefs and sneakers perforated with flesh-colored drains.³⁶ One's experience of the wallpaper and the topsy-turvy landscape it represents shifts in relation to these sculptures, which speak to the body's multiple pleasures and anxieties, including the homoerotic delights of the flesh represented by the ass and its musical score; the juxtaposition of underpants and bared legs; the disgust associated with the drain and its connections to bodily orifices, waste, or disease; and the candle's simultaneous reference to the erect penis and the commemoration of loved ones lost to AIDS. The vertiginous distortions of the wallpaper and the effect of disorientation it produces in relation to these works heightens delight or dread, sometimes both simultaneously, destabilizing the notion of the body and its wishes as contained and uncomplicated.

Gober's *Forest* paper was followed by a wall mural, also of a forest, for his installation at the Dia Center for the Arts in 1993. Although not a paper, there is no meaningful difference between it and the earlier *Forest* printed on paper. Like wallpaper, the scene repeats and was produced by professional scenic painters in a paint-by-numbers approach that approximates the flat, schematic style of a printed paper or backdrop.³⁷ In this work, the wallpaper plays a key role in Gober's exploration of the opposition between "nature" and "culture" within which the artist framed, among other issues, the cultural, religious, and governmental containment of homosexuality. The landscape surround in the piece plays a crucial role in this exploration; as in *Forest*, it is an artistic projection of nature. It also represents the natural source of water diverted into homes (flowing into sinks in the installation) as well as the paper pulp transformed into the newspapers stacked in and around the piece, again a transformation of the natural into the cultural. Finally, in a manner seen in his previous uses of wallpaper, the windows cut through the landscape obstructed with prison bars shift the relation of the natural to the cultural in the opposite direction, undermining any tidy construction of categories by which one may be judged: straight/gay, high/low, inside/outside.

Virgil Marti began working with wallpaper in 1992, and many of his installations utilizing the medium deal explicitly with homosexual identity. From Marti's large number of installations employing wallpaper I have selected three examples, *Bullies* of 1992, *For Oscar Wilde* of 1995, and *Grow Room 3* of 2004, all of which encapsulate much that is char-

acteristic of his installation practice and link it to Warhol's projection of the decorative as the queer. For *Bullies*, Marti inserted the yearbook pictures of tough boys he both feared and desired in junior high school within flocked, glow-in-the-dark garland borders. The paper's first installation was in an isolated boiler room of a former Philadelphia elementary school, a site that evoked various traumatic memories ranging from peer harassment to awkward sexual encounters.[38] Although the paper appropriates the pattern of a French toile, its black velvety surface and psychedelic effects best recall trends in domestic interior decor of the 1970s, an aesthetic that characterizes many of Marti's wallpapers and installations. This too is wrapped up in Marti's retrospective exploration of the evolution of his identity as a homosexual. About the "low" aesthetic style of his wallpapers Marti has stated: "Questioning my own *good* taste and attempting to regain a more innocent state of purely *liking*, I see as analogous to the process of unlearning the dominant tastes and attitudes that contributed to the alienation I felt while I was growing up."[39] In undercutting the masculine aggressiveness of the boys pictured in the wallpaper with a flamboyant decorative pattern, Marti draws a connection between the decorative's association with femininity and its subordination to art that is inspired by Warhol's own embrace of imagery outside dominant good taste.

Marti's *For Oscar Wilde* (see fig. 4), a site-specific installation in and around a prison cell in Philadelphia's defunct Eastern State Penitentiary, draws on a connection between queerness and wallpaper to commemorate the life and work of the Irish playwright. The piece was composed of a garden of live sunflowers marking the prison entrance and a large arrangement of silk lilies in full bloom at the entrance to a single cell outfitted with a small bed covered in pristine white velveteen and two wallpapers—a dado of lilies and an upper design of sunflowers—separated by a stringcourse featuring the author's pithy pronouncements. The installation directly references Wilde's criminal prosecution for "gross indecency" in 1895, resulting in his imprisonment for two years, and his subsequent self-imposed exile in Paris where shortly before his death in 1900 he was quoted as saying, "My wallpaper and I are fighting a duel to the death. One or the other of us has got to go."[40] The installation's use of live and artificial flowers, its embrace of decorative embellishment as art, and its self-conscious stylization of nature also reference Wilde as a leading artist of aestheticism, a movement which championed the purpose of art as a beautiful, refined, or sensuous pleasure

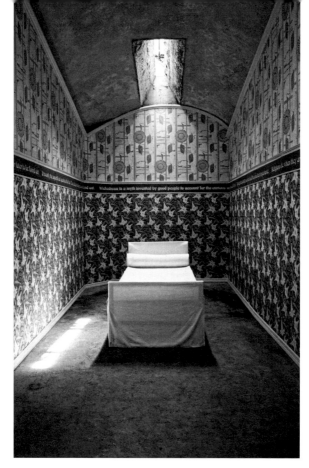

4 Virgil Marti, *For Oscar Wilde*, 1995, silkscreen printed wallpaper, cotton velveteen, and iron bed. Installation view, Eastern State Penitentiary, Philadelphia. Courtesy of the artist.

over any utilitarian or didactic function that connected it to everyday life. The aesthetic movement's embrace of "Art for Art's Sake," that is, its essential uselessness, encompassed an elevation of the decorative arts and interior design in the late Victorian period, redressing the subordination of ornament in the hierarchy of the arts. These transgressions of the aesthetic movement may be connected to Wilde's challenge to Victorian social mores regarding homosexuality. Damned as decadent and unnatural for falling outside the procreative imperative, homosexual sex was also perceived as a form of uselessness—a uselessness, however, that Wilde publicly defended in his trial as of the highest good, a love that "is as pure as it is perfect."[41]

Marti's wallpaper installation, *Grow Room 3*, for the 2004 Whitney Biennial, trades in a subversive nostalgia similar to *Bullies*.[42] For this work Marti installed panels of shiny, reflective Mylar printed with a pattern of free-style macramé webs and dazzling flowers. Hung within the

space are multicolored Venetian-style chandeliers in cast resin featuring antlers tipped with fake flowers. The exquisite effect created by the Mylar and sparkling chandeliers recalls the vogue for mirrored rooms and reflective wallpapers of the 1970s. Mylar is also a material popular among indoor cultivators of marijuana, and the irregular webs are based on the patterns woven by spiders under the influence of psychotropic drugs. The flowers too have a vividness and intensity suggestive of improved growing conditions. Over and above the nostalgic references to home decor of his suburban youth and dreamlike memories of its perfection, Marti's *Grow Room 3* is a visually stunning exploration of beauty and artificiality produced through the intertwining of high and low culture rather than their opposition, a symbiotic pairing essential to Warhol's decorative aesthetic as well.

For artists with explicit feminist intentions, there remains a strong tendency to use wallpaper to address the deep-rooted cultural associations between the decorative and the feminine that informed, in part and unconsciously, the negative reception of Warhol's wallpaper. As such, feminist works utilizing wallpaper ought to be considered first cousins to the queer. Christine Lidrbauch's *Menstrual Blood Wallpaper* of 1991 provides a striking example of this affiliation.[43]

In her analysis of what she called the "gendering of the detail" from antiquity to the modern era, the literary theorist Naomi Schor demonstrated the association of woman with the visual mode of decoration or ornamentation that cast feminine taste as lacking in balance, measure, and meaning.[44] Schor explains the danger of the decorative, or, as she calls it, the detail: The "ornamental style point[s] to what is perhaps most threatening about the detail: its tendency to subvert an internal hierarchic ordering of the work of art which clearly subordinates the periphery to the center, the accessory to the principal, the foreground to the background."[45] Lidrbauch's work addresses the tenacious association of a debased or menacing detail with the feminine along the lines investigated by Schor.[46] Through the adoption of wallpaper, a "low," "craft" medium associated with the domestic sphere, patterned with an unmentionable trace of the female body, Lidrbauch repositions the marginal and the culturally contemptible as the subject of her work. More generally, her use of wallpaper is an ironic challenge to sexist cultural beliefs about women's intellectual and creative deficiencies partly informed by the hierarchy of art and craft and the traditionally low status of women's artistic production within it.[47] In reappropriating the con-

nection between the feminine and the decorative, Lidrbauch's wallpaper continues to address the tacit sexism of the modernist opposition of abstract painting to wallpaper.

In introducing wallpaper into a "high art" context, Warhol's object of critique was the demotion of painting's privileged position in the hierarchy of the arts and the pure aesthetic experience traditionally associated with its exhibition. Indeed, he used the double installation of the *Cow Wallpaper* and *Silver Clouds* to announce the end of his career as a painter. Warhol's use of wallpaper also functioned as a signifier for queerness. Artists such as Robert Gober, Virgil Marti, and Christine Lidrbauch, among others, continue Warhol's legacy, which consisted of both intervening in hierarchies of the high/low and in celebrating the decorative as a specifically queer form. Warhol's understanding of himself as "the wrong thing in the right space" not only conjures up how wallpaper and queerness can both be wrong things in the right space; it also prompts us to question what makes for wrong things and right spaces generally when it comes to art and sexual identity.

NOTES

1. Thomas B. Hess, "Reviews and Previews: Andy Warhol," *ArtNews*, January 1965, 11.
2. The image of the cow was based on a photograph reproduced in an agricultural publication.
3. Rainer Crone, *Andy Warhol* (New York: Praeger, 1970), 30. David Bourdon quotes Geldzahler in his review "Andy Warhol," *Village Voice*, December 3, 1964.
4. Robert Morris, "Size Matters," *Critical Inquiry* 26, no. 3 (spring 2000): 478.
5. On the subject, see Glenn Adamson, *Thinking through Craft* (Oxford: Berg, 2007), chap. 1. See also Elissa Auther, "The Decorative, Abstraction, and the Hierarchy of Art and Craft in the Art Criticism of Clement Greenberg," *Oxford Art Journal* 27, no. 3 (2004): 339–64.
6. For example, the Arts and Crafts movement embraced wallpaper as a craft.
7. Warhol altered the color scheme of the wallpaper for the installation, replacing the pink on lemon yellow combination with red on violet.
8. See Charles F. Stuckey, "Warhol in Context," *The Work of Andy Warhol*, ed. Gary Garrels (Seattle: Bay, 1989), 20. Stuckey suggests that the idea for the Solomon wallpaper predates the production of the *Cow Wallpaper*. His essay is a rare and valuable accounting of Warhol's embrace of art as a form of decoration and his distinctive installations in which wallpaper plays a signature role. My analysis is indebted to Stuckey' groundwork on this topic. See also Charles F. Stuckey, "Andy Warhol's Painted Faces," *Art in America* (May 1980): 102–11.
9. Susan Sontag, "Notes on Camp," *Against Interpretation and Other Essays* (New York: Farrar, Straus and Giroux, 1966), 278. Of course, as full historical studies of

wallpaper will show, it is not *just* camp. What Warhol and other artists using wallpaper demonstrate, however, is that aspects of it—for instance, its artificiality—can be experienced as camp.

10. Cleto Fabio, ed., *Camp: Queer Aesthetics and the Performing of the Subject* (Ann Arbor: University of Michigan Press, 1999).

11. Andy Warhol and Pat Hackett, *POPism: The Warhol Sixties* (New York: Harcourt Brace Jovanovich, 1980), 13.

12. See Geert Wisse, "Manifold Beginnings: Single-Sheet Papers," *The Papered Wall: History, Pattern, Techniques*, ed. Lesley Hoskins (New York: H. N. Abrams, 1994), 8–21.

13. The invention of steam-powered cylinders in the 1840s allowed for printing on continuous paper. See Catherine Lynn, *Wallpaper in America, from the Seventeenth Century to World War I* (New York: W. W. Norton, 1980). See also Nancy McClelland, *Historic Wall Papers, from Their Inception to the Introduction of Machinery* (Philadelphia: J. B. Lippincott, 1924).

14. Leroy wrote for the satirical journal *Le Charivari*. In his review of the first impressionist exhibition, Leroy visits the exhibition with the interlocutor M. Joseph Vincent, an academic landscape painter whose hysterical reaction to impressionist brushwork and composition represented the mainstream art world's and general public's indignation toward the new style of painting. For the full text of the review, see Linda Nochlin, *Impressionism and Post-Impressionism, 1874–1904: Sources and Documents* (Englewood Cliffs, N.J.: Prentice Hall, 1966), 10–14.

15. Tom Taylor, "Winter Exhibitions: The Dudley," *London Times*, December 2, 1875, 4. See Catherine Carter Goebel, "Arrangement in Black and White: The Making of a Whistler Legend," Ph.D. diss., Northwestern University, 1988, 827. Taylor testified against Whistler in *Whistler v. Ruskin* and reiterated this evaluation, adding that "if you bring art down to delicacy of tone, it is only like the tone of wallpaper." See Linda Merrill, *A Pot of Paint: Aesthetics on Trial in* Whistler v. Ruskin (Washington, D.C.: Smithsonian Institution Press, 1992), 179 ff.

16. Harold Rosenberg, "The American Action Painters," *Artnews*, December 1952, 21–22. For a discussion of wallpaper and abstraction prior to abstract expressionism, see Christine Poggi, *In Defiance of Painting: Cubism, Futurism, and the Invention of Collage* (New Haven, Conn.: Yale University Press, 1992), chap. 5.

17. See "A *Life* Round Table on Modern Art," *Life*, October 11, 1948, 62.

18. Ibid.

19. Clement Greenberg, "Review of an Exhibition of Mordecai Ardon-Bronstein and a Discussion of the Reaction in America to Abstract Art" (1948), *Clement Greenberg: The Collected Essays and Criticism*, vol. 2, *Arrogant Purpose: 1945–1949*, ed. John O'Brian (Chicago: University of Chicago Press, 1986), 217.

20. Clement Greenberg, "Review of Exhibitions of Worden Day, Carl Holty and Jackson Pollock" (1948), *Arrogant Purpose*, 201.

21. Clement Greenberg, "The Jackson Pollock Market Soars" (1961), *Clement Greenberg: The Collected Essays and Criticism*, vol. 4, *Modernism with a Vengeance*, ed. John O'Brian (Chicago: University of Chicago Press, 1986), 110. Greenberg's final use of the distinction between wallpaper and Pollock's work occurs in

"Jackson Pollock: 'Inspiration, Vision, Intuitive Decision'" (1967), *Modernism with a Vengeance*, 246.

22. Charles Stuckey reports that it was Irving Blum, not Warhol, who conceived of installing the "Campbell's Soup Cans" on a ledge around the walls of the gallery. See Charles F. Stuckey, "Warhol in Context," 25 n. 4, in *The Work of Andy Warhol*, ed. Gary Garrels (Seattle: Bay, 1989). Warhol's practice of deliberately arranging units of work on top of his wallpapers is part of this pattern of resistance as well.

23. Benjamin H. D. Buchloh, "Andy Warhol's One-Dimensional Art: 1956–1966," *Andy Warhol: a Retrospective*, ed. Kynaston McShine (New York: Museum of Modern Art, 1989), 56.

24. Ibid.

25. L. M. Butler, "Andy Warhol—The Man and His Art Challenge Definition," *Boston after Dark*, October 1966, as quoted by Charles Stuckey, "Warhol in Context," 19.

26. See in particular Jennifer Doyle, Jonathan Flatley, and José Esteban Muñoz, eds., *Pop Out, Queer Warhol* (Durham, N.C.: Duke University Press, 1996). See also Jennifer Doyle, "Queer Wallpaper," *A Companion to Contemporary Art Since 1945*, ed. Amelia Jones (London: Blackwell, 2006), 343–55; Kenneth Silver, "Modes of Disclosure: The Construction of Gay Identity and the Rise of Pop Art," *Hand-Painted Pop: An American Art in Transition, 1955–62*, ed. Russell Ferguson (Los Angeles: Museum of Contemporary Art, 1992), 179–203; Bradford Collins, "Dick Tracy and the Case of Warhol's Closet," *American Art* (fall 2001): 54–79; and Richard Meyer, *Outlaw Representation: Censorship and Homosexuality in Twentieth-Century American Art* (Oxford: Oxford University Press, 2002).

27. Andy Warhol, "Painter Hangs Own Paintings," *New York*, February 5, 1979, 9. As quoted by Charles F. Stuckey, "Andy Warhol's Painted Faces," 105. The *Shadows* consists of eighty-three large-scale paintings of a shadow in seventeen color variations conceived to be installed continuously and low to the ground around the perimeter of the gallery. There is evidence, albeit conflicting, that Warhol shipped a continuous roll of canvas for his second show at the Ferus Gallery in 1964 consisting of the *Elvis* silkscreens and asked for them to be hung as a continuous surround, an effect that also would have produced obvious associations to wallpaper. See Buchloh, "Andy Warhol's One-Dimensional Art," 56. Stuckey claims that Warhol instructed Blum to cut the roll into individual paintings, mount them on stretchers, and hang them "edge to edge—densely around the gallery." See Stuckey, "Warhol in Context," 11.

28. For the reader suspicious of the equation between the discotheque and nonnormative sexuality, consider the "Disco Sucks" campaign of the late 1970s, which culminated in the burning of thousands of disco records at a Chicago White Sox game at Comiskey Park on June 12, 1979. The so-called Disco Demolition Night was part of a larger radio campaign that pitted macho rock lovers against disco and was viewed by many as a thinly veiled assault on the gay liberation and black pride movements of the day. On the subject, see Tim Lawrence, *Love Saves the Day: A History of American Dance Music Culture* (Durham, N.C.: Duke University Press, 2003).

29. Although the list of artists using wallpaper is extensive, little sustained analysis

of the use of the medium in contemporary art exists. One recent attempt to redress this lack of attention to the medium is the survey exhibition "On the Wall: Contemporary Wallpaper and Tableau" organized by Marion Boulton Stroud for the Fabric Workshop and Museum in 2003. This exhibition was a companion to "On the Wall: Wallpaper by Contemporary Artists," curated by Judith Tannenbaum for the Rhode Island School of Design Museum of Art. Both exhibitions are documented in Judith Tannenbaum and Marion Boulton Stroud, *On the Wall: Contemporary Wallpaper* (Providence: Rhode Island School of Design Museum of Art and Philadelphia: Fabric Workshop and Museum, 2003). See also the catalogue for the Wexner Center for the Art's "Apocalyptic Wallpaper," an exhibition in 1997 of wallpaper installations by Robert Gober, Abigail Lane, Virgil Marti, and Andy Warhol: *Apocalyptic Wallpaper: Robert Gober, Abigail Lane, Virgil Marti, and Andy Warhol* (Columbus, Ohio: Wexner Center for the Arts, 1997).

30. The wallpaper was produced by General Idea in 1988 and is based on a composition from 1987 that functioned as a logo of sorts in numerous AIDS awareness campaigns and public demonstrations. General Idea, founded in 1969 by A. A. Bronson, Felix Partz, and Jorge Zontal, was in existence until 1994, the year Partz and Zontal succumbed to AIDS.

31. On the recuperation of the term *queer*, see Douglas Crimp and Adam Rolston, *AIDS Demographics* (Seattle: Bay, 1990).

32. Robert Gober, "Interview with Richard Flood," *Robert Gober*, ed. Lewis Biggs (Liverpool: Serpentine Gallery; London: Tate Gallery, 1993), 13.

33. The image of the sleeping man and hanged man was used by Gober in several other contexts before the production of the wallpaper. The drawings for the *Male and Female Genital Wallpaper* were originally produced for the endpapers of a book designed by Gober for the story *Heat* by Joyce Carol Oates as part of the Whitney Museum's artist/writer publishing program in 1990. See Richard Flood, "Robert Gober: Special Editions, An Interview," *The Print Collector's Newsletter* 21, no. 1 (March–April 1990): 7.

34. The room papered with the *Hanging Man/Sleeping Man Wallpaper* contained the wedding gown and bags of cat litter. The bag of donuts on a pedestal was installed in the room papered with the *Male and Female Genital Wallpaper*.

35. For details of the work's conception, see Richard Flood's interview of Gober in *Robert Gober: Sculpture + Drawing* (Minneapolis: Walker Art Center, 1999), 125.

36. Placed in the center of the gallery was a sculpture of a six-foot-long cigar after René Magritte's painting *The State of Grace* (1959). Regarding drains in Gober's work, see Helen Molesworth, "Stops and Starts," *October* 92 (spring 2000): 157–62; and David Joselit, "Poetics of the Drain," *Art in America* 85, no. 12 (December 1997): 64–70.

37. For details of the installation's construction, see Richard Flood's interview of Gober, 127.

38. The site is now called the Philadelphia Community Education Center.

39. As quoted by Lia Gangitano in the exhibition pamphlet for *Hot Tub*, an installation by Marti for the Thread Waxing Space in 1998.

40. The title of the piece too, *For Oscar Wilde*, is a reference to the message on the calling card—"For Oscar Wilde, posing as a Sodomite"—left by the father of

Wilde's lover, Lord Alfred Douglas, at Wilde's family club. Wilde attempted to sue for libel and was subsequently charged and convicted of "gross indecency."

41. Quoted in H. Montgomery Hyde, *The Trials of Oscar Wilde* (New York: Dover, 1973), 201.

42. See *Whitney Biennial 2004* (New York: Whitney Museum of American Art, 2004), 207.

43. A detail of the work is illustrated in *Sexual Politics: Judy Chicago's Dinner Party in Feminist Art History*, ed. Amelia Jones (Los Angeles: Armand Hammer Museum of Art and Cultural Center; Berkeley: University of California Press, 1996).

44. Naomi Schor, *Reading in Detail: Aesthetics and the Feminine* (New York: Methuen, 1987).

45. Ibid., 20.

46. Elaine Reichek's installation *A Post-Colonial Kinderhood* (1994), and Patricia Cronin's installation *Pony Tales* (2000), both of which incorporate wallpaper, might also be provocatively explored along these lines. See Norman Kleeblatt, ed., *Too Jewish? Challenging Traditional Identities* (New York: Jewish Museum, 1996); and Patricia Cronin, "What a Girl Wants," *Art Journal* (winter 2001): 91–97. See also Nicole Eisenman's wallpaper included in the Fabric Workshop and Museum's exhibition "On the Wall: Wallpaper and Tableau."

47. For a detailed analysis of the categorization of women's art as decorative or craft and the groundbreaking feminist critique of this categorization by Miriam Schapiro, Harmony Hammond, Faith Ringgold, and Judy Chicago, see Elissa Auther, *String, Felt, Thread: The Hierarchy of Art and Craft in American Art* (Minneapolis: University of Minnesota Press, 2010), chap. 3.

Betty Bright
· · · · · · · · · · ·

Handwork and Hybrids

RECASTING THE CRAFT OF LETTERPRESS PRINTING

The work of contemporary book artists demonstrates a shift in the meaning of craft in the choice of the book as an artistic vehicle. There is no longer one craft or one standard. Letterpress printing, called "fine printing" by some, provides a hothouse of different species of craft caught in a historic evolutionary shift. Today, the role of craft is likely to generate questions that expose the conjunctions and disjunctions inherent in contemporary hybridized artworks. In fact, the species began to mutate as far back as the 1960s, as it incorporated new characteristics. In the 1980s, a crucial period in letterpress printing, a retooled printing process facilitated the intersection of content with art-world strategies, structures, and materials. By the twenty-first century, letterpress printing had regrouped and has re-emerged as a medium ripe for artistic restatement, where craft is a part of an object's expressive vocabulary, with equally pliant standards (and preconceptions).

The books of the printers Robin Price and Ken Campbell herald this new paradigm in the craft of letterpress printing. This shift can be discerned in other art-craft hybrids, but in book art its ramifications are particularly complex. The utilitarian object of the book, even in its diminished societal role given digital displacement, initiates an intimate relationship with a reader and so participates in the dual identity of a craft object as both quotidian and symbolic, haptic and auratic. Add to craft the book's textual content and its historical associations with religion (the Book), culture (learned society), and straightforward information re-

trieval. Book art, especially letterpress-printed books, provides an expansive stratum of associative riches for an artist to quarry.

Among the variety of book, booklike, and not-so-booklike objects held within the umbrella term *book art*,[1] letterpress printing inhabits the craft world most decisively.[2] Machinery has always been central to the printing craft. Letterpress is relief printing from blocks, type, and other raised surfaces that are locked up (secured) in the flat bed of a cylinder proofing press. The proofing press allows a printer to work at a slower pace akin to printmaking. The press produces a printed impression via a curved surface (a roller), onto which a sheet of paper is secured. The cylinder is rolled forward across the inked relief surface, whose text and image have been set or rendered in reverse. The inked sheet will emerge with that imagery and text right-reading and impressed into the sheet (hence: letterpress)—medium and message cohered.

Relief printing is, after all, printmaking. But printing books is particularly laborious, and the technology inherently limiting. Type and relief plates sit frozen in the bed of the cylinder press. The size of a press bed determines the largest possible sheet size, and hence the ultimate scale of the book. Until recently printers often printed type separately from woodblocks or locked up the two together in one color run.

Newer cylinder presses are fitted with inking rollers, many of which are electrically driven, which facilitate presswork and ease the repetitive strain on a printer's upper body. Still, the overall process is time-consuming. Beyond the complexities of book design, the prepress process (called makeready) is laborious.[3] Once printing is underway, letterpress requires a printer's constant monitoring so that ink, press, and paper can optimally meet. In addition, every modification to the printed surface must be orchestrated. For example, each time a printer changes ink color, he or she must clean the rollers thoroughly. This means that the greater the number of colors on a page, the greater the time invested in that single page. The larger the book or more complex the printed product, the number of hours invested in the finished object expands exponentially.

Today's letterpress printers continue to find a heritage in the writings of William Morris, who delineated an ethics of craft during England's Arts and Crafts movement. As amply addressed elsewhere in this volume, Morris argued for artistic integrity in design and production, with the artist-writer-publisher as instigator and overseer. He ignored traditional boundaries between art and craft, instead joining the two into

a force to improve society in the face of the Industrial Revolution's dehumanizing effects: "What is an artist but a workman who is determined that, whatever else happens, his work shall be excellent? Nothing can be a work of art which is not useful; that is to say, which does not minister to the body when well under command of the mind, or which does not amuse, soothe, or elevate the mind in a healthy state."[4] Morris believed, along with his mentor John Ruskin, that art and craft conferred a dignity on life and on every person engaged in creative activity. All individuals could tap that creative wellspring to improve their lived environment and so nurture their emotional and intellectual state as well.

What is less well known in the craft world is Morris's commitment to the revitalization of the art and craft of bookmaking. Morris approached book design as he did all his design work, by living it. As a self-described "decorator by profession," he designed tapestries, fabric, wallpaper, stained glass, all aspects of the everyday. His collection of medieval manuscripts and early printed books was small but well chosen, and he was also a respected poet. Those two aspects of his creative life collided when, in jurying a book design competition in 1888 for the first exhibition of the Arts and Crafts Society, he dispiritedly excluded the trade editions of his own writings because of poor design.[5]

By the late 1880s Morris was "thinking of turning printer."[6] Morris leapt into book design with the same gusto that he brought to every endeavor. He underwent an exhaustive research and trial period during which he commissioned the production of ink, paper, and binding designs, and he designed type, decorative capitals, and borders.[7] In 1891 the Kelmscott Press published Morris's novel *The Story of the Glittering Plain* as its first book, to positive reviews. In that book and others Morris sought a balanced page design with text and image interwoven, similar in concept to a tapestry. The result is a graphically assertive page where type and imagery combine in glorious profusion, although reading the gothic-influenced type can prove daunting.

Morris's essays on social activism and craft have not been followed in succeeding generations by writings that consider such issues as they relate to the craft of letterpress printing.[8] Fine press printers today do not so much emulate Morris's page design as they recognize that his philosophy remains hard-wired into the craft standards of letterpress printing. Those standards presume a commitment to quality in materials and hand production, as well as a nuanced sense of *mise-en-page* and transitioning from one page opening to the next.

In the early twentieth century, U.S. printers followed the ideals of the Arts and Crafts, creating page designs that privileged literature and directed visual content toward the supporting role of illustration. In the wider society, Americans succumbed to an Arts and Crafts craze that was more style than substance; Morris's accompanying socialism remained unremarked.[9]

By midcentury a shift was underway. American and British book designers—for both trade and fine press books—turned away from Arts and Crafts foliates in favor of simpler, classical designs. The typographer Stanley Morison, at British Monotype Corporation from 1922 to 1954, led efforts to reform design with an eye toward clarity. Beatrice Warde relocated from her librarian's job at American Typefounders Company to British Monotype from 1927 to 1950, where she joined Morison in promoting a vision of "invisible typography." That vision celebrated the written word as paramount in book design and deemed decorative or strong graphic qualities as disruptive of typography's role in orchestrating a "transparent page."

Fine printers of the period were aware of the efforts of Morison and Warde, but most, including Harry Duncan in the United States, shied away from a strict adherence to their typographical strictures, even as they also eschewed the dense foliates of the Arts and Crafts. Duncan (1917–97) began publishing fine press volumes of contemporary writing in 1939, employing an open page and legible typography that embodied his respect for the austere beauty of the books of England's Doves Press (1900–1916). In this he paid homage to a typographical lineage that extended from the Doves Press back to Nicolas Jenson, a Renaissance printer and typographer renowned for his roman typeface of legibility and grace. In a similar spirit Duncan deployed typefaces such as Bembo and Perpetua in his elegant Cummington Press and Abattoir Editions books. Into the mid-twentieth century, most fine printers sought to emulate the typographical clarity of expression that Duncan achieved in his books.

As the twentieth century unfolded, printers increasingly subjected printing standards to their own artistic sensibilities. With the arrival of the artistic cauldron of the 1960s, some U.S. printers treated fine press strictures playfully, as a point of departure. Walter Hamady, for example, integrated maps, paper scraps, and other found detritus into his Perishable Press books. In his Gabberjabb series (1973–), Hamady parodied a practice of librarians (common in that period) to indelibly mark owner-

ship on even the letterpress-printed books in their special collections. Hamady appropriated such customs toward his own ends: a page in one Gabberjabb is pierced via an "ear tattoo device" (as he described it), or a book arrives sporting a library card pocket, on which Hamady affixed a self-portrait, as if to proudly claim credit for his defacement.

Artists who confronted the conventions of the letterpress aesthetic sought an alter-lineage aligned with an avant-garde heritage, which instigated debate and welcomed improvisation. In other words, they engaged craft from within an art context. In the 1960s some of the books of Claire Van Vliet's Janus Press, for example, integrated Fluxus art techniques and materials. Van Vliet, like Hamady, could print refined letterpress chapbooks if so desired. She chose to do otherwise in her *Four Letter Word Book* (1964), created with the Fluxus artist James McWilliams. In it, offensive language unevenly printed in large wood type appears in a divided-page format common to children's books. The words are effectively cut in half, and only by paging back and forth to assemble different combinations of shapes does the reader solve the puzzle, only to be repeatedly "rewarded" as legibility arrives along with an unpleasant shock of recognition.

What proved to be most influential in the expansion of letterpress work after 1985 was the expressive territory opened up by computer technology. In the 1960s and 1970s the sources for hot metal type were disappearing due to the closing of type foundries. By the 1980s printers worried over doomsday scenarios in which they were literally losing their voice along with type.

Within a decade letterpress printing was back, thanks to luck, insight, and adaptability. Luck, in that just as hot metal type was disappearing, computer technology had developed to a point where improved software could interact with a photopolymer platemaker to create relief plates in plastic in the high resolution required to convey image and text and, indeed, to carry them together on the same plate. The irony of letterpress printing's allegiance with computer technology was not lost on fine printers, wedded to their nineteenth-century presses and the slow time that lies at the heart of craft. Insight and adaptability won out, however, and by 1990 even the most traditional printers were investigating the possibilities of designing on the computer.

In addition, the work of Hamady and Van Vliet prefigured and influenced the kinds of interests that fed the teaching of letterpress as a studio practice, removed from an association solely with a setting in a

library or English department.[10] The maturing studio practice of letterpress and the related book arts in the United States, along with the investment by several campuses in the polymer platemaker technology, spawned a new generation of letterpress printers by the 1980s and 1990s. Most of these printers invest their work with a decisive art-world sensibility, characterized by the interrogation of the associatively complex world of the book in general and of the craft of letterpress in particular.

As in other practices that unite craft with art, a number of viewpoints coexist among artists in the letterpress community. There are printers who embrace tradition, there are printers who subtly undercut standards to raise questions about making and reading, and there are printers who depart absolutely from any recognizable standard in service to a personal vision. Given such a vast range in opinion about craft and art, confusion reigns, and in particular the more experimental printers have yet to articulate their complicated relationship to craft. Rather than posit yet another standard (or antistandard) for craft practice, I will use the work of two printers to illustrate changing attitudes toward craft and art in letterpress today.

The books of these two printers—Robin Price and Ken Campbell—are instructive because of their differences as well as their similarities. Both artists began printing in the 1980s, and both have mastered the demands of their craft. Each deploys concept and craft in approaches that suggest craft's multifaceted profile in twenty-first-century letterpress printing. They do this by engaging with craft as one element of production, as a set of strictures that may be followed or not. This is a self-interrogatory practice of the studio, one that grounds process in a spirit of inquiry or challenge or invention, where craft is a player but not the driver. The willful transgressions of Price and Campbell, along with the memorable quality of their books, capture this moment of challenge and transition in letterpress, even as they point toward more divergent extremes in the work of emerging artists.[11]

The American artist Robin Price sets up a debate between skill and chance, in her book *Slurring at bottom* (2001), subtitled, *a printer's book of errors* (see fig. 1). She turns the artist's internal discourse into content, employing relief printing toward conceptual ends as she adroitly undercuts the historical norms of fine printing that hearken back to William Morris. The first norm haunts every craft-based discipline: perfection. Price decenters the traditional craft world's value system by making her errors her subject. The printer's errors in the book's subtitle refer

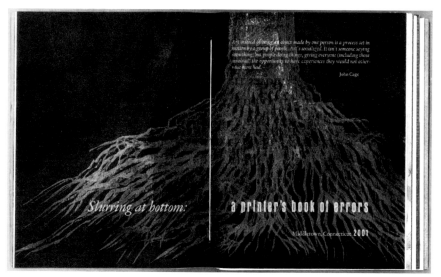

1 Robin Price in collaboration with Emily K. Larned et al., *Slurring at bottom: a printer's book of errors*, 2001, letterpress printed. Ten artists contributed original artwork to selected sheets in the book. Bound by Emily K. Larned, the book is sewn onto cords attached to sanded Plexiglas covers. Edition: sixty copies. 6¾ × 5½ inches. Photo: Derek Dudek.

to the work-up sheets and misprints that printers call "overs," the discarded sheets from earlier book productions that fell short of Price's standards.[12] In *Slurring*, these sheets re-emerge as the pages of the book.

Second norm: consistency (see fig. 2). The concept of editioning presumes consistency to some degree, but in *Slurring* Price conspires with her collaborator, Emily Larned, to undermine those expectations by repeatedly injecting chance into their bookmaking. Sheets rescued from the "slurring" pile were first sanded and painted (or stained), into semi-transparency. These transformed pages were shipped off to ten artists for altering, then returned to Price for further printed additions. The result? No single book is a match of another out of the edition of sixty copies. The finished books are collated consistently only in the first and last sections; the middle four sections differ from copy to copy. Price's process links an Arts and Crafts respect for material integrity with a Fluxian readiness for alterability.

Third norm: content. Among *Slurring*'s mix of writings on chance are printed Price's past exhortations that she had scribbled to herself on the discarded sheets from previous books. In their original context, these off-centered invocations call forth an artist's internal dialogue on

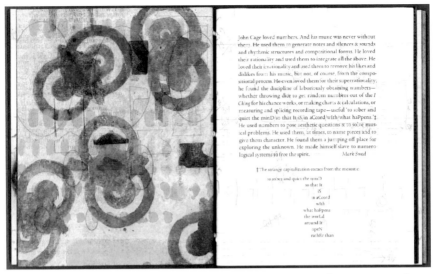

2 Robin Price in collaboration with Emily K. Larned et al., *Slurring at bottom: a printer's book of errors*, 2001, letterpress printed. Ten artists contributed original artwork to selected sheets in the book. Bound by Emily K. Larned, the book is sewn onto cords attached to sanded Plexiglas covers. Edition: sixty copies. 6¾ × 5½ inches. Photo: Derek Dudek.

the mastery of a craft, suggesting corrections to be made and insights gained while at the press. Now injected into a new context, the fragments emerge as an intermittent subtext, printed by Price. The texts appear either nonsensical or provocative, depending on the phrase and the reader's readiness to follow an associative thread into a more complicated reading.

The visual dispensation of each page contributes another strand to the associative fabric woven throughout the book. On one page, for example, a photographic portrait of a young woman appears, disconcertingly, in negative. The woman appears again later in the book, this time in her proper (positive) demeanor. In that later image, we see that her brunette hair loosely falls away as she reclines, head resting on arm, her gaze directed out beyond the reader. In this earlier image, however, which is our first exposure to her (so to speak), the reversed values of the woman's hair appear as flames leaping upward, her eyes and eyebrows written in light, the heat of the image at odds with her cool gaze.

The drama of the image sets off the tiny type printed on the page in two sentence fragments. "Rules not yet in position—CLOSE" sits in an upper inside corner. From there the eye moves diagonally down and

across the woman's ghostly face, to land on, "above 'his,' p. 36 heavy scraping," which is tucked along her shoulder, the visual slant rhyme nearly inciting a wince. The two fragments collide yet entreat the reader to make a connection, to create a connotation. Beyond the obvious physical suggestion of "scraping" lurk other meanings, depending on the reader. Rules, to a printer, for example, designate the metal strips used to print a line, which Price noted were not yet perfectly positioned on the page in that original book. Rejuvenated in *Slurring*, the phrase also conveys a playful tone to indicate that fine printing's expectations about subject matter have been suspended in this book. From here, the other words, "close," in conjunction with, "heavy scraping," take the mind in directions of movement or enclosure, as well as, again, physicality, even impact or damage.[13]

Price's use of found commentary and its shorthand informality avoids overblown "art talk" while posing questions about craft's legacy of commitment and containment—containment in the sense of the standards that circumscribe any craft. Price grapples with the demands of craft as a confident artist seeking to test the limits of content without sacrificing excellence of execution. This intent is not romantic and it's not about the past. It is about one artist setting a conceptual framework within which her creative project takes shape.

Finally, a sense of irony accompanies any reading of *Slurring*. The book is, in short, achingly beautiful in conception and execution. Inspired by an awareness of her own slippages and miscalculations, which have then been altered by other artists and completed, to some degree, by chance, Price transforms her "slurrings" into chance-driven opportunities. Like the haiku poetry discussed in one selection, *Slurring* is witness to a fullness of thought directed by a clarity of execution sought by every poet, painter, or printer.

Book artists like Price understand the insinuative cultural power still wielded by the book, despite the computer's incursions into information storage and access. Add to that the book's sensorial interplay. More perhaps than any other domestic object appropriated for artistic ends, the book requires touch to set its contents into play. Gaze alone cannot discover its meaning, although it should be mentioned that one kind of artist's book, the sculptural bookwork, has traded touch for metaphor.[14] For my purposes, however, I focus here on those books that seek the body and whose challenges are revealed once the book is lifted, held, and paged within a reader's hands.

3 Ken Campbell, *Firedogs*, 1991. Printed by polychrome letterpress deploying hand-worked zinc plate, type-high nails, and sandpaper. Set in Monotype Spartan, Stephenson Blake Bodoni, and a variety of woodletter styles. Printed cover and slipcase. Edition of thirty-three plus seven artist's proofs. 15 × 10 inches. Courtesy of the Rare Book and Special Collections Division, Library of Congress.

Speaking of books that seek the body and of printing's standards transgressed, the letterpress books of the British artist Ken Campbell disregard the canons of printing altogether to achieve an impact reminiscent of the illuminated books of William Blake. Like Blake, Campbell's own poetry finds voice in his books. Campbell's poetry focuses on a family's wrenching conflicts or explodes into war's global scale, as in his searing *Firedogs* (1991) that Campbell published in an edition of thirty-three copies (see fig. 3). Campbell was trained as a graphic designer, in fact as a designer schooled in Beatrice Warde's counsel that "printing should be invisible,"[15] that is, a restrained typographical design should support and not detract from the message of the text. Campbell ignores rules of design and printing. His printing method is assaultive. He prints loud and long, rock-and-roll music thundering in the studio as he lays down ink, surveys the effect, then lays another color down to mask or reveal a line of text, sending each sheet through the press up to twenty-five times.

Passions often ignite new projects for Campbell. Two events trig-

gered the genesis of *Firedogs*: the first Gulf War and the scandal that erupted in London around that time from revelations of the dumping of hospital waste into the Thames River. As a result, the elements of fire and water define the book. In one page opening, reds suggest the conflagrations that glow from across a blue-green luminescence of the Gulf, which Campbell describes as a "dead blue sea-shield; a carapace of messengers." Color emerges from blackness, perhaps evoking the dawn after a bombing raid, oil fires still raging in the distance. Throughout the book, wood type in the margins chants mantras such as "want not, waste not" and "Blood Unravels Blood," a Greek chorus in full cry, joined by brief quotes from the Bible. Luckily, Campbell's own nearly incantatory poetic voice is a match for his visual drama, as in this excerpt, humming with slant rhymes that set the pacing:

Stand by your mystagogues,
your guns, your beds
and stand by me:
artillery
of a ballooning perimeter
the working surfaces becomes:
the very stuff of doing
illumined.
(The balloon went up).
Thank you mystagogue, you stand
for song: for the hymning on
of the miner mined, those born blind:
all singers swimming up onto the skin.[16]

Campbell is as equally uncompromising in inventing pattern as he is unflinching in his poetic locution (see fig. 4). To produce a filigree effect, he attacks his printing plates with a drill, the drill bit skittering across the metal surface to leave striations that appear delicate when inked. In another engagement, Campbell creates a painterly smudge and pull of a mark by overprinting nail heads tapped into bearing material to sit type-high on the bed of his press, awaiting the ink. Another, very different stratum of pattern is discernible in a right-hand inner margin, animated by narrow rectangular shapes. The delicate marks are actually made from pieces of type turned on their sides and made type-high. Occasionally these type pieces break apart in printing, forced to recon-figure themselves under the weight of the roller. The finished page bears

4 Ken Campbell, *Firedogs*, 1991.

witness to this onslaught and is stippled with uneven embossed textures from objects on the bed of the press. The battle metaphors are unmistakable.

Traditional craft standards are irrelevant to processes and pages such as these, at least those standards of fine printing that value type lightly inked on the page, the whole a subtle interplay of thicks and thins. It is not that Campbell rejects craft. Rather, he has absorbed the demands of his medium to the extent that his methods are driven only by the dictates of each book developed during printing. Far from following hallowed craft dictates, Campbell's creative spirit is fed by a craftsmanship born of constant invention and intervention at the press.

The immediacy and physicality of Campbell's creative process is distinctive in the realm of artists' books. Campbell combines an intuitive approach toward building a page and an openness to improvisation, with a focused drive that sustains him over the weeks or months needed to finish a book. Every mark on the page is devised by Campbell himself, printed by his own hand. In *Firedogs*, for example, off-white markings look like glimmerings of light glimpsed through the darkness, or perhaps a night view of exploding shells, reflecting the ghastly beauty of a cataclysm. Whether or not the reader knows how Campbell makes his patterns, a sense of violation lingers after paging through the coated

pages. Somehow, we sense that Campbell will do anything, risk anything, to give voice to his lament.

The dense vistas of color and pattern in Campbell's books rest on the bones of language. Campbell wanted the six poems in *Firedogs* to "marry our world order of waste with an aesthetic of decay and lost form."[17] *Firedogs* connects the distant atrocities of war to London's current calamity of the dumping of hospital waste—to Campbell, the two align as evidence of arrogance and greed. The reader's movement through the book is orchestrated through the typographical design. The poems appear in full, but only as one note in a chorus of language and color. They also shape-shift ahead of and after one another, as Campbell deconstructs and reconstructs selected phrases in a collision of allusion. While paging through the book, the reader discovers a new poetic line or recognizes a familiar one that Campbell has reinserted into a new context, as the book's voices multiply into foreshadowing and lament. Poem one is accompanied by a phrase from poem six, and so on, the incantations emerging from the darkness of the generous margins, shifting in and out of pattern and readability and ultimately returning to the fabric of a page composed of shadow, pattern, and fields of color.

Campbell's books erect a stage upon which the reader is expected to perform. The theatrical analogy works for Price's books as well, as it does for other artists' books, except that on Campbell's stage, turning the pages of a book isn't simply reading. It's not just a visual act, or even a tactile one; it is olfactory, even piquant. The smell of ink wafts up from page after page, as if conveyed by Campbell's commanding poetic voice. Most printed books emit a fragrance, an aide-memoire of every substance brushed or imprinted on their pages. That presence is particularly robust in Campbell's books. Perhaps unpleasant at first, in *Firedogs* the scent permeates the thickened, glossy surface, which takes on the consistency of skin in an odd yet compelling sensuality. Ultimately, Campbell's books act like sensoria of memory. Years after the initial encounter, a reader can still evoke a book's sharp inky odor, still picture the siren call of hues vibrating on the page, still recall the cadence of his poetic voice.

This discussion may suggest that Campbell's books succeed in their provocations over the books by Price. Not true. Robin Price's *Slurring* is no less subversive than Ken Campbell's *Firedogs*; the difference is a matter of strategy and emphasis. Price foregrounds chance and the imperfect as her subject, and like light striking a crystal, she reconsiders

her themes from within a variety of cultural facets reflected in the voices she has chosen. In truth, Price creates conversation more than theater with *Slurring.* In it, the reader's perceptions, ever changeable, shift from the additions of the artists to Price's reflexive jottings of her own self-appraisal. Add to this Price's choice to alter the order of paging in the center four sections from copy to copy, and ultimately Price lets chance finish her book.

Ken Campbell places chance beside him at the press, responding as each book evolves, pattern by pattern, color run by color run, improvisational moment by moment. A hit-and-run analogy is apt for Campbell as we picture him circling the press, feinting in and out with ink, type, and sheets, positioning found objects on the press bed, and drilling into printing plates, the finished page bearing the evidence of his forays. When asked if he ever put too much ink on a page, if he has ever spoiled a book, Campbell replies, "You have to fight your way out of it. I've never thrown a book away, I've never lost a book like that." Campbell punches the sentence out, remembering battles at the press, perhaps disasters overcome. Later, he sums up what brings him back to the press, book after book: the sheer physicality of the process and the "huge risk-taking" that each book entails.[18]

Books by Robin Price and Ken Campbell confound a lingering art-world bias that favors concept and a constant evolution in style, at the expense of a sustained involvement with medium and craft as a crucial aspect of art making. Their books also point toward a shifting craft sensibility that embraces an alchemy of risk as a means to decenter and so invigorate their practice. The twenty-first century has begun with the growing recognition by artists and others that earlier distinctions in the book art field were artificially constructed. These distinctions granted concept-driven work an art context, while work displaying a material involvement with craft was marginalized into a lesser category called the book arts. (Artists in other craft-based disciplines can tell their own tales along these lines.) This divide-and-conquer strategy was undertaken at least in part in the mistaken belief that a separatism that mimicked similar art-world biases would curry favor and a trickle-down membership within the fold. Not all writers followed this line, but those who did found art-world recognition of book art sporadic at best, an approach that confused and degraded understanding of the vital diversity of expression offered by such art-craft hybrids.

What is needed today in letterpress printing are writings that engage

the varying meanings of craft across an aesthetic spectrum. Price and Campbell offer the upcoming generation of printers a platform from which to launch their own expressive forays. That platform is built on the questing and questioning spirit that arose in the 1960s with typographical, structural, and material inventions of printers such as Walter Hamady and Claire Van Vliet. Both of those printers, however, integrated their experiments in books that reflected a mastery of the printing craft. What happens to craft if the printing process itself becomes another expressive tool?

What happens is that the process itself is interrogated and the objects that emerge carry forward that spirit in books that ask questions rather than embody unassailable answers. We are embroiled in those questions today, in a state of healthy confusion, as we seek a paradigm that links craft with art yet is flexible enough to absorb new practices without shutting out the accumulated knowledge that is their backstory.

Some of the best book art today is created from a fluid discipline of inquiry and response, directed by risk, as each artist shapes a method that evolves along with his or her perception of the medium's possibilities.[19] Younger printers view craft traditions anywhere along a trajectory from romantic to negotiable to disposable. They are equally adept at software and makeready, and they don't view craft as a perpetuation of hard-won skills but as an opportunity for debate. Their overriding objective is to fashion a voice.

Most letterpress printers today support craft standards, but some younger printers increasingly view those ideals as a guide rather than an absolute. Their work, as anticipated by the strategies of Robin Price or the methods of Ken Campbell, exposes a fecund source for interrogating process as expression itself. At the same time, a lockstep dismissal of the pursuit of craft would be wrong. Craft inhabits a spectrum of activity in which the interaction of artist with hand and material remains central to that encounter and to the objects that result. Craft need not deny its essential base in process, its sensual core, in order to also engage conceptual concerns. This is not platitudinous. These letterpress books reveal a density of meaning that is the strength of the art-craft hybrid. This is art that communicates on a more resonant level than solely conceptual.

Finally, with book art it is a question of reading. In many artists' books, the reading experience is a paradoxical act. Lines of type do not always conduct the reader along in a linear and rational manner, and

readers do not read to merely gather information or lose themselves in a narrative. The act of comprehension can be changeable, challenging, perhaps revelatory. Reading can be affected or redirected by the visual and physical properties of a book, as artists centralize the experience of reading through its disruption and alteration.

Ultimately, the reading of an artist's book depends on the reader's conscious choice to redirect the art experience back to one that encompasses the body, page by page, and so to traverse a book with every sense firing—sight, sound, and smell, as well as touch, time, and reflection. To readers plugged into today's unrelenting virtual carnival, this vision of direct experience, of slow-time intimacy, and of experience directed by nuance is a radical premise.

Memorable artists' books transform the reading experience from a passive, contemplative process into a participatory and alterable interaction involving intellect, emotion, and the body. Designations of craft and art disappear within the immersive experience of handling and response, of sight, sound, and even smell. Layered inks, mutilations (cuts and tears, embossings with found objects), and overprinted color fields all are a record of printers' tribulations at the press, the hand to the ink to the sheet, their labors, our revelation. Books such as these entreat by their record of making. Touch by touch, page by page, these books are sensory cornucopias to be savored in turn by each reader, the haptic and the analytical convergent within an artist's book's closed covers.

What these books demonstrate is that a restating of the terms of engagement for the letterpress artist is needed, in language that expands rather than contracts the expressive terrain across which book artists travel. As critical writers and historians, let's start with a reading that is affected by all of the elements of a book but directed by physicality and risk. As readers, let's embrace an artist's book as it opens to each of us, not just to our intellect but into our hands and lap, as we heft the weight of it, fingering each page, setting into play a rhythm of reading and response. Such books of handwork and hybridity remember the body, heavy on this planet and in this space and moment, the book in hand completing that circle from artist to press to reader, and completing us in turn.

NOTES

1. Book art encompasses letterpress- or relief-printed books (also called fine press books); suites of prints (if unbound, these works have generated debate in the field

as to their identity as books); books produced in larger edition via offset, laser, or other methods, that I call multiple bookworks; and sculptural bookworks, which can also materialize as installations and performances.

2. Along with the related arts of hand papermaking and hand bookbinding.

3. Makeready comprises activities that go into the preparation of a printing press to print a final print. Tasks include the selection of the proper paper, taking into consideration its size and weight; setting up the plates; choosing ink colors and adjusting ink density; getting the image placement correct (called "registration"); and creating a consistent degree of impression across a sheet of paper. Makeready is complete when the printed product matches the desired proof.

4. William Morris, "Hopes and Fears for Art," *On Art and Socialism: Essays and Lectures*, selected by Holbrook Jackson (Paulton: John Lehmann, 1947), 172.

5. Susan Otis Thompson, *American Book Design and William Morris* (New York: R. R. Bowker, 1977), 20.

6. Quoted by William S. Peterson in *The Kelmscott Press: A History of William Morris's Typographical Adventure* (Berkeley: University of California Press, 1991), 81. Peterson is quoting a letter from Morris to the publisher and bookseller F. S. Ellis, from J. W. Mackail's *The Life of William Morris* (1899), 2:239–40.

7. Often accompanied in his books by the wood engravings of Edward Burne-Jones.

8. Discussions of the social and political implications of craft in letterpress have seldom been engaged in the United States, beyond the embrace of letterpress by the counterculture of the 1960s and 1970s as a means of independent publishing. Most writers of that twenty-year period addressed the particulars of process and historical progenitors of letterpress. See Joseph Blumenthal, *Art of the Printed Book, 1455–1955: Masterpieces of Typography through Five Centuries from the Collections of the Pierpont Morgan Library* (Boston: David R. Godine, 1973); and Blumenthal's *The Printed Book in America* (Boston: David R. Godine, 1977). See also the printer Harry Duncan's collected essays in *Doors of Perception: Essays in Book Typography* (Austin, Tx.: W. Thomas Taylor, 1987), 35. Since 1980, few writers have considered broader issues of letterpress craft. See David Jury, *Letterpress: New Applications for Traditional Skills* (Hove, UK: RotoVision SA, 2006). Broad-based writings on book art offer the reader perspective and context in a diverse field. See Johanna Drucker's *The Century of Artists' Books* (New York: Granary, 1995), and my own book, *No Longer Innocent: Book Art in America, 1960 to 1980* (New York: Granary, 2005). For in-depth analyses of artist book dynamics, see Renée Riese Hubert and Judd D. Hubert, *The Cutting Edge of Reading: Artists' Books* (New York: Granary, 1999), and Keith Smith, *Structure of the Visual Book*, 4th ed. (Rochester, N.Y.: Keith Smith, 2003).

9. The individual most closely associated with the U.S. Arts and Crafts for the general public was the complicated Elbert Hubbard. Hubbard founded the Roycrofters of upstate New York in 1895 and assiduously promoted its array of products until his death in 1915. Hubbard's Roycroft Press publications were issued in a variety of editions to entice collectors, although quality sometimes suffered from the large and varied editions.

10. This is not to suggest that such associations weaken a program, only that letter-

press has benefited from a variety of campus homes. Indeed, several U.S. programs continue to thrive under the auspices of an English department or library. My point is that extending letterpress into art departments broadened the profile of letterpress printing from the 1960s forward, a decisive time of expansion in art-world strategies and movements.

11. Robin Price's books can be found in collections including the UCLA Research Library and William Andrews Clark Library; Yale University Arts of the Book Collection; and the University of Iowa Libraries, Iowa City. A full run of Ken Campbell's books can be found at the Library of Congress Special Collections and the New York Public Library.

12. Slurring refers to one of Price's notes added to a page, pointing out the "slurring at bottom," a smear of ink marring the bottom of a sheet.

13. Price's use of multiple textual threads, including the "found" texts from her earlier note taking, is a strategy adopted by other book artists; here, Price's inspired insertions, with their unsettling undertones, contribute to the book's overall tone of rangy reflection.

14. Sculptural bookworks continue to populate galleries and instigate debates. Their strengths are referential and their successes rely on the complexity of symbolic allusions that they suggest to a viewer.

15. Beatrice Warde wrote and lectured extensively on typography and printing in the United States and England. She delivered the lecture, "Printing Should Be Invisible," to the British Typographers' Guild at St. Bride's Institute in London. The lecture was published in 1932 by the Marchbanks Press, and then reprinted in 1955 by the Sylvan Press. The lecture is included with a new title, "The Crystal Goblet," in a special issue of the journal the *Monotype Recorder* devoted to Warde's addresses and writings (vol. 44, no. 1 [autumn 1970]: 24–25). The special issue is titled "I Am a Communicator," in homage to another theme explored by Warde.

16. *Firedogs* (London, 1991), n.p.

17. Ken Campbell, discussion of *Firedogs*, in *The Maker's Hand: Twenty Books by Ken Campbell* (London: Ken Campbell, 2001), 62.

18. Ken Campbell, telephone interview, July 24, 2007.

19. Discussions that concern the role of risk in craft, as investigated by Robin Price through the strategies of improvisation and chance, and by Ken Campbell through his working methods at the press, have a long tenure in the craft world. In the late twentieth century, writings include David Pye, *The Nature and Art of Workmanship*, first published in 1968 (Bethel, Conn.: Cambium Press; London: Herbert Press, rev. ed. 1995). In it, Pye contrasts a workmanship of certainty (which he associates with mass production) to the workmanship of risk, in which a handcrafted object carries with it the record of the artist's encounter with a material over time and the decisions that happen in the moment as the object is shaped.

Jo Dahn
· · · · · · · ·

Elastic/Expanding

CONTEMPORARY CONCEPTUAL CERAMICS

> In conceptual art the idea or concept is the most important aspect of
> the work . . . all planning and decisions are made beforehand and the
> execution is a perfunctory affair. The idea becomes the machine that
> makes the art.
> —Sol LeWitt, "Paragraphs on Conceptual Art" (1967)

A cursory examination of a range of ceramics-specific pub-
lications will quickly establish that the dominant popular
discourse of ceramics still centers on traditional craft practices.
It revolves around the handling of the clay material and privi-
leges accounts of technique, process, skill, and quality in the pro-
duction of objects, be they functional or otherwise. Could there
be an equivalent to what the critic Lucy Lippard influentially re-
ferred to as LeWitt's "dematerialization" in contemporary con-
ceptual ceramics?[1] To discuss ceramics in relation to demateri-
alization raises questions: What do we mean by *ceramics*? And
what activities can the term encompass? The notion of demateri-
alization seems irreconcilable with the seemingly insistent ma-
terialism of ceramics. But the field is steadily expanding; in this
essay I consider the emergence of a conceptual ceramics mode
that is tantamount to a new genre and prompts a contemporary
reconsideration of LeWitt's formula.

In September 2006, for one night only, in the Raphael gallery
at the Victoria and Albert Museum (v&a) in London, visitors
were treated to Keith Harrison's *Last Supper*, a large table made
of building blocks and laden with thirteen stripped-down ele-
ments from defunct domestic cookers (see fig. 1). Each element

1.1 Keith Harrison, *Last Supper*, 2006, domestic cookers swathed in Egyptian paste and wired in series. Photo: Ted Giffords.

1.2 Keith Harrison, *Last Supper* (detail), 2006. Photo: Ted Giffords.

was mounted on a brick core and swathed in Egyptian paste, a primitive clay that fires to a glassy substance at relatively low temperatures. Attached crocodile clips and electrical wiring were reminiscent of car batteries on charge, while the pastel pinks, greens, and beiges of the Egyptian paste harmonized with the colors of the paintings (actually cartoons for tapestries) on the walls of the room. Cordoned off toward one end of the gallery, with an exquisite altarpiece in the background, the installation evoked church ritual, and of course the title invited a biblical reading. It was also possible to consider it in quite a different way: as Harrison remarked wryly, these ovens had long since baked their last supper. Light levels were low, as befits a room full of Raphaels; when the electricity was switched on and the current ran through one cooker element at a time, the results were subtle. A little smoke, some barely audible crackling, some changes in the surfaces as they heated up and the Egyptian paste fired. This did not deter the enthusiastic audience camped in front of the installation; they seemed to welcome the challenge and concentrated hard so as to catch each effect as it happened.

Last Supper was part of "Clay Rocks," one of a series of sessions at the V&A that were intended to raise the profile of contemporary craft.[2] The same evening Harrison's *London Orbital*, a 1:5000 scale version of the M25, London's notorious ring road, was installed in the sculpture gallery. An undulating 38-meter ribbon made from 167 sections of ceramic Scalextric track, with parallel electric elements buried in calcium borate frit and cobalt, wended its way along the floor, out through the doors into the courtyard garden and back again. It was intended to fire, producing bright blue stripes when the current was turned on, but like its namesake at rush hour, it didn't work. The system fused each time Harrison threw the switch. That viewers were eager to witness something new and different was made palpably clear when they assembled to watch *London Orbital* in action. Some of them took their places at least half an hour in advance. They remained in position, unwilling to give up even when it was obvious that nothing was going to happen. Meanwhile, in the Casts Court of the museum, Clare Twomey's *Trophy* attracted a long queue. She had scattered a flock of four thousand little birds in Wedgwood blue jasper clay all around the gallery; some perched on the casts, the rest spread across the floor (see fig. 2). Each was handmade and stamped underneath with "W" for Wedgwood, "V&A," and the artist's initials "ct." They were instant collectibles. Visitors entered a few at a time; when they left, they could take one of the birds with them—

hence the title: *Trophy*. People wandered about carefully, picking their way between the birds on the floor and enjoying the installation before choosing which one to take as their own "trophy." They became collaborative performers, active participants in the construction of the work's meaning. On leaving, they were asked to send Twomey a photograph of their bird in its new home. She has received many; *Trophy* continues to develop as it spreads out across hundreds and hundreds of private locations.

"Clay Rocks" was a landmark in the development of a new mode of ceramics practice. The siting of *Last Supper, London Orbital,* and *Trophy* in an international cultural center like the v&a is tantamount to institutional validation and suggests that conceptual ceramics, once considered an eccentric minority interest, is becoming mainstream and gaining wider notice. *Trophy* was heralded in the British national press, admittedly as an opportunity to steal something from the museum.

The art historian Paul Greenhalgh situates ceramics among those genres "at the core of the Western artistic tradition." As a craft medium, it has "moved through history, adapting, twisting, changing and surviving extraordinary upheavals" during the modern era.[3] He argues that "the creation of new genres and the collapse of old ones . . . is a dynamic process [. . . and] it is important that we acknowledge our genres; that we continually question them; that we occasionally terminate them; and that we consolidate new ones."[4] Greenhalgh sees the emergence of new genres as serving the continuous, progressive evolution of social and cultural knowledge(s) and believes that notions of interdisciplinarity will govern the "next phase of intellectual growth" in contemporary culture.[5] His ideas ring true for the conceptual ceramics discussed in this essay. They were made by individuals who trained in traditional craft techniques and who may well mobilize aspects of ceramics-as-craft. They have, however, dispensed with the production of ceramics-as-objects-of-exchange, and their work challenges conventional notions of what constitutes and is appropriate to ceramics practice. The key ceramics world trope of the solitary, rural craft potter, spiritually nurtured by handwork, despite (or perhaps because of) material impoverishment, is displaced by urban adventures in collaboration. Contemporary conceptual ceramics operates at the permeable boundary between art and craft, partaking of aspects of both and ultimately demonstrating (or performing) that permeability. A growing faction among the craft

2 Clare Twomey, *Trophy*, 2006, detail of installation in the Cast Court of the Victoria and Albert Museum.

community in Britain welcomes this sort of radical revisioning, as "Clay Rocks" indicated.

Yet there is still no real consensus as to exactly what the phrase "conceptual ceramics" covers. Arguably, Western culture in the early twenty-first century is "post-conceptual" by definition, and certainly the terms *concept* and *conceptual* are used loosely today as buzzwords. As a lecturer in contextual studies at a University School of Art and Design, I routinely discuss aspects of ceramics practice with successive year groups of students. Their understanding of the context(s) within which they are working develops alongside their technical skills and imbues their activities with heightened significance. They would be intellectually blinkered if they were not aware of the so-called art/craft debate. Indeed, many of them have tired of it and are ready to embrace change. There is widespread recognition that, as Alex Buck has observed, the crafts are in a "complementary, symbiotic relationship with painting and sculpture."[6] Ceramics courses at colleges all over the world use the vocabulary of conceptualism to signal that they offer the opportunity to explore exciting new territory. The Royal College of Art in London (RCA), for example, declares that "Ceramics and Glass does not so much imply a fixed set of media, but a site for discursive practice where cultural, social, personal, historical and aesthetic concerns intersect."[7] Nowadays few ceramists achieve recognition without articulating such "concerns," and what is generally understood by "conceptual" is that whatever form their work takes, it is *in*formed by ideas. Tableware, vessels, figurative, abstract forms: all are presented as significant objects whose fullest interpretation depends on a conceptual context and a knowing audience, willing to "unpack" them. When it was first used, however, in relation to developments in art of the 1960s, "conceptual" referred exclusively to practices where the art object had been "dematerialized." In other words, ideas occupied center stage and its material character, its "objecthood," had become little more than a sign of the intellectual process from which it arose.

Contemporary conceptual ceramics often incorporates performative elements and it is worth remembering that ceramics has long been associated with performances of one sort or another. The tea ceremony for instance—whether in its romanticized, meditative, Japanese form or as class-orientated social display—requires a particular behavior from its participants as well as particular types of objects. And ceramic processes, especially firing, have always included spectacle: to take earth

and turn it into something that can be used and admired is the most fundamental kind of alchemy. The transformation from the "raw" to the "cooked" fascinates, and watching it can be marvelous. The audience for process-based ceramics performance has increased exponentially over the last twenty years or so in Britain. Master classes, technical demonstrations, and the like have become staple fare at craft venues up and down the country. Audiences go to see exactly how things are made and be charmed by a dialogue with the maker at the same time. This is a form of theater that can serve to promote an individual's work and boost sales. Though rarely acknowledged as such by the ceramics community, it involves a fetishization of technique and process. Written accounts of such events typically foreground the "how-to" aspects and do not address any conceptual or performative factors.

Originally conceived as a rural "potters' camp" in the 1980s, the International Ceramics Festival in Aberystwyth, on the west coast of Wales, regularly presents a host of ceramists from all over the world.[8] Their performances are usually straightforward expositions of studio craft practices, playing to audiences whose principal interest is extending their own technical expertise. Some are less predictable, however. In 1997, Nina Hole constructed a ceramic "house" from "Magma Clay." Three meters high on a square base, it had two stoke holes and was wood fired under a shroud of ceramic fiber. At 1000° centigrade the shroud was snatched away to reveal the glowing structure. Hole and her assistant Debby English flung sawdust over it to spectacular effect; showers of sparks erupted against the night sky. Activities like this may produce objects: the house was eventually dismantled and reassembled elsewhere, but Hole's process was significant for its own sake, as an event. That same year Maxine O'Reilly built a conical kiln that looked like a large anthill crossed with something from a science fiction novel. When it was fired, O'Reilly played it like a musical instrument, manipulating the flames that spurted from many protruding outlets. There was no product other than the photographic record.

Performance art began in the early twentieth century as a radical way to sidestep the commodification of culture. Faithful to its avant-garde, Dada roots, performance art by performance artists (those for whom this form of expression is absolutely central) is often intended to unsettle the audience. Ceramics performances in the 1990s were more likely to impress and astound, and their good (as in friendly) intentions set most ceramist-performers at a tangent to performance art proper.

For example, with its loud reggae soundtrack, Katsue Ibata's and Rjoji Koie's flamboyant presentation at the 1991 Ceramics Festival was described by one critic as "splendidly anarchic." Despite this it resulted in well-made objects that he saw as "readily understandable in the context of the freely sculptural approach to utilitarian wares that has been the hallmark of the best of Japanese ceramics."[9] Thus it reinforced, rather than challenged, traditional notions of ceramics. Still, the very idea of ceramics-as-performance gives pause for thought, and it is likely that the growth in process-related ceramics performance prepared audiences for something more.

In 1999, surfing the Internet, I came across a site called "Beyond Utility: Psycho-Ceramics."[10] As I wrote at the time: "It features a jerky animation of a live head daubed with slip [liquid clay] by a disembodied hand. I would not like to hazard a guess as to the meaning of the piece, but it is fascinating simply because it exists and demands that we consider it as ceramics. How might it develop? A gradual thickening of the clay layer? A ritual shedding of this second skin? A rebirth?"[11] Six years later, in November 2005, FULL, an event that took place in a Bristol shop window, involved exactly that: a rebirth. Over the course of a very long day, the ceramists Conor Wilson and Paul Sandammeer coiled a huge lidded pot, Sandammeer working from within, Wilson from without.[12] Eventually Sandammeer was completely enclosed—buried alive in what looked a bit like a canoptic jar, to be (re)born, like a chick from an egg, when it was slashed open by Wilson.[13] It took seventeen hours to build the pot and the shop window set included a "small shelf holding bottles of water, which were gradually replaced with bottles containing urine."[14] FULL became a trial of endurance that exhausted both men. Why did they do it? According to Wilson, the performance was an opportunity to relinquish the extreme level of control he generally exerts over environment and materials in his studio. It also tied in with his interest in "the tension between maleness and masculinity" and led him to reflect on the collaborative process in general: "two men working together, observed and under a certain amount of pressure, with no guarantee of success. . . . The circularity of the work—one man moving around the circumference of the vessel, the other forming a turning hub; both pairs of hands meeting at the growing wall; two very different male bodies creating a barrier between themselves, which happens to be a very strong signifier for the female body, and which eventually imprisons one of them."[15] Although FULL utilized craft skills, there was

no exposition of technique. Wilson and Sandammeer elected to explore this approach in parallel to their more conventional, studio-based object production and, for Wilson at least, there was a sense of escape from the craft of making. Their physical exhaustion is reminiscent of the unsettling nature of performance art proper, which frequently entails extreme bodily states.

While still a student, albeit a "mature" one, training in ceramics craft techniques, Philip Lee began to imprint his naked torso onto an earthenware slab or a piece of paper using slip. Raw, wet clay can be seen as a primal material; smeared on the body it evokes at once a return to childhood innocence and, in a middle-aged man, a transgression of socialized masculinity. Lee saw himself as "addressing the taboos associated with exposing the male body" and experienced a personal sense of liberation.[16] His efforts recall early feminist performance. When a naked Carolee Schneeman and friends wrestled and writhed with chicken carcasses (and the rest) in *Meat Joy* (1964), their idea was to celebrate the flesh in a kind of protofeminist erotics. A similar sense of letting go is apparent in the videos that record Lee's ritualized actions. He has exhibited ceramic slabs imprinted with torsos, but these were signs of his performances rather than resolved objects in their own right; it was the experience that concerned him, not the outcome. Clay became a means of exploring and expressing masculine subjectivity. Paradoxically, the viewer was invited to objectify the male body: to imagine its collision with the material, to witness its exposure.

In an influential essay, the jeweler and critic Bruce Metcalf articulated commonly held views about the nature of craft and art. He declared that "craft cannot be dematerialized" and asserted, "In the craftworld, objecthood and material come prior to any other considerations," while "the first priority of art is to address ideas." Referring to a performance event in early 1970s Germany, organized by the U.S. ceramist James Melchert, Metcalf "failed to see how dumping a bucket of slip over somebody is craft" and would no doubt similarly dismiss Philip Lee's performance.[17] But could it be ceramics? Installation and performance-related work has been steadily pushing back the boundaries of ceramics practice and increasingly the terms *art* and *craft* seem irrelevant. Ceramics cannot be subsumed to either; it is an exceptionally elastic and fragmented field, comprising myriad activities and bustling with sign systems. Ceramics can be considered in terms of material culture; of consumer culture; in historical context; as a craft activity; as

sculpture; as design; as process; as display; rural; urban; first world; third world; production; consumption—the list is endless. The only dependable common factor is the presence of, or association with, clay in some form. The ceramist David Cushway has commented on how this works for him: "I'm interested in the way the material adds to the concept . . . the material's intrinsically linked to the concept, . . . I'm interested in all these connotations of what clay is, what it does, what it means and what it can do, and what it's done for centuries: the history of it. And I think you can tap into that and you can use it. . . . It's not a craft medium at all—it's a material, it's another pencil."[18]

Cushway typically initiates transitions from the particular to the universal. Beautiful yet uncanny, his video *Sublimation* (2000) alludes to the fragility of individual life and the indestructibility of a greater life cycle ("earth is where we come from and it's where we return to"[19]). Lasting fifteen minutes, it shows an unfired cast of Cushway's own head dissolving in a tank of water (see fig. 3). The viewer is witness to the gradual unmaking of a skillfully made object. Nothing is actually lost for, in principle at least, the material could be reclaimed from the water and reused. Cushway notes that on occasion *Sublimation* has moved viewers to tears.

Collaboration with the engineering department at the University of Cardiff enabled David Cushway to produce films that show mundane domestic ceramics—a teapot, a cup, a milk jug—breaking. Shot at thousands of frames a second, they capture every detail in slow motion. Though they make no overt reference to clay-craft, the film-craft on display is impressive: "high technology" in action. One at a time, the objects float into view, fall gradually through space and smash in a beautiful, measured, hypnotic ballet of shards. Then the process is reversed, the pieces slowly reassemble and the objects are remade. Becoming more and more complete, they float back up the screen. They are second-hand, industrially manufactured ceramics bought in charity shops (thrift stores). Rejects from the domestic interior, their sheer banality enhances their ability to act as vehicles for symbolic meaning. They are readily imbued with human qualities. A milk jug nose-dives to destruction. As it crumples, a fragment escapes and drifts upward, to become an instant metaphor for hope. Cushway's films operate with psychic intensity. They are remarkably satisfying to watch; perhaps the visible process of reparation fulfils deep psychological needs.

But the time-based (sometimes called "durational") aspects of con-

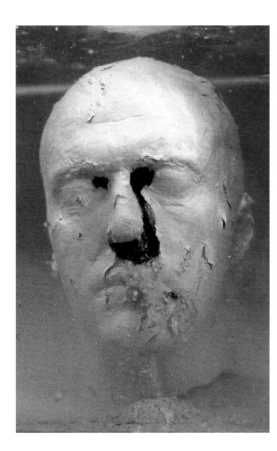

3 David Cushway, *Sublimation* (detail), 2000, unfired clay cast of the artist's head gradually dissolving in a tank of water. Video still courtesy of the artist.

temporary conceptual ceramics are not confined to performance, film, and video work. As Cushway's *Sublimation* demonstrates, raw clay is not a stable material, and consequently it lends itself to open-ended investigations. His *Snowdon*, an unfired cast of an iconic mountain peak, harnesses the future. Drops of condensation on the inside of its sealed glass case show that it is in a state of flux. It appears to be breathing and is gradually accruing a variegated organic surface as molds form. He has set a process in motion so that the object is forever "becoming"; it will never be completely finished. Where and when is the focal point?

For Clare Twomey, a Polaroid photograph signifies a captured memory: "a sense of a permanent thing we possess of a moment that has gone."[20] *The Temporary*, an installation at the Northern Clay Center in Minneapolis in 2006, consisted of a thousand Polaroids installed against a twelve-meter wall of unfired red earthenware. The moisture in the wall affected the photographic ink, so that, like Cushway's *Snowdon*,

the work entered a state of flux, with the Polaroid images dissolving and running into the raw clay background. In 2007 Twomey revisited *The Temporary* and reinstalled it at the Amsterdam Art Fair, but this time she cast the Polaroids in clay, fired, and glazed them. The resulting ceramic wafers were taken away by visitors; thus, like her *Trophy* at the V&A, the work has simultaneously fragmented and expanded—a slow, controlled cultural explosion.

Both David Cushway and Clare Twomey see their practice as a form of research. They are engaged in a process of inquiry, an exploration of ideas, predicated on and exploiting the characteristics of clay. The transformation of the material is a central concern and (semiotic) significance unfolds with making. Cushway has articulated this sensibility: "The whole process of making something can inform the conceptual. . . . I am very particular in that I start with an idea and then render that idea in the best way possible. But I do think that there are times when it is a combination of the two things, of the making and the conceptual, and the space between the brain and the hands can lead you in different ways."[21] For Twomey, an exhibition is an opportunity for personal reflection, to place her work before an audience and for them to "test the theory of the work." Of *The Temporary* she has said, "It really is a large experiment, it's not completed and I am beginning to understand more about this body of work, between the highly temporal and the object . . . it feels like an ongoing conversation that I am learning about all the time. . . . You only truly understand the work when other people engage with it."[22]

Twomey's piece *Consciousness/Conscience* (2002) at the World Ceramic Exposition in Korea elicited a performance from its viewers that clarifies the notion of "conversation" that she seeks in her work. They were invited to walk across a pristine floor of hand-cast porcelain boxes that had been produced in a Korean factory according to Twomey's e-mailed and faxed instructions (see fig. 4). On the other side of the floor they found photographs of the same boxes being made, but the floor crumbled beneath their feet with every step. For Twomey the work "alludes to . . . the responsibility we must all take for the effects of our actions upon nature."[23] The precision, both aesthetic and technical, of the installation was crucial to its success, as was an intimate understanding of the material: the porcelain had to break in exactly the right way, without producing hard sharp fragments. Thinking back to Sol LeWitt's

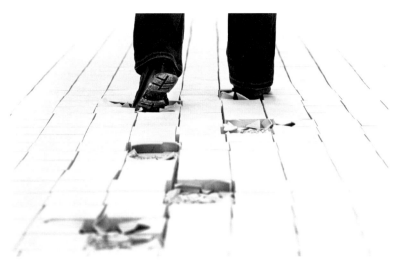

4 Clare Twomey, *Consciousness/Conscience* (detail), 2000, installation with porcelain bricks.

definition of conceptual art, in no way was the execution of this work "a perfunctory affair." Yet it does fit some of his criteria in that the object was dematerialized in another way: *Consciousness/Conscience* was only completely realized while it was being destroyed.

Keith Harrison's work also has a peak "moment" of realization: a distinct time period during which it is completely activated. He sheathes the elements of mundane, domestic electrical appliances with Egyptian paste. Electric fires, storage heaters, and the like (such as the cookers installed at *Last Supper* at the v&A) are transformed in this way, then "fired" at the flick of a switch. The period of "firing" *is* the work; strictly speaking, everything else is before or after.

In the 1960s, Harrison's father was a senior electrical technician in a university laboratory. His son pays him homage with a re-presentation and performance of the technician role. British ceramics has had a vexed relationship with electricity. The products of the electric kiln have been considered inauthentic by craft traditionalists, who see "combustion and the generation of flames and smoke as the proper way to fire ceramics."[24] Wood firing, for instance, feels "organic" and promotes a sense of continuity with the earliest of potters. With this in mind, Keith Harrison's activities are transgressive; indeed, there is something about his demeanor when he constructs his installations that recalls schoolboy

experimentation and situates the viewer as co-conspirator or playfellow. (Perhaps that is why the "Clay Rocks" audience was so reluctant to give up on his *London Orbital*.)

Some of Harrison's early research was carried out in a laboratory at Imperial College, London, the antithesis of a craft studio. His *Bench Block*, cooker rings stacked inside a striped cylinder of Egyptian paste, has a quasi-industrial "grunge" aesthetic; a distinctive and intriguing style, dictated only in part by the components used. The execution may not have been perfunctory in Sol LeWitt's terms, but neither was it meticulous. Seen on video, *Bench Block* looks dangerous. It exudes molten sugar (used as a binder for the Egyptian paste) and emits plumes of steam. There is a background of laboratory benches and snatches of conversation can be heard: technical terms like *resistor* and *wattage*. Often what Harrison does valorizes working-class domesticity. In one untitled piece, a humble bar fire—the most ordinary form of domestic electric heater, with a bar that glows when the current is turned on— comes quietly to life on a patterned carpet in a corner of Eileen Hogg's living room (she is his wife's grandmother). In the background we hear her asking if he wants a sandwich. The effect is utterly banal yet at the same time mesmerising, as the exhibition selector, the sculptor Andrew Lord, commented: "At once familiar and outside any thought I have had of 'ceramic' sculpture, it is thrilling."[25]

For the exhibition "Ceramic Contemporaries 4" in 2002, Harrison installed a series of wall heaters in the Gulbenkian gallery at the RCA. At the private view, the line on the floor beyond which spectators could not pass generated a frisson of anticipation, and by the time he switched the piece on, viewers were jostling for position. This was a constituency of believers, a collaborative audience whose level of engagement was thoroughly informed by its intimate understanding of ceramics-as-craft, just like the audience for "Clay Rocks" at the V&A. Conceptual ceramics may well appeal (and be relevant) to a much wider audience, but it speaks most clearly to those who bring their own experience of methods and materials to bear on their process of consumption. To "understand" Keith Harrison's work, an awareness of ceramics-related technology— specifically of glaze chemistry—is a distinct advantage, and something similar is true of Cushway and Twomey.

It takes those who have handled clay themselves to fully comprehend what was entailed in making David Cushway's *Breath* (2000). It is a thick clay carton inflated by blowing into it, as one would blow up a

balloon, no easy thing to do. The piece recalls an occasion when Cushway was called upon to give artificial resuscitation to a child. Almost prosaic looking, its function is to crystallize his past actions; it was not conceived as an autonomous object. Though not described, the body is evoked and the crux of the work is a strong sense of human presence. *Breath* induces an empathic reaction in the viewer: a heightened awareness of one's own breathing.

In Western art the visual dominates, and although the sense of touch, the haptic system, is important in the crafts, it has traditionally been sidelined.[26] Yet physical manipulation of materials is central to the production of studio ceramics, and touch, in the form of handling, is central to our appreciation, or consumption, of ceramic objects. Bonnie Kemske has spent recent years exploring the haptic system in relation to ceramics. She made a series of forms that were designed to stimulate a tactile response. Their differently textured, highly crafted surfaces and their density are informed by her research into physiology and the operation of touch at cellular level. For her, the challenge has been to produce objects that speak primarily to the haptic system, whose visual character is almost incidental, a consideration en route to a perceptual arena beyond the realm of the visual, so that "the emphasis . . . lies not in the objects themselves but in a final sensual tactile experience."[27] Kemske's work is in some sense time based, for it is incomplete until it is brought into contact with a human body. Once engaged physically, interest in its visual character dwindles; she has observed that when holding and touching her work, viewers may look away and/or close their eyes. The objects trigger social interaction, for individuals are keen to discover and discuss their feelings as they literally embrace each form.

As Kemske's experience suggests, it has become possible to exhibit highly wrought objects that are nevertheless understood to direct the viewer's attention elsewhere than their objecthood and/or their craft identity, an approach that is catching on with other makers. Though well established as a figurative ceramist, Daniel Allen has lately departed from representing the figure as such, in favor of exploring relationship(s) between the body and its immediate environment. He made a perfectly rendered, full-size ceramic chair—the battered old-fashioned wooden sort found in schoolrooms and church halls—and asked someone to sit on it before it was fired, while the clay was still soft enough to take an impression[28] (see fig. 5). Somehow the person who caused the distorted backrest and buckled legs is almost visible. The work catches a ghost, a

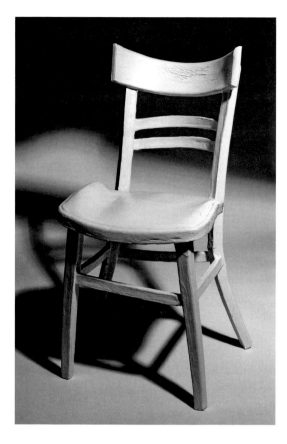

5 Daniel Allen, untitled, from *The Absent Figure* series I, 2005, full-size ceramic chair.

peripheral vision; it holds a moment on "pause." Allen's installation of eight (undistorted) empty chairs anticipates human occupancy. Yet it already feels inhabited and every reconfiguration of the furniture provokes a different narrative, from a single melancholy soul gazing out the window, to an entire encounter group.[29] That the chairs are made from clay signals a symbolic reading; that they can be read as "real" chairs is equally important. The high level of technical expertise—the craft— evident in the look of the work is crucial to its success, but not prime in its construction of deeper meaning.

One might have expected to encounter resistance to contemporary conceptual ceramics from within the craft establishment, and there are indeed those who cannot and never will accept some of the work discussed here as ceramics. This has not proved to be the case in general, however, and an important factor in considering audience response in-

volves the notions of community that pervade what has been called "the craft ideal." According to the academic writer Peter Hobbis, the craft ideal "sees human life as essentially communal and collaborative" and believes that individual craftspeople are "acting positively to serve the interests of others," so that "the productive activity of each harmonises with the goals of all."[30] It is, of course, an ideal that owes much to William Morris's utopian socialist view of craft production as unalienated labor. It leads to an audience for contemporary conceptual ceramics that is warmly optimistic and willing to engage with practices that challenge traditional notions of ceramics, on the premise that such challenges are well meant because they have emerged from and are rooted within the craft community, however tenuous the link may have become. Audiences for conceptual art in a wider sense are "cool," conspicuously flexing their cultural competence and alert to the ironies of the postmodern condition as they swiftly unpack the work, assimilate its message, and move on.[31] The warm, energetic response of the craft audience is very different. It is, and here I draw on my own observations, largely without irony, though socially and culturally informed, and uninhibited in its display of enthusiasm. Such viewer competency allows contemporary conceptual ceramists considerable freedom in their modes of practice. They can, as Sol LeWitt put it, let the "idea become the machine that makes the art" with every expectation of a receptive audience.

For LeWitt and the conceptual artists of an earlier era, the physicality of the creative process became invisible and no longer featured in the discourse that accompanied their activities. For the practitioners I have discussed, however, manipulation of their chosen material is a central consideration. The appearance of their work is distinctive, important, and very often beautiful. Every detail is considered; there is nothing perfunctory about its material construction. On the contrary, it figures large in their construction of meaning. Contemporary conceptual ceramists have not rejected the object out of hand and clay remains central to their activities. But they do apply their craft/material-based skills in new and exciting ways. In a quest to unite aesthetic and conceptual integrity, they seek a symbiotic relationship between idea and object. As much as they challenge and extend the boundaries of what ceramics can be, they also challenge and extend the boundaries of conceptual practice by injecting it with craft sensibilities.

1. See Lucy Lippard, *Six Years: The Dematerialization of the Art Object from 1966 to 1972* (Berkeley: University of California Press, [1973] 1997).

2. "Clay Rocks" evening event at the V&A, September 29, 2006.

3. Paul Greenhalgh, "The Genre," *The Persistence of Craft*, ed. Greenhalgh (London: A and C Black, 2002), 19.

4. Ibid., 27.

5. Greenhalgh, "Complexity," *The Persistence of Craft*, 195.

6. Alex Buck "The Art of Craft," *Obscure Objects of Desire*, ed. Tanya Harrod (London: Crafts Council, 1997), 145.

7. Course description, MA in ceramics and glass, RCA website, http://www.rca.ac.uk/.

8. For more information, see the festival website: http://www.internationalceramicsfestival.org/.

9. Robert Faulkner, "Challenging Orthodoxy," *International* (the journal of the International Ceramics Festival) (1991): 6.

10. See http://bitter.custard.org/beyond/beyond/psycho. The performer is Tonia Clarke.

11. Jo Dahn, "Ceramics as Performance," *Ceramic Review* no. 180 (November/December 1999): 26–29.

12. Coiling is a way of building vessels and other forms from sausagelike "coils" of clay.

13. FULL Plan 9, Bristol, October 22, 2005. See also Jo Dahn, "Sculptor and Figure," *Ceramic Review* no. 219 (May/June 2006): 34–37.

14. Conor Wilson, reflections on FULL, personal communication, April 2007.

15. Wilson, reflections on FULL, personal communication, April 2007.

16. Philip Lee, personal statement, 2003.

17. Bruce Metcalf, "Craft and Art, Culture and Biology," *The Culture of Craft*, ed. Peter Dormer (Manchester: Manchester University Press, 1997), 70–71. Metcalf was referring to James Melchert's *Changes* performance (1972) which took place at Documenta 5 in Germany. See Judith Schwartz, *Confrontational Ceramics* (London: A and C Black, 2008), 122.

18. David Cushway, interview by the author, 2001.

19. David Cushway, "Presence and Absence," edited transcript of presentation given at The Fragmented Figure conference, University of Wales Institute, Cardiff; in *Interpreting Ceramics* edition 8. See http://www.uwic.ac.uk/ICRC/issue008/contents.htm.

20. Clare Twomey, proposal for *The Temporary*, 2007 (personal communication).

21. Cushway, interview by the author, 2001.

22. Recorded conversation between David Cushway and Clare Twomey at Bath School of Art and Design, England, May 2007. Subsequently used as the basis for Jo Dahn, "In Conversation: Clare Twomey and David Cushway," *Crafts* no. 207 (July/August 2007): 22–25.

23. Clare Twomey, application statement for Korea, 2001 (personal communication).

24. Jeffery Jones, "Singing the Body Electric: A Brief History of Electricity and Studio Ceramics," a paper presented at "Situated Knowledges," Design History Society annual conference, Aberystwyth, Wales, 2002.

25. Andrew Lord, "Selectors' Comments," *Ceramic Contemporaries 4*, exhibition catalogue (National Association of Ceramics in Higher Education and Aberystwyth Arts Center, 2002).

26. See Pamela Johnson, "Out of Touch: The Meaning of Making in the Digital Age," in *Obscure Objects of Desire*, ed. Harrod, 292.

27. Bonnie Kemske, "Touching the Body: A Ceramic Possibility," *Interpreting Ceramics* edition 8. See http://www.uwic.ac.uk/ICRC/issue008/contents.htm.

28. Daniel Allen, untitled, *the absent figure* series I (2005).

29. Allen, untitled, *the absent figure* series II (2005).

30. Peter Hobbis, "The Value of Crafts," in *Obscure Objects of Desire*, ed. Harrod, 37.

31. For further discussion, see Julian Stallabrass, *High Art Lite* (London: Verso, 1999).

CRAFTIVISM

Craftivist History

In the fall of 2000, I moved into my aunt's West Village apartment in New York City. Not only was this an incredible opportunity (not to mention incredibly kind offer) to live in an amazing flat in a rent-controlled building but I also didn't know where else to go. Running from my life in North Carolina, I packed my boxes and high-tailed it up the East Coast. In hindsight, this move may not have been the smartest, but it marked a massive turning point in my life. In New York I found myself in the best and worst city in the world, a total juxtaposition of wild and wonderful. One minute I was window shopping and celebrity spotting in my neighborhood, the next I was harassed by screaming individuals holding out scabbed hands seeking spare change. It was unlike anything I had ever experienced, as every day presented itself with horror and beauty to an almost reliable degree.

These new experiences became the perfect breeding ground for creating my own "-ism": Craft. Activism. Craftivism. At that point in 2000, knitting was not all the rage. It may have been on the radar, but no one could have predicted then what has happened to craft in the years since. The cozies, the knitted skulls, the yarn stores popping up everywhere would have seemed, well, out of place and unnoticeable without the resurgence that came before the swell. People were knitting, but no one really talked about it. I moved up to New York City in September and all too soon found myself in the middle of looking for jobs and enjoying autumn as evidenced by the few trees left in my part of the city. September rolled into October, and on Halloween night I ventured out to the end of my aunt's block to watch the annual

Greenwich Village Halloween Parade. It was strange standing there with all my neighbors and only vaguely recognizing a few faces, yet the anonymity was seductive; sometimes it also seemed a bit surreal. We all stood there as if at a subway stop: looking forward instead of at each other. Touching in the city only seems to provoke ire and suspicion in public, especially in a crowd with eyes focused forward. We watched silently and as one as puppeteers and drag queens and costumed beings continued on their march northward.

Somewhere around the turn of the year I started working as a production assistant in a large publishing house. As someone who had always been enamored by words, and who was extremely thankful to obtain a job, I was happy to have the work. I had been in New York for a little over four months, and while the city was constantly providing me with inspiration, it soon became clear that I needed something of my own to bring to the city. I needed to create more than just words on a page; I needed to create outside of commas and semicolons. Thinking back to what older generations can teach us and how I could learn more about history while helping others, I decided that I would learn to knit. At the time, my thought process was: "After all, old people knit, right? Maybe I could find a place to volunteer where I could be taught knitting techniques while keeping someone company! I would be helping to preserve the craft's oral traditions and aiding someone simultaneously!" Genius!

Convinced that it would be my new way forward, I started knitting. Like most beginner knitters, I began with a scarf, an almost universal "learn-to-knit" project because it can easily be created by repeating the knit stitch hundreds of times on hundreds of rows without much variation. After repeating the same stitch over and over to produce a garment several feet in length, the new knitter gains enough confidence to be able to handle the needles and yarn deftly so that more demanding projects can be tackled. Eventually, as my skill set increased, I branched out to knit hats and socks and blankets and sweaters. Now, years later, scarves are still my absolute favorite thing to make, as the repetitiveness of the garment turns it into an almost meditative endeavor and the end product can keep someone warm and cozy. The combination of getting benefit from both process and product allowed me to further my thoughts on craft, making the eventual connection from gentle craft to activist craft inevitable, seeing that as my hands were busy stitching, my mind was free to wander.

Over time I began to recognize that this innate need to create had

been pulling at me since the Greenwich Village Halloween Parade months before, where I was left speechless by the political papier-mâché puppets floating down the Avenue of Americas, moving slowly thanks to the humans at their backs. This movable and visual imagery shook up everything. By omitting words and letting the puppets silently proceed, the puppeteers had illuminated what power our creations can have. These delicate works powerfully conveyed our anger and often helpless thoughts on issues like poverty, welfare, immigration, and racism—without raising a single voice. The visual impact hit me as something imperative to consider, for it was a form of protest without yelling. In a heated debate, it is easy to be drowned out among the many voices; wouldn't it be harder to dismiss something tangible, like a piece of political art or handmade charitable donation? This new way of thinking about how to handle old problems was the beginning of thoughts that I didn't fully formulate until three years later. But it was the beginning.

Several months later, due to a rental law in New York, I could no longer live in my aunt's rent-controlled apartment and I moved back to North Carolina. And I moved back with my knitting. Then came September 11, 2001, and my television revealed a world of confusion, which was followed by hurt, which was then followed by pain, anger, and the start of military conflict.

It seemed that everywhere I looked there was frustration and anger and so much pain. I kept knitting, discovered Jean Railla's Getcrafty.com, and soon moved on to making marble magnets and record handbags and having conversations about creativity as a respite from everything else. The more I talked to people about craft the more I began to realize that there were some traditional handicrafts that were easily teachable, relatively easily practiced, very portable, and, with some exceptions, affordable.

As the military conflict intensified so did my anger, and my mind often went back to the puppets in the Village, to the way they expressed all the emotions I couldn't quite muster when I saw the news and the buildup to the war. They held so much more presence than protesters holding up placards, a rite of passage I had recently completed in Washington, D.C., for a woman's reproductive rights protest. I remember walking on the protest route, yelling and holding up some sign that was handed to me, not entirely sure what I was contributing to the world. That kind of protest has its place but never felt right for me. And I knew I had to do something, anything, and that I could yell and scream all day,

but still the anger and helplessness and frustration would linger in my chest.

That winter I began to think more and more about the intrinsic connection between the words *craft* and *activism*. Both of the terms tended to produce strong reactions, but what if they melded in such a way that allowed and encouraged people to use imagery and creativity as their activism? *Craft* was like the younger child not taken seriously by art, and *activism* made people uncomfortable, conjuring unpleasant images of tear gas and riot gear. What if each was treated as a positive entity? What if they could each use the energy created by the other to take on a new idea?

It began to bother me that two positive words had been culturally redefined as negative. Not entirely sure whether I was onto something, I decided I needed to see what other people thought of this idea to take back the words *craft* and *activism*. After asking the opinions of several of my various online friends and in various crafty online forums, I realized I also needed face-to-face discussion. Soon after I returned to North Carolina, I sent out an e-mail to everyone I knew who I thought might enjoy knitting and sewing, wondering if anyone would be interested in starting a weekly knitting circle. Much to my surprise, the e-mail was forwarded to like-minded people, and soon enough we had a devoted group.

One night, in my newly formed North Carolina knitting circle, I started talking about the ways in which craft and activism were related and my friend Buzz said, "Hey, you could call it *craftivism*." When I got home I discovered that the Church of Craft collective had used the word once online, and I figured it was time to give it more of its due. Established in 2000, the Church of Craft began with two friends on opposite coasts (Tristy Taylor on the west and Callie Janoff on the east), with a mission to "create an environment where any and all acts of making have value to our humanness." By getting people together to socialize and make, their meetings, which soon sprung up all over the world, allowed for true celebration of creativity. I was emboldened to learn that there were others who felt just as I did about the inherent connection between two seemingly disparate entities, and amused to find I wasn't the only one who thought this concept should be explored. Although at times the coinage of the word *craftivism* has been attributed to me, I like to think its usage came about thanks to a few phenomena occur-

ring simultaneously, mainly the frustration at the rule of materialism, the continuing quest for the unique, and the rise of the Internet.

I decided to start a website/blog named after and about this new -ism. Not only was I unsure of what one did when one made up a word; I also was unsure of what happened when one asserted it as an -ism. To make things even more complicated, I then registered the domain name craftivism.com, although I had no idea what the hell I was going to put on the page. At the time all I could think of were clearly negative kinds of -isms: fascism, classism, elitism. Moreover, there seemed to be no handbook of what to do when deciding there needed to be another -ism in the ranks. One thing I was sure of was that I wouldn't place any ads in print or online; I wasn't selling anything; and I was curious as to what happens when one creates a word and places it on the Internet. I wanted to see how my little word would grow, and how and why it would attract others. And, over time, the word grew and grew. Seeing that the word was up for some interpretation I figured it best to let people take from it what they will.

Looking back, it wasn't probably the best idea, releasing a new word and seeing what happened. Even now, the word seems strange to me when other people use it. Indeed, not too long after I started the site, "other people" (people I didn't know) started using the word. My word. Some of them even used it in ways that completely contradicted my definition of it. Some of them abused my word and there was nothing I could do but quizzically wonder what I had gotten myself into. People started using the word in cooler ways than I did, with flashier pages and more arcane examples and I wondered if they would think I had lost my chance with the word, that I let it go downhill by not properly appreciating it. And sometimes I wanted to yell "That's *my* word!" and hug the user when I heard it—although it's not "my" word at all. (I am the one who started coddling it, but the Church of Craft thought of it around the same time as I did.) So I began championing the word online, which means that sometimes (and awkwardly) the word has been attributed as mine. Saying that it's "mine" meant the possibility of trademarks and other intimidating things, as well as forgetting how it really came into being. From the very beginning, my use of the term *craftivism* was born from discussion, which is part of its strength.

I realized that this is what happens when you put an -ism out into the world: it's not yours. It's out there floating around, intangible, like

all the other -isms in existence, a thing but not really a thing at all. Just a concept. Surprisingly, this new thought took a while to get used to, as I was working toward my new role in the word's development. There were times when I was driven to tears because someone had missed the point of "my word," which I had nurtured and cultivated from a seedling. But before you think credits are going to start to roll or I'm just ramping up to a smashing finale, I'm not. I'm going to tell you how I made my peace with craftivism and came to see it as more than just a word.

This peace came, ironically, with the expansion of the war that inspired the term. It happened as I continually saw people not paying attention around me and not being angry about what the so-called war on terror brought about. It happened when I started reading about the casualties on both sides and saw photos of the conflict on the news day after day. It happened as I watched people en masse yell and scream to seemingly deaf ears about not wanting our country to go to war in the first place. It happened as I started thinking about all the people who need aid, and how literally you could spend your whole life just trying to come to grips with it all. And once you go there, you go further and realize that the news North Americans see every day is a kitten compared to the wild tiger roaring in less lucky places. Craftivism was, for me, a way to actively recognize and remember my place in the world, a way to remember how I can take steps toward being an agent of change. Small change? Of course. But done continually and repetitively, small changes aggregate and spread.

I started cross-stitching teeny, tiny pieces that were based on war iconography (see figs. 1 and 2). While it's not finished, one of my ongoing projects is a cross-stitched series of international antiwar graffiti. It began with a piece for an art exhibition that demonstrated how people could use the knitPro application made by Cat Mazza and distributed publicly and free on her anti-sweatshop website Microrevolt .org (see figs. 3 and 4). I used the program to turn a stenciled tag by the British graffiti artist Banksy of a young girl hugging a bomb into a cross-stitch pattern. Once I finished the piece I began to think about all the other antiwar pieces of graffiti around the world, and why they were created, who they belonged to, and what the artists had hoped the response would be.

I watched, as crafters donated in droves to charities like Afghans for Afghans. I talked to people about ways they can use their individual interests to help facilitate change. I began to see how craftivism meant

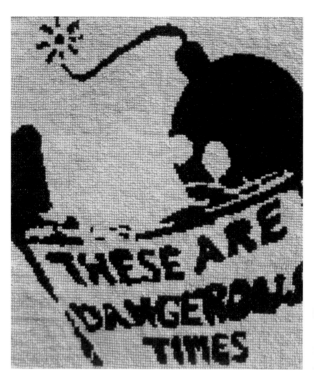

1 Betsy Greer, *Anti-War Graffiti Cross-Stitch*, 2007–8, cotton floss on Aida cloth.

2 Betsy Greer, *Anti-War Graffiti Cross-Stitch*, 2007–8, cotton floss on Aida cloth.

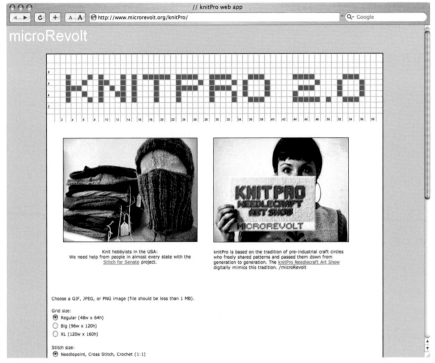

3 Cat Mazza, screen capture of knitPro program available on Microrevolt.org.

4 Legwarmers appropriating commercial logo converted to pattern via knitPro.

more than just craft plus activism; it meant something more akin to *creativity* plus activism. Or *crafty* activism. It was about using what you can to express your feelings outward in a visual manner without yelling or placard waving. It was about paying attention and not letting your anger consume you, it was about channeling that anger in a productive and even loving way.

So, the word is my word. But it's your word, too. And it's yours to do with as you see fit—not to capitalize on the term, but instead to join the many voices fighting for change creatively. Craftivism needs your unique voice, via stitches or paintings or puppets or other crafty endeavor, to further spread the idea that creativity can be a catalyst for change. Or maybe instead of crafting you have your own -ism to create. Either way, go forward with curiosity, strength, and passion—and realize that all it takes is a little idea to make big things happen.

Kirsty Robertson
· · · · · · · · · · · · · · · ·

Rebellious Doilies and Subversive Stitches

WRITING A CRAFTIVIST HISTORY

What thoughts are passing through the bowed head of the embroiderer? So asks Rozsika Parker in her now seminal text on feminism and embroidery, *The Subversive Stitch*, where she suggests that although the position of the needle-worker—head bowed, shoulders hunched—appears to be one of submission, it also contains within it a hint of autonomy and self-containment at odds with any complete subjugation.[1] In her reclamation of embroidery as an important art form, banished from the art canon due to the gender of its practitioners, Parker was very much a part of a 1970s and early 1980s feminist recla-mation of craft as a potentially liberating pastime and, perhaps more importantly, a high art form. Questioning the phallocen-tric and abstract expressionist–dominated art world from which the era's feminist art departed, artists using embroidery, knitting, and sewing attempted to unsettle the ease with which expecta-tions of domesticity and child rearing were imposed on many female artists. In exhibitions such as "Feministo: Women and Work" at the South London Art Gallery in 1975 and "Women and Textiles: Their Lives and Their Work" at the Battersea Arts Center in London in 1983, the so-called feminine work of sew-ing, embroidering, knitting, and weaving was repositioned as having much greater artistic, economic, and social importance than assumed.[2] Political craft for these practitioners was about an escape from the monotony of daily life, about connecting with other women and other artists, and about challenging the boundaries of the art world—in terms both of what was being made and what was being archived within the annals of art his-

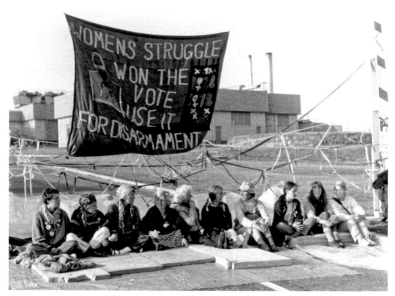

1 Greenham Women's blockade of Brawdy Airfield Pembrokeshire, 1982. Photo: Ian Campbell.

tory.[3] In the art world itself, artists such as Joyce Wieland, Judy Chicago, and Magdalena Abakanowicz did break down some of those barriers, bringing textile work into the authoritative galleries and museums of North America and Europe.[4]

In the same vein, while there were plenty of calls from feminists to leave knitting and sewing behind as emblems of conformity, craft nevertheless played an important role in numerous 1970s and 1980s political actions, including that of knitters involved in the lengthy Women's Peace Camp antinuclear protest, held outside the Greenham Common Royal Air Force Base in England (see fig. 1).[5] In these cases, the very feminine qualities that were used to dismiss textiles as art forms were ironically reversed to demonstrate the peaceful nature of the protests versus the brutality of (masculine) police oppression and the wider politics that had brought the threat of nuclear war.

.

Fast-forward thirty years and textiles are again at the forefront of a politicized praxis, ranging from anarchist knitters braving the tear gas at mass protests to a widespread resurgence of knitting in public, and from

global anti-sweatshop actions to artists using handwork, often knitting or embroidery, to push the boundaries of the global art world. Yet the similar actions of 1970s and 1980s are rarely cited, and any revival of the history of activist craft practice is often trumped by a need to quash still-perpetuated, gendered stereotypes of crafting—"not your grand-mother's crocheted doilies," wrote the curator David McFadden about the exhibition "Radical Knitting and Subversive Lace."[6] It is possible, in fact, to trace this history of ebbs and flows, through embroidered suf-frage banners and back much further to the weaving and unpicking of Penelope's cloth, in a trail of activism constantly broken, crossed over, and erased.[7] This before even mentioning the roles played by textiles in resistances around the globe and across time: from, among others, the encouragement of hand-weaving in the Indian independence move-ment through the role of cotton in the slave trade and abolition move-ment, patchwork *arpilleras* made in Pinochet's Chile, and remembrance quilts created in postapartheid South Africa.[8] Nevertheless, a connected history remains to be written, and it would seem that the history of craft activism is one of constant reinvention. One might go so far as to sug-gest that in the case of today's "craftivism," it is precisely the apparent novelty of activist crafting that grants efficacy to actions that depend on the reversal of stereotype rather than links with second- and third-wave feminism.[9]

Focusing on knitting, this essay examines what might be gained and what is lost through the erasure of a historical trajectory of radical prac-tice. To get at this question I discuss this latest, phoenixlike emergence of craft across a number of seemingly disconnected scenes, including the global art world and the frontlines of protest, to suggest some possible reasons for their simultaneous emergence and disconnection from pre-vious kinds of resistance. Is it possible that the political effectiveness of radical craft practice relies inherently on the gendering of textile work? Is it possible, in other words, that the way that knitting, embroidery, and quilting are used to make political change in some spheres requires their subjugation in others? This might explain the paucity of attention paid to activist crafting practice during the late 1980s and early 1990s, when debates over issues of identity and representation made the use of craft difficult precisely because of the way activist crafting used es-sentializing stereotypes of womanhood and domesticity. This also offers a possible explanation for the resurgence of craftivism as debates over identity politics have in turn been eclipsed by analyses of global capi-

talism, neoliberalism, and the attendant shift of (some) scholarly attention away from difference and toward analysis of connection, flows, and networks.[10]

.

In April 2001, at the massive protests in Quebec City against the signing of the Free Trade Area of the Americas Agreement, a group of protesters gathered in the clouds of tear gas, knitting scarves in response to hastily passed legislation that had forbidden the wearing of facial coverings within the vicinity of the action. The peaceful knitting action amid the increasingly violent altercations between police and (generally) unarmed protesters received very little coverage, lost as it was in an aftermath of analysis that pitted "violent" against "peaceful" protesters and largely obscured the reasons people might have had for putting themselves in the line of fire.[11] Coverage was equally foggy for an action in 2000 that saw activists in Prague knitting a net across a street through which a convoy of participants in the World Trade Organization/International Monetary Fund meeting had to pass. But by 2002, when a group of radical knitters set up a massive anticapitalist knitting circle in Calgary, Canada, at a protest against the G8 meeting in nearby Kananaskis, activist knitting had become a hotly debated topic within the so-called antiglobalization movement.[12] Did knitting contribute to the overall tactics of the "movement of movements," or did its perception as an "unthreatening" activity further stigmatize the direct action so criticized in the mainstream press?

For activist knitters such as the Calgary Revolutionary Knitting Circle—one of the earliest formed that associated itself directly with the politics of anti-, or more accurately alter-globalization, whose activities are outlined and analyzed more closely in this volume by Anthea Black and Nicole Burisch—knitting is seen as a radical alternative to the commodification of all aspects of life. By knitting in groups, activist knitters form bonds that challenge the destruction of community under contemporary capitalism. In addition, a withdrawal from capitalism through the knitting of one's own clothes, charity work (for example, knitting blankets for the homeless), and challenging the media portrayal of activists as violent all form important subcurrents in the increasing number of radical and anarchist knitting circles springing up across the globe.

As Black and Burisch address, the Revolutionary Knitting Circle knitters did receive pseudosympathetic coverage in the mainstream press, something that had, to this point, been unavailable to the vast majority of activists. But in many cases, the peaceful acts of knitters were used to highlight the purported violence of other activists, thereby perpetuating stereotypes and hierarchies that are consistently used to undermine the legitimacy of protest. At best, while offering publicity, such coverage was a double-edged sword, serving simply to reiterate gender and class divisions while eclipsing the politics of anticapitalism. The goals of most radical knitting circles fall under these rubrics, occasionally making connections with the wider politics of the global textiles industry and its record of abusive labor standards and polluting practices.[13]

"This will have you in stitches," "A bunch of dyed in the wool activists," "They'll needle the police"—these were just of few of the headlines in coverage of the Calgary anti-G8 protests.[14] Given the complete lack of attention paid to the knitting action at the much more confrontational protests in 2001 in Quebec, just a year earlier, it is possible that the mainstream (and also independent) media turned their attention to the knitting and "feminine" actions only when an absence of expected violence forced reporters to seek out new content. Even when positive, the reports on the radical knitters tend to be saturated with typecasting: "knitting—long belittled as the preserve of elderly ladies declining towards senility—has become a politically engaged, radical artform," wrote Charlotte Higgins in the *Guardian* in a typical example.[15] What occurs is an interpretation of radical knitting as radical only in its form—in its reversal of stereotype rather than in its content. Though radical or subversive knitting actions now regularly receive extensive coverage, seldom are the goals of the knitters within the wider frame of anticapitalist protest placed above the curiosity factor inherent in the event.

Thus, although a media darling for reporters in search of a good story, radical knitting is just as regularly dismissed or critiqued, not just on the level of gender but often on the level of its supposed futility. "Are we to knit our banana covers to show our contempt for the ruling powers?" asked one reader of an article in the *Guardian* on "rebel knitting." "Forgive me, but what next? Rebellious doilies?"[16] In the dismissals of activist knitting there is often an underlying critique of knitters—even those actually at the protests—that their tactics are so nonconfrontational as to be completely ineffective. Knitting, in other words, is seen as a safe

form of activism (if it is even activism at all), both for those practicing it and those covering it in the media.

Interestingly, the above-mentioned reader cites Greenham Common in her critique, sarcastically suggesting, "Forget Greenham, the peace corps, the unemployed, let's all march in our own-fashioned knitwear and protest; that should do the trick."[17] For this reader, contemporary craftivism is little more than a commodified shadow of its predecessor. And yet, there certainly are similarities to be drawn between the dismissal of Revolutionary Knitters working as a part of the alterglobalization movement and activists who gathered in 1981 against the installation of American cruise missiles at the United States Air Force base at Greenham Common, staging an occupation at the Women's Peace Camp that lasted almost twenty years. Unlike the knitting circles, the occupation of Greenham Common was a woman-only action that reached a height in 1983 when some 30,000 women gathered to "Embrace the Base," joining hands around the perimeter of the facility in a show of solidarity. As with the alterglobalization protesters, nonviolent tactics that often drew on a lexicon of femininity were central to a project that focused on undermining the assumed masculine authority of the military and government.[18]

But even at Greenham, where bodies were put on the line as women were regularly evicted, harassed, and arrested, the strategy of using "feminine" tactics was not universally approved. At a radical feminist workshop, held in London in 1983, questions about whether the women's peace movement and the politics of the antinuclear campaign could coexist with feminism were central, here summarized by a participant, Lynn Alderson:

> On the T.V. and in the newspapers I see women saying that they are here for the good of their families, that they are simply "ordinary" women who are deeply moved by the urgency of the situation, that they are "naturally" concerned to preserve life and defend their children, that if there were no nuclear threat, they could go on being nice, ordinary women and all would be O.K. I'm sure you can see from this the stereotyping of women which—granted, it is coming thro' the media—but it is also deeply interwoven with the politics and tactics of the women's protest.[19]

For Alderson and others at the workshop, it was the idea of the "normal" woman, knitting and hanging baby clothing on the fence outside the

nuclear site, that was inimical to feminist goals. It was the nonviolence of protest, and the assumption that it was a female characteristic to respect life (and hence hate war), that presented a self-contradictory position for both the women involved in the protest at Greenham Common and those who kept away. For many of the women there, however, the action and occupation of Greenham Common was a profoundly feminist event—one where the politics of feminism could be worked out through action rather than theory, and where the performance of femininity was part and parcel of wider acceptances of difference, of collaboration, cooperation, political involvement, and community building.[20]

The questions concerning participation at Greenham Common are still current, with one significant difference: activist knitters are today often assumed as feminist, with questions of female subjugation constituting only a minor motif within the numerous online chats and discussions about activist knitting. However, equally important is the wider social status of knitting and the fact that the radical politics of the Revolutionary Knitters described above remain fringe elements of a much wider resurgence of knitting that began in the late 1990s, culminating with the publication of Debbie Stoller's bestselling *Stitch 'n Bitch* books. The books are accompanied by an ever-increasing number of community knitting groups, along with growing ranks of knitting weblogs, information sites, and publications that speak to a vast network of knitters performing a politics of community making based in a revival of crafting practice that suggests a very different experience and context from that of Greenham.[21]

The politics of these groups, knitters, and sites are often eclectic, ranging from the ultra-conservative to anarchist. As the knitter, activist, and webmaster Betsy Greer argues in her essay in this volume, the resurgence of knitting is a response to the destruction of community wrought by technologies of communication.[22] For Greer, knitting allowed a reconnection with people as a part of the building up of community and the encouragement of friendship—often with people with whom she had little in common other than knitting. In turn, such connections were made possible through the Internet—which has been essential in sustaining this latest revival of knitting.

Like Greer, Stoller, who is the editor of *BUST* magazine as well as author of the *Stitch 'n Bitch* series, argues that the coming together of domestic craft and feminism was in itself subversive.[23] "It dawned on me," writes Stoller in a critique of 1970s feminism, "all those people

who looked down on knitting were not being feminist at all. In fact, they were being anti-feminist, since they seemed to think that those things that men did were worthwhile."[24] Though I sympathize with Greer's and Stoller's sentiments (having followed this journey myself), the failure to acknowledge the importance of handcraft to earlier movements is, I think, a significant flaw in the analysis of the recent activist knitting. Stoller makes this erasure clear when she writes, "The very fact that knitting, sewing, crocheting and other skills of the happy homemaker have been considered too girly to be done in public is proof that these crafts need to be reclaimed by the same feminist movement that initially rejected them."[25]

What results is an argument that knitting in contemporary society is necessarily feminist, anticapitalist, and radical in a way that draws on its appearance as entirely new, leaving the door open for a split between those who describe knitting in this way and those who continue to read it as antifeminist. In her critique of the feminine/feminist resurgence of knitting, for example, the writer Tonya Jameson argues that the very type of knit-resurrection in the United States after 9/11 that Greer's essay discusses is not at all subversive but instead reflects a disengagement with politics. Jameson argues, "Too many sisters fought to free women from aprons and mops for me to voluntarily become Aunt Bee and pretend it's by choice."[26] For Jameson, the "return" to knitting is inimical to radical feminism, underscoring the conservative turn of American politics. "Instead of reconnecting with traditions," she writes, "it seems like we're knitting, cooking and hiding in our homes because we're scared. Creating something with our hands gives us a false sense of control at a time when we have little."[27] Jameson continues, "Instead of fighting for real control, like lobbying legislators for patients' rights, we're playing Holly Homemaker."[28] So too for the well-known feminist writer Germaine Greer, crafting is an "exercise in futility . . . [and] heroic pointlessness."[29] Crafting, Greer argues, is yet another make-work task, more closely related to the oppression of women than the subversion and enjoyment noted by Stitch 'n Bitchers. In 2007, Greer wrote, "Ladies of leisure were not permitted to enjoy their leisure. They couldn't go rambling about or fishing or playing cricket on the green or burying themselves in books. Instead, they had to fill their hours with useless, pointless, unproductive, repetitive work: beadwork, shellwork, tatting, making cut-paper patterns and silhouettes, japanning, plus what George Eliot called 'a little ladylike tinkling and smearing.'"[30] While most radical knitters dismiss

Jameson and Greer out of hand, arguing that knitting *is* political, I would instead suggest that there is a deeply conservative edge to knitting, as there are also strong ties to the military and feminine participation in war tied up in knitting resurgences. As evidenced by the archconservative blogger Michelle Malkin's dismissal of subversive knitting as a "left-wing hobby" and her encouragement of "non-subversive knitters" to knit and crochet "for the troops," knitting certainly can be about containment, tradition, and unequal gender relations.[31]

But what both sides of this argument do is to place knitting as an act of individual emancipation, largely disconnected from wider circumstances and unfortunately caught in unsettling a binary opposition between public and private—or more accurately, public space and domestic space—that has largely been made redundant by the consuming politics of neoliberalism.[32] Further, that which was connected with an errant notion of an essentialist womanhood, in that all women "naturally" knit, has become something that is privileged—now women *choose* to knit as a political stance. What I would like to do here is to draw out what I believe to be the powerful element of both Betsy Greer's and Stoller's arguments, that knitting *is* radical, to extend it into the economic spheres from which handcraft tends to remain apart.

To take a closer look, the resurgence of "feminine" knitting is in fact much more intertwined with the changing "masculine" economy than either those detracting from or supporting knitting as radical might be willing to admit. There is something relevant in the fact that workers from textile plants threatened with closure in North Carolina found themselves marching alongside activist knitters, environmentalists, and anarchists at protests against the World Trade Organization in Seattle in 1999. In those nations where the traditional textile industries have been hard hit by globalization, most notably Britain, the United States, and Canada, we see also the resurgence of crafting practice in wider society, the growing importance of textiles and craft in the global art world and market, and the explosion of research and development surrounding chemically or technologically enhanced fabrics—a series of occurrences that surely must be related.

Whether by accident or design, the latest round of textile activism follows the flight of capital from textile mills and apparel manufacturers in North America and Europe. Though mills continue to exist, the long-term decline of apparel production controlled by minutely detailed and infinitely complicated postwar agreements came to an end in 2005 with

the World Trade Organization's phasing out of Multi-Fiber Arrangement, a set of thousands of policies controlling the manufacture, import, and export of global textiles.[33] As activist (and more mainstream) knitting groups began gathering in North America and Europe, the textiles industry in those same countries was very visibly entering a sharp downturn, with hundreds of thousands laid off, and hundreds of mills silenced.

What came to the public eye as anti-sweatshop actions staged at college campuses throughout the 1990s had deeper and more widespread causes linked to changes in the global textile economy.[34] The complication of this becomes apparent as negotiations at the World Trade Organization to purportedly "level the playing field" and encourage the development of textile industries in the developing world results in the economic conditions that saw both unionized North American textile workers and activist and anarchist knitters take to the streets. With losses in the U.S. textile and apparel industry alone threatening to reach up to 600,000 jobs, and the British textile industry shrinking by 40 percent between 1994 and 2004, the hyperbolic protectionism of union activists cannot help but seem connected, in a larger sense, with the resurgence of public knitting—the last gasp of a seemingly lost domestic textile industry.[35]

Thus, there is a flip in the activism around these issues, for when the exhibition "Feministo" was greeted in the late 1970s with derision for its use of textile work to challenge the art system (in one location a sign reading "Not Suitable for Children" was hung on the door),[36] when Judy Chicago and Joyce Wieland took on the art world, and when activists wove themselves into the fence at Greenham Common, what they shared in common was the ability to make use of a set of shared societal perceptions about the practice of knitting. Though this remains the case, there is always a certain nostalgia in current references, an idea that no one knits anymore—hence the use of grandmothers as a central symbol in many of the sentiments used to dismiss (and acclaim) activist knitters.

When the radical feminist Trisha Longdon wrote in 1983, "At Greenham we aren't [perceived as] shrill, aggressive, short-haired, man-haters but peace-loving, idealistic givers of life,"[37] she was criticizing what she felt was a refusal of the protesters at Greenham Common to "name [their] own oppression as women," preferring to be "co-opted into male struggles" by placing a short-term dispute over nuclear disarmament ahead of the wider project of women's liberation. By contrast, two and

a half decades later, the reporter Tanis Taylor wrote in the *Guardian*: "Our ancestors may have crafted because they had to; women today craft because they want to. Because eight hours in front of a console has left us with a yen to make things and we're tired of buying more generic 'stuff' when we can make it or support female-run cottage industries instead."[38] The difference is one of goals and aims, with Taylor drawing on the rhetoric of feminism's contemporary third wave to suggest an agency and choice in crafting that for Longdon is profoundly tied up in the limits of patriarchal society. In this, though the work of 1970s and 1980s feminists might be seen as similar, there is a fundamental difference, one that I suggest is linked to the changing economics of global capitalism.[39]

In bringing back the question that I asked at the opening of this chapter—is it possible that the way that knitting, embroidery, and quilting are used to make political change in some spheres requires their subjugation in others?—I turn to the changing role of feminism in activist knitting. Could it be that the dismissal of domestic arts by radical feminism in the 1970s through the 1990s opened the door for their incorporation into the mainstream (while also leaving that door closed just enough that they might still play a role in radical actions)? In the late 1970s, Lucy Lippard noted of women artists, "'Female techniques' like sewing, weaving, knitting, ceramics, even the use of pastel colors (pink!) and delicate lines . . . were avoided by women. They knew they could not afford to be called 'feminine artists,' the implications of inferiority having been all too precisely learned from experience."[40] Thirty years later, what was an outwardly trenchant hierarchy has seemingly disintegrated as craft-practice now plays an increasingly important role in the contemporary art world and art market. As addressed in the introduction to this volume, as growing numbers of art biennials mark the global cities to which curators and the art paparazzi trek, the number of art stars using textiles has exploded, the most notorious among them the British artist Tracey Emin, whose quilts and embroideries were, for a time, the center of the global art, fashion, and party world.[41] Such a turn of events, I suggest, is not only connected to the notable successes of female artists but can also be seen as tied to a changing context: the move of textile industries away from traditional centers in the West, the dismissal of textile and handwork by the feminist movement, the fact that sewing, knitting, and embroidery are no longer taught in the home, and the belief that any essentializing notions of gender that might

underlie the dismissal of "feminine" arts are now themselves under attack. And let us not forget the politics of the art world itself.

Julian Stallabrass, in his book *Art Incorporated*, makes the persuasive argument that in spite of its political veneer and daring novelty, contemporary art is intimately connected with the speculative logic of finance capital—"free trade" and "free art" are not antithetical.[42] Stallabrass writes that "globalization has transformed the art world along with the management of racial and cultural difference to follow the model of corporate internationalism."[43] Visibility in the realm of culture is no guarantee of political power, and the increasing privatization of cultural institutions erodes the influence that might once have flowed from that visibility. Instead, diversity is normalized while its critical content is sidestepped. This creates an equation, then, where the feminist politics that might be at work in Emin's sexually explicit embroideries is welcomed as part of an affectless and depoliticized regime where image—the perception of power—trumps any real change. It is a compelling argument, bolstered by the ambiguous engagement with the political ramifications of the art world by those who have most benefited from it. Tracey Emin, for example, writes that she has no interest in the feminist politics of embroidery—she does it because "she's good at it."[44] Add to this the properties of textiles that make them such an apt metaphor for capitalism—fluidity, flexibility, the interwoven—certainly all catchphrases of the new economy, and the incorporation of craftwork into the global art world seems already to be entirely compromised, with no room for any resistant interpretation. The eclipse of identity politics that I argue made the resurgence of knitting possible also made its incorporation into an apolitical art world a fait accompli.

Nevertheless, Stallabrass's argument assumes a rampant contemporaneity in the art world, as if the works produced by such artists are not haunted by their passages through time and space. Emin's own politics might be ironically disengaged, but whether she wants to or not, she drags with her into the gallery the ghosts of textile artists and workers who preceded her and who were shut out of those same vaunted establishments. Take also the more complicated cases of artists who use textiles for specifically political purposes, many of whom are discussed at length elsewhere in this volume. In the work of artists such as Barb Hunt of Canada and Maria Porges of New York, antiwar statements are made through the juxtaposition of the softness and warmth of wool with the form of bombs, guns, and landmines. Both artists knit or felt

weaponry out of pastel-colored wool.[45] The Toronto artist Barbara Todd makes quilts out of suit fabric in the shape of fighter jets to demonstrate the links between capitalism and the military, while the Dutch artist Marianne Jørgensen organized a collaborative project to make a bright pink tea cozy for a military tank (see fig. 2), again contrasting the weaponry with the familiarity and safety of the knitted wool. The New York artist Lisa Anne Auerbach has organized a number of events and works, including the communal knitting of "body count mittens" and a series of detailed knitted clothing and dresses that reflect on current events, such as a sweater juxtaposing the infamous image of a hooded Abu Ghraib prisoner with the text from a speech made by George W. Bush (see fig. 3).[46]

Meanwhile, the artist Margarita Cabrera creates soft sculptures of domestic appliances made in the maquiladoras in Mexico, the accessibility of the works inviting viewers to ask more about their underlying political intent and the parallel of handwork in both the manufacturing of her sculptures and the electronics made in the border factories.[47] Knit Knit's Sabrina Gschwandtner draws on historical references in her *Wartime Knitting Circle*, an installation that combines nine machine-knitted blankets showing images of past uses of knitting during war as a backdrop to a space where the public can work collaboratively on wartime knitting projects and discuss the war in Iraq (often from diverse political perspectives).[48] The group Microrevolt (see fig. 3 in Betsy Greer's essay) makes freely availably plans for individuals to knit their own corporate logos to draw attention to sweatshop labor, while thousands of participants in the Wombs on Washington project knit womb patterns circulated over the Internet, which placed heaps of knitted wombs on the United States Supreme Court steps in support of prochoice legislation. Similar group actions include the Red Sweaters Project, which asks participants to knit a tiny red sweater for each soldier killed in Iraq, and the I Knit UK Knit a River project, which collected enough squares to knit a blue river that could be transported through the streets to draw attention to protecting water resources and creating accessibility for those without (see fig. 4).[49]

In making these points, I do not intend to take away from the success of these works nor to suggest that craft-based art does not have a place in the art world. What does interest me, however, is the (often hidden) legacy of both identity politics and the anti-sweatshop movement in a number of these works. In many of these projects, as well as in the ac-

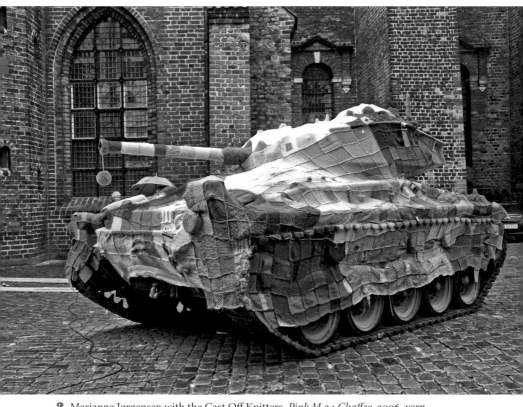

2 Marianne Jørgensen with the Cast Off Knitters, *Pink M.24 Chaffee*, 2006, yarn, thread. Photo: Barbara Katzin.

3 Lisa Anne Auerbach, *Warm Sweaters for the New Cold War*, Steal This Sweater project, 2006, yarn, knitted on a Passap e6000 knitting machine.

tions of the radical knitters and the Stitch 'n Bitchers, there is a sophisticated understanding that the making of any textile is connected to the capitalist system (no matter how tangentially), something that was not a central concern for the activists in the 1970s and 1980s. This understanding, which might seem secondary to the plans of activist knitters and artists, suggests an echo of the all-encompassing system of post-Fordist capitalism playing through many of these actions, which, as I have argued, may have profoundly (though discreetly) affected the acceptance of craft work into spheres from which it was previously unwelcome.

To illustrate, when Tultex, one of the largest apparel manufacturers in the United States, closed its plants in North Carolina, overseers mentioned not only the high cost of labor in North America but also the lack of sewing skills among female trainees.[50] Though this excuse overlooks the fact that other jobs in the plant required training and further assumes an equation between poverty and ability to make one's own clothes, Tultex's position is profoundly linked with many arguments that cover for the exploitation of cheap labor in the textile and garment-making industries. In this sense, it can be extrapolated that the availability of vast amounts of cheaply priced clothing in North America and Europe, arriving as a result of cheap labor, is indirectly responsible for the lack of sewing skill. There was simply no need to sew. This consumerist model contrasts sharply with the position found in many articles on radical knitting, that it was the women's liberation movement, most notably the work of Betty Friedan, that was responsible for the rush to

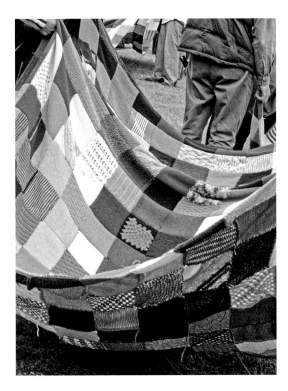

4 I Knit UK, one portion of the Knit a River (for Water Aid) project, May 2007. Photo: Kirsty Robertson.

leave the domestic sphere that began in the 1960s.[51] But surely, if the majority of women continue to refuse to be labeled as feminist, then the reasons behind an inability to sew or knit are inherently more complicated than many mainstream news articles on the resurgence of knitting would have readers believe. If the lack of interest in crafting in the 1990s is in fact more closely related to changes in the system of production and sale of cloth and garments than it is to radical feminism, then the actions of late-1990s and early-twenty-first-century crafters should be seen in a different light and potentially connected to the wider frameworks within which earlier activist crafters were working.

To summarize, I argue that the tentative opening of the art world to craft, that a resurgence in knitting and crafting, and that activism involving knitting are all connected to a shifting economy that has eviscerated the textile industry in North America and Europe, in turn creating conditions ripe for a revival of crafting practice. If this is the case, then I also suggest that actions at Greenham Common and earlier are deeply connected to the projects undertaken by activists today. It seems to me that only by making these links can the trivialization of women's work

that leads to seeing radical knitting as only radical in form be avoided, thereby overcoming seemingly inevitable erasure of this round of radical crafting. Further, because globalization and capitalism affect differently across lines of gender, and because protest is not always a form of dissent open to all, the work of activist knitting and other craft offers a rich promise and the ability to potentially connect across global north and global south divisions. And finally, in all facets of the alterglobalization movement, and across the myriad interpretations of activist knitting groups and textile artists, it should not go unnoticed that, eventually, the activists at Greenham Common won.

NOTES

1. Roszika Parker, *The Subversive Stitch: Embroidery and the Making of the Feminine* (New York: Routledge, 1989), 10.
2. See Janis Jefferies, "Textiles," *Feminist Visual Culture*, ed. Fiona Carson and Claire Pajaczkowska (New York: Routledge, 2001), 190–95, for a more in-depth description of these exhibitions.
3. Parker, *The Subversive Stitch*, 5–8.
4. For more on these artists, see Marie Fleming, ed., *Joyce Wieland* (Toronto: Key Porter, 1987); Joanna Inglot, *The Figurative Sculpture of Magdalena Abakanowicz: Bodies, Environments, and Myths* (Berkeley: University of California Press, 2004); and Lucy Lippard, *Judy Chicago* (New York: Watson-Guptill, 2002).
5. David Fairhall, *Common Ground: The Story of Greenham* (London: I. B. Tauris, 2006); Beth Junor, *Greenham Common Women's Peace Camp: A History of Non-Violent Resistance, 1984–1995* (London: Working Press, 1995).
6. Quoted in Brook S. Mason, "The New York List," *ArtNet*, http://www.artnet .com/.
7. See, for example, Lisa Tickner's impressive text on the use of embroidery in the suffragette movement, *The Spectacle of Women: Imagery of the Suffrage Campaign, 1907–1914* (London: Chatto and Windus, 1987).
8. Marjorie Agosín, *Tapestries of Hope, Threads of Love: The Arpillera Movement in Chile, 1974–94* (Albuquerque: University of New Mexico Press, 1996); Carol Becker, "Amazwi Abesifazane," *Art Journal* (winter 2004): 116–34; Susan S. Bean, "Gandhi and *Khadi*: The Fabric of Indian Independence," *Cloth and the Human Experience*, ed. Jane Schneider and Annette B. Weiner (Washington, D.C.: Smithsonian Institution Press, 1989), 355–76; Joseph E. Inikori, "Slavery and the Revolution in Cotton Textile Production in England," *Social Science History* 13, no. 4 (winter 1989): 343–79; Randall M. Miller, "The Fabric of Control: Slavery in Antebellum Southern Textile Mills," *Business History Review* 55, no. 4 (1981): 471–90. See also the Yes Men's account of their intervention at the "Textiles of the Future" conference in 2001, "Beyond the Golden Parachute," http://www.theyesmen.org/.
9. Sadie Planthas connected the history of weaving and knitting with that of computer programming. Tracing the history of the personal computer back to the punch cards of the Jacquard loom, Plant argues that a female history connecting

the zeros and ones of binary codes with the Ps and Ks of knit stitches has been largely erased in the effort to see technology as masculine. Sadie Plant, *Zeros and Ones: Digital Women and the New Technoculture* (London: Fourth Estate, 1997).

10. An entire debate over the "end" of identity politics and the future of capitalism and knowledge production is collapsed into this sentence. See, for example, Susan Buck-Morss, *Thinking Past Terror: Islamism and Critical Theory on the Left* (London: Verso, 2003); Susan Buck-Morss, "Visual Studies and Global Imagination," *Papers of Surrealism* 2 (summer 2004), http://www.surrealismcentre.ac.uk/papersofsurrealism/index.html; and Gavin Butt, *After Criticism: New Responses to Art and Performance* (Oxford: Blackwell, 2005). See also Coco Fusco's vehement critique of the disappearance of identity politics for a different perspective: "Questioning the Frame," *In These Times*, December 16, 2004, http://www.inthese times.com/.

11. Kirsty Robertson, "Tear Gas Epiphanies: New Economies of Protest, Economy and Vision," PhD diss., Queen's University, 2006.

12. "Revolutionary Knitting Circle," *Revolutionary Knitting Circle*, http://www.revolutionaryknitting.ca.

13. For more on the pollution created through the manufacture of textiles, see Kate Fletcher, "The Circle of Life: Eco-Textiles: The Past, Present and Hopes for the Future," *Selvedge* (January 2006): 33–39.

14. "Microrevolt," *Microrevolt*, http://microrevolt.org; and Revolutionary Knitting Circle, *Revolutionary Knitting Circle*, http://www.revolutionaryknitting.ca.

15. Charlotte Higgins. "Political Protest Turns to the Radical Art of Knitting," *Guardian* (online), January 31, 2005, http://www.guardian.co.uk/.

16. Lorraine Frankish, "Reply Letters and Emails: Purl One, Drop One against the Bomb," *Guardian*, August 2, 2008, 35.

17. Ibid.

18. See Fairhall, *Common Ground*.

19. Lynn Alderson, "Greenham Common and All That . . . A Radical Feminist View," *Breaching the Peace: A Collection of Radical Feminist Papers* (London: OnlyWomen, 1983), 11.

20. Barbara Harford and Sarah Hopkins, *Greenham Common: Women at the Wire* (London: Women's Press, 1984).

21. The changing role of copyright as it applies to the world of craft making, particularly in terms of the protection of patterns, designs, and techniques, is beyond the scope of this essay. Increasingly, the community spirit of crafters, as exemplified by publications such as *Stitch 'n Bitch*, is challenged by a competing need for practitioners to protect their work and designs. As copyright legislation becomes increasingly tight under intellectual property regimes, this division threatens to grow exponentially. See "The Alice Chronicle," December 17, 2002, *The Girl From Auntie* blog, http://www.girlfromauntie.com/journal/; Free to Stitch, *Free to Stitch Free to Bitch*, http://www.freetostitchfreetobitch.org/info.htm.

22. For a more in-depth account of Betsy Greer's thinking on this matter, see her master's thesis, "Taking Back the Knit: Creating Communities via Needlecraft," Goldsmiths College, University of London, 2004.

23. Ibid., 11.

24. Michelle Padgette, "Changing Gender Roles and Knitting," *University News* (Dallas), April 25, 2007, http://media.www.udallasnews.com/.

25. Quoted in Janelle Brown, "Do It Yourself," *Salon*, May 2, 2001, http://www.salon.com/. Knitting in public, for example in classrooms, was an important tactic of the women's liberation movement.

26. Tonya Jameson, "Nesting Urge Won't Remove Cause of Fears," *Charlotte Observer*, March 23, 2003.

27. Ibid.

28. Ibid.

29. Germaine Greer, "Making Pictures from Strips of Cloth Isn't Art at All—but It Mocks Art's Pretentions to the Core," *Guardian*, August 13, 2007. Greer's dismissal of handcraft is made in an article on the work of the patchwork artist Edrica Huws where Greer makes an argument for the uselessness of craft in order to show how such textile art might undermine the pretensions of an art system. The article prompted extensive discussion on blogs and websites.

30. Germaine Greer, "Why Women Don't Relax," *Guardian* (online), May 4, 2006, http://www.guardian.co.uk/.

31. Michelle Malkin, "'Subversive Knitting,'" February 7, 2007, http://michellemalkin.com/.

32. For more on the collapse between public and private, see Lisa Duggan, *The Twilight of Equality? Neoliberalism, Cultural Politics, and the Attack on Democracy* (Boston: Beacon, 2003).

33. Jane L. Collins, *Threads: Gender, Labor and Power in the Global Apparel Industry* (Chicago: University of Chicago Press, 2003), 28–66.

34. Naomi Klein, *No Logo* (New York: Picador, 1999).

35. "Multifiber Agreement," *Selvedge* 5 (April–May 2005): 9.

36. Rozsika Parker, "Portrait of the Artist as a Housewife," *Spare Rib* 7 (1977): 5–8.

37. Trisha Longdon, "Greenham Common," *Breaching the Peace: A Collection of Radical Feminist Papers* (London: Onlywomen, 1983), 16.

38. Tanis Taylor, "The Nigella Effect: Is Craft a Radical Re-Evaluation of Women's Skills or Is It a Slap in the Face of Feminism?" *Guardian*, December 8, 2007, 70.

39. Nevertheless, recent work might find its predecessor in that of Margaret Harrison, whose *Homeworkers* (1975), shown in the exhibition "Women and Work: A Document on the Division of Labour in the Industry," traced the deskilling of female labor through the display of three doilies—one handmade, another photographed, and a third painted, tracing the production of cheap doilies made by women in factories and then sold back to them (Jefferies, "Textiles," 192).

40. Lucy Lippard, "Household Images in Art," *From the Center: Feminist Essays on Women's Art* (New York: E. P. Dutton, 1976), 56–57. Reprinted from *Ms*, March 1973.

41. Julian Stallabrass, *High Art Lite: British Art in the 1990s* (London: Verso, 1999).

42. Julian Stallabrass, *Art Incorporated* (Oxford: Oxford University Press, 2004), 4–5.

43. Ibid., 70.

44. Harriet Zines, "Andy Warhol/Tracey Emin/Adolph Gottlieb," *NYArts*, December 2002, http://nyartsmagazine.com.

45. Kirsty Robertson, "Capturing the Movement: Affect, Anti-War Art and Activism," *Afterimage: The Journal of Media Arts and Cultural Activism* 34, no. 1–2 (fall 2006): 27–30.

46. Lisa Anne Auerbach, "Lisa Anne Auerbach," http://www.lisaanneauerbach.com.

47. Shu Hung and Joseph Magliaro, eds., *By Hand: The Use of Craft in Contemporary Art* (New York: Princeton Architectural Press, 2007).

48. Sabrina Gschwandtner, *Wartime Knitting Circle*, in Radical Lace and Subversive Knitting, Museum of Art and Design, 2007.

49. I Knit, Knit a River, http://www.iknit.org.uk; Red Sweater, http://www.redsweaters.org; Wombs on Washington, http://www.wombsonwashington.org.

50. Collins, *Threads*, 172.

51. Betty Friedan, *The Feminine Mystique* (New York: Norton, 2001); Stephanie Wilson, "Knitting Is the New Rock n' Roll Baby!" *Arthur*, November 22, 2004, http://www.treantarthur.info/.

Anthea Black and Nicole Burisch

Craft Hard Die Free

RADICAL CURATORIAL STRATEGIES FOR CRAFTIVISM

hile craft historians, feminist historians, and fine craft practitioners argue for the recognition of craft within art and academic dialogues, craft supplies are simultaneously mass produced and packaged as hobby commodities for affluent consumers, and craft practices are appropriated into the mainstream marketing of alternative and DIY lifestyles. In addition, the accessibility of global communication networks has contributed to the increased sharing of craft knowledge and skills and has created an overall democratization of crafting practices. This current academic and popular interest in craftivism calls for a discussion of productive strategies to maintain its radical potential.

This interest is focused in particular on those practices that defy tidy classification or that straddle traditionally constructed distinctions between art, craft, curatorial, and activist practices. Craftivists and artists who use politically engaged crafting methods continue to hybridize their practices by joining craft, technology, the politicization of digital space, public spaces, and traditional arts venues. Many of the examples and perspectives explored in this essay emerge from our experience as artists and curators within Canadian artist-run culture.[1]

Politically engaged crafting practices and many contemporary curatorial approaches share a common ability and imperative to challenge the dominant economies in which they are situated. While these approaches generally do not seek legitimacy within mainstream economies or spaces of display, this radical activity continues to be commodified into corporate and insti-

tutional cultures. Radical curatorial strategies that deliberately blur the boundaries between artist, crafter, and curator are of particular interest here, as are their locations within the network of Canadian artist-run centers, where artists, activists, and crafters are often employed as administrators, programmers, and curators. In such sites, we argue, craftivism can be riotously, ethically, and effectively included in—and used to redefine—contemporary curatorial strategies and can contribute to a politicization of these spaces and cultures of display.

As the essays in this volume make clear, the perception of the crafted object as old-fashioned or traditional has now been eschewed in favor of crafting as a strategy to examine and challenge contemporary issues. Rather than viewing craft as preindustrial, current craftivist practices are situated within the challenges of urbanity, globalization, and capitalism in a postindustrial, technology-saturated world. The proliferation of craft on the Internet and in the gallery is further evidence of shifting views on appropriate technologies and spaces for the exchange and contextualization of craft. Diverse spaces, approaches, and materials now exist alongside each other in the maker's political tool kit as effective strategies for sharing skills, techniques, and information.

SURVEY OF PRACTICES

The rise of craftivism and other politically engaged crafting practices—which value the radical potential of a particular craft activity rather than its finished end-product—shift traditional emphasis away from polished, professionally made craft objects themselves and toward a political and conceptual focus, positioning, and deployment of the work involved in making them. This emphasis has made room for reconsiderations of crafts(wo)manship, performativity, mindfulness, tacit knowledge, skill sharing, DIY, anticapitalism, and activism.

In an expanding and diverse field of craftivism, the extraordinarily transformative NAMES Project AIDS Quilt can be seen as an early craftivist precedent. In "Naming Names," Peter Hawkins's celebration and critical discussion of the AIDS quilt offers a comprehensive survey of the contradictory and sometimes problematic ways in which the project is deployed, read, and understood as a politicized craft object.[2] It should be noted that the concerns around the project—particularly around its commodification and its exclusion of people of color and the working class—recur in contemporary forms of craftivism.[3] Despite the project's inability to represent all the aspects of AIDS, and despite

the overwhelming growth and cost of displaying it, the political impact of the quilt continues to occupy a prominent space within mainstream America's awareness of AIDS.[4]

For the founder of the project, Cleve Jones, the tradition and formal qualities of quilting were important links to "comfort, humanity and warmth,"[5] and despite the use of traditional media, the quilt is assembled as a collaged, nonhierarchical mix of quilting styles, skill levels, and aesthetics.[6] The NAMES Project Quilt employs what has come to be a common craftivist method of group making, where each participant contributes one panel to be assembled together into a diverse, collaborative whole.[7]

THE REVOLUTIONARY KNITTING CIRCLE

Calgary's well-known Revolutionary Knitting Circle and other radical crafting groups effectively include the sharing of tacit knowledge in their emphasis on teaching knitting, quilting, or crafting skills in a collaborative or workshop-based environment. The interactions and discussions that take place during group knitting also act as an accessible forum for teaching, sharing, and promoting activist strategies and politics. The Revolutionary Knitting Circle manifesto advocates knitting (and other crafts) as constructive and nonviolent tools for opposing the dominant corporate models of production.[8]

The group also participates in marches, rallies, and protests by conducting group "knit-ins" or by carrying the large, cooperatively knitted Peace Knits banner (see fig. 1). The public knit-ins and the banner serve as peaceful and accessible rallying points for action, discussion, and awareness. The banner is an overtly collaborative project that emphasizes a multiplicity of voices and the democratization of its making. It has something of an intentional anti-aesthetic: the individually knitted panels of thrifted and donated yarn speak to its cooperative construction and its multiple creators.

It is in the act of knitting peacefully in public groups or of carrying the knitted banner that the true revolutionary strength of this group's activity lies. In the text for the exhibition "SUPERSTRING," the curator Anthea Black notes that "it is the simultaneous unruliness and gentleness of public knitting—when a large group of knitters occupies a public space or a place of power with a non-violent action—that creates a constructive dialog."[9]

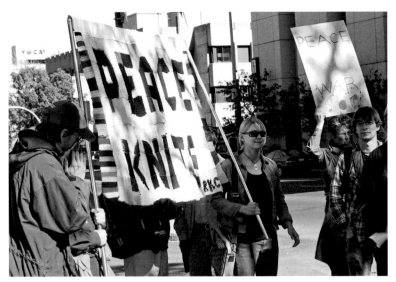

1 Peace Knits banner at the International Day of Action to End War on Iraq, September 24, 2005. Photo: Grant Neufeld.

MARIANNE JØRGENSEN AND THE CAST OFF KNITTERS

Similarly, the Danish artist Marianne Jørgensen's *Pink Tank* project (see figs. 2 and 3) directly situated the collaborative work of crafters and activists within a public space. The artist collaborated with the Cast Off Knitters group and several knitters from around the world to knit and assemble over four thousand squares into a covering for a World War II–era combat tank as a protest against the current war in Iraq.[10] For this project, the Internet functioned as an important tool for spreading the word, recruiting new knitters, and sharing techniques and specifications. The tank was covered from the cannon to the caterpillar tracks with knitted and crocheted squares made with pink yarn.[11]

As Jørgensen has put it, "The main impression of the knitted tank is that it consists of hundreds of patches knitted by many different people in different ways: single colored, stripes with bows or hearts, loosely knitted, closely knitted, various knitted patterns." As such, it represents "a common acknowledgement of a resistance to the war in Iraq."[12] The project uses a democratic process where each contributor is able to knit her or his dissent mindfully. If the blanket is read as a petition, each individual panel of the blanket acts as a stand-in for a signature, but instead of a petition to be delivered pleadingly to a government elite, this gesture defiantly occupies public space.

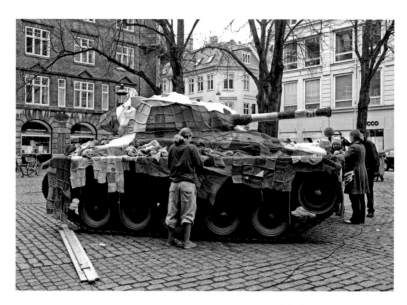

2 and 3 Marianne Jørgensen with the Cast Off Knitters, *Pink M.24 Chaffee* (in progress), 2006. Photo: Barbara Katzin.

The deployment of such a large blanket on such a threatening object in a public space may seem like a disarmingly absurd gesture, but the dramatic use of the crafted object to call attention to what is underneath creates a rupture in the ways in which the public interacts with the tank as a public war monument. The blanket gives the tank a physical presence, rather than a purely symbolic one. While addressing the pink tank

4 Barb Hunt, *antipersonnel*, begun in 1998. Installation view. Art Gallery of Ontario, collection: Agnes Etherington Art Center, York Wilson Endowment Award, Canada Council. Photo: Art Gallery of Ontario.

cover, Jørgensen relies on the contrast between the symbols of tank and blanket: "For me, the tank is a symbol of stepping over other people's borders. When it is covered in pink, it becomes completely unarmed and it loses its authority."[13] It links remembrance of war with our collective ability to reinterpret and affect it through public action, dissent, and dialogue.

BARB HUNT

Barb Hunt's series of knitted and stuffed landmines (see fig. 4) conjures similar associations, using the tension between the formal character of the crafted object and the political context in which it is considered. As part of her project to knit soft pink replicas of the more than 350 different antipersonnel landmines that exist, Hunt has researched the technical aspects of landmine construction and production and the devastating number of casualties that the mines claim each year. During the construction of each replica, she will "sit and knit for a few hours and enjoy it a lot, then suddenly realize that during that time about half a dozen people were injured or killed by a land mine somewhere in the world."[14] Many politically engaged crafters share this awareness of the paradox of linking sedentary leisure activity with political action, and like Jørgensen's pink tank, the knitted landmines are a stark contrast to the origi-

nal object, in both form and intent. Hunt's project "re-focuses attention on the value of small personal gestures that can accumulate into a declaration of caring and hope" and juxtaposes the mindfulness and time dedicated to a knitting project with the contemplation of "knowledge that is otherwise too difficult to bear."[15] In this way, Hunt highlights the usefulness of this labor in bringing politicized content into the gallery.

Unlike many craftivist works, Hunt's *antipersonnel* series is designed for the formal space of the gallery exhibition, where she reappropriates the conventions of museum display to enhance the possibilities for political engagement with the work (see fig. 5). While the objects may at first appear playfully soft and seductively crafted as part of a pristine institutional display, viewers recoil in horror as they discover the global context of the project through a booklet that is distributed as part of the work.[16] The booklet includes detailed information about landmines and their use worldwide (specifically implicating the countries that continue to manufacture landmines or that have not signed the Mine Ban Treaty).

In a museum or public gallery space, the conventional text would be written by an exhibition curator who would interpret the works on display in an accessible language. When *antipersonnel* was exhibited as part of the "Museopathy" project at the Royal Military College of Canada Museum, the work took on an additional layer of meaning. By including information about the political context of *antipersonnel*, the artist was able to use the institutional space—both the museum and the specific context of the military college—as a site for productive resistance. *antipersonnel* directly contradicts the ways that we tend to view works of art and craft and historical objects in gallery and museum spaces as timeless and apolitical.

WEDNESDAY LUPYPCIW'S HANDICRAFTS
FOR HANDICATS WORKSHOP

Craftivist practices share common ground with the DIY aesthetic and its political roots. Ideas concerning the use of craft practices as political tools are again circulating within the growing indie craft movement, where handcrafted (and often locally produced) items are championed as alternatives to mass-produced, globally distributed goods. The indie craft scene includes numerous approaches to making and selling handcrafted goods, as well as varying degrees of political engagement.[17]

The Calgary artist Wednesday Lupypciw uses a variety of craft-related materials and processes in her performance and video work to critique

5.1 and 5.2
Barb Hunt,
antipersonnel
(details).

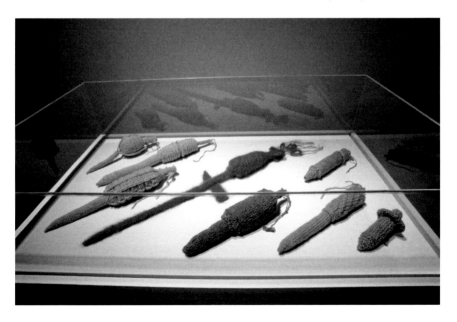

craft traditions as well as recent DIY and indie craft trends. In September 2006 she conducted a craft-based workshop for TRUCK, a Calgary artist-run gallery. Lupypciw's workshop took place in CAMPER (Contemporary Art Mobile Public Exhibition Rig), a converted motor home dating from 1979 and stationed in downtown Calgary (see figs. 6 and 7). Offering hands-on demonstrations in various craft techniques, Lupypciw's workshop exposed visitors to an array of crochet, hot-loops, pipe cleaners, plastic lacing, knitting, and craft projects, encouraging them to (re)consider the aesthetic, social, tactile, and visual potential of these materials. Lupypciw uses materials that are often considered more appropriate for hobby craft or kitsch, and through their use she calls into question the conventionally acceptable materials and outcomes for "fine craft" work.

As DIY and indie craft approaches continue to grow in popular appeal, the ways in which these objects and markets relate to contemporary cultures of craft consumption, display, and understanding are often overlooked. By focusing on the processes of crafting and the use of easily learned techniques, Lupypciw's workshop shifted emphasis away from the production of polished, completed, or functional craft objects (and the of positioning craft objects as saleable commodities). Lupypciw states: "I am interested in dissecting the contemporary DIY ethic with this project instead of being outright cynical about it. The 'IT' in 'Do It Yourself' literature is portrayed far too many times as a gorgeously photographed object, which creates an underlying competitive/consumer mentality."[18]

CONSUMING CRAFT

Throughout this survey of practices, we see that the key features of craftivism include participatory projects that value democratic processes, the use of various cross-disciplinary media, and an ongoing commitment to politicized practices, issues, and actions. Sustainable community-based activity and relationships are emphasized in the creation of politically engaged craft projects. The values and methods of craftivism are located outside of and used to critique both corporate and institutional cultures. However, as the handcrafted aesthetic gains popularity, it is increasingly being used within corporate marketing cultures as a way to affiliate their products with alternative lifestyles without any connection to the political/activist aims of these subcultures.

This may be true also of appropriation of craft into museum and in-

6 and 7
Documentation of Wednesday Lupypciw's Handi Crafts, Handy Cats workshop, 2006. *Left*: Lupypciw crafting; *right*, participant at work. Images courtesy of the artist and TRUCK Contemporary Art in Calgary. Photo: Christine Cheung.

stitutional contexts. Politically engaged crafting is now being presented in formal exhibition spaces such as major museums, national galleries, and educational institutions and is in turn being contextualized within the respective curatorial frameworks and marketing strategies of these institutions. The artist, writer, and performer Andrea Fraser's essay "A Museum Is Not a Business" is a prescient analysis of how the corporate model is applied to arts institutions. She suggests that the ways in which institutions are administered and governed have drastic impacts on curatorial autonomy. She cautions that "the political arguments against global corporate expansion apply to the art world as well—that despite the rhetoric associated with niche marketing, such expansion is producing an institutional monoculture that's destroying diversity."[19] This level of corporate involvement in culture, branding, and audience development initiatives is now often considered a necessary part of adapting to changing funding structures for nonprofit and public arts organizations. When the business model is applied to program development, emphasis is placed on defined outcomes and quantitative measures of the success of a project or exhibition—approaches that are a direct contrast to the values of politically engaged crafting projects. Alanna Heiss points out that "museums are, to a greater extent than alternative spaces, in the audience business, a business that often includes subsuming a work of art to the composition of a room or a theme."[20]

The broad appeal and accessibility of crafting practices is central in achieving the political aims of the craftivist project and presents interesting avenues from which to critique the institutionalization of public cultural organizations. However, Fraser charges that "critical discourse and the politics of democracy no longer appear to provide ready arguments against the corporatization of museums."[21] For public institutions with mandates to involve increasingly broader publics, curating new craft is often positioned as a way to tap into something of popular significance or interest and make the institution seem visionary and fresh. Exhibition press releases for new craft "blockbusters" presented at larger museums and public institutions would suggest that democratized and politically engaged craft works are indeed being recognized for their inclusive appeal.[22] Using these works to engage and develop new audiences, markets, and communities that might have previously been marginalized within the imagined publics of an arts institution shifts the value of the work away from the original practices.[23] This presents the potential for institutional appropriation, in which the institution or

persons working there stand to gain something (economic, social, cultural, or intellectual) by adapting the original context of the works for their own aims. The danger is that this shift in context can also result in the erasure of community identities or of the activist issues that these practices seek to address.

CURATORIAL STRATEGIES

Both craftivism and contemporary curatorial practices critique the mainstream economies that govern their respective disciplines. With the inclusion of craftivist works in these curatorial spaces, exhibitions and their venues must be considerate of the fact that craftivist practice is often deliberately situated outside of traditional approaches and models of presentation. Curators must work to preserve and communicate the original context in which craftivist objects and artworks are made to function. Maintaining curatorial dialogue with artists and activists is a key strategy for avoiding the ethical problems of institutional appropriation. The emphasis on dialogue and participation should be a prominent component of any exhibition that includes craftivist or politically engaged craft work and applies to each of the following strategies:

1. Provide unmediated opportunities for craftivists to speak about their practices and to disseminate information about the political context of their works.
2. Build opportunities for teaching/learning crafting skills, sharing knowledge, and participatory making in the exhibition.
3. Situate craftivist works within an organization that is truly committed to community-driven, structural changes.
4. Use printed matter, documentation, archiving, and diverse distribution networks as a means to preserve and distribute information.

Among the works in "SUPERSTRING," an exhibition at the Stride Gallery in Calgary, the Revolutionary Knitting Circle's Peace Knits banner became the flashpoint for a debate about the legibility of craftivist projects or actions within a gallery space (see fig. 8). As with many craftivist projects, the Peace Knits banner is primarily intended for use by the group in particular contexts of protest and public action and does not "require, or ask for, legitimacy within the art gallery system to be considered productive and politically charged."[24] However, in the context of the exhibition space, the banner was read and assessed as an art

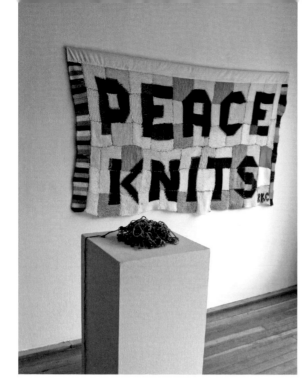

8 Revolutionary Knitting Circle of Calgary, Peace Knits banner, and Kris Lindskoog, *I want to do something nice for the planet*, in the "SUPERSTRING" exhibition at Stride Gallery, 2006. Courtesy of Stride Gallery, Calgary. Photo: Anthea Black.

object, particularly when considered alongside the other works in the gallery.

Yet including this work in the exhibition alongside those of other artists and crafters undermined the exclusivity commonly associated with fine art spaces, including artist-run centers, which admittedly—despite their history and mandates—have become institutionalized in many ways. The members of the Revolutionary Knitting Circle were also invited to host a series of knitting workshops within the gallery, opening up a space for discussion and action that might not have been possible with the display of the banner alone (see fig. 9). By providing space for communicating directly with the public, the workshop format enabled members of the group to speak about their work. These workshops also expanded the network of members of the Revolutionary Knitting Circle and allowed the group to mobilize new participants around issues of independent production, labor, and community building.

Both the Revolutionary Knitting Circle's workshops and Wednesday Lupypciw's practice place participatory making and process-driven approaches at the center of their activities. Their use of skill-sharing and hands-on demonstrations in publicly accessible spaces keeps the focus on the interactions and relational potential of craft making rather than

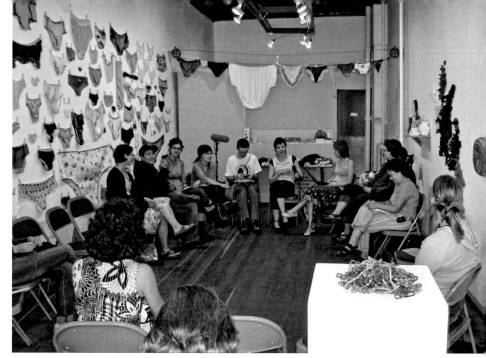

9 "Craftivism" panel discussion at Stride Gallery, August 5, 2006. Photo: Grant Neufeld.

on a passive relationship between viewer and object. Furthermore, the interactive format challenges the notions of solitary artistic work and the emphasis on a highly skilled individual creator. These approaches teach and encourage life-long and sustainable involvement with both crafting and activist practices and distribute the means for empowerment and creation to a broader circle of participants.

Situating craftivist works within an organization that is committed to community-driven, structural changes that address activist concerns is another strategy that can preserve the intent and spirit of the work and instigate political dialogue at an organizational level. Exhibiting craftivism in arts spaces also poses important questions about how these spaces can be used by activists as sites for affecting political and social change.[25] Collaborations between activist groups and arts organizations have the potential to counter the increased corporatization of public spaces and arts spaces alike by providing alternate methods of generating community support.

The artist-run working atmosphere functions simultaneously to critique and to exist as a parallel system to other cultural institutions such as museums and commercial and public galleries. This network of centers is well positioned to facilitate the presentation of craftivist works,

while maintaining their unruly manifestations and politicized contexts. Furthermore, the programming focus for many artist-run centers often emphasizes relational, performative, collaborative, and community-based practices as well as the skill sharing and workshopping of ideas, processes, and projects that are common to many craftivist methods. The staff and committees in artist-run centers are particularly well placed to respond to activist concerns: through their hands-on participation in programming, curatorial directive of the center, and interaction with the center's constituency of members on a day-to-day basis. Among the methods by which true institutional change is achieved, "activists identify concerns important to them to which a particular arts institution may respond."[26] Pressing dialogues that are seeking representation and voice within the center often are reflected through programming and operations that are responsive to community needs.

Exhibitions which extend their reach through the dissemination of printed matter, media, and Web-based resources ensure that politically engaged projects connect with a broad network and remain accessible outside the confines of institutional space. As part of the Pink Tank project, Marianne Jørgensen recruited collaborators using calls for submission, contact, and dialogue with Internet knitting groups. She documented the process of covering the tank with the completed pink blanket on video and displayed this documentation as an integral part of the exhibition. The video now functions as an archive of the intervention and can be exhibited, archived, or distributed separately to raise awareness about the project. All these methods extended the reach of the action and connected crafters, artists, and activists who share common goals to contribute their work to one unified project. Barb Hunt's installation *antipersonnel* also used printed matter to engage viewers beyond the scope of the exhibition, providing further information, reading, and resources with a call to action that encouraged the viewer to take action directly.[27] Maintaining an archived history of craftivist works is important, not only to document the process, objects, and exhibitions but also to serve as a resource for future projects and to preserve the history of this political action.

CONCLUSIONS

Radical approaches to curating politically engaged craft have the potential to suggest new ways of discussing, critiquing, making, exhibiting, deploying, and resituating these practices while preserving the vigor of

the maker's political intent. The organizational methods of craftivism offer new and productive spaces where practitioners create situations for their work outside of dominant institutional or corporate models: protests and marches, websites or Web-based exhibitions, zines collectives, workshops, and off-site events held outside traditional gallery spaces. These new spaces provide open and accessible channels for the creation of alternative economies, new communities, and creative investigation. Even as crafting practices and methods are commodified, these examples offer productive strategies for the exhibition of craft that challenge institutional systems. In turn, continued cross-pollination between the practices of craftivists and politically engaged crafters and the curatorial strategies of galleries, independent artists, crafters, and curators continues to build the pool of appropriate methods for the creation, display, and understanding of craftivist works. By maintaining and allowing for rigorous self-directed strategies within these sites where the critique of dominant arts economies and craftivist practices might cohabit, politically engaged practices will maintain their radical potential.

NOTES

1. Over its thirty-five-year history, the Canadian artist-run culture network has supported the development of new artistic practices, such as video, performance, and new media, and has fostered the development of hybrid curatorial practices.
2. Peter S. Hawkins, "Naming Names: The Art of Memory and the NAMES Project AIDS Quilt," *Thinking about Exhibitions*, ed. Reesa Greenberg, Bruce W. Ferguson, and Sandy Nairne (London: Routledge, 1996), 133–56.
3. Additional criticisms of the AIDS Quilt have included the historical association of quilting with repressed sexuality; the self-censorship and sanitization of queer identities; the fact that the majority of quilting work is carried out by women, yet they are not well represented within the memorialization of AIDS dead; the failure of the quilt to represent both the racial and socioeconomic diversity of communities affected by AIDS and the global AIDS crisis. "More irascible critics have found it 'whitebread,' maudlin, ingratiating, expensive" (Hawkins, "Naming Names," 149–50).
4. Ibid., 152.
5. Cleve Jones, quoted in ibid., 138.
6. Hawkins, "Naming Names," 138–42.
7. Kim Berman's Paper Prayer's project has involved thousands of arts and crafts practitioners, activists, service providers, and people living with or suffering losses from HIV/AIDS in South Africa in collective printmaking, papermaking, and embroidery workshops and creation of "paper prayers." This contemporary example of craftivism was inspired by the Names Project AIDS Quilt and has incorporated

collective methods, information sharing, skills teaching, and sustainable methods of generating income for local communities to instigate broad social change. Kim Berman, "Paper Prayers—A Strategy for AIDS Action in South Africa," paper presented at the "New Craft Future Voices" international conference, Duncan of Jordanstone College of Art and Design, University of Dundee, Scotland, July 4–6, 2007.

8. Grant Neufeld, "The Revolutionary Knitting Circle Proclamation of Constructive Revolution," Revolutionary Knitting Circle website, http://knitting.activist.ca/manifesto.html (visited January 23, 2007).

9. Anthea Black, exhibition text for "SUPERSTRING" (Calgary: Stride Gallery, 2006).

10. The project is one of many international craftivist efforts to protest the current war in Iraq. Some, such as Lisa Auerbach's *Body Count Mittens* in "The Workmanship of Risk" curated by Sabrina Gschwandtner, are ongoing personal projects by one person that blur the line between craftivism and a professional art practice. Others, like Sherri Wood's *Prayer Banner: REPENT* that depicts both the U.S. soldiers who have died in Iraq and every Iraqi citizen killed using tiny coffins and stitches alongside one another, are collaborative and participation-based projects like many of the examples we have cited above. Sabrina Gschwandtner, "The Workmanship of Risk: The Performance of Craft," *KnitKnit* 6, December 2005.

11. Marianne Jørgensen, "Pink M.24 Chaffee: A Tank Wrapped in Pink," Pink M.24 Chaffee website, http://www.marianneart.dk/.

12. Ibid.

13. Ibid.

14. Barb Hunt, "Re: antipersonnel story," e-mail message to Anthea Black, January 2007.

15. Ibid.

16. Ibid.

17. These practices range from independent studios or boutiques (like Smoking Lily), blogs, artist/crafter websites (like anti-factory.com), and home sales, to larger web-shops (e.g., Etsy.com), online listings (e.g., craftrevolution.com), and independent craft fairs (e.g., Renegade Craft Fair). Etsy.com http://www.etsy.com/; S. Blatt and K. Habbley, "The Renegade Craft Fair," Chicago, http://www.renegadecraft.com/holiday/about.html; Stephanie Syjuco, Anti-Factory http://www.stephaniesyjuco.com/antifactory/; Smoking Lily, Victoria, http://www.smokinglily.com/.

18. Wednesday Lupypciw, "Re: article for FFWD," e-mail to Nicole Burisch, September 11, 2006.

19. Andrea Fraser, "A Museum Is Not a Business: It Is Run in a Businesslike Fashion," *Beyond the Box: Diverging Curatorial Practices*, ed. Melanie Townsend (Banff: Banff Centre Press, 2003), 115.

20. Alanna Heiss, quoted in Clive Robertson, "Artist-Run Culture: Locating a History of the Present," *Policy Matters—Administrations of Art and Culture* (Toronto: YYZ, 2006), 13.

21. Fraser, "A Museum Is Not a Business," 117.

22. Recent exhibitions of politically engaged craft have foregrounded the agency

of the artist and the audience to different degrees. Some examples include "Radical Lace and Subversive Knitting" at the Museum of Art and Design in New York; "Common Threads" at the Confederation Centre of the Arts in Charlottetown; and "At Home" at the Rugby Art Gallery and Museum in England.

23. While the corporatization of public arts venues has progressed at particularly alarming speeds in the last fifteen years, the inclusion and appropriation of avant-garde, experimental, or politically engaged works into institutional spaces and the curatorial conundrums that they present are nothing new. Fraser's essay also charts the development of cultural activism, citing various media such as performance, site-specific installation, and relational practices as evidence of its tenuous relationship with institutional spaces (Fraser, "A Museum Is Not a Business," 118–19).

24. Black, exhibition text for "SUPERSTRING."

25. Even the ability of the "SUPERSTRING" exhibition to make room for institutional change within the artist-run community in Calgary was limited by the dominant economies in which it exists: the gallery is a nonprofit organization that relies on government grants, public funding, and a small number of business sponsorships available to arts and culture organizations. When introduced with the idea of involvement with the Calgary Dollars alternate economy (which several Revolutionary Knitting Circle members also use) as part of the gallery's membership structure and fundraising efforts, the limited financial agency of the artist-run center and nonprofit culture made it difficult to use this grassroots currency within the smooth functioning of the organization. We see here that while artist-run centers are invested in and mandated to program politically charged artworks, dominant economies may also prevent them from incorporating activist ideals into their operations structures.

26. Chris Creighton-Kelly, "Bleeding the Memory Membrane: Arts Activism and Cultural Institutions," *Questions of Community*, ed. Daina Augaitis et al. (Banff: Banff Centre Press, 1995), 96.

27. Barb Hunt, "*antipersonnel* booklet," information book exhibited in "Museopathy" at the Royal Military College of Canada Museum (Kingston: self-published, 2001–).

Janis Jefferies
.

Loving Attention

AN OUTBURST OF CRAFT IN CONTEMPORARY ART

CRAFT: This name is given to any profession that requires the use of hands, and is limited to a certain number of mechanical operations to produce the same piece of work, made over and over again, I do not know why people have a low opinion of what this word implies; for we depend on crafts for all necessary things in life.
—Diderot, *Encyclopedia* (1751–80)

The idea of making something by hand, drawing on learned and tacit skills, is providing a rich stream for invention and play, ritual and performance. For many contemporary artists, "Lovecraft," a group show dedicated to "craft's loving attention and its application in contemporary visual art,"[1] threw down the gauntlet. This particular show marked a perceptible shift in valuing how craft was beginning to play a leading role in the significance of the handmade object within contemporary art practice. As the critic Gemma de Cruz stated in 2000, the "outburst of craft being incorporated into painting and sculpture, came not as an alternative but as a new component forcing itself to be accepted."[2] Qualities such as attention to detail, bordering almost on the neurotic, and the obsessive nature of the making process were played out in several exhibitions between 1997 and 2007. What sets apart many of the works in these exhibitions and their curation is an investment in process and attention to many newly learned, perfected techniques that often involve the active participation of and collaboration with the audience.

This essay will focus on exploring the significance of the way in which materials and craft-based processes have been used

conceptually and creatively in such recent exhibitions. Here materials are at the center of a wrestling match between ideas of craft and creativity, played out against a backdrop of leisure activities and hobbies in which popular notions of craft and labor define the language of "makeover" and home improvement television programs, where the domestic DIY fashion is characterized by macramé plant holders, shag carpets, and rag rugs. In these exhibitions, traditional modes of craft reproduction are critiqued or subverted or play with our expectations of genre and experience.[3]

BEGINNINGS AND ENTRY

In the 1980s and early 1990s most writing about the crafts within cultural discourse in England tended to be dominated by two people: Peter Fuller and Peter Dormer, though many feminist practitioners and theorists, including myself, argued against them.[4] Both Fuller and Dormer, in their different ways, asserted that the prime role for the crafts was to safeguard skill. For Dormer, the revival tended to be based on certain readings of English history, using evidence of an aesthetic that was heavily nuanced with moral imperatives.[5] In my view, Dormer's views had little to do with historical fact but rather more with nostalgic reinventions which relied heavily on the ghosts of Arts and Crafts pioneers John Ruskin and William Morris. Fuller also drew heavily on these writers and polemically argued, more than once, that the crafts were primarily rooted in Christianity, part of the symbolic order and expressive of traditional and conservative values.[6]

Christopher Frayling and Helen Snowdon opened up the arguments in a series of essays first published *Crafts* magazine in England throughout 1982. One of the essays relevant here is "Skill: A Word to Start an Argument With."[7] The word *skill*, wrote David Pye in 1968, excluded any reference to "know-how" and instead placed an emphasis on dexterity, mindful of a distinction between manual and mental skill.[8] *Skill*, like *craftsmanship*, became "a word to start an argument with"—an argument that enabled Fuller to call for the learning, mastering, and repetition of perceived timeless skills for the production of good objects. Taking a cue from Fuller, Dormer worried that craft blurred with art produced self-absorbed and self-referential objects removed from function and communal rules. Historically, the generic category of craft was used to gather the well-made, the hand-made, the precious, and the special. From the 1970s, however, craft was considered a cozy, hand-spun

amalgam of brown bread recipes, domestic bliss, macramé potholders, kaftans, and cork sandals—a hangover from the 1960s, full of paradoxes and contradictions. Liz Hoggard, a prominent UK journalist, suggested that craft conjured up images of country folk eating mung beans and recalling the summer of love.[9]

No more. Craft has become the new cool, the new collectible: a rebellion against high-street branding and mall sameness alike, against the globalization of labor exploitation and consumer indifference. In contemporary art, handmade, tailor-made, personalized marks of individual expression and personal statement collide in an excited array of "crafted" and narrative-rich works with a fleshy affection for utopian ideals. When Joseph Beuys said "Everyone is an artist" he did not mean that everyone could make art, or indeed craft, in the traditional sense, but that everyone had the capacity to make meaning out of the art process by participating in that process—a philosophy that I think well-known artists such as Tracey Emin and Grayson Perry have popularized in the twenty-first century. Tracey Emin disclosed her embroidery skills through tents, beds, and quilts as an essential core of her autobiographical confessions that have spoken directly to women's experience. Arguably, it has been Grayson Perry—the outspoken, crossdressing artist whose pottery and stitching revel in the media's domestic and feminist histories, even as the work addresses narratives of child abuse and sadomasochism—who has shifted ideas about what is a "fine artist" by embracing the eccentricities of the hobbyist. He has replaced the obsessive prudery of the country potter with a provocative, explicit sexual, corporeal zest. Something of a celebrity speaker and T V presenter, Perry is also a curator who explores folk traditions through exhibitions like "The Charms of Lincolnshire," a marvellously spooky foray into life in Victorian England, arranged according to themes such as death, religion, and folk art.[10] Hanging with a group of his own embroidery samplers bearing pious sentiments rendered in his own flamboyant manner (Perry also designed a ubiquitous tea towel that served as an exhibition souvenir), the whole invoked a bucolic cliché of the National Trust England while also suggesting that the biscuit-tin idyll of cozy-village Britain—I can sense a wonderful argument here between Perry and Dormer and Fuller, if only the last two were alive now—is now long in the past. It is as if the graffiti sprayed under the sign for Vivienne Westwood's and Malcom McLaren's pioneering punk cloth-

ing shop Sex—"Craft must have clothes but truth loves to go naked"—
has magically come to life.[11]

As the essays in this volume make abundantly clear, the categories of
"art" and "craft" have never been immutable. On the contrary, Howard
Becker's useful book *Art Worlds* shows how materials, practices, and
practitioners migrate across agreed-upon art/craft boundaries from
time to time, often to settle permanently, as in the case of the potter/
stitcher Perry, or the painter/stitcher Michael Raedecker, or Emin and
her sexually explicit embroidered blankets.[12] This assessment acknowl-
edges the challenges to accepted practices and definitions that such mu-
tations involve and the consequences that flow from them: cultural en-
counters and interactions of tension and conflict; dialogic engagement
between those whose practices emerge out of different cultural fields
and political orientations; the productivity of hybrid forms of creativity.
Hybrid is a useful yet slippery category, as it can be purposefully con-
tested and deployed to claim change. Whereas Fuller and Dormer can
be cited as exemplars of preserving a nostalgic form of "traditional sur-
vivals," mixed in a "new world of hybrid forms," the conventional oppo-
sition between tradition and hybrid, art and craft is problematic in the
context of exploring ideas of creativity and transformation.[13]

What I would like to celebrate in this essay is the everyday creativity
that spans all sectors of community across the social and cultural land-
scapes of contemporary life. The 1998 Sydney Biennial held at the New
South Wales Museum and Art Gallery, titled "Every Day," included work
that explored the conceptual possibilities of cloth, basketry, and glass,
bringing together the use of material and processes, not for practical
purposes but as an indication of sites of practice and the "social biog-
raphy of things."[14] Craft media and processes were conjoined with "art,
which seeks to heighten our senses to the proximity of the marvelous,
to find significance in commonplace signs."[15] The objects that might ap-
pear to be commonplace have a history of particular times and places:
the domestic space of childhood clutter and lovers' mantelshelves,
charity shops and car boot sales seduces me, at least, into intimate sce-
narios of memory and reminiscence.

While such sentiments may be considered the stuff of folklore and
the folksy, they are central to the curatorial strategies of Jeremy Deller,

winner of the Turner Prize in 2004, whose work I will discuss more extensively later. He believes that an engagement with the commonplace triggers the love of objects and the making of things, whether directly made by hand or refashioned personalized crafting.[16] It is this quality of attachment and belonging to a thing, and the ways that a thing and these qualities are exchanged between one person and another, that moves and helps us move on: during difficult times of loss, such as funerals; or at moments of hysterical laughter, when a mother gets out the stitched sampler of the good girl of her war-torn childhood; or when I produce my embroidered hippie and act-of-rebellion charity shop clothes as exemplars of the antimaterialistic fashion of my own coming of age. Crafting, decorating, and imbuing a material object can be an embodiment, a sign of personal knowledge, and it can give form to our own stories and memories. The acts of binding, knitting, and tying are the means of piecing together that which has been broken and cut.[17] This is also what connects craft to the work of narratives, as both weld disparate elements to memory and to the construction of what we would call the self. The idea of the everyday, the commonplace, and the processes by which we make and tell stories about our experiences of objects and the making of things within a relational cultural biography recalls another of David Pye's prophetic insights from 1968: "It is high time we separated the idea of the true amateur—that is to say the part-time professional—from the idea of 'do-it-yourself' (at its worse end) and all that is amateurish. The continuance of our culture is going to depend more and more on the true amateur, for he alone will be proof against amateurishness."[18] As others in this volume have addressed, the idea of DIY is not new; such an approach has provided a rich stream for invention and play, ritual and performance for many contemporary artists, individually or collaboratively, with those whom Pye might have described as amateurs as essential partners in craft-based activity, inspiring shifts in attitude toward the evidence of the handmade. DIY encompasses at least three definitions, depending on whether one sees oneself as producing *extreme craft,* as a mix of craft self-consciously "masquerading as art" and vice versa; as a *craftster,* recognizing that no object can be produced without irony; or as involved in *craftivism,* pursuing a crafty life and activating projects with a political agenda.[19]

I believe that these definitions of DIY are linked by their respective remixing of personal creativity and social activities that craft practitioners of previous generations espoused. Superficially, these look quite

similar to the 1970s craft movement, but in substance they are rather different. In the 1970s, we were accused of being naive hippies, baking brown bread and wearing sandals in metropolitan centers, creating crafts in direct opposition to the closed circuit of blue chip galleries (of which London then had very few). Now I would say that the opposition between art and craft, though informed by debates from the 1970s, is irrelevant. Personal forms of creativity are rejuvenated and celebrated through the Web, social networking groups, and via the art and craft of saving the world on a scale unimaginable thirty years ago. If one checks any of the current websites on craft (for example, craftster.org or craftivism.com), the difference is striking. I would suggest the current DIY ethos seeks to confront mass-market consumerism and the blandness of corporate culture on the one hand, and, on the other, to challenge preconceived notions of what gets shown as contemporary art.

CRAFTING THE CONTEMPORARY

Somewhere in the mid-1990s within key metropolitan centers in Great Britain (namely, London and Glasgow), there was a shift—perhaps not remarkable, but a shift nonetheless—in what was being made under the guise of craft. I suggest that what was being produced, curated, and exhibited represented early signs of extreme craft as defined previously.

In 1996 I advised on a show called "Craft," curated by Joan Key and Paul Heber Percy, for the Richard Salmon Gallery in London. It included the work of thirty-five artists, including Grayson Perry, Tracey Emin, Rebecca Warren, Siobhan Hapaska, Richard Wentworth, and Gerard Williams. The aim was not to attempt a critical definition of the difference between art and craft, painting or textiles, sculpture or object, ceramic or video but to enjoy the closeness of these seemingly oppositional pairs in their exchange. Expectations of genre were subverted, the predicament of being a practicing artist was reviewed, and the differences in methods and modes of production were explored.

By 1998, when the show opened at Kettle's Yard in Cambridge, the press release had become quite explicit:

This century has seen many artists abandon the traditional skills of drawing, painting and sculpture, and adopt an ever-widening range of material and techniques. Several artists have made the point that craftsmanship is not their concern, producing work, which is deliberately "craftless," and provoking the response that "a child of six could

do that." At the same time, in an age of mass manufacture, traditional crafts have moved beyond the functional object and now frequently lay claim to the territory of art, creating objects to be looked at rather than used.[20]

Gerard Williams, who was included in this exhibition, made specific reference to David Pye's *The Nature and Art of Workmanship* (1968), which struggles with the meaning of "handmade" and "machine made" and opts instead for the "workmanship of risk" as opposed to the "workmanship of certainty." Williams argued that Pye sets out, unconsciously, to propose many possibilities and starting points for critical making practices. This is embodied in the application of process and material revealing the core territory of debate. Pye's ideas led him to consider that extreme cases of the "workmanship of risk" are those in which a tool is held in the hand and no jig or any other determining system is there to guide it.[21] What Williams is drawing on is Pye's notion that work depends on judgment, dexterity, and care as opposed to predetermining results in advance of something being made.[22]

In their press release for the "Lovecraft" exhibition, which opened the year after "Craft," co-curators Toby Webster and Martin McGeown declared that their intention was to explore "craft's loving attention and its application in contemporary visual art," asserting in the same press release that "crafts that were once part of everyday life have fallen into hobby shop dilution."[23] I interpret this to mean that the love of making things had been so diluted and separated from professional crafts that the idea of amateur creativity and inventiveness was also under threat. It was time and timely to reassert both. If "Lovecraft" favored folk over pop, cottage over industry, and people over media, it was to make just such a point: that in the works on display the artists were revealing an investment in craft processes and many newly learned and perfected techniques that Pye might have approved of, both in terms of risk and critical judgment. The curators considered the ways in which different approaches to the value of craft could revitalize the notion of a "labor of love"—hence the show's title.

Jeremy Deller's contribution to "Lovecraft" was a curatorial project titled *The Uses of Literacy*, a collection of drawings and writings about the UK music band Manic Street Preachers. He wanted to examine the passionate devotion of their fans, which at the time bordered on the obsessive.[24] Deller's ability to engage communities with re-presentations

of their personal and collective creativity developed into the highly successful UK touring exhibition "Folk Archive." It took seven years to make the "Folk Archive" exhibition, which was first shown in 2005 at London's Barbican Curve Gallery.[25] It celebrated the love of things and those things' associations with wonderful, British eccentricities: the knitted tea cozy, meticulously crafted objects obtained from Women's Institute bazaars, the Morris dancer, model making, and matchstick trains. Deller and his collaborator Alan Kane collected images, objects, and things that would not have normally been considered contemporary art and, like Webster and McGeown before them, this collaboration represents both their joint and separate long-term interests in critically examining creative practices and artifacts from inside and outside the art world. The point is not that they make objects themselves but rather they curate and create events, exhibitions, and platforms for those who might not normally have an entry point into the art world.

I think "Folk Archive" can be considered as a tour of "people's art" and an examination of creativity in everyday life, challenging both in its screen-wide and wide-screen vision of what contemporary art can be, in its broadest and most inclusive form. The show included wreaths fashioned from cigarettes, handcrafts acquired at village fetes, photographs of hairdos, embroidered wrestling shorts, gurning, cakes, and photographs of London's Notting Hill Carnival and antiwar marches. The blurring between the "people's art" and art-school-educated artists was striking but significant: the inclusion of Martha Rosler's *Garage Sale*, comprising personal shoes, clothes, and books, was restaged to provoke visitors into recalling political and feminist-based actions in the 1970s. *Garage Sale* was first shown in 1973 in San Diego. For "Folk Archive" it acted as a comment on both what Deller and Kane believe to be the exclusiveness of the "white cube" gallery and contemporary craftivism operating outside the art system. Deller writes about his curatorial strategy and attitudes to his role as an artist-facilitator in the book *Folk Archive: Contemporary Popular Art from the UK*.[26] He argues that there is a direct line through the history of British art connecting the Arts and Crafts movement to punk to a DIY attitude. What is significant is that, as with punks (and my earlier citation of Westwood and McLaren), the anyone-can-do-it culture has been updated and translated into an online, virtual archive of the familiar made strange.

For me, "Craft," "Lovecraft," and the "Folk Archive" marked a shift in valuing how adapting craft techniques and material processes was be-

ginning to invade mainstream visual art practices as well as exhibitions of contemporary art. One could also argue that many pieces in these exhibitions and those also displayed in a show called "New Labour" (2001) were made in reaction to the slick and expensive commodity aesthetic that dominated the 1980s and intended to put handicraft back on the agenda of contemporary art. Or one could read the show's interest in clay, wood, embroidery, fabric, and the use of cloth as another colonialist expansion by painters moving into another field. Or one could say that material simply offered its artists a rich terrain of unrestrained possibility, mixing irony with object. Michael Raedecker uses preposterous techniques (laying wool in patterns and then pulling it from the half-dried paint) and decorative flourishes (leaves run through with gold thread like a trouser-suit trim) to shift perceptions of what we are looking at. Andreas Schlangel made a chair out of rectangular sponge scourers, while dried McDonald's french fries composed his *Chip Girl*. Patricia Ellis put it beautifully at the start of her introductory catalogue essay: "'*New Labour*' demonstrates that the production of art is a democratic activity: anyone can learn these crafts. What makes these artists special is their painstaking process and perfected techniques. Consummate scenarios are fabricated from the cheap and easy . . . [demonstrating that] to re-create believable fabrications, it's not what you do, but how you use it."[27]

Take Anya Gallaccio's *Three Sheets to the Wind*, at the Thomas Dane Gallery in London (2007), which investigated the potential of macramé, the craft of tying string or rope into decorative knots. Her interest in macramé grew out of collaboration in 2004 with Dutch fishermen to make a series of wall-based nets of gold lamé thread. Each net was constructed as a square grid, designed to hang on the wall in varying compositions. This Turner Prize nominee previously made her macramé sculptures out of gold lamé thread. For this exhibition Gallaccio avoided the clichéd hanging pot holder and instead created two huge, rectangular, suspended structures—a recoil from the slightly naff 1970s version of the craft. She sat in the gallery knotting away with hairy, brown hop twine for up to eight hours a day. She taught herself the technique and produced the work herself rather than in collaboration with a macramé expert, as she had done in the past. Gallaccio grew up in the 1960s and 1970s and at the time had a total aversion to macramé, but in *Three Sheets to the Wind* she pursued Pye's "workmanship of risk" and knotted

her way through to produce something resembling a huge hammock in space.[28]

The exhibitions and works cited so far engage in a productive wrestling match between definitions and ideas of extreme craft, personal craft, DIY crafting and creativity, collaboration, and independence. I would argue that these attributes have been played out against a kind of nostalgia for some of the utopian ideals of the 1970s, with the added ingredients of irony and wit. If you follow Deller's position and the views succinctly articulated by Betsy Greer in her contribution to this volume, there is a critical activism at work that encompasses popular notions of craft and labor as well as a dissatisfaction with the blandness of mainstream culture.

One can argue that works and exhibitions made within the cultural framework described here are inflected by differences in modes of production, whether this kind of work is handmade, as in the case of Gallaccio; commissioned or subcontracted, as in the case of Perry's new, woven (rather than embroidered) textiles produced in Afghanistan or London; or anthropological, as in Deller's engagement with folk art. These strategies aim to subvert or play with expectations of genre, and as in the case of Raedecker's and Williams's work, a new remix of style and form is produced. The issue of subcontraction would appear to be at odds with Pye's notion of the "workmanship of risk" insofar as production is in another's hands. There is a chance that the intervention of a third party—the idiosyncrasies of, say, the tool and woodworker—can offer a rogue element that can guide the evolution of the final piece. In answer to questions about subcontracting work like her leather sculptures, and her responses to the question of craft in contemporary art, Claire Barclay has offered this view: "It's important to me to make things myself. Some things are obviously more hand made and this is important to me. I don't know if that's because I enjoy making the work. I've realised that I have a belief that crafts are vital within society, the idea of making something yourself with love, or having something that somebody you know has made for you."[29] And this, I think, is partly the point. The idea of making something yourself or that someone has made for you "with love" represents the highly personal and the emotionally charged. It is this quality of exchange that can act so powerfully to trigger memories, affections, and stories.

Put another way, as I have often written, to craft is to care. *Craft* is a

verb rather than a noun. As a verb, *craft* is active. It is about doing and moving forward. Alison Smith's exhibition "Notion Nanny" at London's Studio Voltaire (2005) was developed in collaboration with two young British curators, Sarah Carrington and Sophie Hope (known profession-ally as B & B). The show was conceived as a touring project whereby Smith "performed" as an itinerant apprentice going around rural and urban areas in England and Wales searching for traditional craft skills and dialogue and recreating these dialogues in the gallery. "Notion Nanny" could easily have appeared in "Folk Archive" as an example of performa-tive, contemporary folklore. "Notion nannies" are also known as peddler dolls, and they were particularly popular in British and American homes during the Victorian period. Smith refashioned herself as a life-size ver-sion of the doll, dressed herself in the traditional red cloak, holding a basket of craft artifacts, tine ware, and needlework. The events sur-rounding the touring exhibition—tea parties, sharing craft skills, eating cakes—were as important as the exhibition itself. Conversations with visitors about folklore and craft over tea and cakes were documented in an archive for future publication. Visitors were invited to become mem-bers of the Notion Nanny Guild, as were many of the textile graduates present at Smith's seminar at the Constance Howard Resource and Re-search Center in Textiles.[30] The seminar, conducted by Smith in full cos-tume, focused on the critical autobiography that reframed her position and personal history as a daughter of a colonial American crafts enthu-siast and an inventor of tradecraft. Through her deployment of props, handicraft, recreated artifacts, and memorabilia, she allies the personal to a broader understanding of the social infrastructures that became part of an American nationalist culture. As outlined in her talk, Smith reconfigures American nationalist mythology in order to interrogate a broader understanding of social mores within the complexities of U.S. history.

At the time "Notion Nanny" opened, "Ceremony" had been closed for a month. "Ceremony" (2005) was co-curated by Sandra Ross and the radical knitter Freddie Robbins. They explored the ways in which different approaches to the value of craft and crafting could make the audience reimagine the meaning of rites of passage within a secular so-ciety. Rites of passage appear in every known culture, and unique, hand-crafted objects play an intrinsic and symbolic role in the way we per-form such rites: the wedding ring, christening shawl, and funeral wreath. Fusing craft objects with live art making, "Ceremony" brought together

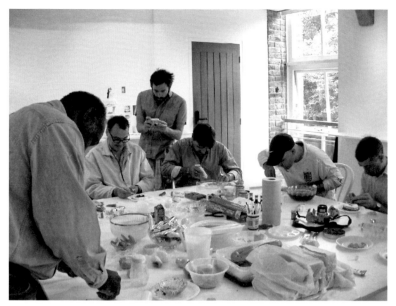

1 "Ceremony" project space, participants engaged in Shane Waltener's *Sweet Nothings: An Intimate History of Cake Making*, 2005. Photo: Sandra Ross, Pump House Gallery.

an eclectic range of works, performances, and projects that explored the performative relationship between object and ritual. Many of the works and projects were especially commissioned for "Ceremony" and encompassed a diverse range of practices, ranging from cake decorating to metalwork to floristry (see fig. 1).[31]

Besides the exhibition of objects, an entire floor of the gallery was transformed into an interactive project space, hosting a diverse range of workshops, demonstrations, screenings, and residencies. Shane Waltener explored the significance of cakes in rites of passage, experimenting with icing and cake-decorating techniques and producing a cornucopia of cakes for all occasions, which visitors made as well as ate. Waltener's *Sweet Nothings: An Intimate History of Cake Making* opened up a space of conversation as the cakes were made and decorated. Waltener has been crafting for years. He has crocheted, knitted, and quilted for as long as I have known him but has recently taken to cake making. For him, craft is a means to connect with his own family culture, and history (his mother was a keen baker), but it is also a way of getting people involved in activities. By asking visitors and members of the public to collaborate in the making of a work, he weaves their social inter-

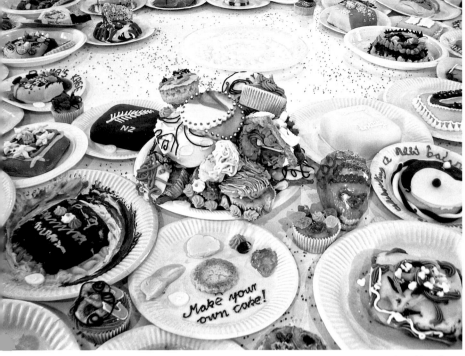

2 Shane Waltener, *Sweet Nothings: An Intimate History of Cake Making* (detail), 2005. Photo: Shane Waltener.

action into its meaning (see fig. 2). *Sweet Nothings* opened up an activated space in which brightly colored, lush cakes, lattice combinations, covered tables and shelves formed an exuberant and colorful background for animated chatter. One cake described a jukebox, another referred to Elvis and celebrations of personal events shared in a public place. The work is about the power that things have to capture personal history and the way we talk about these histories. New skills were being learned, exchanged, or remembered and life stories were told. Waltener says of his work: "I aim to turn this process on its head. Visitors here get a chance, for a sustained period of time, to reflect on what they are doing while engaging with a creative process, be it knitting, cake decorating, or some other craft technique. This creates an opportunity to ponder on what they have seen, what their connection is with any given craft technique, share it with others, and make it relevant to their own understanding of art and craft."[32]

Interaction and *participation* have become key terms within Waltener's work, just as they have been for Deller and Smith in their curatorial projects. Ideas of interaction and participation also informed the rationale for "Extreme Crafts," shown at Contemporary Art Cen-

ter, Vilnius, Lithuania, in 2007. This was an exhibition that embraced the spirit of the DIY movement with major artworks, crackpot projects, and hands-on workshops. Punk knitting, origami, and epic cross-stitch were mixed up and messed up in a flurry of wall and floor installations. A "rogue's gallery" showed documentation and objects of work being made by self-organized groups and individuals across the world. One of the curators, Catherine Hemelyk, revealed in conversation that the intention of "Extreme Crafts" was to propose a democratic "anyone-can-make-and-do" exhibition space in which self-organized groups of artists and makers could create forums for people to make things for themselves. It was crucial to the ethos of "Extreme Crafts" that work shown was not only a product of craft but also revealed the process of crafting in order that the gallery spaces were activated by different groups invited to demonstrate their activities. As with Waltener's *Sweet Nothings*, it was important that visitors and members of the public participated in workshops, brought in personally made things, and posted comments about their experience of crafting on the gallery walls alongside the rogue's gallery. Musical instruments were made out of scraps and debris of people's clutter. Sonya Schönberger spent a week in the gallery space working with visitors sewing an entire newspaper and giving them the opportunity to study the usually swiftly consumed media image (see fig. 3). The final work shown was a collaboration between artist and audience produced in the form of a stitched collage. Another work was a thatched roof, translated and constructed by Lithuanian thatchers into one window of the gallery. Titled *Transitional Thatch*, the work was made of Lithuanian straw, moss, and pine wood, but the skills and experience of making thatched roofs came from Norfolk in England. As an example of the transfer of knowledge it complemented well the DIY workshops held in the gallery.[33]

For artists like Smith in "Notion Nanny," Waltener in "Ceremony," and Schönberger in "Extreme Crafts," different relationships are formed not only between the persistence of skills and an indebtedness to tradition—making a connection to the collective social message that imbued works from the 1960s and 1970s—but also to the process of crafting. As addressed in Paula Owens's contribution to this volume, since the mid-1990s "relational aesthetics" has become an increasingly popular neologism for a series of practices identified in contemporary art by the French curator Nicolas Bourriaud. Central to Bourriaud's vision is the artist as a facilitator rather than a "maker," one who regards art as a form

3.1 Sonya Schönberger
at work in the gallery
of "Extreme Crafts,"
Contemporary Art Center,
Vilnius, Lithuania, 2007.
Photo by Paulius Mazuras.

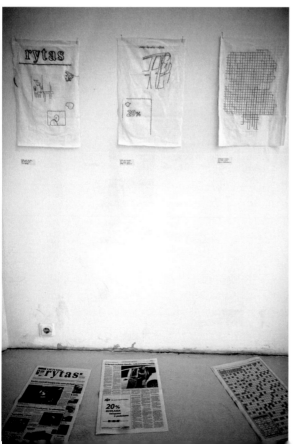

3.2 Sonya Schönberger
installation in the gallery
of "Extreme Crafts,"
Contemporary Art Center,
Vilnius, Lithuania, 2007.
Photo by Paulius Mazuras.

of information exchanged between audiences.[34] The process of crafting, social interaction, and collaboration between the artist and audience embraces a creativity which permeates our personal lives at all levels and on a global scale. "Folk Archive," "Notion Nanny," "Ceremony," and "Extreme Crafts" are examples of this approach, whereas "Love-craft," "Craft," and "New Labour" represent the first wave of exploring craft material and processes that have moved beyond the functional object. Creating objects to be looked at rather than used, as in the textile-craft-related works of Anya Gallaccio and Claire Barclay, and the idea of making something yourself with love, says something about the power that objects have to evoke personal history.

Returning to the entry in Diderot's *Encyclopedia* that began this essay, asserting that "we depend on crafts for all the necessary things in life," there emerges an art that might be regarded as an embodied and creative practice: risky at times, provocative at others, but fundamental to a good and productive life. By this, I mean that the pleasure of making things and the products of the human hand, whether individually fashioned or collectively produced as part of social activities, enhance the qualities of life and communication beyond the mundane, the superficial, and the corporate.

NOTES

1. "Lovecraft" was curated by Martin McGeown and Toby Webster for Glasgow's Center for Contemporary Arts. I saw the exhibition at the South London Gallery, London, in 1997. The exhibition featured work by Jim Iserman, Jeremy Deller, and Marc Camille Chaimowicz, the latter being one of my tutors at art school in the early 1970s.

2. Gemma de Cruz, "British Beauty: Formalism Making Good," *Flash Art* (January/February 2000): 89.

3. I am grateful for feedback on this text by audience members, staff, and students at the School of the Art Institute of Chicago, on October 10, 2007, as part of the "Object of Labor" public talks. With thanks also to Ally Raftery and Gen Doy.

4. For example, see Peter Dormer, "Thoroughly Modern Making," *Arts and Crafts to Avant-Garde: Essays on the Crafts from 1880 to the Present* (London: Southbank Centre, 1992), published to accompany the exhibition "Arts and Crafts to Avant-Garde," held at the Royal Festival Hall, London, May 1–31, 1992.

5. See Peter Dormer, "The Ideal World of Vermeer's Little Lacemaker," *Design after Modernism: Beyond the Object*, ed. John Thackara (London: Thames and Hudson, 1988), 135–44.

6. See Peter Fuller, "Art and Industry," *Images of God: The Consolations of Lost Illusions* (London: Chatto and Windus, 1985), and Peter Fuller, "In Search of a Postmodern Aesthetic," in *Design after Modernism*, ed. Thackara. One of my earliest

arguments with Fuller took place in November 1979 at the conference "Art, Politics and Ideology" at Dartington Hall, England, where he likened my practice at the time to the nappy-liner Mary Kelly. I took it as a compliment.

7. This essay, first published in the May/June issue of *Crafts* in 1982, can be found (along with the other four in the series) in *Craft Classics since the 1940s: An Anthology of Belief and Comment*, selected and edited by John Houston (London: Crafts Council, 1988).

8. David Pye, designer and woodcarver, analyzed the confusion between moral and craftsman principles in *The Nature and Art of Workmanship* (Cambridge: Cambridge University Press, 1968).

9. Liz Hoggard, "The New Craft," *Sunday Observer Review*, February 8, 2004.

10. "The Charms of Lincolnshire," curated by Grayson Perry, was held at the Victoria Miro Gallery, London, July 7 to August 12, 2006.

11. During the 1990s there was an abundant flowering of handiwork and craft-based processes notably mobilizing stitch whether as metaphor for tactility and sexuality (e.g., Tracey Emin, *My Bed*, 1998, nominated for the Turner Prize) or as blended examples of Western fashion hybridized with African ethnicity to create abstracted replicants (e.g., Enrico David). In September 2003, the then arts minister of the United Kingdom Estelle Morris put craftwork very firmly on the agenda, by placing crafts on her office desk. Perry started to exhibit successfully in the 1980s. There was something of a shock within the Dormer/Fuller crafts community that badly made pots could be taken so seriously. When he won the Turner Prize in 2003, his seductively coiled pots confused the art and crafts worlds alike. See *Grayson Perry: Guerrilla Tactics* (Rotterdam: NAi Uitgevers in cooperation with the Stedelijk Museum, 2002), the catalogue accompanying his retrospective, held in 2002 at the Stedelijk Museum in Amsterdam. See also the Turner Prize exhibition brochure, produced in house by Tate Britain, London, December 2003.

12. Howard Becker, *Art Worlds* (Berkeley: University of California Press, 1982).

13. James Clifford, "An Ethnographer in the Field" (interview-essay), *Site-Specificity: The Ethnographic Turn*, ed. Alex Coles (London: Black Dog Publishing, 2000), 52–71.

14. The anthropologist Ivan Kopytoff suggests that we be attentive to what he calls the "social biography of things," just as Arjun Appadurai called for recognition of the "social life of things." Objects, like people, argued Kopytoff, have life cycles, in the course of which they age and move in and out of economic circuits of exchange and appreciation. When this happens we learn something different about what and how we value things and the meanings we give them over the course of their lives. Objects tell stories of our relationship to the world and they offer a material base, not just in terms of production—hand, industrial, or even digital media—but also in relation to how we consume them, long for them, and even obsessively collect them. See Kopytoff, "The Cultural Biography of Things: Commoditization as Process," *The Social Life of Things: Commodities in Cultural Perspective*, ed. Arjun Appadurai (Cambridge: Cambridge University Press, 1986), 66.

15. Jonathan Watkins, catalogue essay for *Every Day Biennial of Sydney* (Sydney: University of New South Wales Press, 1998), 15. Watkins was artistic director of the biennial. He is the director of the Ikon Gallery, Birmingham, UK.

16. Jeremy Deller and Alan Kane, *Folk Archive: Contemporary Popular Art from the UK* (London: Book Works, 2005).

17. Siri Hustvedt, *A Plea for Eros* (Sceptre, 2006).

18. Pye, *The Nature and Art of Workmanship*, 79.

19. The American blogger Betsy Greer's interview in the UK national daily newspaper the *Guardian* on May 29, 2006, revealed how widespread craftivism has become on a global scale. See her website, craftivism.com, and her essay in this volume. She believes that each time you participate in crafting you are making a difference; whether it's fighting against useless materialism or making items for charity, you are fighting for causes you believe in.

20. Press release published on the occasion of "Craft" at Kettle's Yard in Cambridge in 1998.

21. Pye, *The Nature and Art of Workmanship*, 80.

22. Ibid., and discussed in an e-mail exchange between Janis Jefferies and Gerard Williams, Wednesday, June 20, 2007.

23. For a full discussion of Webster's and McGeown's views on notions of craft in contemporary art, see Tony Webster and Martin McGeown, "The Art of Making Things," *Art Monthly*, London edition, October 1997, 6.

24. Jeremy Deller, *Uses of Literacy* (London: Book Works, 1999).

25. The exhibition "Folk Archive" toured for eighteen months around England, Wales, and Switzerland and was shown at Spacex Gallery, Aberystwyth Arts Centre, and Kunsthalle, Basel, in 2005–2006.

26. Deller and Kane, *Folk Archive*.

27. "New Labour" was shown in the old Saatchi Gallery in West London from May to November 2001. The show was curated by Patricia Ellis and included Rebecca Warren, Enrico David, D. J. Simpson, Grayson Perry, and Michael Raedecker. The art critic Jonathan Jones was scathing, suggesting that "*New Labour* at the Saatchi Gallery is a survey of young British art, arguing that work, handicraft and fiddling about with stuff is back. But there never was a time when patience of the hand and eye was all it took to be an artist. Vision, ideas and imagination are more important, argued John Ruskin, who once suggested the best service a monarch might perform for the arts would be to collect all the laborious landscapes of the 17th century Dutch painters, put them in a museum and burn it" (*Guardian*, May 5, 2001).

28. Anna Gallaccio, "On Wine and Macramé," *Crafts: The Magazine of Contemporary Craft* (January/February 2007): 96. She writes, "I try to make things that are unique, but with idiosyncrasies: half way between craft and industrial production. Macramé is another one of these maligned women's handcrafts, but for me it connects to the utopian ideals of the 1970s."

29. Claire Barclay in conversation with Iwona Blaswick, director of Whitechapel Art Gallery, London, as part of the Whitechapel's "Early One Morning" exhibition in 2002. Barclay's work was an example of the shift from the conceptual to the material: "More and more, though, I'm realizing that I don't really have that sort of conceptual practice. There's a certain amount of research, which runs parallel, and it controls the work in terms of what materials I'm using or what reference points I might have. Basically, though, I really do work in a more hands-on way. It's

much more about making—about getting materials, doing things with them and the surprises that occur. Rather than try to mould things to what you want them to mean conceptually, you allow them to dictate to you." Claire Barclay interviewed by Francis McKee in "Out of the Woods," *Make*, no. 87 (March/May 2000): 32.

30. The seminar was given at the Constance Howard Resource and Research Center in Textiles, Goldsmiths, University of London, on November 8, 2005.

31. "Ceremony" was shown in the Pump House Gallery, Battersea Park, London, in October 2005. It featured the video artist Tim Davies, Serenda Korda, Welfare State International, Cast Off: The Knitting Club for Boys and Girls, and Shane Waltener.

32. Shane Waltener in e-mail conversation with Janis Jefferies, June 15, 2007. The London-based Belgian Waltener exhibited *A World Wide Web*, a specially commissioned piece for the exhibition "Radical Lace and Subversive Knitting," at the Museum of Arts and Design in New York. The site-specific installation consisted of twenty-five square meters of knitted shirring elastic suspended between walls and ceiling at the entrance of the museum.

33. I Interviewed Catherine Hemelyyk, one of the UK-based curators of "Extreme Crafts," at the Contemporary Art Center in Vilnius, Lithuania, on July 1, 2007. The other curator was Jennie Syson. The final weekend included a knitting marathon organized by Cast Off, l who also closed the "Ceremony" exhibition cited above by producing a knitted wedding.

34. Nicolas Bourriaud, "Space-Time Exchange Factors," *Relational Aesthetics* (Paris: Le Presses du reel, 1998; translated 2002), 47.

NEW FUNCTIONS, NEW FRONTIERS

Lacey Jane Roberts
· · · · · · · · · · · · · · · · ·

Put Your Thing Down, Flip It, and Reverse It

REIMAGINING CRAFT IDENTITIES
USING TACTICS OF QUEER THEORY

The phrase "identity crisis" has frequently been used to describe the current state of contemporary craft.[1] This identity crisis came to a head when, as discussed in the introduction to this volume, several prominent educational and cultural institutions dropped the word *craft* from their formal names, choosing to exist under the banner of *art*, and in some cases *design*. These institutions' actions seemed to demonstrate that the public image of craft is in shambles—the word itself evokes stigmas and stereotypes with which museums and schools do not wish to be affiliated. In her essay "Homespun Ideas: Reinterpreting Craft in Contemporary Culture," Lydia Matthews writes:

> While the categories of art and design are currently stereotyped and packaged as urban, hip, sexy, potentially transgressive, technologically savvy, intellectually astute, and politically progressive, craft is cast as fundamentally down to earth, time-honored, conventional, non-threatening, and conservative by comparison. Craft is comfort food spooned into a brown-glazed earthenware bowl, while art and design are upscale gourmet fare, plated vertically on Italian porcelain and served with all the economic and class connotations and Eurocentric assumptions suggested by that analogy.[2]

Other stereotypes of craft include objects that result from pursuits considered amateur or hobbyist. When first considering a name change, the institution now named the Museum of

Art and Design hired a "corporate-identity consulting firm" to conduct a survey that asked a focus group its opinion of the word *craft*. One participant stated, "Craft can never shed its macramé pot-holder image no matter what it's done."[3] Items such as crocheted teapot cozies, bulky knitted wearables, whittled wooden tchotchkes, and whimsical blown-glass figurines all have a decidedly gendered and amateurish aura. It was possibly with these stereotypes in mind that David Revere McFadden, head curator at the Museum of Art and Design, articulated the stereotype of craft as "the bimbo of the art world."[4]

The lack of critical theory within the field of craft has contributed to its second-class status in the world of visual and material culture. As of late, many venues—including magazines, journals, and domestic and international conferences—have touted a generation of new-and-progressive critical craft theory as essential for craft to assert itself as a vital and rich part of visual and material culture and simultaneously to challenge the stereotypes that position craft at the bottom of the aesthetic and conceptual food chain. Writing critical craft theory is a formidable task; it must address craft's relationship to the larger arena of visual and material culture as well as the state of crisis that currently characterizes insular circles specifically dedicated to craft practice. In an essay published in 2007 in the newly revamped *American Craft*, the official magazine of the American Craft Council, the influential artist and critic Bruce Metcalf writes: "Cogent theory (or theories) of craft must emerge from the ideas and attitudes that are peculiar to craft. The theory must make virtues of what are often considered limitations."[5] If we recognize that we need to invent a body of critical theory that harnesses both the peculiarity and so-called limitations of craft, what kinds of theoretical models might we turn to? Are there other existing theoretical frameworks that might prove instructive in terms of thinking through craft histories and its manifold current practices?

I argue that there is a theoretical terrain that artists and writers working with craft media could learn from to shape our own progressive discourse. In the past two decades, another discipline has predicated itself on virtues considered non-normative, "other," and peculiar. In the 1990s, queer theory emerged from activist movements, feminist theory, and women's studies. Often thought of as focusing on issues of gender and sexuality, queer theory has intellectually evolved to include discourses regarding race, socioeconomics, disability, and a host of other areas that factor into the makeup of what we call "identity." These almost-always

marginalized groups are often expected to possess certain characteristics and, consequently, are saddled with stereotypes that group people together under a common label of identification despite their differences, resulting in muted individuality.

What makes queer theory so useful to those marginalized communities that must confront the pigeonholing stereotypes that overdetermine and essentialize identities? The tactics of reclamation, reappropriation, and disidentification used in queer theory and praxis give non-normative identities agency as well as question the seemingly stable systems that render them as other. These tactics acknowledge stereotypes, transpose them, and then subvert them to form new models of identity.

The reclamation of the word *queer* itself was a primary tactic to displace stereotypes often saddled on non-normative populations. The impetus for its reclamation came from within as well as outside the academy. AIDS activists played a pivotal role in moving *queer* from a term of denigration into one of agency.[6] Beginning in the 1980s, *queer* as a word was deployed as a tactic to depathologize those who were HIV-positive. Using *gay* as a label to describe those in the population who were considered then to be most at risk for HIV (or who already had AIDS) was deemed essentialist and overdetermined. *Queer* recognized the endless configurations of identity made even more complex by their constant fluidity and it simultaneously served as a banner that could represent a host of people under the common cause of confronting an epidemic—one that was rapidly killing thousands, while the government refused, devastatingly, to acknowledge its existence.[7]

Within the bounds of the academy on which queer theory was anchored, a larger platform of poststructuralism also played a part in moving the connotation of *queer* from one of degradation to one that asserts non-normativity, peculiarity, and so-called otherness as a position of empowerment. The tactic of ambiguity embodied by *queer* resists stereotypes and enables identities to encompass, as Eve Kosofsky Sedgwick has written, "the open mesh of possibilities, gaps, overlaps, dissonances and resonances" that renders labels and classification simplistic. *Queer* expresses a noncomplicity with systems that create and proliferate those stereotypes, which themselves establish and regulate power structures. The word is made further potent because it still carries with it what Sedgwick describes as an "always derogatory underbelly." If the word were to lose all of its stigma and simply become a wholly affirma-

tive term, it would lose the potency that provides what she views as "a near inexhaustible source of transformational energy."[8]

In "The Other Question," Homi Bhabha states that "the basis of a prior political normativity is to dismiss it, not displace it, which is only possible by engaging with its effectivity; with the repertoire of positions of power and resistance, domination and dependence that constructs the . . . identification subject."[9] When confronted with stereotypes that calcify identities, Bhabha contends that to simply dismiss the overgeneralization is ineffective. If the stereotype is simply written off as a nontruth, the systems that constructed it as a means of establishing and maintaining hierarchies and power structures are not brought to light. Instead, if these systems are illuminated, the stereotype is revealed not only to be a gross generalization but also as a tool used to influence and control dynamics within the marginalized group it allegedly represents. To recognize and reclaim the stereotype, Bhabha argues, is the first step toward displacing it.

Reappropriation and performance can take on a variety of different forms. One technique of reappropriation and performance is overperformance. Through overperformance, identities that have been stereotyped are illuminated and exaggerated, and their constructions are revealed. Another avenue for reappropriation is the queering and re-queering of traditional identities, fusing them with elements that challenge and skew the essentialist notions they project. Through this tactic, the stereotype is continuously broken down and challenged, which allows the hybrid identity that is produced to endlessly add new elements and change itself. Simultaneously, this incessant transformation is a strategy that works to deflect mainstream culture's tendencies to co-opt otherness and skew into trends marketed as hip or seemingly transgressive, which ultimately results in reinforcing the suppression of groups and individuals who have struggled with factors once seen as non-normative before this popular absorption.

With these reformulated identities at hand, tactics of disidentification then enable individuals to adopt or reject certain qualities of these new configurations and to reimagine them. José Esteban Muñoz writes in his book *Disidentifications: Queers of Color and the Performance of Politics*:

> Disidentification, as a mode of understanding the movements and circulations of identificatory force, would always foreground that lost

object of identification; it would establish new possibilities while at the same time echoing the materially prescriptive cultural locus of any identification. . . . Disidentification is about recycling and rethinking encoded meaning. The process of disidentification scrambles and reconstructs the encoded meaning of a cultural text in a fashion that both exposes the encoded message's universalizing and exclusionary machinations to account for, include, and empower minority identities and identifications. Thus, disidentification is a step further than cracking open the code of the majority; it proceeds to use this code as raw material for representing a disempowered politics or positionality that has been rendered unthinkable by the dominant culture.[10]

This sequence of reclamation, reappropriation, performance, and disidentification succeeds in remodeling rigid and stagnant stereotyped identities; reformulated identities are possible and endowed with the ability to imagine, morph, and expand. Once the stereotype is identified as the "cultural locus," it can then be transformed from an inhibiting identity immobilizer into the raw material that stereotypes exploit to repress the so-called unthinkable—the many minority identities that threaten and disrupt the supposedly stable identities of those in power. With so many configurations of identity, methods of repression would have to vary, which would require more effort for those of the majority. Stereotypes work to singularize, requiring less exertion for those seeking to control and repress marginalized populations. Disidentification works to make visible these infinite varieties of identity—or nonidentity—that present such a threat to dominant forces; the act plays on the stereotype and moves away from it. It endlessly confuses expectations and future efforts of those in power to reapply revised stereotypes to the minority once the former stereotype has been cracked. Using these tactics of reclamation, reappropriation, and disidentification, the individual, fueled by displaced and reconfigured stereotypes, is given the option to claim an identity, move fluidly between identities, or choose not to identify at all.

Craft can gain from the methods and tools that queer theory has deployed to reclaim and reconfigure its own marginal position into a place of empowerment. By flipping and displacing denigrating and confining stereotypes through tactics of performance and appropriation, craft can reimagine itself in multiple ways, molded and reconfigured by the desires of the maker. Through the dismantling and reconfiguration of its

own stereotypes, craft is positioned as a potent agent to challenge the very systems that create and proliferate stereotypes to maintain hierarchies of visual and material culture.

I maintain that by using the tactics and strategies of queer theory, craft could gain purchase by deliberately asserting an identity that defies fixed or historically prescribed boundaries in relation to its use of materials, processes, or formal vocabularies. This radical, critical position would relocate craft as an aesthetic category that embraces an enormous range of multiple and seemingly contradictory practices, as well as an agent to challenge existing systems that define materiality and makers.[11]

For those deeply invested in craft, to acknowledge stereotypes can be a painful endeavor. It means tracing a history in which specific ways of making—tagged with the word *craft*—have been deemed as less valuable than other forms of labor, thought, materiality, and context. To be able to deconstruct stereotypes most effectively, however, we must examine and pull apart the history of these characterizations and ideas. This history is shaped not only by the ideas about craft that circulate in a contemporary moment but also by the modern origins of fine craftwork, that is, by capitalism and the production of goods—something rarely acknowledged, even in the hypercapitalist art world. Moreover, those who participate in craft circles must realize that they are a largely conservative and homogeneous group in comparison to those who participate in other areas of visual and material culture. Craft culture must come to terms with its insularity, which has contributed to homogeneous demographics and precluded the more diverse configurations of identity present in other areas of material and visual culture.

Those who take part in craft in any role—makers, critics, curators, collectors, and viewers—must consider the fact that *craft* is being applied not only to new practices that are rooted in materiality but also to newer trends of social practice that detach themselves from it. Although a departure from materiality seems contradictory to craft in many ways, it must nonetheless be considered. Practices considered "craft" that deemphasize materiality present a terrain difficult to negotiate and could be viewed as an approach that will present craft with yet more indefinability, which in the past has been explicitly denounced as its undoing.

The conservative approach to this conundrum would be to vehemently oppose this trajectory and take sides pitting practices rooted in materiality against those that deviate from it. However, it would be more

beneficial to understand how these viewpoints work *in relation to each other*. This could itself open up new ways for craft to include those who work more traditionally, those who work more radically, and those who find ground somewhere in between.

While the aforementioned are issues that critical craft theory must address, studying the work of makers who are presently flipping craft stereotypes and reconfiguring identities will ground progressive discourse. So many types of practices and makers exist who are claiming *craft*—the terrain is so deeply rich and endlessly shifting—that critical craft discourse is positioned to redefine material and visual culture. This, in turn, can foster the multifaceted practices that have surfaced and continue to sprout and expand, enabling makers to further conceptualize and contextualize their practices and their identities as makers.

Lia Cook, a faculty member in the textiles department at California College of the Arts, serves as a dynamic example of a maker who asserts craft and dislodges its stereotypes through her processes of making, the contexts in which she exhibits, and her own identity. Cook's roots are in the Studio Craft movement, a group virtually exiled—partly through its own doing—from larger arenas of visual and material culture. Cook began weaving on hand-looms and painting textiles to create complex and intricate illusionary images. In the past few years, she began to weave on a digital Jacquard loom—which also requires the use of the hand—to merge intimate family photos with woven structures (see fig. 1). Cook abstracts these images through pixilation on her computer before uploading them to a CAD program that relays her image to the loom. When taken off the Jacquard and installed, they present large, overwhelming phantom memories of childhoods gone by (see fig. 2).

Through her work, Cook displaces the stereotype of craft even as she simultaneously reclaims it. Although the Jacquard pulses with digital savvy, Cook must integrate the warp and the weft by hand. Weaving requires the constant, repetitive physical motion of the maker, and although the Jacquard is a high-tech, air-compressed beast, it is no exception. The merging of cutting-edge technology and the tedious handwork that is required of Cook is typical and atypical of craft: all at once, technology, standards in architecture, and design curricula are fused with traditional, centuries-old methods to create singular pieces that are rendered difficult, if not impossible, to classify.

Cook further complicates the contradictions embedded in her practice and weavings vis-à-vis her identity as a maker. While still remaining

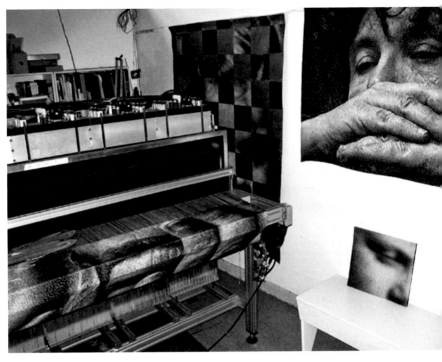

1 Lia Cook's Jacquard loom in her Berkeley, California, studio, pictured with *Resting Digits*, 2005.

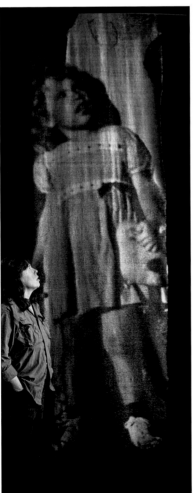

2 Lia Cook, *Big Baby*, 2001, cotton and rayon, woven, 142 × 39 inches.

a Studio Craft mainstay, Cook exhibits within a fine arts context with the Nancy Margolis Gallery in New York City's Chelsea district, and her work was on view at the Cooper-Hewitt Museum in the prestigious National Design Triennial in 2007. Cook is listed as an "artist" on the Nancy Margolis Gallery website, and a "designer" in the National Design Triennial catalogue. Additionally, she was featured at the "Shaping the Future of Craft" conference in 2006 and was a College Art Association conference panelist in 2007 on a program titled "When Is Technique Central to Meaning?" which was dedicated to those who are considered to maintain craft practices.[12]

Craft, reclaimed and reimagined, is the device Cook deploys to break through the prescribed boundaries of material and visual culture. In so doing she complicates her identity and, by virtue of it, the identity of craft. What is particularly exciting about Cook and her work is that she manages to bridge the acknowledged gap between Studio Craft practitioners and a younger generation of makers who identify themselves as hybrid makers or even choose not to identify themselves at all. Although allied with the Studio Craft movement, Cook also merges with makers who are increasingly interdisciplinary, technologically savvy, and unafraid to invade and borrow from other areas of material and visual culture not considered craft. Cook represents part of the older guard of the craft community that has expanded a practice into a multitude of areas and embodies many different positions at once but never has to settle on one.

Liz Collins is a prime example of a younger generation of makers who claim *craft* and employ it as an agent to traverse the constructed perimeters of visual and material culture. After earning both bachelor's and MFA degrees in textiles from the Rhode Island School of Design, Collins immersed herself in garment construction and quickly garnered a reputation as a cutting-edge designer whose apparel was inventive yet simultaneously ready-to-wear. After a five-year tenure running her own, highly acclaimed independent fashion label, Collins began to stage her Knitting Nation performances. Knitting Nation consists of Collins and a team of assembled workers continuously laboring at knitting machines, as well as by hand, to produce large-scale installations. Clad in coveralls bearing the Knitting Nation logo, Collins and her crew operate like honeybees at the hive—little by little, their collective, repetitive motions build a large-patterned entity realized only though cooperation and diligence. Lined up in formation, Collins and her workers are goaded by

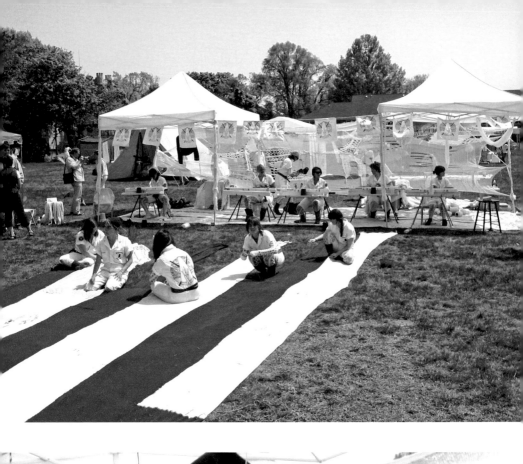

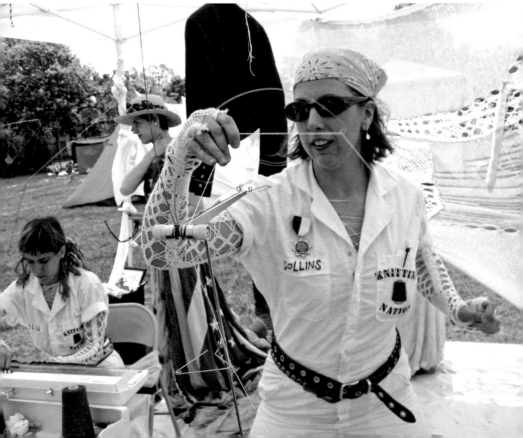

"overseers" to knit faster and faster, immediately evoking sweatshop set-ups that focus on profit rather than the people who do the work. How-ever, there are clues that the Knitting Nation team is decidedly antifac-tory. Though their coveralls are plain, white, and uniform, the knitters have added their own personal embellishments, shedding anonymity for individual expression. Far from the industrial capitalist ideals of using unskilled workers, Knitting Nation is well versed in a variety of textile techniques, sewing by both machine and hand.

Collins's first Knitting Nation performance took place during *The Muster*, a one-day event that occurred on May 14, 2005, on Gover-nor's Island, located near Manhattan.[13] Those taking part in the event were asked to consider the question "What are we fighting for?" as they imagined and prepared their projects. Collins titled her project *Knitting during Wartime* and together with her Knitting Nation troops she con-structed a huge American flag (see fig. 3). Unlike the majority of textile factories, which produce goods for an everyday, utilitarian function, the American flag fabricated by the Knitting Nation Army is so gigantic it could hardly flutter on a flagpole. Additionally, a public that could easily purchase a pristine and shining banner from a hardware store would likely reject its uneven seams and occasionally flawed fabric (see fig. 4). The aesthetics of the flag are funky and handmade, perhaps a fitting tribute to Betsy Ross, who could be viewed as the grande dame of Do-It-Yourself production.

Audiences swarm Collins and her worker bees—the back-and-forth motion of the knitting machines emanating a befitting buzz. Collins and her team produce a spectacle of craft using materiality and performance that can only be accomplished through technical skill and expertise. Knitting Nation's spectacle of slowness offers a time-out to the audience to observe acts of making usually sequestered from the public gaze. The absurdity of an army of knitters branded with matching logos compul-sively stitching a monolithic flag clearly calls into question the blind patriotic fervor of a post-9/11 nation that is no longer considering the question at hand: "What are we fighting for?" The performances of Knit-ting Nation question ideas of nationhood through parody at a critical time in today's tense political climate. In addition, this overperformed nation building warns the craft community that, in spite of its desire to assert a common and collective identity—a nationhood of sorts—this is not the solution to its identity crisis either; this trajectory of forming an identity would only re-stereotype craft once again and stifle the identi-

3 Liz Collins and Knitting Nation perform at Allison Smith's *The Muster* on Governor's Island, 2005.

4 Liz Collins with her knitting machine.

ties of the individuals who, with their incredibly varied practices, claim *craft*.

Collins describes her practice as "firmly rooted in knit construction as a craft."[14] Through this statement she asserts *craft* in a way similar to how *queer* is deployed; *craft* becomes an agent to resist stereotypes and to challenge the constructed systems of visual and material culture. Deliberate acts of making are at the heart and center of what Collins produces, and, as she has said, through the medium of knitting she "transcend[s] boundaries of art, performance, industrial production, and fashion, always maintaining the involvement of my hands in all these endeavors."[15] Her purposeful gestures of skilled construction perform the non-normativity and peculiarity that are rife within craft and serve as her vehicle for infiltrating a variety of arenas. In turn, through her making and fluid movement across perceived boundaries, she continuously shifts and morphs her identity. By doing so, she defies any classification of her work and herself.

Strategies such as overperformance are endorsed by queer theory to critique stereotypes that over-determine identities. Similar to the way in which drag performance functions, the work of Josh Faught magnifies and dismantles prevalent craft stereotypes. Entering Faught's installation *Shitlist*, one encounters granny squares gone rotten. Far from the comfortable and tender intentions typically thought of as infusing a crocheted quilt, the craft in *Shitlist* looks to have been stitched by a serial killer with a sentimental streak, each square a thoughtful materialization of the vengeance that creeps into his mind during banal hours sitting in the john—a notch on his shit list. Much like a campy drag performance, Faught's installation is a masquerade: on first appearance the brightly colored granny squares are familiar, pleasant, and sweet, but in its center is a crass and dirty sense of humor—the word SHITLIST in big block letters. The amateur, homespun associations that *Shitlist* evokes also echo drag productions, created as they are with easily accessible, cheap materials that can be found at the local craft supplies stores. As is true of eccentric characters often found in drag—lunch ladies, grannies, truck drivers, or cheesy, small-town lounge singers who dream of Vegas—an underlying bitterness contrasts with the genial façade of Faught's work. In contrast to slick high-tech shows filled with performers who aim to simply mimic Hollywood types and supermodels with as much authenticity as possible, Faught's work, like drag queens or kings, does not attempt to hide the imperfect but instead magnifies

it. Extracted from their common living room environments, Faught's crocheted afghans engulf the compact space of a bathroom. The densely installed yarn bears down heavily and inescapably. The claustrophobic conditions are replete with symbols of amateurism and femininity: it is suffocation through stereotypes of craft. Chintzy, unsophisticated blankets that scream with femininity (or effeminacy) and amateurism cover not only the walls but also the ceiling and the top of the toilet. There is feeling of unfinished sloppiness as yarn drips from all angles and threatens not only to engulf the bathroom's users but to fall into the toilet water.

Faught's sprawling installation *Nobody Knows I'm a Lesbian* covers an entire wall with layers of materials, images, and techniques (see figs. 5 and 6). Crawling up from the ground, the installation bombards the viewer with images, language, and methods that infinitely contradict each other. Plastered onto the wall is screen-printed wallpaper with the repeated image of a young boy. Some of the faces eerily drip yarn, making the boy look as if he is simultaneously melting and crying. Framed pictures of a man in drag, his face smeared with make-up, are piled in a heap near a crocheted web of metallic sequins. On the floor lays a sheet of sewn gold-lamé and black vinyl—a sort of heretic quilt. A diptych on the right side of the wall presents mirrored images of spread-eagle legs displaying male genitalia in shades of purple and brown. A violet flag with gold writing admits "Nobody Knows I'm a Lesbian" and droopily protrudes from a gaudy yarn base. In this piece, Faught continuously uses craft to disidentify with constructs of queerness and employs queerness to disidentify with conventions of craft.

His statement, *Nobody Knows I'm a Lesbian*, throws his perceived gender and sexual identity as a gay man into question. The person depicted in the piled portraits is Faught himself in campy drag, reinforcing the multiple mismatched gender expressions scattered throughout the piece. Both craft and queerness in *Nobody Knows I'm a Lesbian* are at once genuine and inauthentic. It is overperformed and gaudy but deeply personal at the same time.

Faught's techniques that span the craft spectrum come with their own notions about gender, age, class, and education. Papier-mâché, thrown tinsel, crocheted sequins all relate to amateurism, hobbyist activities, and femininity, in stark contrast to Cook's weavings done on state-of-the-art equipment like the Jacquard loom that showcase a well-studied craftsperson working with the most advanced and expensive

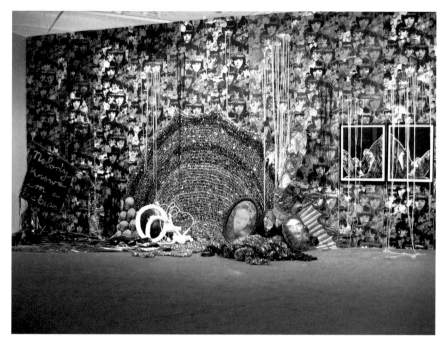

5 Josh Faught, *Nobody Knows I'm a Lesbian*, 2006, hand-woven Jacquard cotton, crocheted sequins, fabric, screenprinted wallpaper, vinyl, tinsel, and yarn.

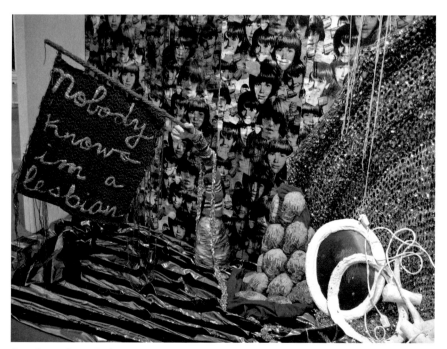

6 Josh Faught, *Nobody Knows I'm a Lesbian* (detail), 2006.

technologies. But, like Cook's work, both the craft Faught practices and the identities he presents therein span an infinite range of overlap and divergence. With so many configurations of craft and identity, stereotyping once again becomes difficult if not impossible.

Through parody and extreme overperformance, Faught's work slits open the derogatory underbelly of craft and spills its guts. Faught has crafted craft's stereotypes; and at once this reclaims them, flips them through camp, and allows him to hew his own identity through tactics of disidentification. For Faught, craft and queerness mirror each other, reflecting the melancholia of marginalization. However, when reconfigured and reimagined together, they provide endless opportunities to continuously morph, affording an invaluable navigational tool for Faught.

A word that has emerged of late when people discuss the future of craft is *hybridity*. When people use *hybridity* in the context of craft and the trajectory that they believe will catapult it into territory that they consider fashionable and cutting edge within material and visual culture, they promote craft's fusion with art and design (and occasionally with fashion and architecture). Cook, Collins, and Faught are certainly examples of this often-discussed hybridity. In fact, all three had their work shown at the "Shaping the Future of Craft" national leadership conference sponsored by the American Craft Council in Houston in 2006.[16] However, in talking about hybridity one runs the risk of unwittingly reinforcing constructed and stereotypical categories within material and visual culture. For example, if the elements of certain processes or finished work are identified by way of conventional classifications—art, craft, design, fashion, architecture—these traditional categories are inadvertently strengthened and reified. Hybridity can be a tremendous asset and breakthrough, if elements in a piece are so thoroughly confused that the elements can no longer be defined as one category or another. The tactic of disidentification can come into play to reinforce hybridity as a concept that breaks down stereotypes rather than reinforces them.

Having a lack or loss of identity creates the opportunity for identity to be invented anew. Much of craft is about making. By not declaring a fixed identity for craft, it could always be *in the making*. If craft were constantly in formation, it could resist being stereotyped and could include many different types of makers. Its inability to be defined could be transformed into an asset and an agent of power to challenge systems

that use definition to limit. Instead of being ignored or denied, stereotypes can be made into raw material and transformed, much like the physical materials that Lia Cook, Liz Collins, and Josh Faught use to break down preconceptions about their work and themselves.[17]

Ironically, the lack of critical craft theory to date has opened up infinite possibilities to create new theoretical avenues to conceptualize and contextualize craft—a wide-open playing field. Queer theory can teach craft through its tactics of reclamation, reappropriation, performance, and disidentification. These methods present a potent and provocative template for craft on which to model new and progressive critical theory. If positioned in this way, craft criticism could be unearthed from its current quagmire to become a provocative part of craft instruction, scholarship, and criticism and to provide a dynamic framework for makers to conceptualize their own practices.

NOTES

1. Lydia Matthews uses this phrase in her "Homespun Ideas: Reinterpreting Craft in Contemporary Culture," which first appeared in the catalogue for "Practice Makes Perfect: Bay Area Conceptual Craft," an exhibition featuring conceptual craft at the Southern Exposure Gallery in San Francisco. Debbie Hagan uses it as well in her article "Identity Crisis? Naming Craft Museums Proves Difficult," which appeared in the January 2005 issue of *Art Business News*. Additionally, Dennis Stevens uses the phrase in his blog "Redefining Craft" as does John Perrault in his blog "Artopia."

2. Matthews. "Homespun Ideas," *Practice Makes Perfect: Bay Area Conceptual Craft* (San Francisco: Southern Exposure, 2005), 8–9.

3. Carol Kino, "The Art Form That Dare Not Speak Its Name," *New York Times*, March 30, 2005, G8.

4. Suzanne Ramljak, "Interview: David Revere McFadden," *Metalsmith* (fall 2004): 20.

5. Bruce Metcalf, "Looking Back, Looking Forward," *American Craft* (December 2006/January 2007): 22.

6. Annemarie Jagose, *Queer Theory: An Introduction* (New York: New York University Press, 1996), 93–96; Douglas Crimp, "Right On Girlfriend," *Fear of A Queer Planet*, ed. Michael Warner (Minneapolis: University of Minnesota Press, 1993), 314; Lee Edelman, *Homographesis: Essays in Gay Literary and Cultural Theory* (New York: Routledge, 1994), 96–113.

7. Crimp, "Right On Girlfriend," 314; and Edelman, *Homographesis*, 111.

8. Eve Kosofsky Sedgwick, *Tendencies* (Durham, N.C.: Duke University Press, 1993), 105–6.

9. Homi Bhabha, "The Other Question: Stereotype, Discrimination and the Discourse of Colonialism," *The Location of Culture* (New York: Routledge, 1994), 67. A reading of critical race and postcolonial theory greatly enhances queer theory

and vice versa. Read together, these two areas of study offer a variety of angles from which to consider matters of identity, struggle, and resistance.

10. Jose Muñoz, *Disidentifications: Queers of Color and the Performance of Politics* (Minneapolis: University of Minnesota Press, 1999), 30–31.

11. Additionally, it is important to consider that this theory could be applied to a variety of makers who claim the use of *craft*. How could traditional makers use this theoretical framework to think through or recontextualize their practices in different ways? How would the concept of an ever-shifting identity affect the maker and his or her practice alike? Would this theoretical template attract radical makers looking for new ways to conceptualize themselves and their work?

12. The "Shaping the Future of Craft" conference brought together 270 people considered to be leaders in the field of craft. The lack of diversity of the participants was an issue that was repeatedly addressed. The absence of young people and students was particularly noted, though it was also evident that the audience was overwhelmingly white, middle-aged, and did not identify as queer, among other factors.

13. Alison Smith, *The Muster* (New York: Distributed Art Publishers, 2007), 42–43.

14. Liz Collins, "New Artists/New Work, Session 2," *Shaping the Future of Craft*, National Leadership Conference publication (New York: American Craft Council, 2007).

15. Ibid, 144–145.

16. Ibid, 145.

17. It should be noted that each of these makers was educated and received his or her MFA at a prestigious school: Liz Collins at Rhode Island School of Design; Lia Cook at California College of the Arts (then California College of Arts and Crafts); and Josh Faught at the School of the Art Institute of Chicago. This is certainly a topic that craft circles should take note of when considering what is being touted as the current and future trajectories of craft. I acknowledge here my own studio practice in fibers, which accounts for my interest in makers who use textiles as a key component in their practices and perhaps display their own lack of diversity.

Andrew Jackson
.

Men Who Make

THE "FLOW" OF THE AMATEUR DESIGNER/MAKER

Glynn Edwards makes wooden sea kayaks in his spare time (see fig. 1). Each canoe takes around three months to complete and is crafted from hardwood strips and "two-pack" polyester resins. Made to his own design, these objects are sophisticated high-performance sports craft, built to a standard higher than that achieved by most professional boat builders. But why does Glynn build these canoes? He earns his living by being a general carpenter and odd-job man. Although a keen canoeist himself, he doesn't keep his kayaks for his own use—in fact he is anxious to see them leave his small workshop so that he can free up the space required to start the next project. Although he sells his canoes, it is very difficult for him to recover the costs incurred during the making process, and impossible to truly recompense for his labor. As Glynn puts it, "I spend my spare time working for the minimum wage."[1]

Glynn is one of a growing number of amateur male makers who are deeply involved in activities that require much time, effort, and skill yet produce little or no financial or status compensation. This essay asks whether such activities for which extrinsic rewards are minimal provide men today with a set of intrinsic rewards of their own—and if so, what are these rewards?

ACCOUNTING FOR DO-IT-YOURSELF

In the period after the Second World War a huge interest in home improvement and home craft activity emerged in Britain and the United States. As a response to this, publishers and manufacturers developed new periodicals and product ranges, which in turn

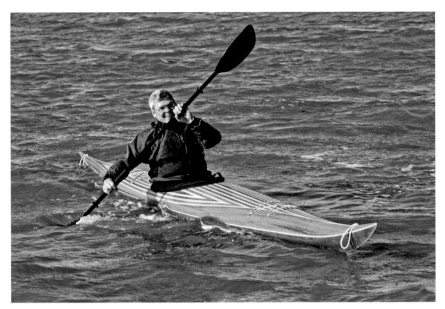

1 Glynn Edwards, sea kayak, 2006, North American cedar and polyester resin composite. Photo: Andy Mullins.

further stimulated demand.² In this period home ownership grew enormously, and there was a change in the attitude of the householder. Home improvement was no longer tackled only out of necessity but as part of a project leading to more aestheticized lifestyles, a way of establishing status and identity, and a means for self-actualization.³

In spite of the social and cultural significance of DIY, very little research has been carried out in the area of amateur making. Judy Attfield acknowledged that "DIY is an aspect often mentioned in passing, but still not accorded much attention by design historians," while Paul Atkinson believes that one of the reasons that DIY has rarely been examined in published studies is the problem of definition.⁴ There is uncertainty about where it should sit in relation to the discourses of art, design, and craft, and the phrase *Do It Yourself* means different things to different people. The common-sense understanding of the term (in both the UK and the United States), and the angle taken by a large proportion of the published research on the area, is a reference to home improvement activity.⁵ In other words, it popularly relates to the carrying out of tasks normally associated with the building trade, by amateurs in their own home and on their own time. However, as several essays in this volume investigate, over the past thirty years DIY has taken on a

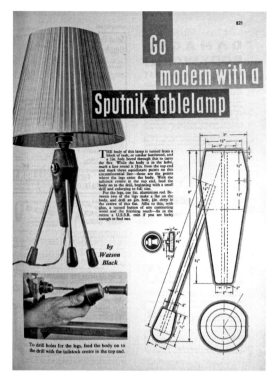

2 How-to illustration, *Practical Householder* magazine (UK), August 1961. © IPC Media 2009.

much broader range of meanings. At one extreme the term can be used to describe the most prosaic of home maintenance activity—applying a coat of paint to a wall, or putting up basic shelving—while at the other, it represents home-grown political protest—from underground publishing and alternative music to the organization of anticorporate protest movements discussed elsewhere in this volume. Historically, the content of popular DIY magazines published during the 1950s and 1960s is further evidence of the flexibility of the term.[6] The subject matter of British magazines such as *Practical Householder* moved from instructions on house maintenance and basic building jobs to, by the early 1960s, catalogues of design ideas, with technical drawings detailing the design and construction of household furnishings, such as lights and wardrobes (see fig. 2).[7]

As well as struggling with definition, recent studies have also tended to focus on utilitarian, rational, and economic factors (such as the saving of money and increasing the value of one's house) together with the social qualities of the activity (conspicuous consumption, the objectification of identity, and so on).[8] While these studies emphasize the re-

sults rather than the process, this discussion does not consider amateur making as purely a form of symbolic representation—as signs and symbols—but centers instead on the materiality of the experience. In *Materiality and Society*, Tim Dant has argued that approaches that treat material culture purely as symbolic representation fail to recognize the specificity of the object.[9] According to Dant, "material objects contribute to human cultural life in an even more fundamental way than signification, through embodied interaction with the object," with subjectivity being "enhanced as material forms extend the possible actions of the body."[10] Human/object interaction is more than simply a means of communication. It is also a form of "work"; it is about sustaining and maintaining environments and artifacts that enable a particular lifestyle to continue. In addition to this functional appraisal, human/object interaction may also be a form of pleasure seeking, a quest for sensation and emotion. Every act of exteriorization is also an act of interiorization—objects are extensions of our minds. As Merleau-Ponty observed, one's own body is not only a thing, a potential object of study for science, but also a permanent condition of experience, a constituent of the perceptual openness to the world and to its investment.[11]

THE PRO-AM

DIY in the context discussed here refers to the making of complex, self-contained objects, which are made in what is considered by the makers to be their leisure time—time outside of their paid profession. These making activities contain varying levels of design input, from minimal modification of existing patterns to completely original conception of new objects. Though they may sell their work, financial reward is unlikely to be the prime motivating force for these makers. So, to return to the central question: why is the experience of making things so compelling that many will spend large amounts of their free time carrying out activities that others would regard as alienating work? In order to answer this, it is helpful to consider the relation between work and leisure, and between the professional and the amateur.

In their report *The Pro-Am Revolution*, Charles Leadbeater and Paul Miller observe how the twentieth century was shaped by the rise of the professional.[12] In all areas, formerly amateur activities gradually became more organized, with knowledge and procedures becoming increasingly codified and regulated: "As professionalism grew, often with hierarchical organizations and formal systems for accrediting knowledge, so ama-

teurs came to be seen as second rate. Amateurism came to be a term of derision. Professionalism was a mark of seriousness, and high standards."[13] Fundamental to Leadbeater's and Miller's definition of Pro-Am is the fact that the results achieved by amateurs are often as good as if not better than those achieved by professionals working in the same area. Many of the Pro-Ams identified in their report have an ambition to take up their pastime professionally, either when they reach their next life stage or, in the case of semi-professional sportspeople and musicians, if they are able to get a break that allows them to give up their day job. For most this break never comes, and they continue to pursue their activities as Pro-Ams, often sinking large amounts of their professional income into their amateur activities. The cost of achieving professional standards, however, is continually falling; affordable amateur equipment is now equal in sophistication to the professional equivalent. The increasing sophistication and availability of power tools, for instance, means that amateur makers now have techniques and processes at their disposal that twenty years ago would only be available to professionals.

Leadbeater and Miller place Pro-Am on a continuum between professional and amateur:[14]

		Pro-Ams		
devotees, fans, dabblers, and spectators	skilled amateurs	serious and committed amateurs	quasi-professionals	fully fledged professionals

3 The Amateur/Professional continuum

As Robert Stebbins has observed, the Pro-Am pursues an activity as an amateur, mainly for the love of it, but aims to set a professional standard. Pro-Ams work at their leisure, but they force us to distinguish between "serious leisure" and "casual leisure," between "active leisure" and "passive leisure."[15] Above all Pro-Ams report being absorbed in their activities, which yield intense experiences of creativity and self-expression. If we use the psychologist Abraham Maslow's oft-cited "hierarchy of needs" to position Do-It-Yourself, then house maintenance might be positioned fairly near the bottom of the hierarchy, while the self-directed making of objects is closer to Maslow's idea of self-actualization, which is positioned at the top—it is the motivation that comes into play when all other needs have been met. For Maslow,

the characteristics of self-actualizers include spontaneity in ideas and actions, creativity, and an interest in solving problems.

WORK AND LEISURE

In *The Art of Work*, Roger Coleman gives a powerful and familiar description of the limitations imposed by extrinsic reward and the ways in which this helps to define the nature of professional work—a description informed by work he performed as bench joiner.[16] The joiner is constrained by his employer, the building firm. He has no choice about what he makes, how he makes it, or the length of time he is allowed to spend making it. Consequently, he also has no control over the standard to which he is able to work. Poor pay and a bonus system ensure that he has little choice and little power over his working life. The alternative to employment as a joiner is work as an independent self-employed craftsman, which grants more freedom and control to the worker. He can set his own standard and determine his own hours. If he designs the work himself, he can also choose his materials and invest in the work the qualities he thinks it ought to have. However, his customers are willing to pay only a certain amount for his work—and this is often less than the work is worth—so he ends up exploiting himself, much of the time, "working long hours for little financial reward, worrying about money and the quality of my work, and trying to balance the pressure of bills against my own desire to work creatively."[17]

Owing a heavy debt to the writings of John Ruskin and William Morris, Coleman's book presents a romantic view of preindustrial society. However, some of the concepts he draws from his accounts of pre-industrial societies do offer valuable insights for our modern understanding of free time. Describing the attitude of the "great Renaissance artists," he writes: "Work for them was not the alienating self-denying anti-autonomous activity that we see."[18] He justifies this assertion by discussing the idea of surplus value, arguing that in preindustrial societies, surplus value was expressed as free time.[19] In these societies, ritual activities abound—activities that may, in another context, well be regarded as work. This "work" acted as a way of making free time more significant: a ritualized, social, and cohesive activity that was part of natural and instinctive creativity. In contrast, as industrialization took hold, and as the division of labor became the key to increasing productivity and the efficient use of labor, the surplus value produced by the crafts was no longer available as free time that could be reinvested into

social well-being but was instead stripped away as profit. In other words, rather than being invested in the work itself, surplus value was instead invested in machines to replace skill, and the trades and crafts were rapidly and inevitably dehumanized.

For Coleman there are two alternative motivating forces for work. He describes them: "Profit: Something extracted from labor and raw materials via a reductive process in which everything is expressed as money. Or art: a constructive process in which labor and raw materials are converted into complex cultural goods which have the ability to provide for a broad spectrum of physical and spiritual and emotional needs."[20] In order to overcome the alienating affects of dominant, profit-driven work, Coleman proposes a world that depends not on "finalized, finite designs, but on open procedures in which people can participate in designing and making their own surroundings."[21] In effect Coleman was making an early case for customized consumption: the principle that the involvement of the consumer in self-directed completion of the production process (which is itself incorporated into the act of consumption) can overcome the alienation inherent in mass production and its corollary, mass consumption.

INTRINSIC REWARDS AND OPTIMAL EXPERIENCE

There is a parallel between Coleman's embryonic ideas put forward in the late 1980s and a more recent study by Colin Campbell.[22] The idea of "interpretive consumption"—the theory that the meaning of mass-produced objects is somehow "completed" by the act of consumption—has been commonplace in cultural and media studies since the 1960s. However, in an attempt to identify what he sees as a new model of consumer, Campbell has defined "craft consumers." He argues for a category that could describe the consumer as "self-actualizer," which, he suggests, is an addition to Don Slater's models of consumer as either "hero" or "dupe," and Mike Featherstone's idea of the consumer as "postmodern strategist."[23] For Campbell there is a category of consumers who "consume principally out of a desire to engage in creative acts of self-expression . . . [though] there is no assumption that they are trying to create, or even necessarily to maintain a sense of identity."[24] As Campbell points out, this is not to deny that consumption may relate to issues of identity. "It is merely to reject the prevalent postmodern assumption that consuming is motivated by a desire to create identity."[25] Craft consumption involves the production of an object that is both

designed and made by the same person, and it involves the application of skill and judgment; it can be understood as a way of maintaining a sense of individual agency in the face of alienating mass production. As examples of craft consumption Campbell cites the planning and preparation of a meal, the assembly of a wardrobe of clothes, and the design and maintenance of a garden. Although this is similar to the definition of craft used to describe preindustrial production, the crucial difference is that the components used in craft consumption are themselves industrially produced. Campbell's craft consumption is also defined as having an autotelic or aesthetic dimension, which gives it a fundamental resemblance to play—or, to use the terminology of the American psychologist and scholar Mihaly Csikszentmihalyi, "flow."[26]

Flow is described by Csikszentmihalyi as a form of pleasure resulting from a merging of action and experience; a loss of ego in which the participant can neither reflect on an activity nor consider the results—but nevertheless remains in control of his or her actions and environment. The ideal conditions for the state of flow occur when the participant is challenged but not overwhelmed by the activity. Pursuits that are too demanding cause anxiety and are unpleasant, while those that fail to stretch the participant are quickly perceived as boring and are dropped in favor of more interesting activity. According to Csikszentmihalyi, flow takes place somewhere between anxiety and boredom. It is the essence of experienced creativity: deep concentration, problems left behind, lack of self-consciousness, time forgotten, and an experience worth having simply for its own sake and with no other reward.

Csikszentmihalyi uses the example of sailing in a fresh breeze to illustrate the idea of flow: "It is what the sailor holding a tight course feels when the wind whips through her hair, when the boat lunges through the waves like a colt—sails, hull, wind, and sea humming a harmony that vibrates in the sailor's veins."[27] In *Optimal Experience*, Csikszentmihalyi observes how artists become completely engrossed in the process of making a painting, the work filling their thoughts twenty-four hours a day.[28] But "as soon as the paint was dry, [the artist] usually stacked the canvas in a distant corner of the studio against a wall and promptly forgot about it."[29]

Most artists recognize that their work is not going to make them famous or rich—so what, he asks, is the motivation for their continued practice as painters? Since the mid-sixties Csikszentmihalyi has devoted his career to understanding the intrinsic rewards that are associated

with the making of art, the playing of sports, and working in fulfilling oc-
cupations. His aim, over the thirty years during which he has developed
his ideas, has been to apply the concept to as many fields as possible.
Indeed, his ideas are pervasive: they have been taken up and applied by
academics in fields as varied as education, business studies, sports psy-
chology, and subcultural theory.

Is flow related to most people's experience of leisure? Csikszentmi-
halyi reports that the flow experience occurs more than three times as
often in work as in leisure. One might also question the relevance of flow
to leisure as most leisure activities in our culture tend to be passive and
nonchallenging—and flow depends on an optimal relationship between
challenge and skill.

In order to resolve this contradiction, it is worth considering the re-
lation between work and the kinds of active and frequently demanding
pursuits associated with amateur crafts. Are these activities a relief from
work, a compensation for the qualities deemed to be missing from the
experience of work, or is the job experience so powerful that it spills over
into free time, causing leisure activities to become a mirror of work?
The historian Stephen Gelber, who has carried out extensive research
into the hobbies and pastimes of pre-1950s America, pins his study on
the concept of "productive leisure" and the impossibility of separating
work from free time; he is interested in the inevitable seepage between
the two.[30] Gelber coins the phrase "disguised affirmation" to describe the
ways that work values are replicated in the home, while simultaneously
compensating for its deficits. He writes: *"The productive leisure of hob-
bies has operated as a form of disguised affirmation, helping to sustain
the overarching ideology of capitalism by serving up its ideals in the pal-
atable form of domestic leisure."*[31] In order to avoid a simplistic oppo-
sition between labor and leisure, he argues that if his thesis is correct,
"people should embrace leisure that reflects values that originate in their
work and avoid activities that contradict those beliefs."[32]

MALE SPACE

Changes in the fundamental structure of the family home have further
contributed to the place of hobbies and pastimes there. A number of
social historians argue that during the twentieth century, working-class
interdependent communities largely gave way to privatized, insulated
spaces—a phenomenon which seems to have reached its apotheosis in
what Faith Popcorn terms "cocooning." Cocooning is the act of insulat-

ing or hiding oneself from the normal social environment, which may be perceived as distracting, unfriendly, dangerous, or otherwise unwelcome. The telephone and the Internet are inventions that have made possible a kind of socialized cocooning in which one can live in physical isolation while maintaining contact with others through telecommunication. Interestingly, Popcorn attributes multi-billion-dollar businesses of home improvement and private security in the United States to the trend of cocooning.[33]

The issues of privatized family spaces and changing domestic hierarchies were first raised in the 1960s and 1970s by Michael Young and Peter Wilmot in their two classic studies, *Family and Kinship in East London* and *The Symmetrical Family*,[34] in which they recognized that family homes had become privatized in an economic sense as well as a symbolic one. Home ownership increased rapidly after the Second World War, with rented accommodation giving way to mortgaged properties. The home became an economic asset as well as a place of residence, and home improvement was seen as the easiest way of maximizing the investment inherent in home ownership. Although men's role at this time was primarily seen as a provider of stable income, the amount of leisure time available to them was gradually increasing. Paid holidays became commonplace, and the working week shortened, often giving men weekends free of work for the first time. As the amount of leisure time increased, men were expected to spend more time in the home, supporting their family and contributing to the running of the household. Men found themselves in a situation where they were required to be simultaneously masculine and domestic. Some feared that they would become subsumed into an undifferentiated identity with their wives. This situation was in opposition to notions of masculinity that had developed in the nineteenth century around technology and industry. Unlike the predominantly private world occupied by female members of the household, the masculine sphere of work was for the most part public. In addition, while the man's role could be characterized as one of production, women were more likely to see themselves (and be seen) as consumers. As these values were carried over into men's function as homebuilders, a new domestic masculine space developed.

In *Slow Motion: Changing Masculinities, Changing Men*, Lynne Segal draws attention to home improvement as a component of family life. She cites a manual from 1958 for middle-class men that "indicates what [men] might have been up to in the home: hammers, saws, smoothing

tools, gripping tools, boring and drilling tools, scissors, nails, screws and glue are successively illustrated and explained. The book contains not a single reference to children, housework or any activity traditionally regarded as women's work."[35] DIY and home improvements allowed men to actively participate in family activities while retaining spatial and functional autonomy. Household repairs and maintenance allowed men to stay at home without feeling emasculated. They replicated and reinforced work values and provided a sense of psychological fulfillment. Because jobs around the house had an economic value attached to them, they also carried the legitimacy of masculine skilled labor. Women could carry on the role of prime consumer by making decorating decisions and buying specially packaged tools as gifts for their husbands, while men could sustain and reinforce their role as producers. Father-son relationships were key to these activities, and home workshops were seen as a healthy way of building respect among the male members of the family. Like sport, craft became an emblem of masculinity—an equivalent to the public sphere of work but in the domestic environment. It was considered good for the son to see the father working and reinforced the father-son bond.

More recently, the publication of *Make* magazine reveals that many amateur makers earn their living from a field related to their hobby but use their leisure time to work in a way that the strictures and structures of their job disallow (see fig. 4).[36] The makers featured in this quarterly magazine engage in forms of extreme hobbyism, examples of which range from the designing and building of a working roller coaster in a domestic yard to the making of an alarm clock that wakes the user by frying strips of bacon. The *Make* motto, "If you can't open it, you don't own it," neatly expresses the desire among some consumers to regain control of the individual agency that is sacrificed when products arrive hermetically sealed and impervious to any creative modification or repair by the end-user.

Sometimes described as being driven by a "protestant leisure ethic," extreme pastimes such as these have been referred to as "serious leisure." Serious leisure is substantial enough for the participant to engage in the long-term acquisition of a range of special skills, knowledge, and experience. The activity integrates participants into a subculture and provides them with the benchmarks by which they can measure their performance. People seeking flow in their pastimes will tend to make them

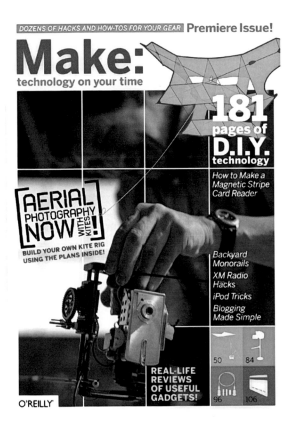

DOZENS OF HACKS AND HOW-TOS FOR YOUR GEAR | **Premiere Issue!**

Make:
technology on your time

181
pages of
D.I.Y.
technology

How to Make a
Magnetic Stripe
Card Reader

[AERIAL
PHOTOGRAPHY
NOW WITH KITES !]
BUILD YOUR OWN KITE RIG
USING THE PLANS INSIDE!

Backyard
Monorails
XM Radio
Hacks
iPod Tricks
Blogging
Made Simple

50 84

**REAL-LIFE
REVIEWS
OF USEFUL
GADGETS!** 96 106

O'REILLY

4 *Make: Technology on Your Time*, volume 1, premiere issue, February 2005. Published by O'Reilly Media, Inc. Copyright 2005 O'Reilly Media, Inc.

more worklike, hence more challenging—always safe in the knowledge that they can quit if the challenge becomes overwhelming. Some leisure activities are worklike in that they are complex and demanding, and even at times unpleasant, but they remain within the boundaries of leisure, because they are self-directed and contain an element of freedom of choice.

THE FLOW OF MAKING

The intrinsic rewards associated with the experience of making are a powerful motivational goal in the choice of leisure activities. Glynn Edwards compares the experience of individually fitting the strips of timber on his handmade canoes with the pleasure felt when he is on his own in his kayak, simply paddling out to sea. Glynn was originally in the Royal Navy but has since learned his making skills in the course of renovating his flat. It was the profits from the sale of this property

that allowed him to invest in a small workshop and begin making his canoes. Although he sells his canoes, he acknowledges that the amount of work that he puts into them means that he would never recoup his costs, though he regards the work as more than simply a hobby. Whenever he has a break in his paid work—which is unrelated to his canoe building—he comes to his small workshop and, as he puts it, "enters into another world." Glynn's previous job working as a CAD operator for an engineering company had him "going stir crazy," and although he now has a paid occupation that is more suited to his practical nature, he still regards the time spent in his own workshop as a form of therapy. The construction of a new kayak requires some research and planning but once the jig is built, a series of familiar processes ensue. These are demanding, but because Glynn has developed the skills necessary to carry them out effectively, they do not cause anxiety.

The fact that he is working in the controlled and secure space of his own workshop allows him to control his actions and environment and center his attention on a limited stimulus field. His tasks provide coherent demands for action and offer immediate feedback. For Glynn, making his kayaks allows him to lose his sense of self in his activity, and his sense of time becomes altered. Although the reward is partly constituted by the completion of a beautiful new kayak, the prime motivation for Glynn is intrinsic to the process of making, and his account of the experience of making things has all the qualities of the Csikszentmihalyi flow model.

Glenn's kayak making exemplifies how the motivation for amateur making cannot be fully accounted for under models of the consumer as rational economic agent, careful manipulator of symbols, or passive dupe of the market. By interrogating the moment-by-moment experience of making things, we can see that the experience of the activity, rather than the symbolic or functional content of the results, provides a motivational force that transcends material and social rewards. It is likely that these intrinsic rewards not only encourage amateur makers to return to their hobby again and again but also allow them to regain a sense of personal agency and well-being. Studies in consumption have consistently drawn on the Hegelian notion of alienation in order to describe the state of unhappy consciousness that results from a world in which the production of objective culture has far exceeded our ability to incorporate it subjectively into our personal and social development.

Put simply, in order to assimilate the objective world into our subjective consciousness we have to recognize the world as made by us. If we fail to see this, then we comprehend our material surroundings literally as alien to us. Our agency, our ability to act as an autonomous and creative power, is reduced to our capacity simply to choose and consume from a range of predetermined objects and practices. As this fieldwork has shown, the wish of amateurs to craft, to engage in creative acts of production, is motivated by a desire not only to enjoy the intrinsic rewards associated with the flow of the making process but also to escape the alienating characteristics of constrained work.

NOTES

1. As part of a wider program of ethnographic research carried out between 2007 and 2009, ten in-depth interviews were carried out with a range of amateur makers living in South-East England. These were all men who had built and maintained their own workshops in, or close to, their own home. This article focuses on the experience of Glynn, who was one of the first to take part in the study.

2. Carolyn M. Goldstein, *Do It Yourself: Home Improvement in Twentieth Century America* (New York: Princeton Architectural Press, 1998).

3. Abraham H. Maslow, *Motivation and Personality*, 2nd ed. (New York: Harper and Row, [1954] 1970). This process seems to concur with Maslow's hierarchy of needs. The psychologist Abraham Maslow placed "self-actualization" at the pinnacle of the hierarchy of human needs, to be satisfied only after the basic needs for food, clothing and shelter, safety, belonging, and esteem. The realization that the consumer culture of the 1960s was ripe for new self-actualizing products led to a revolution in marketing in 1970s America.

4. Judy Attfield, *Wild Things: The Material Culture of Everyday Life* (Oxford: Berg, 2000), 73; Paul Atkinson, "Do It Yourself: Democracy and Design," *Journal of Design History* 19, no. 1 (2006): 1–10. Also see Gerry Beegan and Paul Atkinson, "Professionalism, Amateurism and the Boundaries of Design," *Journal of Design History* 21, no. 4 (2008): 305–13, for a discussion of the meanings of professional and amateur in relation to design.

5. Alison J. Clarke, "The Aesthetics of Social Aspiration," *Home Possessions: Material Culture Behind Closed Doors*, ed. Daniel Miller (Oxford: Berg, 2001), 23–45; Goldstein, *Do It Yourself*; Kevin Melchionne, "Of Bookworms and Busybees: Cultural Theory and the Age of Do-It-Yourselfing," *Journal of Aesthetics and Art Criticism* 57, no. 2 (1999): 247–55.

6. Magazines consulted for this research included *Practical Householder* and *Do-it-yourself*, both published in the UK from the mid-1950s, with *Practical Householder* running until the early 1990s.

7. Andrew Jackson, "Labour as Leisure—The Mirror Dinghy and DIY Sailors," *Journal of Design History* 19, no. 1 (2006): 57–67.

8. J. Dent, "The DIY Pioneers," *All Mod Cons* (UK: BBC TV Broadcast/VHS, 1997);

Clive Edwards, "Home Is Where the Art Is: Women Handicrafts and Home Improvements, 1750–1900," *Journal of Design History* 19, no. 1 (2006): 11–21; Attfield, *Wild Things*; Miller, ed., *Home Possessions*; H. F. Moorhouse, *Driving Ambitions: An Analysis of the American Hot Rod Enthusiasm* (Manchester: Manchester University Press, 1991); Elizabeth Shove et al., *The Design of Everyday Life* (Oxford: Berg, 2007); Jo Turney, "Here's One I Made Earlier: Making and Living with Home Craft in Contemporary Britain," *Journal of Design History* 17, no. 3 (2004): 267–81.

9. Tim Dant, *Materiality and Society* (Maidenhead: Open University Press, 2005).

10. Ibid., 109.

11. Maurice Merleau-Ponty, *Phenomenology of Perception* (London: Routledge, [1945] 1992).

12. Charles Leadbeater and Paul Miller, *The Pro-Am Revolution: How Enthusiasts Are Changing Our Society and Economy* (London: Demos, 2004).

13. Ibid., 12.

14. Ibid., 20.

15. Robert Stebbins, *Amateurs, Professionals and Serious Leisure* (Montreal: McGill-Queens University Press, 1992).

16. Roger Coleman, *The Art of Work: An Epitaph to Skill* (London: Pluto, 1988), 143. In his long and varied career since graduating from art school in the 1960s, Coleman has worked as a performing artist, joiner, political activist, designer-maker, and self-sufficiency expert. At the time of writing Coleman is now professor of inclusive design and co-director of the Helen Hamlyn Research Center at the Royal College of Art, London.

17. Ibid., 144.

18. Ibid., 141.

19. Ibid., 141–50.

20. Ibid., 148.

21. Ibid., 149.

22. Colin Campbell, "The Craft Consumer: Culture, Craft and Consumption in a Post-Modern Society," *Journal of Consumer Culture* 5, no. 1 (2005): 23–42.

23. Don Slater, *Consumer Culture and Modernity* (Cambridge: Polity, 1997); Mike Featherstone, *Consumer Culture and Postmodernism* (London: Sage, 1991).

24. Campbell, "The Craft Consumer," 24.

25. Ibid., 40.

26. Mihaly Csikszentmihalyi, *Beyond Boredom and Anxiety: Experiencing Flow in Work and Play* (San Francisco: Jossey-Bass, [1975] 2000).

27. Ibid., 3.

28. Mihaly Csikszentmihalyi and Isabella Selega Csikszentmihalyi, *Optimal Experience: Psychological Studies of Flow in Consciousness* (Cambridge: Cambridge University Press, [1988] 1992).

29. Ibid., 3.

30. Steven M. Gelber, *Hobbies: Leisure and the Culture of Work in America* (New York: Columbia University Press, 1999), 2.

31. Ibid., 11.

32. Ibid., 15.

33. See "Cocooning" in Faith Popcorn's Trend Bank, http://www.faithpopcorn .com/ (visited January 28, 2005).

34. Michael Young and Peter Wilmot, *Family and Kinship in East London* (London: Routledge and Kegan Paul, 1957); Michael Young and Peter Wilmot, *The Symmetrical Family* (London: Routledge and Kegan Paul, 1973).

35. Lynne Segal, *Slow Motion: Changing Masculinities, Changing Men* (London: Virago, 1990), 4.

36. Bob Parks, *Makers: All Kinds of People Making Amazing Things in Garages, Basements, and Backyards* (Sebastapol: O'Reilly Media, 2006).

Maria Elena Buszek
.

Crochet and the Cosmos

AN INTERVIEW WITH MARGARET WERTHEIM

argaret Wertheim is a science writer and cultural historian who, with her sister Christine Wertheim, a cultural studies professor, founded the Institute for Figuring (IFF) in 2003 in order to promote the public understanding of the poetic and aesthetic dimensions of science, mathematics, and the technical arts. Her research interests regarding the history of mathematics and physics led her to the work of Daina Taimina, a mathematician at Cornell University.

For two thousand years mathematicians knew about only two kinds of geometry: the plane and the sphere. The Greek mathematician Euclid established around the third century BCE the five major axioms, or postulates, of planar geometry. As Wertheim describes these in her *Field Guide to Hyperbolic Space*: "The first three are mundane enough, defining a line segment, an extended straight line, and a circle. The fourth also seems uncontroversial and is usually interpreted to mean that all right angles are equal." And "Euclid's fifth postulate also sounds eminently reasonable: it defines the conditions for parallel lines. But mathematicians have always sensed that this apparently sensible proposition needed further investigation . . . [as] Euclid's fifth axiom says that there is no more than one line I can draw through [any] point that will never meet the original line."[1]

In the early nineteenth century mathematicians became aware of another space, one in which parallel lines meandered in aberrant formations, which came to be known as the hyperbolic plane, in homage to the abundant excess of parallel lines it encompassed. Though the formalities of this space were known for

1 Margaret Wertheim, *Orange Anemone*, from the *Hyperbolic Crochet Coral Reef.* Copyright the Institute for Figuring. Photo: Alyssa Gorelick.

two hundred years, it was considered a purely theoretical space—impossible to represent in all but the most convoluted or fragile models. However, in 1997 Daina Taimina finally worked out how to make a simple and durable physical model of the hyperbolic plane using crochet, by simply increasing the number of stitches in each row. The resulting, warped surface of the crocheted object accommodates lines that violate Euclid's fifth postulate—a fact that is easily demonstrated by sewing stitched lines onto its surface to "verify materially the manifest untruth of Euclid's axiom" (see fig. 1).[2] These forms are also seen in nature, in ways that mathematicians are now starting to understand, in lettuces and kelps and corals, and the frills of other reef-dwelling sea creatures.

In *A Field Guide to Hyperbolic Space* and in the IFF's *Hyperbolic Crochet Coral Reef* project, Margaret Wertheim has delighted audiences with her accessible history of hyperbolic space and guides to its various manifestations in humble craft media. In this interview, Wertheim and the art historian Maria Elena Buszek discuss the ways in which these projects demystify the seemingly impenetrable world of advanced geometry, elevate the status of craft media from hobby to laboratory, and suggest a manner in which the so-called feminine or domestic arts might hold the answers to some of the most challenging scientific questions of the post-Enlightenment world.

Maria Elena Buszek: Tell me about why you began the Institute for Figuring.

Margaret Wertheim: The Institute for Figuring was really founded out of my frustration as a writer, journalist, and science communicator—which I've been doing for about twenty-five years now, my entire career—over the fact that there were all these areas of science and technology that I thought were interesting and that I was having trouble getting editors at science magazines and newspapers to see the value of. Stories like the Cornell University mathematician Daina Taimina crocheting hyperbolic space, or the chair of the CalTech Physics department (who works on gravity waves) with a hobby project about the making of individual snowflakes, on which he is a world expert. The snowflakes project actually addresses a very big problem in physics, since we don't exactly know how snowflakes form. I thought these stories were fascinating and would be a great way of communicating about science to people who don't subscribe to magazines like *Scientific American*, but I had a lot of trouble convincing editors to let me write about these things. They didn't see the importance of them, because what is deemed important in the minds of many scientists focuses on the supposedly "big" questions: How is the universe formed? What are the fundamental constituents of matter? And so on.

So, there's an enormous amount of coverage in the science press about things like string theory, and big bang cosmology, and particle physics. And, although such things are interesting—and they're certainly interesting to me—they represent a very limited end of the scientific spectrum, they are subjects that become pretty quickly arcane. They're great for people who have a fair bit of prior knowledge about science, but they seem absolutely abstruse and fairly impenetrable to the majority of people. I wanted to form an organization that would be a vehicle for me as a science writer to communicate about science, technology, and mathematics in new and innovative ways, focusing on what I consider to be their poetic and aesthetic ends of these disciplines.

MEB: That leads me to the IFF's book and exhibition *The Guide to Hyperbolic Space*, which seems to me one of those projects that you had a hard time getting the scientific community interested in, precisely because of its poetic potential.

MW: The project basically emerged after I read an article in late 2003 in an English science magazine about Dr. Taimina. The story of hyperbolic

space is one of the most amazing stories in the history of mathematics. For two thousand years, mathematicians from Euclid on had tried to prove that such a space was essentially impossible. It was only in the nineteenth century that mathematicians have realized that it *was* possible—in fact it was logically necessary. But it seemed a purely abstract thing. Then in 1997 Daina figured out that you could make models of this geometry using crochet. (Actually, she first tried knitting, but you quickly get lots of needles on the stitches, and crochet was a much better way.) So, this woman comes along, who grew up doing handicrafts in Latvia, and she said: "Well, you know, I *can* make models of this type of space using crochet."

This was pretty surprising to the mathematics world, and she and her husband—the Cornell mathematician David Henderson—began using them in their non-Euclidian geometry classes. And Daina has been invited by mathematics programs all over the world to make these models, because they're such a fantastic pedagogical tool; you can actually see the space, and feel it, and explore it with your hands. Mathematicians have never had that ability before; they've always had to represent hyperbolic space in a symbolic way, which is quite difficult for students to wrap their minds around. Daina's model has given them a tangible, physical model to see what it looks like.

And the funny thing is that hyperbolic geometry is not only *not* impossible, but organisms in the marine world have been utilizing these structures for hundreds of millions of years. Indeed, quite a lot of marine organisms have hyperbolic anatomical features: sea slugs with their crenellated frills, and a lot of corals and kelp and sponges are essentially versions of hyperbolic space.

Why didn't the mathematics world actually perceive that this is quite a common geometry in nature? Why did they believe that you couldn't have a model of this? Why was it that it took a woman to do it? This struck me as a project that had many ramifications, from higher mathematics, and the discovery of one of the most abstract forms of geometry, to physics, where this non-Euclidean geometry is the mathematics that underlies general relativity and our universe may be a hyperbolic structure. So this is a subject that links feminine handicraft to the biggest questions about the universe.

The project embodies so much of what I want the IFF to stand for: it speaks to the ways in which this realm of higher theoretical mathematics

2 The Institute for Figuring, *Hyperbolic Crochet Coral Reef*, with urchins by Christine Wertheim and sea slug by Marianne Midelburg. Copyright the Institute for Figuring. Photo: Alyssa Gorelick.

and physics are not removed from the other areas of our lives. Here is a link between a daily, delicate feminine practice and cosmology and also happens to link with marine biology. So, the hyperbolic space project has evolved into the *Hyperbolic Crochet Coral Reef* (see fig. 2) as a way to say that we could bring something beautiful into being through handicraft and show you the beauty of these coral forms—which people love and really relate to in a very tactile, amusing, charming way—and draw attention to the fact that reef ecologies are being devastated by global warming the world over, and if current trends continue there won't be any coral reefs on earth by the end of the century—maybe even a lot sooner. The current predictions are pretty dire.

And this leads to another aspect of the project that I find really critical: what I call its evolutionary aspect. The forms that our participants are now making—at this stage there are many hundreds of serious contributors around the world—allow people to bring new things to the project that Christine and I never would have initiated. All these forms, originated from very simple, algorithmic seeds that were developed by

Daina Taimina in order to make hyperbolic spaces. In this, all you have to do is increase stitches in each row: knit-(n) stitches, increase one; knit-(n) stitches, increase one. When you increase stitches every two stitches, for example, you get a model that gets crenellated very quickly; if you increase every twenty stitches, on the other hand, you get a form that is relatively flat and a lot less frilly. That was the complete initial discovery—utterly simple and utterly brilliant. But Christine and I gradually found that when we began deviating from that original formula the models started to look quite different and a lot more organic. For instance, we tried increasing every three stitches for a while, then every four, then every five, then back to three for a while, and we found that the forms changed quite substantially. So, what we've come to is that this is like an experiment in practical evolution; you have this simple, underlying code, but slight shifts in the code make radical differences to the morphology of the finished form. So do changes in the materials: if I make a form of synthetic yarn, I get something that looks very different than if I make that same form in a cotton thread, or a hairy thread, or plastic string. What we've found is that as we explore and make little deviations in the crochet "code," it's a parallel with making little deviations in the genetic code of life on earth. You get radical deviations as new "crochet species" come into being through shifts in the code, or materials (see fig. 3).

And, to our astonishment, every contributor who comes to this brings new innovations and new forms and new twists on old themes that we couldn't have imagined. In the process, it's become a global, practical, communal experiment in evolution. We have, for example, a contributor in Australia, Helen Bernasconi, who is a former mathematician and teacher, and now runs a sheep farm in Bonnydoon. Helen raises the sheep, spins the yarn, dyes the yarn, and crochets it—and she does the most meticulous mathematical constructions with this hyperbolic crochet. (Indeed, she makes spreadsheets of all the tentacles of its progress that she's going to make, so she can calculate exactly how much yarn in which colors she's going to have to produce.) And she makes these astonishing octopus-like forms, with a fundamental, hyperbolic circular form in the middle, from which shoot all these little hyperbolic pods, or pseudo-pods in tentacles off from the center. This is something we would have never imagined for ourselves, and Helen now has this sub-branch of the crocheted-species universe all to herself. Then we have another contributor in Los Angeles, an African American woman

3 *Ladies Silurian Atoll*, from the *Hyperbolic Crochet Coral Reef*. Photo copyright the Institute for Figuring. Photo: Margaret Wertheim.

named Shari Porter—who makes these fantastic, free-form pieces—who claims that the Holy Spirit guides her. She doesn't count stitches, or even formally know what she's doing, but like the great Shaker women crafters she's channeling the Holy Spirit, who guides her hand in making these free-form pieces. Never in a million years would Christine and I have arrived at these forms on our own, so we see this thing as not only a collective, communal, feminist engagement but also a genuine experiment in evolution. How many ways can the formula be tweaked? How many little riffs on the underlying algorithm can you make? And we've come to the conclusion that it's actually infinite—that there's no end to the diversity of life, and so there is no end to the diversity of these forms.

MEB: And each individual in this community is essentially their own "laboratory," experimenting with these forms.

MW: I've never thought of it quite like that, but absolutely! It demonstrates that these women—and our contributors *are* 99.999 percent women—are effectively doing experiments. They're exploring the methodologies of science through a domestic handicraft. And that is one of the most powerful elements of this project, and a wonderful example of how scientific practices and ways of thinking can indeed play themselves out in an arena that wouldn't be included as part of the sci-

entific domain. But it is, indeed, a scientific way of thinking and a scientific practice that is being enacted here.

Ultimately, this all reflects the fact that the IFF is trying to promote the notion that mathematics and science are not things that happen in a vacuum. It's not just the super-brains like Stephen Hawking thinking higher thoughts away from the rest of the world, but that these subjects have their tentacles in almost every area of mundane, daily life. I want us to make these connections in science—let's not just present science in this abstract, disembodied void. Let us see how it invests itself in all kinds of practices and environments, and is done by all kinds of people—not just professors at Harvard and Princeton and MIT.

MEB: Do you find that, besides the "hard science" community's hostility toward this kind of interdisciplinary knowledge that you're describing, this particular distrust also reflects a certain amount of sexism?

MW: The scientific community isn't hostile to what we're doing. For the most part they just haven't been much interested. All the IFF support so far has come from the art world, and that's really surprised me, because the project was conceived as a way of communicating to people about science and technology, as an outgrowth of my work as a science writer. I think there's also the issue that the IFF is not happening within the framework of an accredited university; we're just a quirky little foundation that's not operating off of any campus. So, it raises the issue of the "authority" of who is putting this on, and I think the science world is one that has become very concerned with issues of authority. This raises some very important questions for me: Why does such a project have to be endorsed under the auspices of an existing authority? Why does it have to be authorized by some Ivy League institution?

That said, I think that with the *Crochet Reef* project there *is* a specific issue over the fact that overwhelmingly the people doing the work are women. They are also people who are outside of positions of power in educational institutions: housewives, students, the elderly, kids from youth centers. Some of them are actually former mathematicians and research scientists. But participants are overwhelmingly ordinary women. And I think the science world, for all of its much-vaunted espousal of needing to reach out to wider communities about science, targets itself at a fairly elite, prestigious audience.

I think increasingly one of the problems with science is that it is presented in ways that are pretty alienating to many people. Yet, when one

sets up something like the IFF's crochet project, which demonstrates that science can be a tactile, enjoyable, aesthetically pleasing experience—which is a powerful way to introduce all sorts of people to some deep scientific areas—there doesn't seem to be any way of getting it supported—at least not financially . . . Keeping this afloat has been a real challenge.

MEB: It's interesting to me that you bring up the subject of hierarchies and authority in the scientific community that you've come up against, where certain sites of knowledge are policed or guarded. Because this comes up again and again in discussions about art and craft. Have you instead found that the traditional barriers between art and craft are more permeable in your dealing with both art museums and crafters?

MW: It's hard for me to comment on that because I'm not from the art world, but I'll comment in the way that I can. I came to the project looking at it as a craft-based project entwined with mathematics and science and ecology. It was Christine's idea to crochet the coral reef, and she's someone who knows a lot more about the art world than I do. She teaches at CalArts and taught at Goldsmith's College in London for a long time, so she's been teaching critical studies in art schools for at least fifteen years. But neither of us considers ourselves an artist, and we didn't conceive the project out of a desire to become artists; Christine has her own linguistic projects, and I still consider myself primarily a science writer—and for me that's where the project is located. The fact that we've been invited to some pretty important galleries I find pretty amusing, as I had thought that where we'd be invited was the science and natural history museums. But, the art world's been really open to it, and all thanks to them (see fig. 4).

The only definition of art that I've ever encountered that I can personally relate to is one that was written by a Welsh writer named Merrily Harpur, which I think is beautiful. She said: "The duty of artists everywhere is to enchant the conceptual landscape." By that definition of what an artist is, I'm willing to sign off on it. I think if you look at that definition, it's not about what medium you work in, or how you practice, but that you have this end goal or obligation. So, in some ways, the IFF was founded on the view that science and mathematics also fulfill this goal definition. I don't know if they have a "duty" to enchant the conceptual landscape, but it's certainly one of the functions—that they can,

4 The Institute for Figuring, *Hyperbolic Crochet Coral Reef*, 2009. Installation view, Track 16 Gallery, Santa Monica, California. Photo: Francine McDougall.

and often do fulfill. So, I'm not really interested in whether or not one is called an artist, but the activity of enchanting the conceptual landscape.

MEB: So, do you think that the humble and familiar materials by which the works in these projects are made is part of what has indeed "enchanted" the many audiences who have been drawn to it?

MW: Well, yes, definitely. There's no question that what makes them appealing is the confluence of very familiar, very good handiwork and an object whose understanding we have come to from some of the most difficult, intellectual mathematical thinking in our history. And I think for the women who engage with it, they find it enormously authorizing of themselves and their work to have it revealed to them that, through their own hands, and this domestic, feminine craft they can intersect with some of the very highbrow reaches of mathematical thinking. It's clear to me from the many, many workshops we've had that the women themselves get an enormous sense of uplift from that, and they can go home and tell their friends and family that they're not only crocheting the coral reef—which has ecological ramifications—but what they're actually doing has intersections with both mathematics and cosmology. Personally I don't think they need that authorization in order to validate the fact that they're sitting down to enjoy a knitting circle, but it's clear that it gives them an enormous sense of pride and a feeling that there are other dimensions to their work and what they're doing that are validated by other sections of society. What is funny to me is that the other

sections of society that value the mathematics and cosmology aspect of this project often disdain or ignore the crochet part of it.

MEB: That doesn't surprise me one bit, since as you've discussed it that community is so based on authority and hierarchies. And here is this project that is giving many unexpected populations access to that knowledge in ways that usurp their authority.

MW: Yes, I guess what I'd say is that it's very disappointing. I went into this project perhaps with a bit of utopian thinking, assuming that the scientific world would value the work these women are doing. And it's been disappointing to me, personally, because my professional background is in physics and math—I spent seven years at university doing both subjects because I loved them. I really thought that I was beginning a project that would lead to the enfranchisement of a certain population that the official rhetoric of the science community claims to want to include and that they would embrace the project. That hasn't happened so far.

MEB: Especially when schools like MIT are congratulating themselves for putting lectures by professors like Walter H. G. Lewin on the Internet, supposedly leading to the teaching of physics to new audiences, which is still under the auspices of this Ivy League university and likely accessed only by relatively privileged audiences with computers and iPods.

MW: I'd be willing to bet that although Dr. Lewin's audience likely reaches all over the world—which I think is marvelous—it's clear from his website's comments that his audience is mostly men. There's certainly nothing wrong with being a great communicator and reaching men all over the world—he seems to have fans from India and Korea and very likely Africa—and being a tremendous teacher. But the fact is that women everywhere, including the United States, are disenfranchised from science education because the modalities for talking about it are distancing, alienating, and often uninteresting to them. And if we're really serious about wanting to incorporate women into the discussion, the science community needs to explore new ways of communicating. I believe that this project is a remarkably powerful way to communicate that knowledge, and we've seen it in workshop after workshop. Christine and I start them by talking about the wholeness of the project, and its mathematical as well as its marine biological and ecological dimensions,

and it's amazing to see these women soaking it up. They get it! And by the end of it, we have quite sophisticated conversations, and they make sophisticated observations about non-Euclidean geometry. This *is* science education, genuine scientific discourse, and it's not happening on a university campus, and it's reaching audiences who would never subscribe to *Scientific American*.

MEB: Do you feel, as someone who is coming to these craft media and processes from the science world, that you might be the ideal person not only to share what your research has taught you about the craftiness of the sciences but also to teach the sciences about the intelligence of craft?

MW: Actually, I grew up knitting, sewing, and crocheting.

MEB: So, you began this project open to the potential of these crosscurrents.

MW: Yes. Christine and I were brought up as complete girly-girls! Our mother, Barbara Wertheim, taught us to sew and knit and embroider. I literally cannot remember a time when I did not do those things. I went through my entire life doing these things, which fell by the wayside when I became a professional working woman. But when I heard about Daina's discovery, I thought: "Fantastic! I'd like to try this!" So, I ran out and bought some crochet hooks and wool and started doing it—and that was four years ago now. Since then, crochet has taken over my house. Literally! These forms have filled up the house where Christine and I live. Its really taken over our lives—like that giant carnivorous plant in the Roger Corman film *Little Shop of Horrors*.

For me, it's been utterly marvelous that I've been able to pair the making processes of my childhood—which I'd never lost the value of— with the scientific and mathematical principles that I'd studied as an adult.

I think it's a great pity that, while craft is back in fashion and craft is clearly groovy again, in the preceding decades it was very passé. I know lots of women in their thirties and forties who didn't grow up crafting and are learning it now, and I'm delighted to see the convergence of these practices.

MEB: As someone who has written rather extensively about the history of women in the sciences, and someone with a deep engagement with feminist history and theory, do you feel that the evolution of feminist

thought has brought about this new freedom to rethink the possibility of so-called feminine handicraft?

MW: I've wondered that myself, and I don't really feel that I could give anything but a personal answer to that question. I would like to think that feminism has played a role here, but I think that initially—in the seventies and eighties—feminism may have played a role in devaluing these processes. I mean, my mother, who had done all this crafting her whole life, was also a leading feminist advocate in Australia in the seventies. (Indeed, she set up some of the first women's shelters in Australia.) But for a while there it seemed that doing those "girly things" was something that women needed to *stop* doing—so they could go and become physicists and astronauts and so on. For a while, I think, feminism itself was a mitigating force *against* doing handicrafts. And I want to say that I totally understand that reaction.

But, thankfully, we've reached a new era of feminism that insists we reclaim all women's historical traditions by insisting that what women have done throughout history is valued and matters. I never know what "wave" feminism is in—fourth wave? fifth wave?—but I do think that we *are* in a new wave of feminism that does actually value these craft traditions.

That said, I think that we've hit something troubling at the moment in that craft is to a large degree being claimed by men as well—which I have no problem with! But somewhere on the IFF site, it mentions crochet as a "female practice," and we get these angry e-mails from men that say: "You can't say that! Men practice crochet, too!" And I have a standard e-mail that I send back to them more or less saying: "Thank you for your comments . . . but while it is certainly true that men do these things, it is *also* true that it has traditionally been a female practice, and we mean to claim that as a good thing."

You know, there was an article about the *Crochet Reef* project in an issue of *American Craft*[3]—as you know, the most established organ of the American craft movement—and, every major article in the magazine was about the work of men. Even the cover had a gorgeous photo of a very pretty young man [the artist William Ladd].

MEB: But, I think that this is a troubling part of the entire Studio Craft movement, going back to its origins in the nineteenth century. Right back to William Morris, who essentially took the needlework traditions practiced by women like his working-class wife Jane Burden and gave

them the artistic seal of approval that these women's work never enjoyed, by "studying," practicing, and marketing them as an upper-class, professional man. It's much like the professionalization of any practice historically associated with women, from cooking to education: in order for it to be taken seriously, it must be taken up by men. This isn't a new thing, but something that it seems to me generations of craft practitioners have in common.

MW: I'm sure you're right about that—but, honestly, when I received this issue of *American Craft*, I was just furious![4]

MEB: . . . about this masculine bias and fear of the amateur?

MW: It was just so stark and shocking to me. The IFF has a policy about our crochet project: any serious contributor is allowed in, and as curators of the project Christine and I can't "edit people out." One of our most amazing contributors is a woman named Evelyn Hardin, in Cedar Hill, Texas. Evelyn produces things, which she began sending us about a year ago, and they started as some of the most god-awful things you've ever seen. And then another box arrived, and it was even more ugly . . . and then *another* box of even more ugly stuff. But the woman is a genius! She produces stuff with a completely delicate loveliness that is astounding—but mostly it's just this crazy, feral work. It made us realize how precious our perspectives on the project had become, and how "pretty" everything was. And once Evelyn's boxes started arriving, it rejuvenated us and made us realize how wild we needed the project to remain. She illuminated the project's raw, vital, and always-forming qualities, and our need for it to never become tchotchke-ized. Because that is what's happening with craft magazines—the work is reduced to eminently purchasable tchotchkes. They sell pretty things for tens of thousands of dollars and aim to show the work in the white cube of the art gallery.

We do not want the IFF's crochet to become tchotchkes and want to maintain the participation of people who may have never encountered that white cube. Granted, we are absolutely joyful that we are able to get women like Evelyn Hardin into the Heyward Gallery or the Andy Warhol Museum—but because these major art galleries generally don't show middle-aged women at all, and certainly not those from Cedar Hill, Texas. So, we feel like one little thing that we can do is to insert these voices into these places. Evelyn's certainly not going to be next Jeff Koons, but the idea that audiences at an art museum are looking

at Evelyn Hardin rather than Jeff Koons for a change is a powerful and positive thing.

MEB: As is simply valuing and promoting the idea of "the feral," whether it's in regard to art or craft or science!

MW: One of the ways in which we think about the IFF is precisely as a feral science communication project. Quite apart from crochet, we have many projects that are done by outsiders to the science and math communities, to promote the bigger issue that these disciplines are being practiced by those outside of academia. Science and mathematics are actually embedded out there in "the hinterlands"—let us not just look to Harvard and Princeton, but Cedar Hill. Maybe not in ways that will be published in *Scientific American* or in physical-review letters, but are nevertheless exciting and interesting.

NOTES

1. Margaret Wertheim, *A Field Guide to Hyperbolic Space: An Exploration of the Intersection of Higher Geometry and Feminine Handicraft* (Los Angeles: Institute for Figuring, 2006), 14, 21.
2. Ibid., 38.
3. Wertheim is here referring to the following issue, whose cover feature concerned the designers Stephen and William Ladd: *American Craft* 67, no. 6 (December/January 2008/09).
4. While Wertheim's frustration was largely aimed at the fact that this was the much-anticipated inaugural issue of the newly reorganized and staffed *American Craft*, and I feel that it is important to point out that the cover stories in all the issues since have focused mostly on women artists.

CONTRIBUTORS

ELISSA AUTHER is an associate professor of contemporary art at the University of Colorado, Colorado Springs. Her book *String, Felt, Thread: The Hierarchy of Art and Craft in American Art* examines the innovative use of fiber in American art and the impact of the medium's elevation on the conceptual boundaries distinguishing "art" from "craft" in the postwar era. She is a co-editor of the forthcoming volume *The Countercultural Experiment: Consciousness and Encounters at the Edge of Art.* Auther also codirects Feminism and Co.: Art, Sex, Politics, a public program at the Museum of Contemporary Art, Denver, designed to explore feminist issues in popular culture, social policy, and art through creative forms of pedagogy.

ANTHEA BLACK is a Canadian artist, art writer, and cultural worker. Her projects in printmaking, collaborative performance, writing, and curating take various forms but most often feel at home within the Canadian artist-run network. Her work has been exhibited in "GENDER ALARM! Nouveaux féminismes en art actuel" at La Centrale in Montreal (2008) and "Gestures of Resistance" at the Museum of Contemporary Craft in Portland (2010). She has held positions at several galleries, arts organizations, and periodicals, including Stride Gallery, the Art Gallery of Alberta, M:ST Performative Art Festival, *Shotgun-Review.ca*, and *FUSE Magazine*.

BETTY BRIGHT is an independent scholar, curator, and teacher. She helped start the Minnesota Center for Book Arts, a leading U.S. book arts center, where she worked for nine years as program director and curator of more than fifty exhibitions, several of which toured nationally with catalogues. In her book *No Longer Innocent: Book Art in America, 1960 to 1980,* Bright discusses key works and larger societal influences that shaped book arts, thus demonstrating how the book form affected art movements sympathetic to its properties and potential as a site and source of art making. Bright is currently researching the rejuvenation of letterpress printing in the United States from 1980 to the present, supported in part by a grant from the Center for Craft, Creativity and Design.

NICOLE BURISCH is a Canadian artist, critic, curator, and cultural worker. Her practice focuses on contemporary craft and craft theory—in particular cross-disciplinary uses of craft-based media and their intersections with historical craft, activism, performance, social practice, and curatorial approaches. She

has presented and published writing on this topic for both Canadian and international conferences, and for publications including *Utopic Impulses: Essays in Contemporary Ceramics* and *The Craft Reader*. Burisch worked as the director of the Mountain Standard Time Performative Art Festival from 2007 to 2009, and is the co-founder (with Anthea Black) of the Alberta-based arts journal *Shotgun-Review.ca*.

MARIA ELENA BUSZEK is a critic, curator, and associate professor of art history at the University of Colorado, Denver. She is the author of *Pin-Up Grrrls: Feminism, Sexuality, Popular Culture* and has contributed to numerous international anthologies and exhibition catalogues. Her writing has appeared in such journals as *Art in America*, *Photography Quarterly*, TDR: *The Journal of Performance Studies*, and *Woman's Art Journal*. Buszek is also a longtime contributor to the popular feminist magazine BUST.

JO DAHN is a senior lecturer in historical and critical studies in art and design and a higher degrees tutor for art and design at Bath Spa University, England. She has published many articles on ceramics, many of which challenge and expand readers' perception of contemporary work in clay. Dahn is also the submissions editor for *Interpreting Ceramics*, an international peer-reviewed journal.

M. ANNA FARIELLO is a professional curator, a research professor and director of the Craft Revival at Western Carolina University, and a former James Renwick Fellow in American Craft. A former research fellow with the Smithsonian American Art Museum and field researcher for the Smithsonian Folklife Center, she is the recipient of the 2010 Brown Hudson Award from the North Carolina Folklore Society. Fariello serves on the board of the World Craft Council and was a senior Fulbright Scholar. She is the author of several works, including *Cherokee Basketry: From the Hands of Our Elders*, and co-author of the textbook *Objects and Meaning: New Perspectives on Art and Craft*.

BETSY GREER is the founder of craftivism.com. She writes, makes, and thinks too much in a small college town in North Carolina. While getting her master's in sociology from Goldsmiths, University of London, she helped teach knitting lessons in venues throughout England, actively spreading the word about radical crafting and its political possibilities.

ANDREW JACKSON is a senior lecturer at Canterbury Christ Church University. He has a background in commercial design and applied arts and holds a master's degree in design history from Middlesex University. His research interests center on theories of consumption, particularly in relation to amateur design and craft practice. His work has been published in the *Journal of Design and Culture*, and in 2006 he was a contributor to the special Do-It-Yourself issue of the *Journal of Design History*. His quest for flow leads him to devote his spare time to sailing, drumming, and, naturally, DIY.

JANIS JEFFERIES is a professor of visual arts at Goldsmiths, University of London. She is an artist, writer, and curator, as well as the director of the Constance Howard Resource and Research Centre in Textiles and artistic director of Gold-

smiths Digital Studios, an interdisciplinary research center for art, technology, and cultural processes. She was one of the founding editors of *Textile: The Journal of Cloth and Culture* and recently edited *Transformations: Objects, Traces and Technology*. Recent publications include "Laboured Cloth: Translations of Hybridity in Contemporary Art," in *The Object of Labor: Art, Cloth, and Cultural Production*, and "Contemporary Textiles: The Art Fabric," in *Contemporary Textiles: The Fabric of Fine Art*. For the last three decades, her artwork, criticism, and curatorial activities have been at the center of debates about art and craft, feminist visual culture, and labor and cultural production.

LOUISE MAZANTI lives in Denmark, where she works as a teacher, curator, and writer. She is also the author of a comprehensive series of articles and catalogue contributions on crafts. In 2006 Mazanti obtained Scandinavia's first PhD degree in craft theory, from the Danish Design School, where she developed a theoretical position which identifies craft as a practice independent of art and design discourses. She is a former professor of craft and design theory and history at Konstfack in Stockholm, a member of THINK TANK: A European Initiative for the Applied Arts, and exhibition reviews editor of the *Journal of Modern Craft*. Mazanti has also held numerous honorary positions at Danish and foreign institutions and lectured in numerous countries. Currently she is planning an exhibition program at the Telemark Artist's Center in Norway.

PAULA OWEN has been the president of the Southwest School of Art (Texas) since 1996 and was the director of the Visual Art Center of Richmond (Virginia) from 1985 to 1996. She holds an MFA from Virginia Commonwealth University and has served on numerous national boards and panels, including the Visual Arts Panel for the National Endowment for the Arts, and has written for *Art Lies*, *Art Papers*, *New Art Examiner*, and *American Craft*. She has curated over sixty exhibitions and organized the conference "Women and the Craft Arts" at the National Museum of Women in the Arts in 1993. With M. Anna Fariello she edited *Objects and Meaning: New Perspectives on Art and Cr*aft in 2003. Owen is also a practicing artist with works in both public and private collections.

KARIN E. PETERSON is an associate professor of sociology at the University of North Carolina, Asheville. Her research explores the construction and maintenance of cultural hierarchies, as well as gender and culture more broadly. She has published work on French art galleries and on quilts as art.

LACEY JANE ROBERTS holds a master's of fine arts degree and a master's degree in visual and critical studies from California College of the Arts. She completed bachelor's degrees in studio art and English at the University of Vermont. Her current critical writing focuses on rethinking the rhetoric of craft to propose a more progressive discourse in the field, and her academic interests include queer theory and feminist theory. Her studio practice consists of large-scale site-specific knitted installations that occasionally include guerilla actions. She is the past recipient of the Ian Crawford Memorial Award, the Ora Mary Pelham Poetry Prize, the Toni Lowenthal Memorial Scholarship, a Murphy Cadogan Fellowship, the Dennis Leon Award, and the Searchlight Artist Award from the American Craft

Council. In 2009 she was a Smack Mellon Hot Pick artist. She is the 2010–11 emerging artist-in-residence in the craft and materials studies department at Virginia Commonwealth University.

KIRSTY ROBERTSON is professor of museum studies and contemporary art at the University of Western Ontario. Robertson's research focuses on activism, visual culture, and changing economies. She has published widely on the topic and is currently finishing her book *Tear Gas Epiphanies: New Economies of Protest, Vision and Culture in Canada*. Robertson also recently completed a Social Sciences and Humanities Research Council postdoctoral fellowship at Goldsmiths, University of London, focusing on the study of wearable technologies, immersive environments, and the potential overlap between textiles and technologies. She considered these issues within the framework of globalization, activism, and burgeoning "creative economies." Robertson has published widely on these topics, in forums ranging from *FUSE magazine* to the *Communication Review* to recent collections such as *Fluid Screens, Expanded Cinema*.

DENNIS STEVENS'S research, writings, and multimedia productions have engaged the hybrid intersections of art, craft, and design while analyzing the triumphs and failures of craft object makers and their products in the struggle to achieve professional validation within the domain of art. Since 2006, Stevens has lived in New York City, and in the summer of 2010, he completed his doctorate of education degree in the college teaching of art program at Teachers College, Columbia University. He also holds a master's of education degree in instructional technology from San Jose State University and a bachelor's of fine arts degree in ceramics from Clemson University. Additional information about Stevens and his work in craft can be found online at www.RedefiningCraft.com; details on his current projects can be reviewed at www.DennisStevens.net.

MARGARET WERTHEIM is a science writer and author of books on the cultural history of physics, including *Pythagoras' Trousers*; a history of the relationship between physics and religion; and *The Pearly Gates of Cyberspace*, one book in a three-part history of Western concepts of space, from Dante to the Internet. She is currently at work on the third volume in this trilogy, *Lithium Legs and Apocalyptic Photons: A Trailer Park Owner's Theory of Everything*, which explores the life and work of the outsider scientist James Carter and the role of imagination in theoretical physics. Wertheim also founded the Los Angeles–based Institute for Figuring, an organization devoted to enhancing public engagement with the aesthetic and poetic dimensions of science and mathematics. Through the IFF, Margaret and her twin sister, Christine, have spearheaded the *Hyperbolic Crochet Coral Reef* project, which now engages thousands of women around the world in an enterprise that resides at the intersection of mathematics, marine biology, feminine handicraft, environmental activism, and community art practice. The project has been exhibited at the Hayward Gallery in London, the Smithsonian National Museum of Natural History, and galleries in New York, Los Angeles, and Chicago.

INDEX

Italicized page numbers indicate illustrations.

Abakanowicz, Magdalena, 185
Abattoir Editions, 138
Absent Figures (Allen), *168*
"Abstract Design in American Quilts"
 (Holstein and van der Hoof), 106–9
abstract expressionism, 4, 28, 103, 105,
 107, 118, 184
Abu Ghraib (prison), 196
activism. *See* craftivism
Adamson, Glenn, 2, 8
aesthetics (field), 14, 23, 35, 59–82,
 100–106, 128, 235
Afghans for Afghans (charity), 180
African Americans, 12, 30–31, *31*, 34
Afro Abe II (Clark), *12*
AIDS (General Idea), 122, *123*
AIDS Memorial Quilt, 18, 205–6, 219n3
Albers, Anni, 35–36
Alderson, Lynn, 189
Allanstand Cottage Industries, 35
Allen, Daniel, 16, 167–68, *168*
alterglobalization, 184–203. *See also*
 capitalism; globalization
Amer, Ghada, 5–6, *7*
American Craft Council, 24, 39–40,
 244, 257
American Craft (magazine), 244, 288–
 89, 290n4
American Craft Museum, 8
American Typefounders Company, 138
Anastasi, William, 88–89
Anderson, Walter Truett, 55–56

Andy Warhol Museum, 289
Another Spring (Amer), *7*
antipersonnel (Hunt), *209*, 210, *211*,
 218
Anti-War Graffiti Cross-Stitch (Greer),
 181
Antoni, Janine, 9, *10–11*, 83
Appadurai, Arjun, 238n14
Armstrong, Samuel, 30
Arrowmont School of Arts and Crafts,
 35
art: autonomy of, 68–73, 77, 79–80;
 commodification and, 204–21, 248;
 definitions of, 26, 284–85; dis-
 courses of, 143; education in the
 field, 4, 30–31; hierarchies within,
 2–19, 23–24, 26, 29, 39, 49, 61, 106,
 129, 148, 159–61, 194–95, 199; as hy-
 brid with craft, 135–52; intention
 and, 89; as motive, 266; process art,
 88–90; relationship of, to life, 63–65,
 68, 71–72, 74–75, 78–80; "world"
 of, 66–67. *See also* capitalism; craft;
 fine arts; museums; *specific artists,
 shows, venues, and works*
Art as Experience (Dewey), 32
Art Center College of Design, 68
art criticism, 23, 60
Artforum (periodical), 47
art history, 18, 23, 29, 184–204
Art in America (periodical), 47
Art Incorporated (Stallabrass), 195

ArtNews (periodical), 47

Art of Work, The (Coleman), 265

Arts and Crafts movement, 12, 24, 27–29, 51, 73–75, 136–38, 223, 260–75

Arts and Crafts Society, 137

Art vs. Craft (craft fair), 52

Art Worlds (Becker), 225

Attfield, Judy, 80, 261

Auerbach, Lisa Anne, *198*, 220n10

Auther, Elissa, 15, 106, 115–34

autonomy (term), 14–15, 62–80, 100–101, 109–10, 119–21

avant-garde, 4, 36, 65–67, 73–75, 78–79, 159

baby boom generation, 14, 48–49, 54

B&B, 232

Banksy (artist), 180

Barach, Kathleen, 109

Barbican Cave Gallery, 229

Barclay, Claire, 231, 237, 239n29

Barthes, Roland, 54, 58n21

Battersea Arts Center, 184

Bauhaus movement, 35–36

Bazaar Bizarre, 52

Becker, Howard, 225

Bed (Rauschenburg), 4–5

Bench Block (Harrison), 166

Benglis, Lynda, 93

Berea College, 33–34

Berman, Kim, 219n7

Bernasconi, Helen, 281

Betty Parsons Gallery, 120

Beuys, Joseph, 224

Bhabha, Homi, 246

Big Baby (Cook), *250*

Bild Zeitung (newspapers), 66

Biltmore Estate Industries, 35

Bishop, Claire, 84

Black, Anthea, 17, 187–88, 204–21

Black Mountain College, 35

Blake, William, 144

book art, 135–52

bookmaking, 16, 135–52

Book of Pottery, A (Poor), 39

boundaries and boundary-crossing, 12–13, 16, 225–27. *See also* craft; hybridity

Bourdieu, Pierre, 100, 108

Bourriaud, Nicolas, 14, 83–86, 88, 235

"Boys Who Sew" (show), 8

Breath (Cushway), 166–67

Bright, Betty, 16, 135–52

Brinch, Jes, 66, *66*

Britain (as home of craft movements), 27–30

British Craft Council, 8

British Monotype Corporation, 138

Buchloh, Benjamin, 121

Bullies (Marti), 126–28

Burden, Chris, 83–84

Burden, Jane, 288

Bürger, Peter, 67–69, 72–73, 79

Burisch, Nicole, 17, 187–88, 204–21

Bush, George W., 196

BUST (magazine), 190

Buszek, Maria, 1–19, 276–90

By Hand (Hung and Magliaro), 59–60

Cabrera, Margarita, 196

Calgary Revolutionary Knitting Circle, 187–90, 206, 215–16, *216*, 221n25

California College of Arts and Crafts, 8, 249

camp (term), 117, 130n9

Campbell, Colin, 266

Campbell, Ken, 16, 135, 140, 144, *144*, 145–46, *146*, 147–49

Campbell's Soup Cans (Warhol), 121

capitalism, 17, 43–45, 52–53, 186–221, 248, 253

Carrington, Sarah, 232

Cast Off Knitters (group), 207

Cathedral (Pollock), 119

Center for Contemporary Art, 8

Centering (Richards), 25

Century of Ceramics in the United States, A (Clark), 61

"Ceramic Contemporaries 4" (show), 166

ceramics, 4, 16, 39, 47, 62, 75, 153–71.

See also specific artists, crafters, and shows

"Ceremony" (show), 232–33, *233,* 235, 237

Chambers (Shepard), *91*

"Charms of Lincolnshire, The" (show), 224

Chicago, Judy, 5, 110, 185, 193

Chip Girl (Schlangel), 230

Christiansburg Industrial Institute, 30–32

Church of Craft (collective), 178–79

Clark, Garth, 61

Clark, Sonya Y. S., 12, *12*

clay. *See* ceramics

"Clay Rocks" (show), 153–55, 157, 166

cocooning (term), 268–69

Cole, Dave, 89

Coleman, Roger, 265–66, 274n16

College Art Association, 47, 251

Collins, Liz, 18, 251, *252,* 254, 257–58

community: importance of, to craft, 43–56, 187, 201n21, 217–18

concepts and the conceptual, 158–59, 169

Consciousness/Conscience (Twomey), 164–65, *165*

Constance Howard Resource and Research Center in Textiles, 232

Contemporary Art Center, 234–35

contenting and contents: in and of craft objects, 83–96, 141

Cook, Lia, 249, *250,* 251, 255, 257–58

Cooper-Hewitt Museum, 251

Corman, Roger, 287

Cornell University, 276–78

Cotton States Convention, 30

Cow Wallpaper (Warhol), 115–16, *116,* 117, 130

craft: aesthetic position of, 59–82; amateurs and, 260–75; in American education, 30–31; Americanness of, 27–28, 30; anticapitalist movements and, 17; authenticity and validity in, 43–56, 60–61, 68, 71–72, 112; autonomy and, 14–15, 62–80, 100–101, 109–10, 119–21, 214; as blue-collar work, 43–44; boundary-crossing potential of, 12, 157, 161, 204–21, 225, 227, 251; collectors of, 45; commodification and, 204–21, 221n23, 253; communities of practice and, 43–56; consumption of, 266–67, 272; content in and contents of, 83–96; criteria of, 8, 13; critical theory and, 243–59, 259n11; culturing of, 75–77; curatorial decisions and, 17, 204–40; definitions of, 3, 18, 23–27, 40, 43, 49, 59, 71, 149, 222, 231–32, 243–44; differences in, between American South and North, 35; displaying decisions concerning, 102–4; distinctions with design in, 60, 72; function and, 36–38; galleries' and museums' roles in, 8; gendering of, 115–34, 161, 185–203, 284–86, 288–89; identity and, 2–3, 46, 59, 62, 127, 243–59; Industrial Revolution's impact on, 2–3, 26, 53, 73–74, 137; Internet and, 43–56; irony in, 50–55; know-how and, 43; language of criticism and, 23–42; as making, 23; marginality and, 5, 18, 34–35, 71, 109–10, 117, 148, 214, 245–47, 257; objects of, 61; political agendas and, 66–67, 70–72, 137, 145, 169, 184–222, 226, 231, 243–59, 282; practices of, 14, 43–59, 62, 71, 75, 93, 216; queer theory and identity and, 117–35, 243–59; reading and, 149–50; relationship of, to art, 8, 13, 15–18, 23–24, 26, 39, 61, 106, 129, 199, 222–40, 243; relevance of, in technology-saturated world, 1; romance of, 6; science and, 18; socioeconomic reforms and, 34–35; subversive nature of, 184–203; traditions of, 12–13; values and value of, 45. *See also* aesthetics (field); art; Arts and Crafts movement; craftivism; *specific artists, authors, crafters, media, and shows*

"Craft" (show), 227–29

craft criticism, 8–9

craft fairs, 52

"Craft Hard Die Free" (Black and Burisch), 17

craftivism: curatorial strategies and, 204–21; definition of, 175; history of, 175–203, 239n19; introduction to, 16–17; practices of, 205–6

Craftivism.com, 16, 53, 227

craft media, 2, 12. *See also specific media*

"Craft of Design Art, The" (Julius), 60

Craft Revival (movement), 35

Crafts (magazine), 60, 223

Craftsman (magazine), 28, 30, 33–34

Craftster.org, 53, 227

critical (craft) theory, 243–59, 259n11

crochet, 276–90

Crone, Rainer, 115

Cronin, Patricia, 134n46

Csikszentmihalyi, Mihaly, 267–68

cubism, 28

Cultured Primitiveness—Exclusively Folksy (show), 75, *76–77*

Culture of Craft, The (Dormer), 8, 41n2

Cummington Press, 138

curation, 17, 204–21

Cushway, David, 16, 162–63, *163*, 164, 166–67

Dadaism, 28, 67, 74, 159

Dahn, Jo, 16, 153–71

Dant, Tim, 263

Davenport, Bill, 93

David, Enrico, 238n11

de Antonio, Emile, 118

decorative art. *See specific fields and media*

de Cruz, Gemma, 222

Deitch Gallery, 1

de Kooning, Willem, 105

Deller, Jeremy, 225, 228–29, 231, 234

design (as art form), 24–25, 60, 62, 68–72, 77

Design and Crime (Foster), 70

de Waal, Edmund, 62, *64*, 65

Dewey, John, 32–33

Dia Center for the Arts, 126

Diderot, Denis, 222, 237

"Disco Sucks" (ad campaign), 132n28

Disidentifications (Muñoz), 246–47

disinterestedness (aesthetic requirement), 100, 105

DIY movement, 16, 50–55, 204–35, 253, 260–75

Dormer, Peter, 8, 41n2, 223–25, 238n11

Doves Press, 138

Duncan, Carol, 100

Duncan, Harry, 138

Eastern State Penitentiary, 127

Eaton, Allen, 28

eco-gastronomy (movement), 16

education, 29–35. *See also* Dewey; Frost; Long; Washington

"Educational Program for Appalachian America, An" (Frost), 34

Edwards, Glynn, 260, *261*, 271–72

elasticity, 153–71

Eliot, George, 191

Ellis, Patricia, 230

Emin, Tracy, 9, 194–95, 224–25, 238n11

encounter (term), 83–96

Encyclopedia (Diderot), 222, 237

English, Debby, 159

Eternal Sunshine of the Spotless Mind (Gondry), 1

Euclid, 276

"Every Day" (show), 225

exhibitions, 77–78. *See also specific shows*

extraordinary (definition), 99

ExtremeCraft.com, 53

"Extreme Crafts" (show), 8, 234–35, *236*, 237

fabrication, 83–96

"Fabrication and Encounter" (Owen), 14, 83–96

Family and Kinship in East London (Young and Wilmot), 269

Farago, Claire, 100

Fariello, M. Anna, 3, 13, 23–42, 50
Faught, Josh, 254–55, *256*, 257–58
Featherstone, Mike, 266
feminisms: critiques of fine-art world and, 110, 129–30, 223, 244; manifestations of, in craft, 184–203; quilting and, 18, 106–8; science and, 280–88; second-wave, 12, 186, 191; third-wave, 16, 51, 54, 57n18, 186, 194; Western aesthetics and, 88–89
Feminist Art Journal, 107
"Feministo: Women and Work" (show), 184, 193
Ferus Gallery, 121
fiber arts, 4, 9, *10–12*, 17, 26, 35, 39, 93, 276–90. *See also* knitting; *specific artists and media*
Field Guide to Hyperbolic Space (Wertheim), 276–78
film (medium), 162
fine arts (as opposed to craft), 3, 39, 118, 121, 148, 194, 224–27, 243
Finneran, Bean, 90, *91*
Firedogs (Campbell), 144, *144*, 145, *146*, 147–48
Fireside Industries, 33, *33*
flow (term), 267–75
Flowers (Warhol), 115, *117*
Fluxus (collective), 84, 139
Folk Archive (Deller), 229
"Folk Archive" (show), 229, 232, 237
Forcefield collective, 9
Forest (Gober), 125–26
formalisms, 84, 100, 108–9, 112n4
For Oscar Wilde (Marti), 126–27, *128*
Foster, Hal, 14, 70, 79–80
Found and Lost Grotto for Saint Antonio (Steiner and Lenzlinger), 85
Four Letter Word Book (Van Vliet), 139
Frankenthaler, Helen, 4
Fraser, Andrea, 214
Frayling, Christopher, 223
Free Trade Area of the Americans Agreement, 187

Friedan, Betty, 198
From an Historical Anecdote about Fashion (McElheny), 90, 92
Frost, William, 28, 34–35
FULL (event), 160
Fuller, Peter, 223–25, 238n11
functionality (in understanding craft), 36–39, 75, 77–78

Gabberjabb (book series), 138–39
Gallaccio, Anya, 230–31, 237
galleries. *See* capitalism; craft; fine arts; *specific shows and venues*
Garage Sale (Rosler), 229
Gardner, Howard, 44
gaze (concept), 100, 109
Gelber, Stephen, 268
Geldzahler, Henry, 115
gendering, 17, 115–34, 185–203, 268, 284–89. *See also* feminisms; identity; queer theory
General Idea (collective), 122, *123*
Generation X, 14, 47–52, 54–55
Generation Y, 14, 47, 51–52
geometry, 276–90
German Idealism, 73
Getcrafty.com, 177
Giddens, Anthony, 46
Glambek, Ingeborg, 73
glass (medium), 39, 47
globalization, 185–221
Gober, Robert, 15, 118, 122–23, *124*, 125–26, 130
Godard, Jean-Luc, 54
goldsmithing, 40
Goldsmith's College, 284
Goldsworthy, Andy, 89
Gondry, Michael, 1, 2
Gonzales-Torres, Felix, 14–15, 83
Gramsci, Antonio, 50
Greenbacker, Liz, 109
Greenberg, Clement, 3–4, 67, 105–6, 120–21
Greenhalgh, Paul, 23, 157
Greenham Common Royal Air Force Base, 185, *185*, 189–90, 193, 199–200

Greenwich Village Halloween Parade, 176–77
Greer, Betsy, 16, 175–83, *181*, 190–92, 231, 239n19
Greer, Germaine, 191, 202n29
Grow Room 3 (Marti), 126, 128–29
Guardian, The, 188, 194
Gulf War, 145

Hamady, Walter, 138–39, 149
Hamilton, Ann, 86, *87*
Hampton Institute, 30, *31*, 34
"Handwork and Hybrids" (Bright), 16
Handy Cats Workshop, *213*
Hanging Man/Sleeping Man (Gober), 125
Hardin, Evelyn, 289–90
Harpur, Merrily, 284
Harrison, Charles, 112n4
Harrison, Keith, 153, *154*, 155, 157, 165–66
Harrison, Margaret, 202n39
Harvard University, 283, 290
Hawking, Stephen, 283
Hawkins, Peter, 205
Hegel, G. W. F., 272
hegemony, 50
Heiss, Alanna, 214
Hemelyk, Catherine, 235
Henderson, David, 279
Henricksen, Kent, 71
Hess, Thomas, 115
Heyward Gallery, 289
Hickey, Dave, 47–48
Higgins, Charlotte, 188
Hobbis, Peter, 169
Hogg, Eileen, 166
Hoggard, Liz, 224
Hole, Nina, 159
Holstein, Jonathan, 15, 99, 101–8, 111, 112n1
"Homespun Ideas" (Matthews), 243, 258n1
Homeworkers (Harrison), 202n39
homosexuality, 115–34
Honest Labor (Burden), 83

Hope, Sophie, 232
"How the Ordinary Becomes Extraordinary" (Peterson), 15
Hubbard, Elbert, 151n9
Hung, Shu, 59–60, 71–72
Hunt, Barb, 195, 209, *209*, 210, *211*, 218
Hutchins, Linda, 83
Huws, Edrica, 202n29
Huxley, Aldous, 119–20
hybridity (in art genres), 16, 43, 56, 85, 135–52, 225–27, 257–58
Hyperbolic Crochet Coral Reef (Wertheim), 277, *277*, 280, *280*, 282, 283–84, *285*, 288
hyperbolic space, 276–90

Ibata, Katsue, 160
identity, 243–59, 261. *See also* feminisms; gendering; queer theory
I Knit UK Knit a River (project), 196, *199*
Imperial College (London), 166
Impression, Sunrise (Monet), 119
Index (design event), 68, *70*
Indiana, Robert, 123
Indigo Blue (Hamilton), *87*
"Industrial Art in the Public Schools" (*Craftsman*), 34
Industrial Revolution, 2–3, 26, 53, 73–74, 137
installation art, 115–34, 161
Institute for Figuring (IFF), 18, 276–79, 283–84, *285*, 288
International Ceramics Festival, 159
International Monetary Fund, 187
Internet, 43–56
"Intimate Matters" (Ramljak), 86
Invention of Art, The (Shiner), 74
Invisible Core, The (Wildenhain), 39
Iraq War, 177–83, 196, 207, 220n10
irony, 50–55

Jackson, Andrew, 18, 260–75
Jameson, Tonya, 191–92
Janoff, Callie, 178
Janus Press, 139

Jefferies, Janis, 17–18, 222–40
Jenson, Nicolas, 138
Jeu de Paume Gallery, 125
John C. Campbell Folk School, 35
Johnson, Garth, 13
Jørgensen, Marianne, 196, *197*, 207, *208*, 209, 218
Joyce, Tom, 89
Julius, Corinne, 60, 71

Kane, Alan, 229
Kant, Immanuel, 73
Karp, Ivan, 100
Kelley, Mike, 9
Kemske, Bonnie, 167
Kennedy, John F., 54
Kentucky Museum of Art and Design, 8
Kettle's Yard, 227
Key, Joan, 227
kitsch, 52, 117, 212
Klein, Jody, 110
Knit Knit (group), 196
knitPro (application), 180, *182*
knitting, 16, 18, 89, 175–221, 238n11
Knitting during Wartime (Collins), 253
Knitting Machine (Cole), 89
Knitting Nation, 18, 251, *252*, 253–54
Koie, Rjoji, 160
Koons, Jeff, 5–6, 289–90
Kopytoff, Ivan, 238n14
Koshalek, Richard, 68
Kramer, Hilton, 106–7
Krauss, Alyssa Dee, 86
Kubler, George, 36–37

Laboratory School of Chicago, 32
"Labor of Love" (show), 8, 93
Ladd, William, 288
Ladies Silurian Atoll (Wertheim), *282*
language (in craft theory), 23–42
Larned, Emily, 141
Larsson, Carl, 77
Last Supper (Harrison), 153, *154*, 157, 165
Lavine, Steven, 100

Leach, Bernard, 24
Leadbeater, Charles, 263–64
Le Dray, Charles, 83
Lee, Philip, 161
Leedy, Jim, 4
Lenzlinger, Jorg, 85
Leo Castelli Gallery, 115
Leroy, Louis, 119, 131n14
"Lessons in Practical Cabinet Work" (*Craftsman*), 33
letterpress printing, 135–52
Lewin, Walter H. G., 286
LeWitt, Sol, 153, 164, 166, 169
Lidrbauch, Christine, 122, 129–30
Life (magazine), 119
LifeStraw, 68, *69*, 70
Lippard, Lucy, 153, 194
Little Shop of Horrors (Corman), 287
London Orbital (Harrison), 155, 157
Lone Star Foundation, 122
Long, Edgar, 32–34
Longdon, Trisha, 193
Long View, The (de Waal), *64*
Loos, Adolf, 70
Lord, Andrew, 166
Lou, Liza, 83
Louis, Morris, 88
"Lovecraft" (show), 8, 222, 228–29
LOVE (Indiana), 123
"Loving Attention" (Jefferies), 17
Lozano-Hemmer, Raphael, 85–86
Lucero, Michael, 93
Lupypciw, Wednesday, 210, 212, *213*, 216

Magliaro, Joseph, 59–60, 71–72
Mainardi, Patricia, 107–8
Make (magazine), 270, *271*
"Making and Naming" (Fariello), 13
making (process), 23
Malkin, Michelle, 192
Manet, Edouard, 3
Manic Street Preachers, 228
"Manual Training and Citizenship" (*Craftsman*), 34
Mao Wallpaper (Warhol), 117, 123

marginalization, 5, 18, 34–35, 71, 109–
 17, 148, 167, 214, 245–47
Marti, Virgil, 15, 118, 122–23, 126–28,
 128, 129–30
Martin, Agnes, 4
Marx, Karl, 74
marxism, 67
Maslow, Abraham, 264, 273n3
material culture (term), 61, 73, 75
Materiality and Society (Dant), 263
mathematics, 276–90
May, Victoria, 71
Mazanti, Louise, 14, 59–82
McElheny, Josiah, 15, 90, 92, *92*
McFadden, David, 186, 244
McGeown, Martin, 228–29
McLaren, Malcolm, 225, 229
McLaurin, Cathy, 89
McWilliams, James, 139
Meat Joy (Lee), 161
Melchert, James, 161
Memory Map (Welch), 85
Menstrual Blood Wallpaper (Lidr-
 bauch), 129
"Men Who Make" (Jackson), 18
Merleau-Ponty, Maurice, 263
Messager, Annette, 9
metalwork, 28, 39, 47
Metcalf, Bruce, 44, 161, 244
Microrevolt.org, 180, 196
Midelburg, Marianne, *280*
Miller, Paul, 263–64
minimalism, 88
Mobility for Each One, 68
Moderna Museet, 116
modern eye (definition), 100
modernism, 3–4, 15, 28–31, 36, 73–74,
 100, 108–19
"Modernism" (Harrison), 112n4
Monday Morning Weekly (publica-
 tion), 68
Monet, Claude, 119
"Moral Value of Hard Work, The"
 (*Craftsman*), 34
Morison, Stanley, 138
Morris, Estelle, 238n11

Morris, Robert, 95, 116
Morris, William, 2, 16, 27–28, 74, 136–
 40, 169, 223, 265, 288
Morris and Company, 27
Most, Henrik, 60, 71–72
MotelHaus Objects (Novak), 62, *63*
Muñoz, José Esteban, 246–47
Museopathy (project), 210
"Museum Is Not Just a Business, A"
 (Fraser), 214
Museum of Art and Design, 8, 243–44
Museum of Contemporary Craft, 8
Museum of Fine Arts (Houston), 111
museums, 8, 100–102, 108, 214. *See
 also specific galleries and museums*
Muster, The (Collins), 253
My Bed (Emin), 238n11

NAMES project, 205–6
"Naming Names" (Hawkins), 205
Nancy Margolis Gallery, 251
National Association of Teachers in
 Colored Schools, 32
National Trust England, 224
Nature of Art and Workmanship, The
 (Pye), 228
netroots movement, 14, 47
New Bedford Textile School, 34
Newkirk, Kori, 9
"New Labour" (show), 230, 237, 239n27
Newman, Barnett, 103, 105, 108
New Museum of Contemporary Art, 8
New South Wales Museum and Art
 Gallery, 225
New York Times, 106
New York Trade School, 34
9/11 (as political rupture), 17, 177, 191
Nobody Knows I'm a Lesbian (Faught),
 255, *256*
Nocturne (Whistler), 119
Northern Clay Center, 163
"Notion Nanny" (exhibition), 232, 235,
 237
Notion Nanny Guild, 232
Novak, Justin, 62, *63*
Nytorv, Kongens, 66

Object as Poet, The (Slivka), 38, *38*
objects, 61–82
On Weaving (Albers), 36
Optimal Experience (Csikszentmiha-
 lyi), 267
Orange Anemone (Wertheim), *277*
O'Reilly, Maxine, 159
"Ornament and Crime" (Loos), 70
"Other Question, The" (Bhabha), 246
Out to Dry (Scott), *6*
Owen, Paula, 14, 83–96, 235

Paper Prayers (project), 219n7
Parker, Roszika, 3, 8, 184
Participation (Bishop), 84
Paula Cooper Gallery, 125
Peace Knits (banner), 206, *207*, *216*
Penland School of Crafts, 35
Percy, Paul Heber, 227
performance art, 159–61, 210
Perry, Grayson, 9, 224–25, 231, 238n11
Peterson, Karin, 15, 99–114
photography, 5, 102–3, 163
Pink M.24 Chaffee (Jørgensen), *197*,
 207, *208*, 209, 218
Pinochet, Augusto, 186
Planthas, Sadie, 200n9
Plenge Jakobsen, Henrik, 65, *66*, 67, 71,
 79–80
Polanyi, Michael, 43
Pollock, Jackson, 88, 105, 119–21
Poor, Henry Varnum, 39
Popcorn, Faith, 268–69
Porges, Maria, 195
Porter, Shari, 282
postmodernism, 4–6, 12, 15, 50–56, 245
Potter's Book, A (Leach), 24
Practical Householder (magazine), 262,
 262
practice (as component of craft), 14,
 43–62, 71, 75, 93, 216
Predella II (de Waal), *64*
Preziosi, Donald, 100
Price, Ken, 93
Price, Robin, 16, 135, 140–41, *141*, 142,
 142, 143, 147–49

"Pricked: Extreme Embroidery"
 (show), 8
Princeton University, 283, 290
Pro-Am Revolution, The (Leadbeater
 and Miller), 263
Pro-Ams, 263–64
process art, 88–90
professionalism (in DIY movement),
 263–64
Progressive Education Association, 32
punk movement, 50
puppeteering, 176–77
Puryear, Martin, 93
Pye, David, 223, 226, 228, 230–31

Quebec City, 187–88
queer theory, 16–18, 117–34, 245
quilts and quilting, 5, 9, 15, 99–114, *102*
"Quilts of Gee's Bend" (show), 15, 111

radical knitting, 184–203, *198*
"Radical Lace and Subversive Knitting"
 (show), 8, 186, 240n32
Raedecker, Michael, 225, 230–31
Railla, Jean, 177
Ramljak, Suzanne, 86
Rauschenberg, Robert, 4
reading, 149–50
"Rebellious Doilies and Subversive
 Stitches" (Robertson), 17
Red Oval (Finneran), *91*
Red Sweaters Project, 196
Reichek, Elaine, 93, *94*, 134n46
"Reimagining Craft Identities Using
 Tactics of Queer Theory" (Roberts),
 18
Relational Aesthetics (Bourriaud), 83
Renegade Craft Fair, 52
Renwick Gallery, 38
Revolutionary Knitting Circle, 187–90,
 206, 215–16, *216*, 221n25
Rhode Island School of Design, 251
Richards, Mary Caroline, 25
Richard Salmon Gallery, 227
Ringgold, Faith, 5, 110
Riot Grrrl movement, 50

Risatti, Howard, 2–4, 93
Robbins, David, 54
Robbins, Freddie, 232
Roberts, Lacey Jane, 18, 243–59
Robertson, Kirsty, 17, 184–203
Robinson, Jean, 8–9
Rookwood Pottery Company, 28
Rosenberg, Harold, 119, 121
Rose Valley, 28
Rosler, Martha, 229
Ross, Betsy, 253
Ross, Sandra, 232
Rothko, Mark, 4, 105
Royal College of Art (RCA), 158, 166
Royal Military College of Canada, 210
Ruskin, John, 2–3, 27–28, 30, 39, 137,
 223, 265
Russian Constructivism, 67

Salas, Carolyn, 71
Sampler (The Ultimate) (Reichek), 94
Sandammeer, Paul, 160–61
Schapiro, Miriam, 5, 110
Schlangel, Andreas, 230
Schneeman, Carolee, 161
Schönberger, Sonya, 235, 236
schools (craft's use in), 29–35. See also
 specific institutes and schools
Schor, Naomi, 129
science and science education, 280–88
Science of Sleep (Gondry), 1, 2
Scientific American (magazine), 278,
 287, 290
Scott, Joyce, 5, 6, 12
Scrupe, Mara Adamitz, 83
sculpture, 8–9, 40, 83, 89, 111. See also
 specific artists and shows
Second World War, 3–4, 260, 269
Sedgwick, Eve, 245
Segal, Lynne, 269
self-actualization, 264–66, 273n3
Self-Portrait Wallpaper (Warhol), 117
September 11th. See 9/11
Seven Lamps of Architecture, The
 (Ruskin), 39
Sex (store), 225

Shadows (Warhol), 122, 132n27
Shape of Time, The (Kubler), 36
"Shaping the Future of Craft" (confer-
 ence), 251, 257
Shepard, Piper, 14–15, 90, 91
Sherman, Cindy, 5
Shiner, Larry, 74
Shitlist (Faught), 254
Shonibare, Yinka, 9, 9
Siesbye, Alev, 62, 63
Silver Clouds (Warhol), 115, 130
skill (concept), 223
"Skill" (Pye), 223
Skilled Work (Risatti), 93
Slater, Don, 266
Slivka, Rose, 38, 38, 39
Slow Motion (Segal), 269
Slumber (Antoni), 10
Slurring at bottom (Price), 140–41,
 141–42, 143, 147
Smashed Parking (Brinch and Plenge
 Jakobsen), 66, 66
Smith, Alison, 232, 234–35
Smith, Kiki, 9, 71
Smithson, Robert, 89
Snowdon, Helen, 223
Snowdon (Cushway), 163
Solomon, Holly, 117
"Some Craftwork in a Southern High
 School" (Craftsman), 34
Sontag, Susan, 117
South London Gallery, 8, 184
Southwest Center for Craft Art, 8
Spinning Wheel (production center),
 35
Stallabrass, Julian, 195
Starling, Simon, 9
Stebbins, Robert, 264
Steiner, Gerda, 85
stereotypes. See identity
Stevens, Dennis, 13–14, 43–56
Stickley, Gustav, 28
Still, Clyfford, 105
Stitch 'n Bitch (Stoller), 190
"Stitch n' Bitch" knitting clubs, 16
Stoller, Debbie, 190–92

Storey, John, 46
Storr, Robert, 88
Story of the Glittering Plain, The (Morris), 137
Stride (gallery), 215, *217*
Stroud, Marion Boulton, 132n29
Stuckey, Charles, 130n8
Studio Craft movement, 2–3, 12–14, 23–42, 50, 74, 249, 251, 288
studio quilters, 109
Studio Voltaire, 232
Sublimation (Cushway), 162–63, *163*
subversion, 184–203
Subversive Stitch, The (Parker), 8, 184
Suda, Yoshihiro, 9
SuperNaturale.com, 53
super-object (term), 61–82
"SUPERSTRING" (show), 206, 215, 221n25
surrealism, 28, 67
Swallow, Ricky, 8
sweatshops, 196
Sweet Nothings (Waltener), 233, *233*, 234, *234*, 235
Sydney Biennial, 225
Symmetrical Family, The (Young and Wilmot), 269

Taimina, Daina, 18, 276–77, 279, 281, 287
Tawney, Lenore, 4
Taylor, Tanis, 194
Taylor, Tom, 119
Taylor, Tristy, 178
Temporary, The (Twomey), 163–64
Tepper, Irvin, 92
textiles (medium), 47, 184–203. *See also* fiber arts
Thames River, 145
Theory of the Avant-Garde (Bürger), 67
Thinking through Craft (Adamson), 8
"Think with the Senses, Feel with the Mind" (Storr), 88
Thomas Dane Gallery, 230
Three Graces (Shonibare), *9*

Three Sheets to the Wind (Gallaccio), 230
Tiffany, Louis Comfort, 28
Tiravanija, Rirkrit, 14–15, 83, 85, 94–95
Todd, Barbara, 196
Tönnie, Ferdinand, 46
Tophøj, Anne, 75, *76*, 77, *77*, 78–79
Transitional Thatch (Schönberger), 235
Trockel, Rosemarie, 9, 89
Trophy (Twomey), 155, *156*, 157, 164
TRUCK (gallery), 212
Tucker, Marcia, 93
Tultex (company), 198
Turner Prize, 9, 226, 230
Tuskegee Institute, 30
Twomey, Clare, 9, 16, 155, *156*, 157, 163–66, *165*

Ukeles, Mierle, 85
Ullrich, Polly, 86, 88
Ulmann, Doris, 25
Undoing Aesthetics (Welsch), 70
U. S. Bureau of Labor, 34
University School of Art and Design, 158
Untitled (Gober), *124*
Urquhart, Shari, 93
Uses of Literacy, The (Deller), 228

"Validity Is in the Eye of the Beholder" (Stevens), 13, 43–56
van der Hoof, Gail, 15, 99, 101–4, 107, 112n1
Van Vliet, Claire, 139, 149
Vasari, George, 40
Vectorial Elevation (Lozano-Hemmer), 85
Venice Biennale, 9, 88, 90
Victoria, Queen, 29
Victoria and Albert Museum, 23, 153–55, 157, 164
Vietnam War, 54
Voulkos, Peter, 4

wallpaper, 115–34
wallpaper (medium), 15

"Wallpaper, the Decorative, and
 Contemporary Installation Art"
 (Auther), 15
Waltener, Shane, 233, *233*, 234, *234*, 235
Warde, Beatrice, 138, 144, 152n15
Warhol, Andy, 15, 103, 115–16, *116*, 117–
 18, 121–23, 127, 129–30
Warm Sweaters for the New Cold War
 (Auerbach), *198*
War on Terror, 176–83
Washington, Booker T., 30, 34–35
weaving, 26, 35
Webb, Aileen Osborn, 56
Weber, Max, 48–49
Webster, Toby, 228–29
Welch, Roger, 85
Welsch, Wolfgang, 70
Wertheim, Barbara, 287
Wertheim, Christine, 276, 280, *280*,
 281–82, 284, 286–87, 289
Wertheim, Margaret, 18, 276–90, *277*,
 282
Westwood, Vivienne, 224, 229
WhipUp.net, 53
Whistler, James, 119
The White Stripes, 1
Whitney, Kathleen, 89–90

Whitney Biennials, 9, 128
Whitney Museum, 15, 99, 103–11, 116
Whittier, Nancy, 47–48
Wieland, Joyce, 185, 193
Wilde, Oscar, 127–28
Wildenhain, Marguerite, 39
Wild Things (Attfield), 80
Williams, Gerard, 228, 231
Wilmot, Peter, 269
Wilson, Anne, 93
Wilson, Conor, 160–61
Wolfe, Eva, *37*
Wombs on Washington, 196
women, 12
"Women and Textiles" (show), 184
Women's Peace Camp, 185, *185*, 189
wood (medium), 8, 47
wood firing (in ceramics), 165
wool (medium), 195–96
workmanship, 222–40
World Ceramic Exposition, 164
World Trade Organization, 187, 192–93
wormholes, 66–71, 79
writing (associations with craft), 23

Yellin, Samuel, 28, 29
Young, Michael, 269

MARIA ELENA BUSZEK is an associate professor of art history in the
College of Arts and Media at the University of Colorado, Denver. She is the
author of *Pin-Up Grrrls: Feminism, Sexuality, Popular Culture*, also from
Duke University Press.

Library of Congress Cataloging-in-Publication Data
Extra/ordinary : craft and contemporary art / edited by Maria Elena Buszek.
p. cm.
Includes bibliographical references and index.
ISBN 978-0-8223-4739-2 (cloth : alk. paper)
ISBN 978-0-8223-4762-0 (pbk. : alk. paper)
1. Handicraft—Social aspects. 2. Handicraft—Political aspects.
3. Art, Modern—21st century.
I. Buszek, Maria Elena, 1971–
II. Title.
TT145.E987 2011
745.5—dc22 2010038075